THE TAPESTRY COLLECTION

Medieval and Renaissance

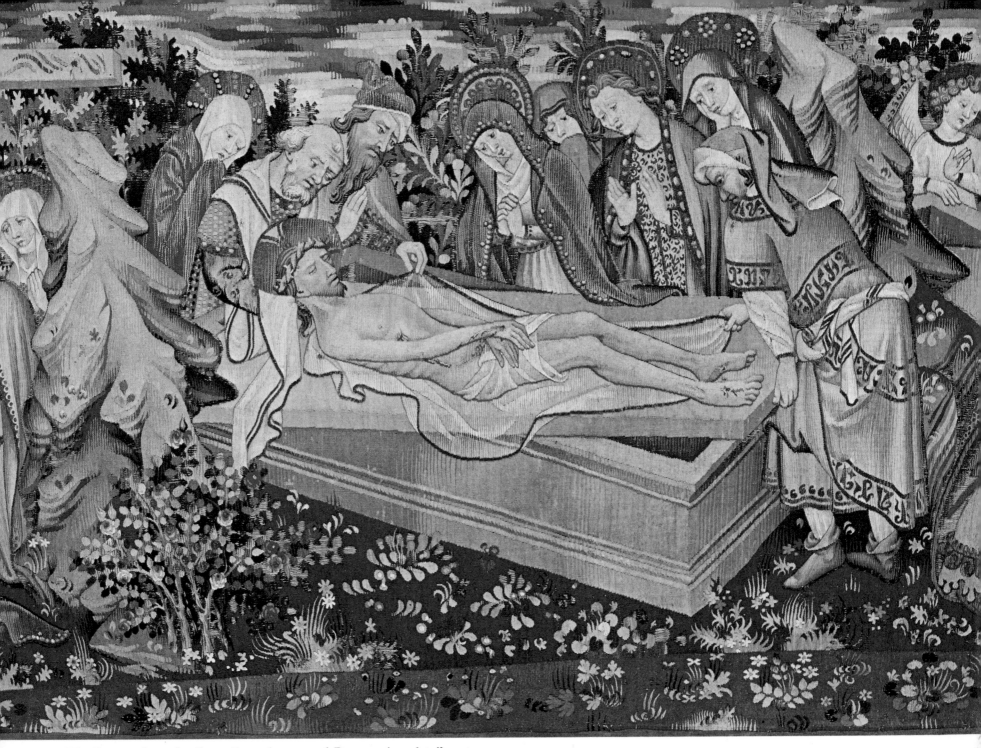

The Descent from the Cross, Entombment and Resurrection, detail; cat. no. 1.

VICTORIA & ALBERT MUSEUM

THE
TAPESTRY
COLLECTION

MEDIEVAL AND RENAISSANCE

George Wingfield Digby

assisted by Wendy Hefford

London: Her Majesty's Stationery Office

© *Crown copyright 1980*

First published 1980

ISBN 0 11 290246 4*

Designed by HMSO Graphic Design

Printed in England for Her Majesty's Stationery Office
by W. S. Cowell Ltd, Butter Market, Ipswich
Dd 496462 K13

The account of the tapestries given in this volume is illustrated with each tapestry shown in full, as well as sections and details to show something of their essential qualities of design and texture. The information about them begins with matters of general interest, leading on to more specialised knowledge. Many of them are sufficiently important to require long notices and there are interesting associations with other pieces represented elsewhere in Europe and America. To begin with, special mention should be made of a few of the most celebrated: the four great *Hunting Tapestries* dating from before the middle of the fifteenth century are a remarkable record of the life of the Middle Ages; the still earlier *Passion* tapestry with three scenes of the Descent from the Cross, Entombment and Resurrection, in the style of Arras; the *Trojan War*, which is one of the most fully documented among famous medieval tapestries, with the original designs still preserved; the *Triumphs of Petrarch* from early sixteenth century Brussels before Raphael's cartoons for the Sistine Chapel hangings arrived there and revolutionised tapestry design; the *Playing Boys* of Giulio Romano (bequeathed by George Salting with the original sketch for the design), one of a series which enjoyed a long-lasting popularity taken up again at Mortlake in the seventeenth century; and from the very end of our period, two long tapestries representing the *Planets* and their influences on mankind, woven in a minutely detailed manner at Oudenarde (a most unfamiliar style for this centre).

But there are others where there are two or more which are interesting particularly for the group they represent. For instance, late medieval tapestries with 'mille-fleurs' grounds are a hotly debated subject. Which were made in France and which are of Flemish origin? These and other *Verdure* tapestries, *Landscape and Garden* subjects, and *Grotesques* are all discussed as groups (in addition to the individual entries). The English tapestries originating with William Sheldon in the latter part of the sixteenth century are better represented here, in the National Collection, than anywhere else. The involved history of the Sheldon and Hickes families is, therefore, rather fully set out, so that the significance and documentation of the individual pieces can better be understood.

This collection was made principally by purchase, with some generous gifts and bequests, the Royal collections of England (such as were not sold under the Commonwealth in the middle of the seventeenth century) still being the property of the Crown: the remains of the Tudor collection hangs at Hampton Court Palace. Luckily the Victoria and Albert Museum was early in the field for purchases. £25 or less was a good

Introduction

price for a medieval tapestry around 1858. The Museum seems to have begun by buying German tapestries. The *Search after Truth* (No.14) was bought for £10 in 1856; the *Buzzard* (No.13) for £10 in 1858, and the *Labours of the Months* (No.12) cost £6 in 1867. Also in 1858 the lovely *Contarini Landscape* hangings (a set of four, with an *entre-fenêtre*) were bought for £20 under the misapprehension that they were German (Nos.52–56). None the less, the small group of German and Swiss tapestries is of the highest quality and rarity (although greatly outnumbered by the very distinguished group in the Burrell Collection, Glasgow).

In 1859 other important tapestries were bought. From the Soulages collection the two splendid *Pastorals* (Nos.19, 20) were acquired for only £25 together, and the refined *Esther* (No.29) for another £25. The *Three Fates* (No.26) cost only £24 in 1866, and even the great *War of Troy* (No.6), which had been recently hanging on the stairway of the Paris Bibliothèque Nationale, and was supposed to have come from the Château de Bayard, was bought for no more than £1,200. In 1872 *Susanna and the Elders* (No.17), a tapestry in superb condition, was acquired for £190 after the architect and designer, Sir Matthew Digby Wyatt, had been consulted; he recommended, 'The price is large for one piece out of a set . . . I think this is desirable at about £150', and he noted that prices had fallen with the 'French war' (Franco-Prussian war of 1870). In 1889 a very highly prized tapestry was bought for £1,176 from the Castellani collection, Rome; it was the *Adoration of the Infant Saviour* (No.27), richly woven with gold and silver. Sir Frederick Leighton, John Henry Middleton and William Morris were all consulted and wrote letters of recommendation; it is interesting to find Morris praising with enthusiasm this sweet and elegantly rendered composition (letter quoted under No.27, 'Museum acquisition'). About this time, the Museum set store on coloured reproductions either entirely painted in water-colour or on an enlarged photographic basis. No.26, which had cost £24 in 1866, was copied for £45 in 1886; No.13, which had cost £10 in 1858, was copied in 1891 for £30. Probably the idea was to show what these pieces had looked like in their prime, with heightened colours. In 1895 the still modest sum of £358 15s 8d was paid for the wonderfully well-preserved *Armorial with the arms of Giovio of Como* on a blue mille-fleurs ground (No.38). As late as 1921 that rare example of Arras tapestry, still in extraordinarily good condition, the *Deposition, Entombment and Resurrection* (No.1) was bought for £3,000.

During the half century and more up to 1914 when the Museum was making these purchases great prices were paid for tapestries, but these were the richly woven Renaissance hangings, or elegant eighteenth century sets, which could be displayed in the great saloons of private houses. Presumably it was the high cost which prevented two of the most splendid of early sixteenth century sets, rich in gold and silver, coming to the Museum from Sir Richard Wallace: the very rare *Romance of the Rose* (four pieces) and the *Swan Knight* (two pieces). Bought by the Stieglitz Museum in 1900 they are now in the Hermitage (see Hermitage, Leningrad, *Gothic & Renaissance Tapestries*, 1965; Robert Cecil, *Burlington Magazine*, vol. XCVIII, 1956, p.116). On the other hand, the famous gold and silver *Mazarin Tapestry* (the Glorification of Christ) was loaned to the Museum by J. Pierpont Morgan Jr from 1901 to 1910. But even if none of these can today be seen here, or at the Wallace Collection, the magnificent Bernard van Orley set of the *Story of Abraham*, purchased by Henry VIII, is still to be seen in the Great Hall at Hampton Court. For, amongst the inevitable *lacunae* in a built-up Museum collection such as this, the Van Orley school of design is perhaps the most sadly lacking. Those interested in the price of tapestries on the market throughout this period, and their real value as compared with present-day ones, are recommended to consult Gerald Reitlinger's *Economics of Taste*, vol. II (London, 1963).

How tapestries were made, the designs, cartoons, the looms, yarns, dyeing, and the highly skilled methods of weaving and finishing, is too complex for simple explanations, which can be misleading. This was a craftsman's trade that demanded seven years' apprenticeship and was handed down through generations of families. The reader is referred to what is probably the best modern account, written by François Tabard of the well-known Aubusson atelier, which goes back in the same family to the seventeenth century – it was to François Tabard that Jean Lurçat went to learn the trade on his looms in the 1930s. Tabard's well-illustrated study of high and low-warp weaving, entitled 'The Weaver's Art', can be found in *The Art of Tapestry*, edited by Joseph Jobé (Lausanne and London, 1965). The relationship between the warp count (given here as a measure of each tapestry's fineness, according to common usage) and the number of *portées* composing the warp will be found given there. There is also an interesting essay by Pierre Verlet of the Louvre in this same book on the uses and hanging of tapestries in the Middle Ages. With regard to the designing of a tapestry and the relation of the design to the work of painters

of reputation and their schools, what has to be borne in mind is that there are two main stages in designing: (1) the preliminary picture or sketch, known as a *petit patron*; and (2) the actual-size cartoon, which has to be prepared in detail before weaving can commence. The *patroonschilders*, or *peintres-cartonniers*, were nearly always the key factor because of their knowledge of workshop requirements and their liaison with the master-weavers. Speaking generally, for the normal needs of the tapestry workshops and their clients, the *patroonschilders* were capable of producing cartoons from stock material and with judicious borrowings. But designs by painters of repute were used for important commissions. Only in rare cases was the interpretation of the designs into cartoons, and into woven tapestry, supervised by the artist himself or an associate. Examples of this were: (1) Tommaso Vincidor of Bologna was sent to Brussels by Pope Leo X to supervise his exceptionally expensive *Giuochi di Putti* with Medici insignia, which was being woven in Pieter van Aelst's workshops in 1521 (see under No.66); (2) for the *Conquest of Tunis* the Emperor Charles V had Jan Vermeyen supply William Pannemaker with both *petits patrons* and finished cartoons (which are still preserved in Vienna) and to supervise the work; (3) Sigismund II Augustus, King of Poland, assigned Roderick van de Moyen to Brussels in 1564 to oversee his *Grotesques* and *Pugna Ferarum*, which were being woven there for Wawel Castle. All these were exceptional orders where no expense was spared. But generally, on account of the division between preliminary sketch and the finished cartoon, it is impossible to attribute most tapestries, even very accomplished ones, to a known painter. A school style can be recognised, but usually at one remove. Dr Dora Heinz has made this relationship between tapestries and the style of the great schools of painting her special theme in *Europäische Wandteppiche*. The study of the work of leading painters in designing tapestries is still a relatively neglected subject, not only in the difficult late medieval period but also later. It needed a talent for large-scale decorative design, was not unlucrative, but the final product was always a cooperative effort of many minds and hands.

The cleaning and restoration of tapestries is an important matter. The Museum has had since the nineteenth century a long tradition of repair-work in its department of Conservation. The older method used for several decades by John Loxley and his predecessor was a charming technique, which alters the existing fabric as little as possible and introduces no new colours. This was particularly suitable at a period when most of

the tapestries were shown in frames behind glass. In the 1950s, when the first air-conditioned gallery for tapestries was in preparation, a large programme of restoration was started. Owing to the great number of man-hours needed in this repair-work, several tapestries were sent over a period of time to Tabard's workshops at Aubusson. The *Hunting Tapestries* were restored over eight years at workshops in Haarlem, Holland. These restorations are recorded here in the entries under *Condition*.

Acknowledgments

Since the publication in 1924 of the second edition of A.F. Kendrick's catalogue, the Museum's collection of tapestries has increased very considerably and so has the information recorded in the departmental archives. In 1946 H.C. Marillier bequeathed his invaluable Subject Index of Tapestries to the Textile Department. Muriel Clayton had been working with him on his records for some years prior to this; much of Muriel Clayton's researches have been used in the present pages, as has A.J.B. Wace's work in collaboration with E.A.B. Barnard on the problems of the Sheldon looms. The notes on the heraldry are largely the work of the late A. Van de Put, formerly Keeper of the Library. A publication of this sort obviously owes much to many colleagues over the years, but Frances Fox-Robinson's preparation of the bibliographical references to the tapestries discussed here should be specially mentioned: it is hoped that this will prove a thorough but easily workable documentation. Our special thanks are due to Donald King, Keeper of the Department of Textiles, who has helped us throughout with many criticisms and suggestions and in addition has seen the work through the press.

We would like to express our thanks to the following authorities for helpful information and also in many cases for supplying comparative photographs:

The late Dr J.P. Asselberghs
Musées Royaux d'Art & d'Histoire, Brussels

M. Jacques Boussard
Bibliothèque de l'Arsenal, Paris

Messrs P.&D. Colnaghi
London

The Department of Prints and Drawings
National Gallery of Scotland, Edinburgh

Dr J. Duverger
St Amandsberg, Belgium

Sen. Maria Teresa Gomes Ferreira
Museu Calouste Gulbenkian, Lisbon

Dr Dora Heinz
Oesterreichisches Museum für angewandte Kunst, Vienna

Mme Madeleine Jarry
Mobilier National, Paris

Señor João Jorge Rodrigues Jesuita
Secretary General, Banco Nacional Ultramarino, Lisbon

Señor Miguel Lacerda
Fundação Abel de Lacerda, Museu do Caramulo, Caramulo, Portugal

Mme Louise Mulder-Erkelens
Rijksmuseum, Amsterdam

John F. Ormond Esq.
Rome

Philip Pouncey Esq.
Sotheby & Co.

Dr Jenny Schneider
Schweizerisches Landesmuseum, Zurich

Dr Michael Stettler
Abegg-Stiftung, Bern

M. Roger A. Weigert
Bibliothèque Nationale, Paris

William Wells Esq.
Burrell Collection, Glasgow

Dr Gustav Wilhelm
Sammlungen des Regierenden Fürsten von Liechtenstein

Dr Eva Zimmermann
Badisches Landesmuseum, Karlsruhe

No. 1. (pls. 1A & B)
Descent from the Cross, Entombment and Resurrection

ARRAS; first quarter of 15th century.
H. 3ft 8in. (1·12m.) W. 9ft 11in. (3·02m.).
Wool and silk, with silver and gold thread: 15–16
warp threads to inch (6 to cm.).

Condition. Colours remarkably fresh; texture well
preserved and unrepaired. But the warp shows in
many places where the weft has perished, particu-
larly the browns and near-blacks; the bare warps
are mostly visible where there was shading on the
forest-horizon along the top, particularly above the
Resurrection scene, and also in the foreground
rose-bush. A narrow strip added along the bottom.

Possibly intended as an altar frontal or dorsal, this
tapestry with three scenes from the Passion is woven
in an apparently simple and free style; but the
weaving is deceptively skilful and with considerable
precision of detail. The effect is enhanced with the
use of gold and silver thread. The treatment of the
groups of figures against the lightly sketched rocks,
trees and flowers, with the still more stylised clouds
in the blue sky above, shows a feeling for fluent
rhythms quite unlike the architectonic style
developed at Tournai a generation later. This
Arras tapestry is quietly expressionist in character.
As A.F. Kendrick wrote of it, there is 'no theatrical
note in gesture or facial expression'. But it conveys
deep feeling.

Attributing it to the looms of Arras, Dr Betty
Kurth compared it in style with the *Passion* tapestry
at La Seo, Saragossa, the *Story of Saints Piat and
Eleuthère* at Tournai, and the *Romance of Jourdain de
Blaye* at Padua. The *Piat and Eleuthère* tapestry (now
divided into four pieces), which once bore an in-
scription stating that it was ordered by a Canon of
Tournai Cathedral, Toussaint Prier, from Pierre
Feré of Arras, with the date 1402, is the key to the
series, as it is the only tapestry surviving which can

be demonstrably connected with this queen of
tapestry cities. This early group of tapestries has
been studied by R.A. d'Hulst (*Tapisseries flamandes*,
Nos. 2–6, pp. 7–48) where they are well illustrated.
More recently, M. Stucky-Schürer in her mono-
graph on the Passion Tapestries at St Mark's
Venice (*Schriften der Abegg-Stiftung*, Bern) has re-
viewed eight tapestries attributable to early 15th
century Arras and she has constructed three tables
of workshop formulae for the treatment of the
leaves of trees, flowers, grass and clouds, and of
Füllmotiven (fabrics, stone and wood, with their
habitual renderings), following the method of
Robert Wyss for the Tournai *Caesar* tapestries at
Bern (pp. 105–12, figs. 78–80). Apart from our
tapestry and the three already mentioned, the
group includes the small *Resurrection* and the
Offering of the Heart (Cluny Museum, Paris), the
Pratt *Annunciation* (Cloisters, New York), the Peyre
Romance scenes (Musée des Arts Décoratifs, Paris),
together with the Saint Mark's *Passion* (in ten
scenes). The group certainly seems to hang
together, but the keynote may be chronological
rather than specifically Arrageois.

The smaller *Resurrection* in Paris (Davillier
Collection, Louvre, now Cluny Museum) is finely
woven with much silk and metal thread and was
clearly intended as an altar hanging (height only
0·77m.) (B. Kurth, pl. 12). Another comparable
altar frontal bears the arms of Maria de Luna
(d. 1407) and Martin of Aragon (d. 1410) (Thyssen-
Bornemisza Collection, Lugano). It is clear that the
finest tapestry was used for this purpose in the 15th
century. Henry VII of England bought two
tapestry altar frontals from Jean Grenier of Tournai
in 1487–8 (W.G. Thomson, p. 110) and the two
well-known Sens pieces, with the arms of Cardinal
Charles de Bourbon, 1476–88, are referred to as
paramenz in the Cathedral's 1595 inventory. How-
ever, M. Stucky-Schürer argues for the use of the
Museum tapestry, like the St Mark's *Passion*, in the
cult of the Holy Sepulchre (pp. 45–6).

Stylistically, V.C. Habicht has compared our

tapestry with the Resurrection altar from Kunde
(in the Historical Museum, Stockholm) and so with
Lower Saxony and the Hamburg-Lüneburg dis-
trict, but the comparison (which can refer to the
design only and not the cartoon) seems tenuous.
There is some affinity between the Entombment
scene and the Lüneburg *Goldene Tafel* of about
1418, where the dead Christ is also laid on the lid
of the sarcophagus placed diagonally on its base
(Stucky-Schürer, p. 89, referring to S. Schiller,
Ikonographie der Christlichen Kunst, vol. II, 1968).

Description. The Descent from the Cross, the En-
tombment and the Resurrection, form a continuous
scene divided by rocks, set against a background of
sky and trees and a foreground of verdure. On the
left the body of Christ rests in the lap of the Virgin.
St John, kneeling, holds the right hand to his lips.
Behind are the figures of Joseph of Arimathea,
Nicodemus and the Holy Women. In the centre
scene the body of Christ rests on a cere cloth on the
lid of the tomb, round three sides of which are
grouped the other figures. On the right Christ,
holding the banner of the Resurrection, steps out
of the tomb; St Mary Magdalene kneels in front,
the soldiers are grouped around and an angel
stands behind the tomb.

Further information. This tapestry is compared in
detail with the St Mark's *Passion*, which is in ten
scenes (two with doubled subjects) and dates from
1420–30, in M. Stucky-Schürer's monograph
(pp. 89–92); the excellent detailed photographic
comparisons are particularly striking (figs. 68, 70,
72) and demonstrate the high quality of the
Museum piece. The St Mark's tapestry is thought
to have been woven in Venice by Flemish weavers,
probably from Arras.

Museum acquisition. T.1–1921. Bought from the
Spanish Art Gallery (Lionel Harris) for £3,000
from the funds of the Murray bequest. Formerly in
the possession of Lord Willoughby de Broke at

Compton Verney, Warwickshire (sold at Sotheby, 11 Feb. 1921, lot 120). The tapestry had been on loan to the Museum from 1 August 1913 to 15 June 1914.

Said to have been rolled up in a chest over a long period, hence its remarkably fresh condition.

Literature

Habicht, V.C., *Niedersächsische Kunst in England*, Hanover, 1930, p.41

Hulst, R.A.d', *Tapisseries flamandes du XIVe au XVIIIe siècle*, Brussels, 1960, Nos.2–6, pp.7–40

Kendrick, A.F., 'A Tapestry in the Murray Collection' in *Burlington Magazine*, vol.XLI, 1922, p.259

Kendrick, A.F., *Victoria and Albert Museum Catalogue of Tapestries*, 2nd ed., London, 1924, No.10b, pl.IX

Kurth, B., *Gotische Bildteppiche aus Frankreich und Flandern*, Munich, 1923, No.12, pl.12

Stucky-Schürer, M., 'Die Passionsteppiche von San Marco in Venedig' in *Schriften der Abegg-Stiftung*, vol.II, Bern, 1972, pp.45–6, 89–92, 105–12, figs.68, 70, 72, 78–80

Thomson, W.G., *A History of Tapestry*, London, 1930, p.110 (citing Campbell, *Materials of a History of the reign of Henry VII*, vol.II, pp.34, 281)

Nos. 2–5 (*pls.2–11*)
The Devonshire Hunting Tapestries

Probably ARRAS; 1425–50.
Wool: 12 warp threads to inch (5 to cm.).

Condition. The tapestries were restored when taken down from the Long Gallery at Hardwick, 1900–14, each having been cut into three vertical strips. The *Deer Hunt* was again restored in 1950 by M. & G. Petit of Paris in collaboration with J. Brégère of Neuilly-sur-Seine. The three others were restored for the Museum at Haarlem, Holland, by the Stichting Werkplaats tot Herstel van Antieke Textiel between 1958 and 1966. A full account of the restoration is given in *Victoria and Albert Museum Bulletin*, vol.II, no.3, July 1966.

These four hangings, of very large proportions, were at Hardwick Hall in Derbyshire till 1899 and may have been there since it was built in the 1590s. The Hardwick inventory of 1601 describes tapestries of unusual height, four in the hall and two in Lady Shrewsbury's chamber, which may refer to these: 'In the hale ffoure peeces of tapestrie hanginges with personages of forrest worke of fyftene foote and a half deep . . .' (The other two pieces are described similarly; the hangings may already have been in six pieces at this time). The 6th Duke of Devonshire, William George Spencer Cavendish, describes in his privately printed *Handbook of Chatsworth and Hardwick*, 1844–5, how he hung the tapestries in the Long Gallery in the bays between the windows to preserve them from a worse fate. It was there they were 'discovered' in 1899, taken down, reassembled as four almost complete tapestries, and restored during the following decade.

Hunting and hawking in the Middle Ages had their formalities and etiquette as well as their moments of physical danger in which long hours spent in forest and woodland might suddenly culminate. Both aspects are shown here: fine and fashionable clothes alongside the practical attire of kennelman and woodsman, and dramatic and somewhat gruesome scenes in a forest setting not without its romance of glimpsed castle against the skyline. Tapestries with hunting subjects were much in favour throughout the 15th century, as the inventories of the Burgundian Dukes and other notables record (see *The Devonshire Hunting Tapestries*, 1971, ch.1, sect.6, where a number of examples are given). Particularly remarkable are the details of medieval hunting and falconry shown here, the accoutrement of the chase and hawking, and the stylish and varied costume. These and other points of interest are fully discussed in the monograph on the *Devonshire Hunting Tapestries* published by the Museum in 1971.

The artists responsible for the designs, and for the cartoons (which had to be prepared full scale before the weaving could start), were obviously familiar with the work of contemporary miniaturists in the Hunting Books, of which Gaston Phébus' *Livre de la Chasse* was one of the most notable and particularly well illustrated (Paris, Bibliothèque Nationale, Manuscrit Français 616); many interesting points of comparison can be made between these illustrations and the tapestries. The turbaned Saracens taking part in the bear hunt (*Otter and Swan* tapestry) repeat a feature also seen in the Hunting Books. Hawking was even more conscious of a strong influence from the Mohammedan lands in the Near East, and Frederick II Hohenstaufen's *Art of Falconry*, written at his Court in Sicily, remained the leading text-book in the field for two hundred years.

The commanding impression made by these tapestries is due first to the overall effect of a great backdrop of forest scenery; secondly to the vigour of individual incident and detail. Stylistically they are designed in the flamboyant taste of 'the style around 1400', as described in Panofsky's *Early Netherlandish Painting*. Affinities with the work of the Malouel family and the Limburg Brothers has often been pointed out, although the tapestries show a considerable time-lag. Here, there is no attempt at perspective or of scale, although the planes of composition and the skyline give some sense of recession; the dramatic interest depends on the lively detail and there is a grand overall pattern. Undoubtedly the effect as monumental wall decoration is most successful. Among surviving murals which clearly echo the same style, those at the Castello di Buonconsiglio at Trento, in the Torre Aquila, are the foremost; they have been described by Lord Clark as a 'perfect representation of the International Gothic' of the early 15th century. The *Fountain of Youth* mural in the Castello della Manta (Saluzzo, Piedmont) closely recalls the left side of the *Falconry* tapestry; it is datable to 1444.

Records indicate that the workshops of Jehan Walois of Arras supplied tapestries with hunting subjects from the early 15th century onwards, as M. Crick-Kuntziger has shown; examples are quoted by d'Hulst in his well-considered study of these tapestries (*Tapisseries flamandes*, No.6). Arras is undoubtedly the most likely place for the manufacture of the Devonshire tapestries. But as D. Heinz and R.A. d'Hulst have pointed out, these *Hunts* bear somewhat isolated witness to a style of tapestry composition mid-way between what is known of the earlier Arras and that which developed at Tournai shortly after 1450. Since artists working at Arras and Tournai are known to have supplied designs to workshops in each other's cities, Tournai cannot be altogether ruled out as the place of origin.

As for their possible historical connections, W.G. Thomson put forward a theory that *Falconry*, which has a courtship or flirtation scene, commemorates the betrothal of Margaret, daughter of Duke René of Anjou, the titular King of Jerusalem, with Henry VI of England (1444, solemnised at Nancy, March 1445, by Henry's proxy, the Earl of Suffolk); he backed this up with the inscription 'Monte le desire' on the *Boar and Bear*, the Saracen figures on the *Otter and Swan*, and the letter 'M' on bridles in *Falconry*. But this hypothesis can hardly be sustained (see Museum monograph, ch.1, sect.8), although historical personages did figure in tapestry at this date.

It has been said of the *Devonshire Hunting Tapestries* that they are as characteristic of 15th century Burgundy and its courtly pastimes in the woods and fields as are the *Hunts of Maximilian* for the succeeding Habsburgs (d'Hulst, op.cit., p.41). Although woven entirely in wool the quality of the weaving is excellent.

Descriptions: Nos. 2–5

Deer Hunt (*pls.3B, 10, 11*)

H. 13ft 5in. (4·09m.)　W. 28ft 6in. (8·08m.).

The *Deer Hunt* is the least grand of the four pieces and the smallest. The left and centre foreground show a red deer about to meet its death with a spear-thrust, and the rewarding of the hounds in a 'hot curée'. Above and on the right are various hawking scenes, with a weir and mill on a river in the centre. The miller's wife (holding a distaff) is the subject of advances from one of the men who has been taking part in the chase.

Boar and Bear Hunt (*pls.2A, 4, 5*)

H. 13ft 4in. (4·07m.)　W. 33ft 6in. (10·21m.)

The *Boar and Bear Hunt* shows the hunting of the boar on the left and the bear on the right. The noblemen and ladies who take part in the chase are splendidly dressed; some are on foot, some mounted on horseback, and they are accompanied by hunting dogs. The lady on the footbridge has letters on her gown which read: 'Monte (or moult) le désire' (reversed). The trees and bushes of the middle ground make a forest skyline above and castles are to be seen in the distance. In one place a deer is visible leaping through the undergrowth. This piece is almost complete and still maintains its original height; it is intact on the right side but has been somewhat cut on the left.

Falconry (*pls.2B, 6, 7A & B*)

H. 14ft 6in. (4·42m.)　W. 35ft 4in. (10·77m.)

In *Falconry* the figures are on a larger scale and the detail of their sumptuous costume is even more explicit. This tapestry has been more cut about than the others and apparently lost something in height as well as on the left side. It is notable for the group of splendidly apparelled horsemen on the left and particularly the lady on the white palfrey. The noblemen and ladies move off to the right, past a mill by a stream, and the rest of the tapestry shows them flying falcons or hawks at duck; many interesting details of medieval falconry and of country life can be studied here. As well as grooms and an old woodman or huntsman, there are two scenes of a cowherd with his pipe and a shepherdess with her flock in the landscape above; one of the ladies carries a lapdog and the greyhounds, terrier, setter and hunting dogs are worth observing.

Otter and Swan (*pls.3A, 8, 9*)

H. 13ft 11in. (4·24m.)　W. 36ft 8in. (11·18m.).

The *Otter and Swan* shows an otter hunt in progress on the left, a rather gruesome scene mitigated by the rescue of a young and minute otter by a lady in a green gown. In the centre ships (or carracks) are seen at sea and a boat rows out from a castellated seaport, whilst boys rob a swan's nest in a lake or river on the shore side of the port and a heron's nest in trees above this. On the right a ferocious bear hunt takes place, three of the men wearing turbans and oriental dress (two of them riding dromedaries). The skyline, partly with a sea horizon, and the two sides encompassed by rock and forest, frame this great hanging in a most spectacular manner; the tapestry must be almost complete.

Further information. The opinion put forward by H. Göbel (*Wandteppiche, Die Niederlande*, 1923, pt.i, p.270), that the *Boar and Bear* was stylistically somewhat earlier than both *Falconry* and the *Otter and Swan*, which he dated c.1450, while the *Deer Hunt* was coarser in execution and derived from an inferior and probably earlier cartoon (later rehandled), appears acceptable (except the date is too late). From the costume the *Boar and Bear* tapestry may be slightly earlier in date than *Falconry*, while stylistically the scale of the figures

and the details of the dress are certainly less developed than in both *Falconry* and the *Otter and Swan*. Again, the *Boar and Bear* is a low-warp weaving, judging from the reversal of the inscription, etc., whilst *Falconry* and the *Otter and Swan* are probably high-warp and undoubtedly of superior quality: its association with these two pieces is in fact questionable, as is that of the *Deer Hunt*. Neither can have been woven as part of the same set as the two more splendid high-warp tapestries. Even *Falconry* and the *Otter and Swan* show marked differences of style. *Falconry* has the greater feeling for fashionable costume, whereas the use of heavier dark outlines in the *Otter and Swan* and the wine-red or crimson dye give it a markedly different colour tonality. *Falconry* may have been the only one of the four with personal or family associations suggested by the letter 'M'. That these tapestries are the remains of three, or more probably four, different sets seems to be incontrovertible: the question of when they were brought together can only be conjecture.

A *Falconry* tapestry in the Minneapolis Institute of Arts is so close in style to the *Otter and Swan* tapestry that they may originally have belonged to one set. The Burrell Collection, Glasgow, has a portion of a *Boar Hunt* which, although later in date, is based on part of the cartoon of the *Boar and Bear Hunt*. There is also in the Burrell Collection a later fragment of a *Bear Hunt*. A small portion of tapestry at the Institut de France, Château de Langeais, has a scene of the death of a stag, before the curée; the scene takes place under the walls of a castle. It dates from the latter part of the 15th century and is of interest in connection with No.2 (Tournai exhibition, 1970, No.23).

For a study of the connection between murals and tapestries in the 15th century, see William D. Wixom's article on 'Tradition in the Chaumont Tapestries' in *Cleveland Museum of Art Bulletin* (vol. 48, No.7, 1961); also F. Wittgens, 'Ciclo di Affreschi di Caccia' in *Dedalo*, vol.XIII, 1933.

The costume, often portrayed in great detail and on a scale larger than can readily be seen elsewhere at this date, is fully discussed in the Museum monograph (Appendix C) under the following heads: (1) Hose and Points, (2) Hoods and Hats, (3) the Ladies' Headdress, (4) the Miller's Wife, (5) the Oriental Figures. The initial 'M', which figures prominently in *Falconry*, is commented on in Appendix D of the monograph.

Museum acquisition. T.202–1957 *Falconry.* T.203–1957 *Otter and Swan.* T.204–1957 *Boar and Bear Hunt.* T.205–1957 *Deer Hunt.* Acquired from the Trustees of the Devonshire Estates in 1957 on the death of the 10th Duke of Devonshire.

Literature

Asselberghs, J.P., *Tapisseries héraldiques et de la vie quotidienne*, Catalogue of the exhibition, Tournai, 1970, Nos.17, 23

Clark, Kenneth, *Landscape into Art*, London, 1949, p.13

Crick-Kuntziger, M., 'Les Tapisseries' in *Trésor de l'art flamand du Moyen Age au XVIIIme siècle, Mémorial de l'Exposition d'Art flamand ancien à Anvers 1930*, Paris, 1932, vol.II, pp.53–68

Crick-Kuntziger, M., 'La tapisserie bruxelloise au XVe siècle' in *Bruxelles au XVe siècle*, Catalogue of the exhibition, Brussels, 1953, pp.85–102

Digby, G. Wingfield, 'The Restoration of the Devonshire Hunting Tapestries' in *Victoria and Albert Museum Bulletin*, vol.II, no.3, July 1966

Digby, G. Wingfield, and Hefford, W., *The Devonshire Hunting Tapestries*, London, HMSO for Victoria and Albert Museum, 1971

Griseri, A., *Jacquerio e il Realismo Gotico in Piemonte*, Turin, 1966

Göbel, H., *Wandteppiche I. Die Niederlande*, Leipzig, 1923, pt.I, p.270

Heinz, D., *Europäische Wandteppiche*, vol.I, Braunschweig, 1963

Hulst, R.A.d', *Tapisseries flamandes du XIVe au XVIIIe siècle*, Brussels, 1960

Kurth, B., *Gotische Bildteppiche aus Frankreich und Flandern*, Munich, 1923

Panofsky, E., *Early Netherlandish Painting*, Cambridge, Mass., 1951

Phébus, Gaston, *Livre de la Chasse*, Paris, Bibliothèque Nationale, Manuscrit Français 616

Rasmo, Nicolo, *The Frescoes at the Torre Aquila in Trento*, Rovereto, 1962

Thomson, W.G., 'The Hardwick Hunting Tapestries' in *Art Workers' Quarterly*, vol.I, no.3, July 1902, pp.77–80; vol.III, no.9, January 1904, pp.1–7

Thomson, W.G., *A History of Tapestry*, 2nd ed., London, 1930, pp.154–60

Tournai, *Exhibition 1970*, see Asselberghs, J.P.

Wells, W., 'The Earliest Flemish Tapestries in the Burrell Collection' in *L'Âge d'Or de la tapisserie flamande, Colloque International 1961*, Brussels, 1969, pp.433–4, fig.1

Wittgens, F., 'Ciclo di Affreschi di Caccia Lombardi del Quattrocento' in *Dedalo*, vol.XIII, Milan and Rome, 1933, pp.65–83

Wixom, W.D., 'Tradition in the Chaumont Tapestries' in *Cleveland Museum of Art Bulletin*, vol.48, no.7, 1961

No.6 (*pls.12–14*)
The War of Troy

TOURNAI; 1475–90.
H. 13ft 8in. (4·16m.) W. 24ft. 2in. (7·37m.).
Wool and silk: 17 warp threads to inch (7 to cm.).

Condition. Cut into three vertical sections, the two left sections being again cut horizontally. The inscription (in French) along the top is missing. The warp is bare in places and there are several holes which have been repaired with tinted patches applied under the fabric. Otherwise the texture of the tapestry is original and unrepaired.

This comes from one of the most important sets of tapestry woven in the latter part of the 15th century. The *Trojan War* tapestries are remarkable among all other medieval sets in that the original designs (*petits patrons*) still exist (eight large drawings in the Louvre). Until recently it has been generally accepted that the *editio princeps* was presented by the City and magistrates of Bruges to Charles the Bold of Burgundy in 1472; Henry VII of England had a set delivered to him in 1488; Charles VIII of France furnished the castle of Amboise in 1492–3 with these *Trojan War* tapestries for the reception of Anne of Brittany, after their marriage in December 1491; the four well-preserved tapestries which belong to the cathedral at Zamora were probably originally in the possession of Ferdinand I of Naples; Matthias Corvinus, King of Hungary (d.1490), also had a set, recorded there in 1495. The archival records of the first three of the sets mentioned are unusually satisfactory, with Pasquier Grenier of Tournai named as the entrepreneur who supplied the tapestries for Charles the Bold, and again to Henry VII, this time together with his son, Jean. Most important of all, a residue of the tapestries themselves has survived, no longer as complete sets, but sufficient to make an imposing impression of powerful design on a great scale and brilliant technical achievement.

Recently Nicole Reynaud has proposed a new theory about the origin of the *Troy* tapestries in a study published in the *Revue de l'art* (No.22, 1973–4). Her thesis is based on the attribution of the eight Louvre drawings to the brothers Conrad and Henri de Vulcop, painters to Charles VII of France and Marie d'Anjou, and to their second son, Charles of France (brother of Louis XII). She suggests that the original set was prepared about 1467 for Dunois, the Bastard of Orléans, who had among his tapestries at his death in 1468 'XIIII patrons de Troye'. This hypothetical origin ties in better, according to N. Reynaud, with the *petits patrons* and the entourage of the court painters Vulcop, than the accepted idea of the *editio princeps*; also, because the accounts of the City of Bruges offer their gift to Charles the Bold in these terms: 'à notre respecté seigneur et prince à son instante prière et désir' – a phrase which perhaps suggests he had already seen the new *Troy* tapestries or knew of their preparation (unless, of course, the reference was to his interest in the subject). Nicole Reynaud goes on to propose that the *Troy* tapestries re-emblazoned with Charles VIII's device for Amboise was this, the original set, which had meantime passed to him – and from which the Museum tapestry comes (see Paris, Exhibition, *Chefs-d'œuvre de la tapisserie du XIVe au XVIe siècle*, 1973, No.7).

The *War of Troy* tapestries consisted of eleven hangings each about 4·8 metres high (c.15ft) and 9–10 metres long (c.30ft). They were inscribed with French verses explaining the scenes above and beneath in Latin on a red ground; this double inscription is very unusual. The Museum tapestry is the ninth in the series, which showed: (a) Penthesilea, Queen of the Amazons, kneeling before Priam and offering her services to the Trojans; (b) the Amazons, issued from the Dardanid Gate, engaging in the twenty-first battle with the Greeks; (c) the young Pyrrhus, Achilles' son, in his tent being armed by Ajax Telamon with his fallen father's armour, in the presence of Agamemnon and others; (d) the twenty-second battle. In our tapestry this last scene, that is about one quarter of the whole on the right side, is missing. The scene is shown in the Louvre drawing, which has the complete design.

A great deal has been written about these *Troy* tapestries; in 1972 an authoritative study made by J.P. Asselberghs was published for the Musées royaux d'Art et d'Histoire of Brussels, with an amendment on Charles VIII's set added by Geneviève Souchal. The latter is particularly relevant to our tapestry and supersedes the article published by Asselberghs in the Victoria and Albert Museum's *Yearbook* of 1969. The point concerns the medallion near the top left-hand corner of the tapestry, which contains a rayed sun with the letter 'S' encircled by the motto 'Plus quaurte'. (The top section of the medallion has been cut). These are the emblems and motto used by Charles VIII and Anne of Brittany and are found, for instance, in his manuscripts (Bibliothèque Nationale). Later, after his conquest of Naples, from 1495 Charles used the device of a flaming sword (*épée palmée*), but there is general consent that the former badge on the tapestry establishes it as being one of the set of eleven (the ninth piece) listed in the Amboise inventory of 1494. It has also been established that the emblematic medallion is woven into the tapestry and, indeed, appeared to be original (inspection and use of ultra-violet light reaction). However, Madame Souchal has discovered in the Amboise accounts a payment to Jehan le Feuvre, tapister-in-ordinary to the King, 'pour avoir osté les armoiries de la *Destruction de Troyes* et remis et fait ung soleil en chaque pièce' (and for other work). These accounts run from 1 October for the year 1495–6, so that the change of arms is likely to have been done in 1494 or early 1495, the tapestries having been acquired some time before the inventory was taken on 14 May 1494. The tapestries must, indeed, have been sent to furnish Amboise and have belonged to Charles VIII, but they were not new at the time of their acquisition, though at most ten or fifteen years old. Since the new emblem was expertly woven in to replace the original arms, and since this reweaving (from the point of view of nearly five hundred years later) is almost contemporary with the original tapestry, it is obviously impossible to distinguish any difference. Madame Souchal has not been able to discover whose were the original arms. Charles did not possess any other *Troy* tapestries.

The designs for the *War of Troy* were based on the literary versions popular in the Middle Ages, not on Homer, who had to await Jean Lemaire in the 16th century to regain recognition. Two late

Roman writers, the pseudo-annalists, Dyctis of Crete and Dares of Phrygia, wrote long accounts of the Wars, the one from the Greek, the other the Trojan side, which gained credence although they were entirely fictional. But this dull Latin was versified (30,000 octosyllabic verses) by a Norman clerk for Eleanor of Guyenne, Henry II of England's Queen, in about 1184, entitled *Le Roman de Troie*. A prose version was rendered from this in Sicily by Guido da Colonna (1287) and was read as widely as the numerous translations of *Le Roman*. Philip the Good's library contained seventeen manuscripts of the Troy story and Raoul Lefèvre was charged to edit a *Recueil des Histoires de Troie*, but, as only the first two books were produced (1464), to which Guido's version was added in French, the tapestries can really be said to be based on Benoît de Sainte-Maure's *Roman de Troie* (Asselberghs, 'Les tapisseries tournaisiennes de la Guerre de Troie', pp.69–73). The story of Troy was a popular subject in medieval Europe. Italy and France were believed to have been founded by the heroes Aeneas and Francio, who escaped from the sack of Troy. The Burgundian dukes claimed descent from Priam. The original weaving of this particular set of tapestries was probably intended (so Asselberghs and others have thought) as a compliment to Charles the Bold of Burgundy and may have been suggested at the time of his marriage to Margaret of York (1468).

The drawings or *petits patrons*, of which there are eight (two damaged), in the Louvre (Cabinet des Dessins) are on paper with watermark attributable to Champagne in north-west France and the years 1465–70. They are done in pen and ink and touched with water-colour, measuring 31 × 57cm. They have been attributed on slender grounds to various miniaturists, but Asselberghs suggests that they are more likely to come from specialist designers attached to tapestry workshops at Tournai (or Arras, where Bauduin de Bailleul's followers were still active). Asselberghs points out the need to bear in mind the three stages in the production of a tapestry: the initial designs, the cartoons which have to be worked up on a full scale with exact details complete, and finally the weavers with their modicum of interpretation and their own idioms. His comments on the slight divergences between the Louvre design and the V & A tapestry are given later, following the description; in his opinion, after careful analysis of this and the Zamora tapestries and the others, the slight alterations observable were workshop adjustments subsequent to the preparation of the original *petits patrons*. Nicole Reynaud has more recently attributed the drawings to Conrad and Henri de Vulcop (*Revue de l'art*, No.22, 1973, pp.6–21).

The overwhelming effect of the *War of Troy* tapestries can now only be seen at Zamora in Spain, where four pieces hang side by side (three being still complete). Their quality is excellent (though not completely consistent) but it seems questionable whether they are superior to our piece, where Asselberghs detects some stiffness and lack of relief, as well as slight simplification in Priam's costume and a certain lack of expression in his face. The strength and severity of the design, without the suggestion of caricature, comes over powerfully and it is only at Zamora that a more complete *Trojan War* tapestry can still be seen.

Description. The tapestry represents three episodes in the story. On the left Queen Penthesilea comes to join the Trojan forces against the Greeks; she is accompanied by her Amazon warriors and kneels before King Priam at the gate of Troy. The next scene shows the Queen and her warriors in the battle; Diomedes is thrown to the ground, while his horse is led away by an Amazon; behind him Ajax, son of Telamon, attacks the Queen with his uplifted sword; in the background the Greeks are hard pressed by the Trojan warriors, led by Polydamas and Philimenes. The third scene represents the arming of the youthful Pyrrhus with the armour of his father Achilles; he stands at the entrance of a tent, with Ajax son of Telamon on one side, and Agamemnon on the other.

A further scene on the right is now almost entirely missing; it represented Pyrrhus joining the Greek forces in their resistance to Penthesilea.

Inscriptions. The inscribed names on the tapestry are as follows: on the left 'panthasilee, roy priăt, eneas, anthenor, troye, la porte imbree, ylion regis, la porte dard'; in the middle, 'diomedes [twice], la raine panthasilee, polidamas, philimenes, ajax thilamonius'; on the right 'agamenō, pirus [twice], aiax thelamō'.

Below the scenes are Latin inscriptions, explaining the subjects, as follows:

(Left)	Pergunt troiam cum panthasilea
	Bellatrices mille federate
	Ut hectorem vindicent galea
	Hiis priamus favit ordinate
(Centre)	Philimenes et eneas vincit
	Polidamas et panthasilea
	Diomedes regina revincit
	Equum dedit suis hec trophea
(Right)	Loco patirs (=patris) pirrus statuitur
	Polidamas per hunc succubuit
	Philimenes item cumprimitur
	Diomedes sic morte caruit

Corresponding inscriptions in French ran originally across the top of the tapestry and can be read on the original design in the Louvre (see Asselberghs, 'Les tapisseries tournaisiennes de la Guerre de Troie', pp.31–2 for transcriptions).

The medallion near the top left-hand corner of the tapestry has been identified as the device (a rayed medallion with the letter 'S') and motto (*Plus quautre*) of Charles VIII of France.

Comparison of tapestry with Louvre drawing. Asselberghs notes the following differences of detail (p.31). Scene 1: An Amazon added who carries the train of Penthesilea's robe; Priam's and Penthesilea's robes, which are plain in the drawing are richly brocaded in the tapestry. Scene 2: in the drawing Penthesilea, the central figure in the

battle, is menaced by a crouching soldier with spear (immediately above the fallen soldier); in the tapestry the figure is blocked out by the forequarters of a horse. Scene 3: Ajax and Agamemnon wear cloaks in the tapestry, but not in the drawing.

Further information. For Charles the Bold's tapestries the Bruges archives show payments to Pasquier Grenier of Tournai from 1471–2, continuing till 1475–6, 'pour certaines belles et grandes tapisseries comprenant l'histoire de Troye lesquelles furent données par cette ville ... à notre respecté seigneur et prince à son instante prière et désir'. H.C. Marillier and later Asselberghs considered that seven more or less fragmentary pieces, which Jubinal published (with drawings executed by Victor Sansonetti) in 1838 as being at the Castle of Aulhac and in the Courts of Justice at Issoire, were from this set, at least in part. But in the light of Geneviève Souchal's thesis about Charles VIII's set these allocations may need revising. Three of these Aulhac-Issoire pieces can now be seen in public collections, as follows: The first two come from the sixth hanging, the *Tent of Achilles:* (1) *Hector and Andromache* (H. 4·69m., W. 2·64m.) in the Metropolitan Museum, New York; (2) *Achilles, Agamemnon and Hector* (H. 0·78m., W. 1·65m.) in the Cloisters, New York. The third piece comes from the tenth hanging, *The Betrayal;* a vertical strip from the right-centre of the scene, it shows the *Vow of Peace* and is in the Musée des Beaux-Arts, Montreal (H. 4·32m., W. 1·85m.).

Henry VII of England's set was studied by H.C. Marillier in an article in the *Burlington Magazine*, 1925, entitled, 'Tapestries of the Painted Chamber' (Westminster Palace), and again by Asselberghs. Henry VII informed his Guardian of the Privy Seal, the Bishop of Exeter, on 13 March 1488 that he had bought from Jean Grenier of Tournai 'XI pieces of clothes of Arras of th'istorye of Troye' and asked him to see to it that they paid no taxes on arrival at the port of Sandwich (W. Campbell, *Materials for a History of the Reign of Henry VII*, vol.II,

London, 1877, pp.280–1). Previously, in September 1486, the King had accorded protection to 'Paschal' and 'John' Grenier, merchants of Tournai in France, allowing them to import into England 'pecias pannorum, clothes of Arras, tapysserie werk & Carpets' (op.cit., p.34). These eleven Troy hangings were at Windsor in 1539 and appear in Henry VIII's inventory of 1549 (Thomson, pp.152, 245–60; see also British Museum, Harleian MSS, 1419, f.299); the measurements given are in reasonable accord with those of Charles the Bold's and the Zamora pieces (Asselberghs, pp.79–80). They were still at Windsor in the 1650 inventory, only are numbered as twelve, one presumably having been cut in two (Asselberghs, p.80, Thomson, p.316); they were reserved for Protector Cromwell. By 1688 they appear to have been divided, six pieces being recorded at Whitehall in 1695, and in 1713 six were cleaned and repaired for the Committee Room at Westminster. In 1799 John Carter copied five of them, omitting the inscriptions, these drawings now being in this Museum (Department of Prints and Drawings); they are numbers 2, 3, 4, 5, 10, as listed below. An article in the *Gentleman's Magazine* the same year led to a proposal of purchase by the Royal Academy, which came to nothing. They were taken down the following year and sold off in 1820 for £10; nothing more is known of them. It has been suggested that the Burrell piece, *Ulysses & Diomedes at the Court of Priam* (H. 4·5m. W. 3·68m.), may come from Henry VII's set, but Asselberghs thinks it was reduced in height at the time of weaving, which differentiates it from the piece drawn by Carter (p.88).

Three of the four great Zamora tapestries are complete (2, 8, 11) and one has a quarter missing (6). Given to the Cathedral, where they are now impressively shown, by the sixth Count of Alba and Alista, they bore the arms of Mendoza, second Count of Tendilla, but these had been added to them and they are thought to have originally

belonged to Ferdinand I, King of Naples; Mendoza carried out a successful mission at Naples in 1486 (M. Gómez-Moreno, *Arte Español*, 1919; Asselberghs, 'Les tapisseries tournaisiennes . . .', pp.10 and 82–4).

As regards quality, Asselberghs places the surviving Aulhac-Issoire pieces (possibly from the *editio princeps*) first; then the Zamora tapestries and those once at the Château de Sully (now, Burrell Collection, *Death of Hector;* Higgins Collection, Worcester, U.S.A., *Battle with Centaurs*, and *Paris slaying Palamedes*). Survivors from the King of Hungary's set do not yet seem to have been identified.

A reconstruction of the eleven tapestries of the War of Troy, with principal sources, is as follows (based on Asselberghs, pp.14–40):

1. *Mission of Antenor.* No remains. Source: Louvre drawing (R.F.2140) and Jubinal's publication (Aulhac-Issoire).
2. *Rape of Helen.* Complete at Zamora. See also John Carter's drawing of Westminster piece, V & A M (E.2225–1924). Boston fragment, three soldiers' heads.
3. *Achilles at Delphi, Capture of Tenedos, Ulysses and Diomedes with Priam.* Carter drawing: *Achilles at Delphi, Capture of Tenedos* (E.2235–1924); Burrell Collection: *Ulysses at Court of Priam.*
4. *Disembarkation of Greeks, First Battle.* Louvre drawing (R.F.2141); Carter drawing (E.2251–1924).
5. *Fourth Battle.* Louvre drawing (R.F.2142); Carter drawing (E.2245–1924).
6. *Tent of Achilles.* Zamora (one quarter missing on left); Louvre drawing (fragment only) (R.F.2143); Jubinal's three Aulhac-Issoire fragments; *Centaur* piece, Metropolitan Museum; *Hector and Andromache*, Metropolitan Museum; Sully fragment, now Higgins Collection, Worcester, U.S.A.
7. *Achilles and Polyxena.* Scene 1: Louvre drawing has accompanying verses only. Scene 2: Burrell Collection, *Anniversary (or Funeral) of*

Hector; two Worcester fragments of inscriptions; Scene 3: Louvre drawing (R.F.2143) and Worcester fragments.

8. *Death of Achilles (nineteenth Battle)*. Zamora (complete); Louvre drawing (R.F.2144).

9. *Arming of Pyrrhus (twenty-first and twenty-second Battles)*. Louvre drawing (complete; R.F. 2145); V & A M (one quarter missing at right) (6–1887).

10. *The Betrayal (twenty-third Battle)*. Louvre drawing (R.F.2146); Carter drawing (E.2238–1924); Jubinal's three Aulhac-Issoire pieces; vertical strip at Montreal. Also the later tapestry in the Liria Palace, Madrid.

11. *Fall of Troy* (with the author depicted). Zamora (complete); Louvre drawing (R.F. 2147).

Museum acquisition. 6–1887. At one time in the Château de Bayard, near Grenoble, whence it passed early in the 19th century into private hands; subsequently it was given to the Bibliothèque Nationale in Paris to be hung on the great staircase, but was returned to the heirs of the donor on the demolition of the staircase in 1869. Purchased in 1887 (£1,200).

Literature

Asselberghs, J.P., 'Marguerite d'York, la Nouvelle Hélène, et les tapisseries tournaisiennes de la Guerre de Troie' in Catalogue of the exhibition *Marguerite d'York et son temps*, Brussels, 1967

Asselberghs, J.P., 'La tenture de la Guerre de Troie et les tapisseries tournaisiennes de la seconde moitié du XVe siècle' in Catalogue of the exhibition *La tapisserie tournaisienne au XVe siècle*, Tournai, 1967

Asselberghs, J.P., 'Charles VIII's Trojan War Tapestry' in *Victoria and Albert Museum Yearbook*, no.1, 1969, pp.80–4

Asselberghs, J.P., 'Les tapisseries tournaisiennes de la Guerre de Troie' in *Revue belge d'archéologie et d'histoire de l'art*, vol.XXXIX, 1970. Subsequently

published in *Artes Belgicae*, Brussels, Musées royaux d'art et d'histoire, 1972

Bayot, A., 'La legende de Troie à la cour de Bourgogne' in *Société d'émulation de Bruges*, Mélanges I, Bruges, 1908

British Museum, *Harleian MSS*, 1419, f.299

Brussels, *Exhibition 1967*, See Asselberghs, J.P.

Campbell, W., *Materials for a History of the reign of Henry VII*, vol. II, London, 1877, p.34, pp.280–1

Forsyth, W.H., 'The Trojan War in Medieval Tapestries' in *Metropolitan Museum Bulletin*, vol.XIV, New York, 1955–6, pp.76–84

Gómez Martinez, A. and Chillón Sampredo, B., *Los Tapices de la Catedral de Zamora*, Zamora, 1925

Gómez-Moreno, M., 'La gran tapiceria de la guerra de Troya' in *Arte Español*, vol. IV, 1919, pp.265–81

Gómez-Moreno, M., *Catálogo Monumental de España. Provincia de Zamora*, Madrid, 1927

Guiffrey, J., 'La Guerre de Troie, A propos des dessins récemment acquis par le Louvre' in *Revue de l'art ancien et moderne*, vol.V, 1899, pp.205a, 503

Joly, A., *Benoît de Sainte-More et le Roman de Troie*, Paris, 1870–1

Jubinal, A., *Les anciennes tapisseries historiées; ou, collection des monuments les plus remarquables de ce genre*, Paris, 1838

Kendrick, A.F., *Victoria and Albert Museum Catalogue of Tapestries*, London, 1924, no.11, pls.X, XI

Lavallée, P., *Le dessin français du XIIIe au XVIe siècle*, Paris, 1930, pp.74–5

Lugt, F., *Musée du Louvre. Inventaire générale des dessins des écoles du Nord*, Paris, 1968, pp.17–19

Marillier, H.C., 'The Tapestries of the Painted Chamber' in *Burlington Magazine*, vol.XLVI, 1925, p.40

Marillier, H.C., *Subject Catalogue of Tapestries*, Victoria and Albert Museum, Department of Textiles, Ms., n.d.

Müntz, E., *Histoire générale de la tapisserie . . . en Italie*, Paris, 1880–1

Paris, *Exhibition 1973*, See Salet, F., and Souchal, G.

Pinchart, A., *Histoire générale de la tapisserie . . . dans les Flandres*, Paris, 1880–1

Reynaud, N., 'Un peintre français cartonnier de tapisserie au XVe siècle, Henri de Vulcop' in *Revue de l'art*, no.22, 1973, pp.6–71

Rorimer, J.J., 'A Fifteenth Century Tapestry with scenes of the Trojan War' in *Metropolitan Museum Bulletin*, vol.XXXIV, 1939, pp.224–7

Salet, F., and Souchal, G., *Chefs-d'œuvre de la tapisserie du XIVe au XVIe siècle*, Catalogue of the exhibition, Grand Palais, Paris, 1973–4, no.7

Scherer, M.R., *The Legends of Troy in Art and Literature*, New York, Metropolitan Museum, 1963

Schumann, P., *Der Trojanische Krieg*, Dresden, 1898

Soil, E.J., 'Les tapisseries de Tournai, les tapissiers et haut-lisseurs de cette ville' in *Société historique et littéraire, Mémoires*, vol.XXII, Tournai-Lille, 1891

Souchal, G., 'Charles VIII et la tenture de la Guerre de Troie. Les tapisseries tournaisiennes de la Guerre de Troie' in *Revue belge d'archéologie et d'histoire de l'art*, vol.XXXIX, 1970

Thomson, W.G., *A History of Tapestry*, London, 1930

Tournai, *Exhibition 1967*, See Asselberghs, J.P.

No.7 (*pl.15*)
The Battle of Roncevaux

FRANCO-BURGUNDIAN (probably Tournai); 3rd quarter of 15th century.
H. 8ft 3in. (2·52m.) W. 11ft 0in. (3·56m.).
Wool and silk: 13–14 warp threads to inch (5–6 cm.).

Condition. Fragmentary, repaired; the fabric of the tapestry and colours are relatively well preserved.

A fragment from a large hanging, probably from a *History of Charlemagne* series. The story is taken from a later version of the *Chanson de Roland*. There is a large portion of a similar tapestry with this subject

in the Brussels Cinquantenaire Museum and another in the Bargello, Florence. These pieces have been studied by Göbel and by M. Crick-Kuntziger. D. Heinz has referred to the *Roncevaux* tapestries, together with the *Caesar* tapestries in Bern, as the extreme examples of the Tournai style of the third quarter of the 15th century, where the detail of arms and armour, costume and horse-trappings fill out the entire scene, and yet despite the *horror vacui* and apparent loss of contour of forms and figures, a convincing pattern is recreated (D. Heinz, p.78, figs.42, 43; pl.vi for *Caesar*).

More recently other fragments, similar to ours, have come to light. The Museum piece and two others were shown at the Tournai Exhibition, 1967, and were studied by J.P. Asselberghs in the Catalogue. Because of the fragment of Charlemagne supervising the building of a church from the same source, now in the Musée des Beaux-Arts, Dijon, Asselberghs suggests that the *Battle of Roncevaux* tapestries derive from a *History of Charlemagne*, a title met with in Henry VIII's inventory and elsewhere. He also argues that the remains have come from two distinct sets: (a) the Brussels and Florence large portions, together with a piece from the Lelong (later Astor) collection; (b) the smaller but better preserved fragments, which include ours, the Dijon *Charlemagne* and two other *Roncevaux* pieces at Tournai, Musée d'Histoire et d'Archéologie, and the National Museum, Stockholm. Asselberghs regards the latter pieces as probably coming from the earlier set, because of some superiority in details of the drawing.

Description. The episode in this portion shows a mêlée in the battle of Roncevaux. Roland with his sword Durendal, is in combat with King Marsile (all inscribed); Oliver brandishes his sword on the left.

Inscriptions: 'roland', 'durendal', 'marsille', 'bau' (duin), 'olivier'.

Further information. The best known 15th century *Charlemagne* tapestry is the double-panel lent by the Hon. J.J. Astor to the Anglo-French exhibition at the V & A M in 1921 (No.59), with inscription. The *Charlemagne* tapestry and fragments in the treasury of St Mark's, Venice (Ackerman, *Mirror of Civilisation*, pl.xii) may in fact represent the coronation of the Emperor Sigismund; the subject is still disputed. There are three other fragments of the V & A *Roncevaux* in private possession in France.

M. Crick-Kuntziger has argued for the Tournai origin of these tapestries because of Burgundian archaisms in Roland's arms, the *fleur de lys* showing his relationship with Charlemagne; and the Tournai dialect is noticeable in the inscriptions ('busleage', 'tieste', 'raine', etc.), just as it is in inscriptions on the *Swan Knight* and *Julius Caesar* tapestries. (The former was delivered to Philip the Good by Pasquier Grenier in 1462, the latter belonged to Louis of Luxembourg (d.1475)). The style of composition of *Roncevaux* shows the extreme limits of a surface-filling design, which Crick-Kuntziger thinks derived from the workshops of Robert Campin (Tournai) and Bauduin de Bailleul (Arras) – the two workshops were connected – through the intermediary of cartoon painters attached to tapestry workshops.

The source of the story as shown in the tapestries is pseudo-Turpin's version of the *Chanson de Roland* and especially *La Bataille de Rainchevaux*, a 13th century account deriving from pseudo-Turpin.

Museum acquisition. T.95–1962. Bought at Sotheby & Co. (£2,300), 18 May 1962. Cleaned and restored by Tabard of Aubusson.

Literature
Ackerman, P., *Tapestry, the Mirror of Civilisation*, New York, 1933, pp.79–80, pl.XII
Asselberghs, J.P., 'La tenture de la Guerre de Troie et les tapisseries tournaisiennes de la seconde moitié du XVe siècle' in *La tapisserie tournaisienne au XVe siècle*, Catalogue of the exhibition, Tournai 1967, Nos.10–13, p.25

Crick-Kuntziger, M., *Catalogue des tapisseries*, Musées royaux d'art et d'histoire, Brussels, 1956, no.3, pp.17–19, pls.4, 5
Gallo, R., 'Il Tesoro di S. Marco, Gli arazzi' in *Rivista della città di Venezia*, 1926
Göbel, H., *Wandteppiche I. Die Niederlande*, Leipzig, 1923, pt.i, p.273, pt.ii, pl.216
Heinz, D., *Europaïsche Wandteppiche*, vol.i., Braunschweig, 1963, p.73, figs.42, 43
Masschelein-Kleiner, L., Maes, L., Znamensky-Festraets, N., 'Les colorants des tapisseries tournaisiennes au XVe siècle. Etude comparative de trois fragments de la Bataille de Roncevaux' in *Bulletin de l'Institut Royal du Patrimoine Artistique*, vol. x, Brussels, 1967–8, pp.126–39
Victoria and Albert Museum, *The Franco-British Exhibition of Textiles*, Catalogue of the exhibition, London, HMSO, 1921, No.59

No. 8 (*pl.16*)
Confirmation from *The Seven Sacraments*

TOURNAI; 1470–75.
H. 6ft 1in. (1·85m.) W. 3ft 11in. (1·19m.).
Wool and silk: 13 warp threads to inch (5 to cm.).

Condition. The excellent appearance is partly due to restoration which (although otherwise light) has intensified the highlights with new silk thread. The panel has not been reversed.

This well-preserved fragment is of importance because of its connection with Pasquier Grenier, the leading tapestry-merchant of Tournai, who supplied Philip the Good and the French Court. The fragment represents the sacrament of *Confirmation* and comes from a large hanging of *The Seven Sacraments* woven with scenes arranged in two registers around a central scene depicting an apparition of the Holy Ghost. The lower register contained scenes of the sacraments with the participants in mid-15th century dress; the upper register contained Old Testament prefigurations of the

sacraments. Between these two sets of scenes were explanatory texts. The text relating to this fragment is mainly preserved, along with the prefiguration of Confirmation, *Jacob blessing Joseph's children*, in the Metropolitan Museum of Art, New York; and in the Burrell Collection, Glasgow, are a few words with a patchwork of figures from *The Seven Sacraments* including the figure of a priest from the right of *Confirmation*. The text reads: 'Adfin qua vigheur sabandonnent creatures prelas leur donnent / confirmation et tunsure·et de che samblanche en d(ro)iture / Jacob le patriarche fist·qui ses mains sur ii enfa(nts) mist.' The Metropolitan Museum owns seven scenes from the two ends of the tapestry, while the Burrell Collection fragments come from the central section. A reconstruction of the tapestry has been suggested by J.J. Rorimer (*Bulletin, Metropolitan Museum of Art*, 1940) and later, more satisfactorily, by William Wells (*Burlington Magazine*, 1959).

Although these appear to be the only surviving remains from the 15th century, there are four records of important *Sacrament* tapestries: (1) In 1439–40 Philip the Good purchased a tapestry under this title to give to his son Charles (G.L. Hunter, 1925, etc.); (2) Jean Chevrot, Bishop of Tournai (1438–61), bequeathed one in 1458 to the church of St Hippolyte at Poligny, his birth-place; the citation infers it was made in Tournai (L. Fourez, *Revue belge*, 1954); (3) Pasquier Grenier and his wife Marguerite de Lannoy, who helped to finance the rebuilding of the church of St Quentin in Tournai (1464–74), dedicated a chapel at their expense to the Seven Sacraments and presented tapestries of this subject showing the Sacraments with their Old Testament prefigurations (P. Roland, *Revue belge*, 1936); (4) Isabella the Catholic's inventory drawn up in Segovia in 1503 records another large *Sacraments* tapestry (F.J. Sanchez Canton, 1950). This last is of interest because the five New York pieces (and one of the two Burrell pieces) can be traced back through Albert Goupil (Sale of 1888) to the painter Mariano

Fortuny, who said he had acquired them from the Royal Chapel of Ferdinand and Isabella at Granada (1871).

The origin of the existing tapestries has been hotly disputed because of the tempting association with Pasquier Grenier, and Fortuny's testimony has sometimes been discountenanced. But J.P. Asselberghs seems to have summed up the situation reasonably in the catalogue of the Tournai exhibition (1967). The tapestries cannot be as early as the first recorded gift (1440): a date around 1470 is generally agreed. It suggests, therefore, a common origin for the three later recorded *Sacrament* tapestries, as it would be normal for Pasquier Grenier to have repeat sets of this important commission woven, and it would be quite consistent for him to supply Jean Chevrot (a favourite of Philip the Good and an art patron, whom he most probably knew), as well as Ferdinand and Isabella, and to choose this same composition to be woven for his own chapel at Tournai.

Description. On the right stands a bishop, facing right, wearing a mitre and cope, with an open book in his left hand, while with his right he clips with shears the hair of a boy who kneels before him. On the left are a boy and girl, kneeling; behind them a kneeling woman, and behind her a man standing. The background is patterned like a damask.

The scenes are separated by columns and by descriptive texts in the full tapestry.

Further Information. The five Metropolitan Museum pieces have seven scenes: Baptism, Marriage, and Extreme Unction, each with its prefiguration, and the prefiguration to Confirmation with the inscription. Two of these pieces have been reversed (probably on account of wear and fading). The New York pieces and the larger Burrell piece come (as previously stated) on Fortuny's evidence from the Royal Chapel at Granada. The Museum panel and Eucharist fragments at Glasgow are of uncertain origin, but conjecturally from the same

source. The story of Pasquier Grenier's part in the re-building of St Quentin is set out in an article published in the *Revue belge* (1936), to which Paul Roland, M. Crick-Kuntziger and M. Morelowski contributed. He gave up a portion of his garden for the absidal chapels which were built. The account in Sanderus' unpublished *Tornacum Illustratum* (c.1650) of the tapestries still hanging in the church at that time is there quoted and considered:

'Chorus illius (ecclesiae) cum tribus capellis quae retro sunt anno 1469 a fundamentis renovata sunt, Paschasio Grenier cive Tornacensi, cum uxore Margareta De Lannoy præeuntibus et conferentibus pecuniam ad erigendas octo columnas, quae fornices chori fulciunt et post etiam capellam quae post altare summum est . . . quorum liberalitas eo magis exemplaris fuit quod proles non minus septemdecim haberent, ut patet ex tapetibus, quos confici curarunt ad ornamentum chori, septem ecclesiae sacramenta, cum suis figuris ex antiquo testamento depromptis, luculenter exprimantibus' (Sanderus, *Projet manuscrit d'Histoire de Tournai*, Biblioth. Commun. Tournai, Nos.183, 184).

Grenier gave the money for the funerary chapel, dedicated to the Seven Sacraments, which has his arms on the ceiling, and he founded masses to be said there 'en le capielle des diz fondateurs Pasquier Grenier et sa femme, décorée al honneur du Saint Sacrement, estant derière le coeur en la dicte eglise Saint-Quentin, que fist faire et décorer de son vivant ledit Pasquier Grenier, quatre messes la sepmaine . . .' (Cartul. de 1509, fol., 127r.). The account of Pasquier Grenier's gift of tapestries is given alongside the text of Jean Chevrot's gift of 1458 to Poligny in Asselbergh's Tournai exhibition catalogue (1967). (See also L. Fourez's article in the *Revue belge*, 1954). William Wells has discussed the iconography of the tapestries with reference, in particular, to embroidered orphreys at the Bern Historical Museum, and the Van der Weyden altarpiece (which originally belonged to the Tournai bishop, Jean Chevrot) now in Antwerp. He also quotes Dr Betty Kurth's (incomplete) comments on the Burrell pieces.

There are four silver-point drawings in the Ashmolean Museum, Oxford, which show the same type of design and have been associated with the school of Roger van der Weyden. Two of them, *Ordination* and *Extreme Unction*, can be associated with the scenes on the orphreys of the Bern Cope. Another two similar drawings showing *Baptism* and *Matrimony* are in the Musée du Louvre, Paris (see F. Winkler, 'Some Early Netherlands Drawings' in *Burlington Magazine*, vol.xxiv; J. Stammler, *Der Paramentenschatz*, Bern; M. Sonkes, *Dessins du xve siècle: groupe de Van der Weyden*, Brussels, Centre national de Recherches 'Primitifs Flamands', 1969).

Museum Acquisition. T.131–1931. Purchased from Mrs Enid du Cane for £1,000 (funds of Murray bequest). The panel had been on loan in the Museum for many years and was shown in the Franco-British Textile Exhibition of 1921 (Catalogue No. 61, pl.xxiv).

Literature
Asselberghs, J.P., 'La tenture de la Guerre de Troie et les tapisseries tournaisiennes de la seconde moitié du XVe siècle' in *La tapisserie tournaisienne au XVe siècle*, Catalogue of the exhibition, Tournai, 1967, No.29, pl.29
Fourez, L., 'L'Evêque Chevrot de Tournai et sa Cité de Dieu' in *Revue belge d'archéologie et d'histoire*, vol.xxiii, 1954, pp.82, 105
Göbel, H., *Wandteppiche I. Die Niederlande*, Leipzig, 1923, pt.i, p.271
Hunter, G.L., *The Practical Book of Tapestries*, London and Philadelphia, 1925, pp.46–51
Marillier, H.C., 'Sir William Burrell's Sacrament Tapestry' in *Archaeological Journal*, vol.xciii, 1936, pp.45–50
Roland, P., Crick-Kuntziger, M., Morelowski, M., 'Le tapissier Pasquier Grenier et l'église Saint-Quentin de Tournai' in *Revue belge d'archéologie et d'histoire*, vol.vi, 1936, pp.203–21
Rorimer, J.J., 'A Fifteenth Century Tapestry of the Seven Sacraments' in *Metropolitan Museum Bulletin*, vol.xxxv, New York, 1940, pp.84–7
Sánchez Cánton, F.J., *Libros, tapices y cuadros que coleccionó Isabel la Catolica*, Madrid, 1950, p.112
Sonkes, M., *Dessins du XVe siècle; groupe de Van der Weyden*, Centre national de Recherches 'Primitifs flamands', Brussels, 1969
Stammler, J., *Der Paramentenschatz im Historischen Museum zu Wort und Bild*, Bern, Historisches Museum, 1895
Victoria and Albert Museum, *The Franco-British Exhibition of Textiles*, Catalogue of the exhibition, London, 1921, No.59
Wells, W., 'The Seven Sacraments Tapestry – A New Discovery' in *Burlington Magazine*, vol.ci, 1959, pp.97–105
Wells, W., 'The Earliest Flemish Tapestries in the Burrell Collection' in *L'Âge d'Or de la tapisserie flamande. Colloque International 1961*, Brussels, 1969
Winkler, F., 'Some Early Netherlands Drawings' in *Burlington Magazine*, vol.xxiv, 1913–14, p.224

No. 9 (*pl.17*)
Verdure with a rabbit warren

FRANCO-BURGUNDIAN; early 15th century.
H. 3ft 9in. (1·15m.) W. 6ft 4½in. (1·95m.).
Wool and silk: 16 warp threads to inch (6–7 to cm.).

Condition. A fragment in good condition, the greens faded to blue.

A rabbit warren, trees and flowers, set in a field with rabbits and deer amidst foliage. The ground is dark blue.

Another piece of the tapestry is in the Dumbarton Oaks Collection, Washington D.C. A remarkably similar rabbit warren is to be seen in a manuscript in the Bibliothèque Nationale, Paris, ascribed to the school of Haincelin de Hagenau (see Fierens-Gevaert, p.97). In the *Livre de la Chasse* of Gaston Phébus, Comte de Foix, the beautifully illustrated manuscript (Paris, Bibliothèque Nationale, Ms. Fr.616) has two pictures showing bushes and rabbits treated as in this tapestry (pls. 10, 11 of the printed reproduction).

Museum acquisition. T.37–1914. Purchased (£40) from the executors of J.H. Fitzhenry Esq. Mr Fitzhenry had lent the tapestry to the Museum from 3 March 1906 onwards.

Literature
Fierens-Gevaert, H., *Études sur l'art flamand. La Renaissance Septentrionale et les premiers maîtres des Flandres*, Brussels, 1905, p.97
Kurth, B., *Gotische Bildteppiche aus Frankreich und Flandern*, Munich, 1923, pl.14
Kendrick, A.F., *Victoria and Albert Museum Catalogue of Tapestries*, 2nd ed., London, 1924, no.10A, pl.viii
Phébus, Gaston, *Livre de la Chasse*, Paris, Bibliothèque Nationale, Manuscrit Français 616

No. 10 (*pls.18A & B*)
Border of St Gereon Tapestry

Probably GERMAN, Cologne; 11th century.
H. 6in. (0·15m) W. 15in. (0·43m.).
Wool and linen: 14–15 warp threads to the inch (5–6 to cm.).

Condition. A fragment, faded.

Three portions of this tapestry from St Gereon's church, Cologne, exist besides this fragment from the border: (1) a piece in the Germanisches Nationalmuseum, Nuremberg, which has two roundels of the main field (top segment cut) and the bottom and right border (illustrated, Heinz, fig. 13); (2) the Musée des Tissus, Lyons, has a portion with one almost complete roundel, with linking lion mask roundel (one complete, one on right

cut), also the lower border (ill. Kurth, II, pls.1 and 2) – this piece is illustrated here; (3) a piece formerly in the Berlin Schlossmuseum, similar in size and shape to the Lyons portion but a little more cut at the top and on the right (ill. Göbel, pl.1). The tapestry formerly hung in the choir of St Gereon and was cut up and disposed of by Dr Franz Bock (Göbel, pp.2–3), from whom our fragment came.

The St Gereon tapestry is the earliest surviving example of a small group of Romanesque hangings and the only one with a purely decorative design; it has been studied by Betty Kurth and H. Göbel, who have sifted a good deal of earlier writing on this unique piece, and the information is summarised by D. Heinz. Kurth quotes the earlier literature extensively and, following Otto von Falke, shows that the design is based on a Byzantine silk, with a border added in Romanesque taste. A silk from nearby St Ursula's church in Cologne, from the tomb of a daughter of Pepin the Short (died second half 8th century) has a similar design: a griffin attacking a bullock disposed within a roundel, with small roundels where the large ones intersect. Another silk with the same theme comes from a tomb of 1074 in the St Waldburg Convent at Eichstätt; here the border of the main roundels has the same heart-shaped motif as in the St Gereon tapestry. Both these are illustrated by Kurth (vol.I, figs.8, 9), who also cites parallels for the Romanesque lion-masks and border scrolls.

The date generally ascribed to the tapestry is the 11th century, probably the second half, and for the weaving there is a tentative attribution to Cologne.

The nearest tapestries of comparable date are the *Abraham*, *Apostle* and *Charlemagne* (with philosophers) hangings at Halberstadt, and the April and May scenes (from the *Months*) from Baldishol in Norway; but these are generally ascribed to the late 12th–13th centuries (illustrated and discussed by Kurth, Göbel and Heinz).

The St Gereon tapestry is woven with seven colours (Göbel, p.3), with red and blue or green

predominating on a white background. It has a coarse texture so that the colours are juxtaposed in a mosaic manner and the curvature of the roundels has a stepped effect (Heinz, p.29). As decoration, despite the summary treatment, it must have been effective enough when the colours were strong and fresh.

Description. The ground is white with blue scrolls outlined in red; the quatrefoils in the scrolls are yellow, outlined in purple, as are the white lion-masks.

Museum acquisition. 8241–1863. Purchased (Bock Collection).

Literature

Bock, F., *Die Geschichte der Liturgischen Gewänder des Mittelalters*, vol.III, Bonn, 1871, pp.115–6, pl.XIX, fig.1

Falke, O. von, *Kunstgeschichte der Seidenweberei*, vol.II, Berlin, 1913, p.3

Göbel, H., *Wandteppiche III. Die Germanischen und Slawischen Länder*, pt.1, Berlin, 1933, pp.2–3, pl.1

Guiffrey, J., 'Les tapisseries du XIIe à la fin du XVIe siècle' in *Histoire générale des arts appliqués à l'industrie du Ve à la fin du XVIe siècle*, vol.VI, Paris, 1911, p.3, fig.2

Heinz, D., *Europäische Wandteppiche*, vol.I, Braunschweig, 1963, pp.29–31, fig.13

Kurth, B., *Die Deutschen Bildteppiche des Mittelalters*, Vienna, 1926, vol.I, pp.26–7, figs.8, 9, p.205; vol.II, pls.1, 2

Müntz, E., *La tapisserie*, Paris, 1882, p.94, ill. p.93

Rathgens, H., *Die Kunstdenkmäler der Stadt Köln*, vol.II, Düsseldorf, 1911, p.98

Thomson, W.G., *A History of Tapestry*, London, 1930, p.46

No. 11 (*pls.19A & B*)
Wild Men with Animals

SWISS, LUCERNE OR BASEL; mid 15th century.

H. 2ft 11in. (0·89m.) W. 7ft 4in. (2·24m.).
Wool: 12 warp threads to the inch (5 to cm.).

Condition. Good, with strong colours. On left side, cut unevenly; the right edge complete, with small insertion at top. Slight spots of restoration.

A fine example of the medieval theme of Wild Men and Women with fabulous animals; expertly woven in a strong style on a commanding scale. This large panel comes from the Figdor collection, Vienna. Burckhardt and Kurth have pointed out that it is modelled on an earlier piece, now in the Landesmuseum, Zurich, dating from 1430–40; in the Zurich piece the vegetable forms are more copious and crowded, as is the filling of the foreground, but the general disposition of figures and animals is the same, with differences in detail. The Figdor piece, now in this Museum, has been boldly simplified with striking effect (the two pieces are illustrated together, Kurth, 1926, pls.49 a and b).

The panel came from the St Anna Kloster in Bruch, near Lucerne, and Burckhardt, who first published it, considered it was probably made in Lucerne, though it is very close to the Basel school. Kurth and Göbel leave the matter undecided. A typical example of the Basel school is the piece in Vienna (Kunsthistorisches Museum). The wild people with their monsters have inscribed banner-scrolls, which announce that they shun the maliciousness of the world and fly to the '*dierlin*' (animals). In commenting on the tapestry, Göbel corroborates Kurth in rejecting the old idea that Wild Men subjects represent a fight against evil passions portrayed by the beasts or monsters. It is now recognised that the theme is quite otherwise; the beasts represent uncontaminated Nature and the complaint against the evils and restrictions of the world of men is symbolised. (See also comments on another tapestry in Vienna, Karlsruhe Exhibition Catalogue, No.255, p.286).

F. Gysin, in his *Tapisseries suisses de l'Epoque*

Gothique, illustrates Wild Men tapestries with a variety of inscriptions. One of these depicting fabulous beasts and young couples in courtly dress has: (Youth) 'No animal can escape me, I do all that by my ruses'; (Maiden) 'By my love I can master wild animals – also men' (woven in Basel, c.1490; pl.6).

In the German-speaking world of the late 14th–15th centuries the role of Wild People and fabulous beasts was the most favoured theme in art, poetry and pageant, beside romantic subjects and religion. Richard Bernheimer's study (*Wild Men in the Middle Ages*) has greatly elucidated the subject. '[Wildness] ... in the Middle Ages implied everything that eluded Christian norms and the established framework of Christian society, referring to what was uncanny, unruly, raw, unpredictable, foreign, uncultured, and uncultivated ... Just as the wilderness is the background against which medieval society is delineated, so wildness in the widest sense is the background of God's lucid order of creation. Man in his unreconstructed state, faraway nations, and savage creatures at home thus came to share in the same essential quality. This quality was one which had considerable fascination for many men in the Middle Ages, as a counterpoise against traditional limitations of thought and behaviour' (p.20). Wild Men and beasts, as in this tapestry, accordingly imply freedom, energy, the natural instincts. 'It became fashionable to identify oneself with savage things, to slip into the wild man's garb ...' in pageants and masquerades. Patricians and burghers liked to see this theme represented in their houses on the walls, on tiles, on embroideries and tapestries, and on various utensils. Wild men were favoured as supporters to coats of arms and as wedding tokens; 'wildness in the sense of the natural and untamed could thus carry an erotic flavour and the ardent lover would think of himself as "wild"' (Bernheimer, ch.5).

Wild Men, or *homines agrestes*, were rendered in English by Wycliffe in his translation of the Vulgate as *wodewose* (Bernheimer, p.98). The theme is of course not confined to German-speaking lands (see Heinz, p.135).

Description. In the centre is a wild woman of the woods, clothed in blue hair, turning half to the right, with her left hand on the neck of an animal which stands facing her in profile with its head turned back. The animal has a blue-green body, with cloven fore-hoofs and webbed hind feet; from its head sprout three feathers; round its neck is an inverted crown, beneath which hang three rows of pink feathers, and in the middle of its back is a bunch of pink hair. On the other side of this animal is a wild man of the woods dressed in pink hair, advancing to the left with his right arm half raised.

On the other side of the blue woman, with its back to her, is an animal with a very long neck joined onto a pair of hind-legs (it has no forelegs). The head is dragon-like, with long jaws and large teeth. The neck is covered with yellow feathers, the feet are clawed and on the rump is perched a bunch of pink hair. Round the base of the neck is a collar, with hanging feathers, to which is attached a ribbon held in the hand of a wild man, who stands half facing the animal. He is covered in pink hair and has a wreath round his head and a large club in his right hand. On his other side is the front part of an animal advancing towards him. It has cloven hoofs, blue legs and head, and a yellow mane.

The background is dark blue, covered with floral stems. In the foreground are rabbits and a bird.

Museum acquisition. T.117–1937. After leaving Kloster Bruch, the tapestry was in the Meyer-am-Rhyn and Roman Abt collections, Lucerne, before going to Dr Albert Figdor. Bought from F.A. Drey (£2,800), who acquired it in the Albert Figdor Sale, Vienna.

Literature
Bernheimer, R., *Wild Men in the Middle Ages*, Massachusetts, 1952, pp.20, 98, 154–5

Burckhardt, R.F., *Gewirkte Bildteppiche des XV and XVI Jahrhunderts im Historischen Museum zu Basel*, Leipzig, 1923, p.25, note 6, fig.33b
Göbel, H., *Wandteppiche III. Die Germanischen und Slawischen Länder*, Berlin, 1933–4, pt.i, pp.26–7, pp.31–2, pl.9
Gysin, Fritz, *Tapisseries suisses de l'Epoque gothique*, 2nd ed., Basel, 1947, pls.6, 7, 8
Heinz, D., *Europäische Wandteppiche*, vol.1, Braunschweig, 1963, p.135
Karlsruhe, *Spätgotik am Oberrhein 1450–1530*, Exhibition Catalogue, Badisches Landesmuseum, 1970, No.255, p.286
Kurth, B., 'Mittelhochdeutsche Dichtungen auf Wirkteppichen des XV Jahrhunderts' in *Kunsthistorische Sammlungen des Kaiserhauses*, *Jahrbuch*, vol.XXXII, Vienna, 1915, p.233
Kurth, B., *Die Deutschen Bildteppiche des Mittelalters*, 3 vols., Vienna, 1926, pp.95–102, p.217, pls.49a & b
Wyss, R.L., *Bildteppiche des 15 und 16 Jahrhunderts*, Zurich, Schweizerisches Landesmuseum, 1955, pls.3, 5, p.5

No. 12 (*pls.20A–B, 24A*)
The Labours of the Months

ALSACE; middle of the 15th century.
H. 1ft. 3¼in. (0·39m.) W. 8ft. 11½in. (2.73m.).
Wool and linen; linen warp: 15 warp threads to the inch (6 warp threads to cm.).

Condition. Good, colours fresh; slight restoration.

A long narrow tapestry or *Rücklaken* (dorsal) intended to hang over a wooden bench. It shows the labours of the months from July to December with the names of the months inscribed on scrolls over each scene. These names, particularly 'fuilmonet' 'herbstmonet' and 'volrot', are Alsatian dialect and establish the origin of the weaving.

Description. In July (*howmonet*) peasants cut and gather the hay; August (*ougst*), the corn is reaped; September (*fuilmonet*), harrowing and sowing; October (*herbstmonet*), cutting down the grapes and making wine; November (*vitermonet*), slaughtering an ox; December (*volrot* or 'full circle'), the peasants enjoy the fruits of their labours and sit eating at a table.

Further information. This tapestry was formerly in the possession of Freiherr Joseph von Lassberg of Meersburg on Lake Constance, who also owned most of the other half, the months February to June, but the whereabouts of this is now unknown.

H. Göbel's attribution to the Lake Constance (Bodensee) district is not generally accepted.

Museum acquisition. 6–1867. Bought from Dr Franz Bock for £6.

Literature
Göbel, H., *Wandteppiche III. Die Germanischen und Slawischen Länder*, Berlin, 1933–4, pt.i, p.101, pl.78
Karlsruhe, *Spätgotik am Oberrhein 1450–1530*, Exhibition Catalogue, Badisches Landesmuseum, 1970, No.254
Kurth, B., *Die Deutschen Bildteppiche des Mittelalters*, Vienna, 1926, pp.128, 236; pls.127–30

No. 13 (*pls.21A & B, 23B*)
The Buzzard ('*Der Busant*')

ALSACE (probably Strassburg); c.1470–90.
H. 2ft 6in. (0·76m.) W. 12ft 6½in. (3·76m.).
Wool, white linen, silk and gold thread, with cotton used in faces and hands, and with knotted pile for parts of costume (jackets, hats, fur) and for flowers; on linen warp; 17 warp threads to the inch (7 to cm.).

Condition. Cut at both ends, edges frayed; relatively good state of preservation with minor worn spots and repairs.

This long narrow band, or *Rücklaken*, for hanging behind a bench, tells the *Story of the Buzzard* (*Busant*), a Middle High German romance written in poetry in the early 14th century, in Alsace. The scenes are identified with inscriptions on decorative bands.

The complete story is as follows: the Prince of England goes to school in Paris, and there meets the Princess of France, who is betrothed against her will to the King of Morocco. They plan that he shall return on her wedding day and carry her off. The Prince goes back to England, takes three horses and a fiddle and returns later to the French court disguised as a minstrel. The King of Morocco has come to claim his bride, but the lovers escape. They ride through the forest on the prince's horse, until they decide to dismount and rest. The princess, tired from the day's events, falls asleep with her head on the prince's lap, while he looks at her ring, which he has pulled from her finger. Suddenly a buzzard swoops down from the heavens and snatches the trinket away. As he pursues the bird, trying in vain to hit it with sticks and stones, the prince penetrates deeper and deeper into the forest and loses his way. It dawns upon him after a frantic search that he cannot find his beloved, whom he has left behind. He becomes violent and demented, tears off his fine clothes, the tokens of his humanity, and proceeds to roam the woods, beast-like, on all fours, as a wild man. The princess, meanwhile, much less perturbed than he, finds refuge in a mill, and later is received incognita into the castle of a local nobleman. A year passes. Then chance wills it that the hunters should come upon a hairy wild man, whom they bring to the castle as a curiosity. The kindly duke, aware that the creature may not always have been wild, sees to it that he is treated with consideration and taught to walk upright. Recognition of the wild man's former identity and the reunion of the lovers is effected when the prince, upon being taken to the hunt, engages in the eccentricity of biting off the head of a buzzard. Asked what had brought on such strange behaviour, he explains that he hates buzzards because, years ago, a buzzard had caused him to lose his beloved. Knights are sent out to inform the parents of the two lovers, the wedding takes place with feasting and a tournament.

The Buzzard *Rücklaken* is unusually long, with other strips in Nuremberg, Cologne, Glasgow and the Louvre (the two last from a second, rather later, weaving).

Der Busant belongs to a group which forms itself round the Vienna hunting tapestry (Kurth, *Deutsche Bildteppiche*, p.131, pls.138–9). The group includes *The Queen of France and the Unfaithful Steward* in the Nuremberg Museum; a *Minneteppich* in the Benda Collection, Vienna; the *Pair of Lovers hunting on Horseback*, formerly in the Engel-Gros Collection, Basel (now lost); and the *Maiden and the Unicorn* in the Historical Museum, Basel (see Karlsruhe Cat., on cover in colour, no.262). These all have points of similarity, though not close enough to support a theory that they were designed by the same hand. They date from the end of the 15th century. On the *Queen of France* is the date (14)92, according to Hampe's Catalogue (cf. *Anzeiger für Kunde der deutschen Vorzeit*, 1855). Kurth, however, thinks the date should be read '72', which would be more in accordance with the costumes. The Vienna hunt is probably the earliest of the group; *Der Busant* is a little later, to judge from the turban-like headdress of the women, which is very like that in Holbein's portrait of Dorothea Kannengiesser, dated 1516.

There is no doubt that the whole group is of Alsatian origin. This is proved by the dialect of the inscriptions (cf. Karl Weinhold, *Alemannische Grammatik*, 1863). Also there is no mistaking their relationship to the Vienna tapestry, and this has two shields of arms, which are those of the Strassburg families of Boecklin von Boecklinsau and of

Mühlheim. Since 15th century tapestries in Germany were very local in origin, it is unlikely that a tapestry containing Alsatian shields would have been made elsewhere than in Alsace. The design is Alsatian in character and may derive from book illustrations.

Description. There are six scenes (seven others are preserved in strips elsewhere), with inscriptions on scrolling bands:
1. The return to England of the King's son. Inscribed: 'Bisz gottwilkum dusnt stunt / grosser froyd wart uns nie kunt' (Be welcome a thousand times: greater joy have we never known).
2. He asks his servants for three horses and a fiddle: 'Frumer dienr bestelle mir / dri ros ein gige is min begir / Herre ich wil mich des genietē / un tun noch dein gebieten' (Good servant, give orders for me, three horses and a fiddle is my desire. Sir, I will . . . and do thy bidding).
3. The horses are brought and the Prince sets out: 'Gige un rosz sint bereit / als un(?) uger geůd het geseit. / Wol hien gluck zu diser vart / nie kein reise mir lieber wart' (Fiddle and horses are ready . . . ? If good fortune should be in this journey, no travelling could be dearer to me).
4. The Prince is welcomed at the court of the French king: 'Mich dunckt du kumst von land vit / dien mir zu der hochziit / Ich hab vor eim ior geriht / einer tuben und mich yr werpflicht' (Methinks thou comest from a far land: serve me at the wedding. I have . . . and betrothed myself to her).
5. The King of Morocco comes for his bride: 'Umb semlich ich nun kume bin / wo is die junge kunigin. / Bis wilku lieb dochte man / wie . . . e(?) wir dz brulofft an' (I am come now . . . where is the young queen? Welcome noblest of men . . .).
6. The Prince escapes with the Princess: 'De brutione dut we uver scheide / aber ich bin sin in grosse freiden' (The bridegroom . . . but I am hers with the greatest joy).

Further information. Other pieces of this tapestry, illustrating much of the rest of the story, are in the Kunstgewerbe Museum, Cologne (Clemens Collection; 68cm. long); the Germanisches Museum, Nuremberg (1·18m. and 1·985m. long); the former Figdor Collection, Vienna; the Louvre; the Burrell Collection, Glasgow. The two scenes at Cologne continue our strip with: (1) the lovers asleep in the forest; (2) the buzzard making off with one of the rings. These two scenes are also found in the piece at Glasgow. The five scenes in the Nuremberg strips are: (1) after the reunion of the lovers, news is sent out to their parents; (2) the marriage; (3) the marriage feast; (4) a tournament; (5) the lovers return to England mounted on one horse. The last two scenes are also found on the piece in the Louvre.

There are, therefore, remains of two weavings from the same cartoon, with minor variations. Kurth's view that the Nuremberg pieces are from the second weaving of about 1490 is currently accepted. Frau Dr Braun-Ronsdorf believes that the costume on this Museum's strip indicates a date in the decade 1460–70, in particular the pointed shoes, the short belted tunic of the men and their hose; also their capes and the Queen's *houpeland* (letter quoted in the Karlsruhe Exhibition Catalogue, 1970, no.258, pp.289–90).

The poem has been published by N. Meyer and E.F. Mooyer, *Altdeutsche Dichtungen*, 1833, and by F.H. Hagen, *Gesammtabenteuer: Hundert altdeutsche Erzählungen*, vol.I, 1850, XVI. Hagen ascribes the Ms. to the beginning of the 15th century, and to the Basel district. F. Vogt, *Geschichte der mittelhochdeutschen Literatur*, 1902, places the poem in the Middle Rhine district. A second Ms. was found in the Library at Karlsruhe, and both manuscripts are attributed to Alsace, and the Alsatian origin of the poem strongly maintained by Eugen Glaser, *Über das mittelhochdeutsche Gedicht Der Busant*, 1904. The poem goes back to the 13th century French romance *L'Escoufle*. See Rheinhold Kohler, 'Das altdeutsche Gedicht Der Busant und das alt-französische L'Escoufle' in *Germania, Vierteljahrschrift für deutsche Altertumskunde*, vol.XVII, 1872. See also Wolfgang Stammler, *Reallexicon*, vol.3, 1954.

Museum acquisition. 4509–1858. Bought (£10). A watercolour copy was commissioned in 1891 for £30.

Literature
Bernheimer, R., *Wild Men in the Middle Ages*, Massachusetts, 1952, pp.15–17
Burlington Fine Arts Club, *Catalogue of an Exhibition of Gothic Art in Europe (c.1200–c.1500)*, London, 1936, no.35
Cologne, *Sammlung Clemens*, Exhibition Catalogue, Kunstgewerbemuseum, 1963, no.894
Düsseldorf, *Kunst-historische Ausstellung*, Catalogue, 1902, no.2532
Göbel, H., *Wandteppiche III. Die Germanischen und Slawischen Länder*, Berlin, 1933–4, pt.i, p.97, pls.70, 71
Hampe, T., *Katalog der Gewebesammlung des Germanischen Nationalmuseums*, Nuremberg, 1896, no.678
Heinz, D., *Europäische Wandteppiche*, vol.I, Braunschweig, 1963, p.148, fig.102
Karlsruhe, *Spätgotik am Oberrhein 1450–1530*, Badisches Landesmuseum, Exhibition Catalogue, 1970, nos.256–8, 262, figs.231–3
Kurth, B., 'Mittelhochdeutsche Dichtungen auf Wirkteppichen des XV Jahrhunderts' in *Kunsthistorische Sammlungen des Kaiserhauses, Jahrbuch*, Vienna, vol.XXXII, 1915, pp.233–53
Kurth, B., *Die Deutschen Bildteppiche des Mittelalters*, vol.I, Vienna, 1926, pp.131, 239; pls.138–9, 142–50
Munich, *Katalog der Ausstellung von Meisterwerken der Renaissance aus Privatbesitz*, 1901, no.711
Stammler, W., 'Busant' in *Reallexikon zur Deutschen Kunstgeschichte*, herausgegeben von O. Schmidt, Stuttgart, 1954, pp.238–9
Weinhold, K., *Grammatik der deutschen Mundarten. II Alemannische Grammatik*, Berlin, 1863

Ysselsteyn, G.T. van, *Tapestry*, The Hague and
Brussels, 1969, p.170

No. 14 (*pls.22A & B, 23A*)
The Search after Truth

GERMAN, MIDDLE RHINE; c.1490
H. 2ft 9½in. (0·9m.) W. 11ft. 4in. (3·5m.).
Wool, white linen and silk; linen warps; 16–17
warp threads to inch (6–7 to the cm.). The facial
features are embroidered.

Condition. Good, colours fresh.

The five scenes of this *Rücklaken*, a narrow band of
tapestry, are preceded by six scenes in a strip
preserved in the Kunstgewerbemuseum in Cologne.
The girl in search of truth first meets a hermit, the
Virgin Mary appears to her, she enquires of man's
earthly love; then follow the five scenes shown here
which end in her entering a Convent as the Bride
of Christ. The scenes are identified on banner
scrolls in Middle German speech.

Kurth and Göbel agree in attributing this
tapestry to the Middle Rhine and the latter sug-
gests a convent in Mainz because of the high
quality of the work; the monastic outlook comes
through strongly in the story. Göbel also follows
Max Creutz in seeing the influence of the House-
book Master in the drawing, though indirectly
and the faces are admittedly cruder. Göbel thinks
the designs are probably based on woodcuts,
pointing to the stiff, flamelike treatment of the
grass; and he sees an amalgamation of the old
Convent style, which avoided modelling, with the
influence of Flemish tapestries. Kurth compares
the *Search after Truth* for date and provenance with
an altar frontal with Anna Selbdritt and saints
(Kurth, 1926, pl.206).

Description. Five scenes are shown, on a green
ground, depicting a young woman's experience in

search of truth. Inscriptions are added to each
scene:
1. She decides to confess her sins. Inscribed: 'Das
 mir maria kindt in trew moge werden / so wil
 ich myn sunde bichten uf erden' (That Mary's
 son may be merciful to me, I will confess my sin
 upon earth).
2. She makes her confession. Inscribed: 'Bicht din
 sunde mit ernst sonder spot / so findestu ewig
 trew bygot. Her myn sunde wil ich uch clagen /
 uff das mir gots trew moge behagen' (Confess
 thy sin with earnestness without mockery, so
 shalt thou find mercy with God everlastingly.
 Sir, I will bewail my sin to you in order that
 God's mercy may comfort me).
3. She washes her heart in blood. Inscribed: 'Sal
 ich myn sunde hi leshen / so muss ich my herz
 im blod wesche(n)' (If I am to blot out my sin
 here then I must wash my heart in the blood).
4. She receives Holy Communion. Inscribed:
 'Liber her nu versorget mich / mit gottes trew
 das bitten ich. Entphang in trewen den waren
 crist / divil dyn herz nu reyn ist so' [sic] (Dear
 Sir, provide for me now with God's mercy, I
 beseech thee. Receive in faith the true Christ
 while thy heart is now so clean).
5. She enters a nunnery. Inscribed: 'Kum brudt
 christi wol gemeidt / nym dy kron dy dir got hat
 bereit' (Come, bride of Christ, well pleased,
 receive thy crown that God hath prepared for
 thee).
On the apparel of the priest's alb is the name
'Anna'(?), and on the convent door 'Diss ist eyn
huss godes un ey port des hymels' (This is a house
of God and a gate of heaven).

Further information. Closely related tapestries are *The
Life of the Virgin* in Schloss Maihingen (Göbel,
III, pt.i, pls.92–3), and the *Story of Susanna* (Kurth,
pls.208–11). A commoner and rather earlier type
of *Search for Truth* tapestry in the Middle and
Upper Rhine districts was depicted in the guise of a
maiden with scenting hounds hunting, sometimes

with reference to the fickleness of worldly love
(see Emil Major, fig.9).

Göbel has indicated two comparable woodcut
series with similar theme: (1) *Christ and the Soul* (in
the guise of a maiden), c.1480, arranged in rows
one above the other (Paul Kristeller, *Kupferstich-
kabinett zu Berlin*, no.179); (2) a series in the
Hofbibliothek, Vienna (F. Martin Haberditzl,
vol.i, pls.102–3).

Museum acquisition. 4025–1856. Purchased for £10.

Literature
Creutz, Max, 'Ein rheinische Wirkteppich' in
Deutsche Monatshefte, (*Zeitschrift für die gesammten
Culturinteressen des deutschen Vaterlands*), 1873–76,
II Jahrg., Heft 12
Cologne, *Jahres-Bericht des Kunstgewerbe-Museums der
Städt Cöln*, vol.xix, 1909, p.13
Göbel, H., *Wandteppiche III. Die Germanischen und
Slawischen Länder*, Berlin, 1933–4, pt.i, p.117 ff;
pls.91, 92, 93
Haberditzl, F.M., *Die Einblattdrucke des XV Jahr-
hunderts in der Kupferstichsammlung der Hof-
bibliothek zu Wien*, vol.i, Vienna, 1920, no.163;
pls.102–3
Kristeller, P., *Holzschnitte im Königl. Kupferstich-
kabinett zu Berlin*, Series 2, Berlin, 1915, No.179
Kurth, B., 'Ein Erzeugnis mittel-rheinischen Bild-
wirkerkunst' in *Mainzer Zeitschrift*, Mainz, 1915,
p.87
Kurth, B., *Die Deutschen Bildteppiche des Mittelalters*,
3 vols., Vienna, 1926, p.151; pls.204, 205b, 208–
11
Major, Emil, *Strassburger Bildteppiche aus gotischer
Zeit*, Basel, 1943, pp.20–2; fig. 9

No. 15 (*pl.24B*)
Super-frontal with inscription (*part*)

GERMAN (RHENISH); 15th century.
H. 6⅜in. (0·16m.) W. 2ft 10¼in.(0.88m.).

Wool, linen, silk and metal thread on a linen warp: 28 warp threads to the inch (11 to the cm.).

Condition. Cut at the left: nearly one half is missing. The painted features of the Virgin and the Child have been lost but the condition of the weave is good.

A similar super-frontal illustrated in Göbel, *Die Wandteppiche III*, pt.i, pl.145d, contains the inscription 'Ave regina celorum mater regis angelorū'. Part of another super-frontal of the same type in the Musée Historique des Tissus, Lyons, has in the centre Christ holding a chalice.

Description. On a dark red ground is part of an inscription woven in white gothic lettering: ' . . . a mantibus ad te ivgit' ['amantibus ad te iugiter']. After the first remaining letter is a standing figure of the Virgin, carrying the Child. Above and below the letters runs a meandering stem bearing fantastic flowers and leaves, with offshoots between each word.

Museum acquisition. 7–1867. Purchased from the Bock Collection for £6.

Literature
Göbel, H., *Wandteppiche III. Die Germanischen und Slawischen Länder*, Berlin, 1933–4, pt.i, pl.145d

No. 16 (*pl.25*)
Verdure, a fragment

FLEMISH; c.1500.
H. 6ft (1·82m.) W. 6ft 9in. (2·05m.).
Wool with some silk: 14 warp threads to inch (5–6 to the cm.).

Condition. Considerable restoration.

A fragment in rather poor state, but representative of a large group of late medieval tapestries commonly known as 'mille-fleurs'. Old documents and inventories refer to them as: 'à fond de fleurettes', or 'pièces de menue verdure'. As in this piece, the plants and flowers are often interspersed with birds and animals. Mille-fleurs verdures vary greatly in quality and were woven in many different centres and workshops, particularly in northern France and Flanders.

Description. A unicorn, partridges, and a cock seizing a worm amidst flowering plants which bestrew a dark blue ground. The tapestry may have once been a large hanging.

Further information. 'Mille-fleurs' tapestries. There has been considerable controversy over the origins and centres of production of the mille-fleurs tapestries, which include several distinct groups using these flowery grounds for figure or heraldic subjects of different sorts. The expression 'mille-fleurs' is a modern coinage to distinguish the medieval verdures from later types; mille-fleurs tapestries have the ground bestrewn all over with flowering plants on which the figures (or heraldic devices) are set without any illusion of landscape. In the Museum collection, besides the fragment No.16, there is the earlier piece with *A rabbit warren*, No.9, the *Three Fates*, No.26, the superb hanging with the *Arms of Giovio of Como*, No.38 and the late, coarse mille-fleurs Nos.39 and 40. The two *Pastorals*, Nos.19, 20, are not in this class of mille-fleurs verdures because of their landscape settings.

The most generally appealing and best known to the public are those in the French museums, many of which came from châteaux, particularly of the Loire and neighbouring districts, and religious tapestries once in French churches. For instance, there are the concert, garden and pastoral (*Vie Seigneuriale*) scenes in the Louvre, Cluny Museum, Musée des Arts Décoratifs and Gobelins Museum, and at Angers the beautiful *Angels with the Instruments of the Passion*. The *Lady with the Unicorn* is the undisputed 'chef-d'œuvre' among the mille-fleurs of superior quality, which were woven from designs undoubtedly furnished by painters and miniaturists of repute (although so far unidentified). Two of the seven *Hunts of the Unicorn* in the Cloisters, New York, the *Unicorn Captured* and the *Departure for the Hunt*, are verdures of this same high quality, and of even finer material and texture (the other five falling outside the verdure category). Among other notable pieces are the tapestry of Jean de Daillon (at Montacute House, National Trust) which appears to have been woven at Tournai between 1477–83; *Narcissus at a fountain* (Boston, Museum of Fine Art); and the *Armorials* with arms and devices of (1) John Dynham (Cloisters, New York), and (2) Jacqueline de Luxembourg (Château de Langeais) – which lead back to the superb *Armorial of Philip the Good*, supplied by Jean de Haze of Brussels in 1466 (Bern, Historical Museum). Unlike pieces such as these, which represent special orders and very superior quality, the ordinary run of mille-fleurs tapestries show unmistakably that the composition was put together by workshop cartoonists from stock material and scenes or figures culled from engravings, old cartoons, etc. (the same figure is found repeated in different tapestries – see Weigert, p.77). The older view on the production of these tapestries, which originated with hypothetical attributions suggested by Jules Guiffrey and Marquet de Vasselot, can be found summarised by D. Heinz and discussed fairly fully by R.A. Weigert. But this view, that these mille-fleurs tapestries were largely the work of itinerant weavers, or workshops attached to the French Court at its different residences in the Loire district, has been widely challenged.

An article published by M. Crick-Kuntziger in 1954 reviewed the origins of the *Lady of the Unicorn*, in association with the (hitherto unpublished) *Story of Perseus*, and *Penelope* (in Boston) from a set of *Famous Women*, and proposed a Flemish origin, possibly at Bruges. S. Schneebalg-Perelman has since then made an extensive study of the Brussels

archives (sadly depleted by the blows of history, and by ill-chance unduly neglected by tapestry historians), and established that Jean de Haze of Brussels supplied the Dukes of Burgundy with the finest quality verdure tapestries, of which an extant example is the famous *Armorial of Philip the Good*, one of eight tapestries purchased in 1466, at Bern Historical Museum (d'Hulst, No.10). In a considered review of the evidence, Francis Salet (Paris, 1973) has written that it is, 'grand temps d'abandonner l'hypothèse d'ateliers itinérants travaillant "sur les bords de la Loire" ' – a hypothesis which he says now leads nowhere. Rather, one must look to the region of northern France and Belgium, which was French in cultural tradition and outlook, whether the individual cities owned allegiance to France, Burgundy or the Empire as their sovereign. Briefly, the main arguments which Salet accepts are: (1) Brussels was an undoubted source of tapestry 'à menue verdure', the dispute there between painters and weavers of 1476 proving that workshop designers were competent for 'fleurettes, petits paysages', etc., and well established; (2) French kings (Charles VIII, Louis XII) and notables of State and Church ordered tapestries from Flemish cities (for instance, for Charles VIII in 1487, eight 'tentures de Flandre à bergeries assises sur verdure'); (3) the French aune, or ell (1·20m.) disappears from the royal accounts in the 15th century in favour of the Flemish aune (0·74m.). Brussels was, of course, only one of the many Flemish tapestry centres, which included Tournai, Oudenarde, Enghien, Bruges, Antwerp and others.

The typical work of these centres may, or may not, prove identifiable: the Tournai Exhibition of 1970 showed the limits and uncertainties. Francis Salet argues that preoccupation with centres of origin, confined to single cities, has obscured the more general picture of the organisation of the tapestry industry in the 15th century, without the understanding of which false trails are followed and mistakes of emphasis and fact are made (Introduction to Catalogue, *Chefs-d'œuvre de la tapisserie du XIVe au XVIe siècle*, Paris, 1973). The questions seem to resolve themselves more realistically into determining, where possible, the designers of the really outstanding sets, and recognising this as distinct from the place of weaving. There seems to have been a specifically French taste in tapestries which ran counter to the main stream of development in Brussels and the Netherlands at the end of the 15th century. This is shown, for instance, in E. Scheicher's iconographical study of the Vienna *Triumphs*, and in the papers published in 1961 in the Cleveland Art Museum Bulletin on the *Chaumont* tapestries, which have been further reviewed by Geneviève Souchal (*Bulletin Monumental*). This taste seems to be reflected in the finer mille-fleurs verdures, such as some of those mentioned above. Apart from this, there remains as a separate problem the more ordinary and less costly work of the lesser workshops distributed throughout the many weaving centres of Flanders, Artois, and Brabant. These provided the much greater number of tapestries whose cartoons were put together from stock designs incorporating elements borrowed from other available sources, as the Brussels act of 1476 implies.

H. Göbel quoted the 1514 inventory of the Château de la Motte-Feuilly (the residence of Charlotte d'Albret, Duchess of Valentinois, Caesar Borgia's widow) as showing numerous verdures ascribed to Felletin (Aubusson's neighbour in the La Marche district): 'Une autre pièce de tapicerie de Feulletin à menue verdure sur bandes rouges, blanches et vert brune'; 'Une pièce de tappicerie de Feulletin de menue feuillage en champ doré' (Göbel, *Die Niederlande*, pt.i, p.178).

Göbel is also still of interest on the origin of verdures, which he believes were exclusively armorial in the 14th century, the flowers being family or personal emblems, as were heraldic beasts and birds (Göbel, p.97). Further, he pointed out the part played by the 'hortus conclusus' in establishing the idea of the 'verger' (Göbel, p.170), hence the herbaceous 'islands' in a wider mille-fleurs field as seen in the *Lady of the Unicorn* (the one with its 'branches plantées', the other with its 'branches arrachées').

In conclusion it can be said that, as decoration for walls, and also for beds and benches, the 'mille-fleurs' style held favour for a hundred and fifty years and more, and was common to the artist-craftsman tradition of the tapestry weavers of northern Europe.

Museum acquisition. 232–1894. Bought from Mme E. Auzière of Paris, £63.

Literature

Cleveland, *Museum of Art Bulletin*, vol.48, no.7, September 1961, pp.159–76, 178–88

Crick-Kuntziger, M., 'Un chef-d'œuvre inconnu du Maître de la "Dame à la Licorne" ' in *Revue belge d'archéologie et d'histoire de l'art*, vol.XXIII, 1954, 1–2, pp.3–20

Duverger, J., 'Brusselse Patroonschilders uit de XIVe en de XVe Eeuw' in *International Colloque 1961. L'Âge d'Or de la tapisserie flamande*, Brussels, 1969, pp.205–25

Göbel, H., *Wandteppiche I. Die Niederlande*, Leipzig, 1923, pt.i, ch. 'Die Deutung des Wandteppichs', pp.97, 170, 178

Guiffrey, J.J., *Histoire générale de la tapisserie . . . en France*, Paris, 1878–85

Guiffrey, J.J., *Histoire générale des arts appliqués à l'industrie. Les tapisseries du XIIe à la fin du XVIe siècle*, vol.VI, Paris, 1911

Heinz, D., *Europäische Wandteppiche*, vol.I, Braunschweig, 1963

Hulst, R.A.d', *Tapisseries flamandes du XIVe au XVIIIe siècle*, Brussels, 1960

Kurth, B., *Gotische Bildteppiche aus Frankreich und Flandern*, Munich, 1923

Marquet de Vasselot, J.J., *Catalogue raisonné de la collection Martin Le Roy. IV Tapisseries et broderie*, Paris, 1908

Marquet de Vasselot, J.J., and Weigert, R.A., *Bibliographie de la tapisserie, des tapis et de la broderie*

en France, Société de l'Histoire de l'Art française, Archives de l'art française, 4 S., vol.XVIII, 1935

Paris, *Exhibition 1973*, see F. Salet and G. Souchal

Salet, F., 'Chronique', *Bulletin Monumental*, vols. CXXIII–CXXIV, 1965–6, pp.433–6

Salet, F., Introduction, Catalogue of the exhibition *Chefs-d'œuvre de la tapisserie du XIVe au XVIe siècle*, Grand Palais, Paris, 1973–4

Scheicher, E., 'Die Trionfi: eine Tapisserienfolge des Kunsthistorischen Museums in Wien' in *Jahrbuch der Kunsthistorischen Sammlungen in Wien*, vol.67, 1971, pp.7–46

Schneebalg-Perelman, S., 'La tenture armoriée de Philippe le Bon à Berne' in *Jahrbuch, Historisches Museum Bern*, vol.XXXIX–XL, 1959–60

Schneebalg-Perelman, S., 'Les sources de l'histoire de la tapisserie bruxelloise et la tapisserie en tant que source' in *Annales de La Société Royale d'Archéologie de Bruxelles*, no.51, 1966, pp.279–337

Schneebalg-Perelman, S., ' "La Dame à la Licorne" a été tissée à Bruxelles' in *Gazette des beaux-arts*, 6S., 1967, vol.LXX, p.253

Souchal, G., 'Chronique', *Bulletin Monumental*, vols. CXXIII–CXXIV, 1965–6, pp.219–25

Souchal, G., Catalogue of the exhibition *Chefs-d'œuvre de la tapisserie du XIVe au XVIe siécle*, Grand Palais, Paris, 1973–4

Thomson, W.G., *A History of Tapestry*, 2nd ed., London, 1930, p.192

Verlet, P., and Salet, F., *La Dame et la Licorne*, Paris, 1960

Weigert, R.A., *French Tapestry*, London, 1962, p.77

No. 17 (*pls. 26–27*)
Susanna and the Elders

Probably TOURNAI; c.1500.
H. 13ft 5in. (4·02m.) W. 11ft 0½in. (3·36m.)
Wool and silk: 14 warp threads to inch (5–6 to the cm.).

Condition. Excellent.

The story of Susanna is an apocryphal writing found in the Greek Bible or Septuagint; it is placed at the beginning of the *Book of Daniel*. It is an account of Daniel's discovery of a malicious slander against the good woman Susanna. Tapestries with this subject, which was popular from the late Middle Ages onwards, were sometimes referred to as the *Judgement of Daniel*. The coats of arms woven into the borders (one is embroidered and has been added over a blank shield) are those of three patrician families of Augsburg and it seems certain that this tapestry was a special order. The design and proportions of the borders are very unusual and call to mind the *Tournament* tapestry at Valenciennes, which was a Saxon order (see later). There were several marriage alliances in the 15th and 16th centuries between the three families whose arms are shown: Gossenbrot, Rehlinger and Welser. The juxtaposition of the shields suggests the exemplification, at the top of the tapestry, of the marriage of Sigmund Gossenbrot with Anne Rehlinger (1476), and of those beneath of Lucas Welser with Ursula Gossenbrot (after 1500). A Sigmund Gossenbrot was Bürgermeister of Augsburg on nine occasions between 1484 and 1500.

H. Göbel has pointed out that bathing the feet before a meal was a custom among German patricians and that a trough and fountain was a common feature in 15th century patrician gardens (Göbel, *Wandteppiche I*, pt.i, p.171).

Description. Susanna is seated bathing her feet in a trough, within a garden enclosed by a high wall. Her maid is leaving the garden by an arched doorway. The two elders approach on the right. In the foreground to the left is a fountain of Gothic design supported by four crouching lions. On the edge of the trough the word 'Susenne' is inscribed. The scene is enclosed within a frame-work formed by two variegated marble columns, supporting a flattened arch edged with cresting. There is a broad border of leafwork with birds on a dark blue

ground. Shields of arms are hung by ribbons to the stems at each corner of the border.

Further information. There is no doubt of the German character of the unusual borders of this hanging. They are remarkable because of their great width and the character of the large leaf-scroll with birds, also the size and prominence of the coats of arms. H. Göbel suggested (*Wandteppiche I*, i., p.440) that this shows the influence of German illuminated manuscript borders and it is true that Brussels tapestries of the first quality, whose borders are influenced by manuscript designs, are quite different. A comparision with the three following examples will demonstrate this: the Cinquantenaire *Baptism* (M. Crick-Kuntziger, Brussels Cat., no.21, pls. 28, 29), the Vienna *Baptism* (Göbel *Wandteppiche I*, ii, pl.387) and the Vatican *Carrying the Cross* (Göbel, *Wandteppiche I*, ii, pl.388). One can also point to a widespread tradition of German design in late Gothic tapestries and embroidered textiles. Firstly, large scrolling vegetable forms with spiky and curling leaves were a favourite background for South German tapestries in the 15th century, and are very familiar on linen embroideries. More precisely, coats of arms of exaggerated size, often with animal supporters, placed on great vegetable scrolls, were a favourite German style. For example, (a) four frieze-like tapestry strips (*Rücklaken*) in the Hesse Landesmuseum at Darmstadt (Kurth, vol.III, pls.180–81); (b) a frontal with the *Adoration of the Kings* from Franconia, c.1497, has side-borders in this manner (Nuremberg, Sebalduskirche; Kurth, vol.III, pls. 310–12); (c) a *Crucifixion* tapestry in the Würzburg University Museum has such borders with coats of arms prominent in the four corners, from Nuremberg, last quarter of 15th century (Kurth, vol.III, pl.304); (d) a large upright tapestry of the *Passion* in the Bamberg Domschatz with nine scenes arranged in three rows, has kindred borders but with four formalised roses in the corners, from

Franconia, 1490–1500 (Kurth, vol.III, pl.309; Göbel, *III*, i, pl.141); (e) a table-carpet dated 1610 with the arms of Ernest, Duke of Brunswick-Lüneburg, has the field composed of scrolling floral forms in somewhat similar vein – it is attributed by M. Crick-Kuntziger in her catalogue, to Lower Saxony, possibly Wolfenbüttel (Brussels Cat., no.49, pl.56); (f) a very close analogy in linen embroidery (with some silk) is the *Rücklaken* formerly in the Figdor collection, then Berlin Schlossmuseum (now burnt), with leaf-scrolls and birds in the style of the *Susanna* tapestry's borders (V. Trudel, *Schweizerische Leinenstickereien*, pl.v, p.137, no.10u). For the manner in which a tapestry such as this would have been commissioned in Tournai, one can read the Canon of Reims, Simon de Roussy, ordering six tapestries depicting the *Life of St Symphorien* from Jehan du Molin, 'tapissier demeurant a Tournay' in 1535 and 1536 and mentioning the 'patron' or model agreed on (see Soil, pp.46, 409–10).

The *Tournament* tapestry, which was also a German order for an apparently single tapestry at a leading Flemish centre, has borders in somewhat the same manner. They are very wide, particularly for this period, and have nineteen Saxon coats of arms prominently displayed, in this case on a 'brocade' ground. The subject of the tapestry is a tournament and it was probably commissioned for Friedrich III, Elector of Saxony; it is now in the Valenciennes Museum and dates from c.1500. (M. Crick-Kuntziger, Brussels, *Cinq siècles d'art*, 1936; Paris, *Chefs-d'œuvre*, 1973).

At the Musée Marmottan, Paris, there are five *Story of Susanna* tapestries (in eight scenes) with the arms of Bénigne de Cirey and Guillaumette Jacqueron, who married c.1500.

The Arms. The four coats upon this tapestry may be blazoned as follows:

I, IV Azure, the bust of a bearded man, vested and chaperonned gules; for Gossenbrot.

II. Azure two piles issuing from the base, each

terminating in a rose, all argent; for Rehlingen.

III. Party argent and gules a fleur-de-lys counterchanged; for Welser.

From the circumstance that the Welser insignia are of subsequent date to the weaving of the tapestry it would appear that the original intention was to exemplify, by a symmetrical arrangement of arms, an alliance between the families Gossenbrot and Rehlingen. The relative positions of the latter coats, moreover, especially the precedence assigned to the Gossenbrot insignia, indicate that the primary alliance was between a male Gossenbrot and a dame of the Rehlingen family.

In the Rehlingen pedigrees by Gabriel Bucelinus[1] are the following marriages which, it is hardly doubtful, are those exmplified in the tapestry:–

Sigmund Gossenbrot [I] = 1476, Anna Rehlingerin [II]

Lucas Welser [III] = Ursula Gossenbrotin [IV]

The dates of decease of the first-named individuals are not specified, nor is that of the marriage between Ursula Gossenbrot and Lucas Welser; in the next generation their daughter, Helena Welser, married Leonard Christoph Rehlingen in 1531.

Museum acquisition. 546–1872. Bought (£190). Sir Matthew Digby Wyatt recommended: 'The price is large for one piece out of a set . . . I think this very desirable at about £150.' He noted that prices had fallen with the 'French War' (of 1870).

Crick-Kuntziger, M., *Cinq siècles d'art, Mémorial de l'Exposition*, Memorial volume to the *Exposition*

[1]. *Germaniæ topo-chrono-stemmatographicæ sacræ et profanæ pars altera* (in which see 'Genealogica Germaniæ notitia', p.247; also the unpaginated pedigrees, Rehlingen, Nos.2 and 5), 1662.

Universelle et Internationale de Bruxelles 1935, vol.II, Brussels, 1936, p.6

Crick-Kuntziger, M., *Musées royaux d'art et d'histoire de Bruxelles, Catalogue des tapisseries*, Brussels, 1956, no.21, pls.28, 29; no. 49, pl.56

Göbel, H., *Wandteppiche I. Die Niederlande*, Leipzig, 1923, pt.i, pp.171, 440; pt.ii, pls.387, 388

Göbel, H., *Wandteppiche III. Die Germanischen und Slawischen Länder*, Berlin, 1933–4, pt.i, pls. 82a, 141

Kendrick, A.F., *Victoria and Albert Museum Catalogue of Tapestries*, London, 1924, no.12, pl.XII

Kurth, B., *Die Deutschen Bildteppiche des Mittelalters*, vol.III, Vienna, 1926, pls.180–1, 304, 307–8, 309, 310–12

Paris, *Catalogue du Musée Marmottan*, Paris, 1934

Paris, *Exhibition 1973–4*, see Salet, F. and Souchal, G.

Salet, F., Introduction to the Catalogue, *Chefs-d'oeuvre de la tapisserie du XIVe au XVIe siècle*, Grand Palais, Paris, 1973–4, no.17

Soil, E.J., 'Les tapisseries de Tournai, les tapissiers et haut-lisseurs de cette ville' in *Société historique et littéraire, Mémoires*, vol.XXII, Tournai-Lille, 1891, pp.46, 409–10

Souchal, G., Catalogue of the exhibition *Chefs-d'œuvre de la tapisserie du XIVe au XVIe siécle*, Paris, 1973–4, no.17 (illustrated with colour detail)

Trudel, V., *Schweizerische Leinenstickereien des Mittelalters und der Renaissance*, Bern, 1954, pl.v, p.137, no.10u

No. 18 (*pls.28A & B, 29*)
Landing at Calcutta
'In the manner of the Portuguese and Indies'

TOURNAI; 1500–1510.
H. 12ft (3·66m.) W. 10ft 5in. (3·18m.).
Woven in wool and silk: 14–15 warp threads to inch (5–6 to the cm.).

Condition. Cut in two and the large central portion missing; the texture well preserved although patched and with some restoration. (There are two holes on the left and a patch upper right). The borders have been added.

These two panels are the remains of an important tapestry. The *Story of Wild Men and Beasts in the Manner of Calcutta*, or '*The Portuguese and Indies*', was a subject which came into great favour at the turn of the century. In 1504 Jean Grenier delivered to Philip the Fair tapestries under the title: *A la manière de Portugal and de l'Indye*. In 1513 Arnould Poissonnier, also of Tournai, sold five *Voyage de Caluce* to Robert de Wytfel, a councillor of King Henry VIII. In his will of 1519 Arnould Poissonnier mentions a number of hangings under similar titles. Pieter van Aelst, in 1522, supplied the Emperor Charles V with six pieces of *L'histoire indienne à oliffans et jeraffes*. There are many references to these tapestries with exotic themes; the most complete and descriptive title is probably: *Histoire de gens et de bêtes sauvages à la manière de Calcut* (1510). Wild and strange beasts, 'savage' people, caravans of dromedaries, giraffes and elephants, a lion hunt and a port scene with a menagerie of strange creatures (including birds) being unladen from ships, are the subjects depicted. This last was the subject of our tapestry. A complete version of the piece was recorded by de Farcy at the Château de Brézé in 1912; this was probably the same as the one sold at the Hôtel Drouot in Paris in 1931. A complete version in Lisbon is illustrated on plate 29.

Connected with this exotic theme was another in the early years of the 16th century, the gipsies; the tapestries went under the title, *The Egyptians* or *Carrabara*. The gipsies excited curiosity rather than fear by this time in Northern Europe and their alien features and costume served painters as models for the people of distant lands, such as the Portuguese adventurers and traders had encountered in the Indies. Hence the similarity with the 'savage'

people in their costume as shown in the two groups of tapestries.

Exotic themes for tapestry had a long-standing appeal, as H. Göbel has pointed out. The Duc de Berry had a *History of the Great Khan* in 1416 (probably deriving from the book *Les Merveilles du Monde*, which knew of Marco Polo's travels); and the Duke of Burgundy had a *Story of Mahomet* a century before our tapestries. Emanuel I of Portugal sent an embassy to Rome with gifts from 'the Indies' in 1514, which excited wide interest. The borders on the Museum tapestry are applied, but probably original, and the same borders are found on the *Caravan of Dromedaries*, a contemporary piece at the Château de Saint-Brice, Cognac. A typical border for the series has a deep top frieze (missing in ours) with bells and tassels, and sometimes with mannikins perched among them striking the bells (see the Stockholm *Caravan* and pieces at Caramulo, Portugal).

Description. (Left side): a kneeling messenger presents a document to an imposing personage wearing a turban, bearded, and sumptuously dressed, who holds a long feathered lance. A counsellor is on his right and soldiers behind him issue from the city gate, with onlookers on the ramparts. The bows of a caravel can just be seen in the background. (Right side): another regal personage talks to a richly clad lady beside him with feathered headdress, again before the walls of a city. Armed attendants in the background.

Missing centre: see plate which shows the ships in the harbour being unloaded of their strange cargo of exotic beasts.

Borders: an arrangement of floral sprays on sinuous stems with grapes, and tied in places with ribbons, on a dark blue ground.

Note. Inscriptions on the pennants flown by the caravels in the Brézé-Drouot tapestry have been read as: 'Nief' (nef), 'Jonea Mosle' (John the Moslem).

Further Information. The *Wild Men and Beasts of Calcutta* or the *Voyage to Calcutta* was first studied by Louis de Farcy, who wrote on the three pieces belonging to the Marquis de Dreux-Brézé in 1913. J. Boettiger published the Stockholm *Caravan* in 1921 and subsequent to H. Göbel (1923) there was part of a monograph on the Rockefeller-McCormick Tapestries devoted to this subject by Dr Phyllis Ackerman (1932). According to Ackerman there are six subjects in the series: (1) the landing at Calcutta; (2) the attack on the fleet; (3) the giraffe caravan; (4) the camel caravan; (5) the elephant caravan; (6) the lion hunt. No.2 is very doubtful as one of the original subjects. Ackerman illustrates several of the better known pieces, including the Rita Lydig pieces (New York, Sale 1913) and the *Lion Hunt*, which came from Knole (Ricci, Paris, 1913). Particularly interesting are tapestries she illustrates with motifs taken from these tapestries and used in verdure settings. At the Museu do Caramulo, Portugal, there are now several tapestries of this series, including four pieces which came from George Kolkhorst's collection at Yarnton Manor, near Oxford; but these must date from the middle, rather than the early years of the 16th century. A small portion of the central part of the *Landing at Calcutta* was illustrated by Göbel (*I*, ii, pl.227) and belonged to Nachemsohn (London) in 1926; this and another similar piece is now at Lisbon in the Marine Museum.

J.P. Asselberghs assembled six of the series at Tournai for the 1968 exhibition and has studied them in the catalogue. He places the extant pieces in four series; the two V & A panels and the Cognac *Dromedary Caravan*, which has similar borders, being the earliest. He allows for three principal subjects: (1) the Hunt; (2) the Port (or 'Calcutta') scene; (3) the long Caravan in various parts. He leaves four tapestries unclassified, including the *Bad Tempered Dromedaries* in the Burrell Collection. Madeleine Jarry, in an article on the Wild Men theme in relation to the Indian

and Gipsy tapestries, has published a hitherto unknown tapestry with related subject, although it can hardly be from the *Calcutta* set, as African Negroes figure predominantly; the painter is shown and his name clearly given, 'CEVADERO PINTOR', probably Juan Cevadero of Seville.

It should be remembered that the equally famous *Portuguese in India* tapestries were woven in the middle years of the 16th century in Brussels, commemorating the deeds of the Viceregent, Joao de Castro; his Triumph at Goa was celebrated in 1546–7. The leading set is in Vienna (Kunsthistorisches Museum) and Pieter Coecke and Jan Vermeyen may both have been connected with the designs.

Note. See no.18a for another tapestry of this group.

Museum acquisition. 5667 and A-1859. Bought (Soulages Collection, £18).

18a
The Giraffe Caravan

TOURNAI; early 16th century.
H. 14ft 3in. (4·34m.) W. 21ft (6·40m.).
Woven in wool and silk: 14–15 warp threads to inch (5–6 to cm.).

Condition. Extremely worn and in a state beyond repair. This is the parlous remains of a piece from the set of designs described above, no.18 (q.v.).

Description. Women and armed men walk beside richly caparisoned giraffes on which children are riding. Soldiers in the middle distance and trees in the background.

Borders: along the top, traces of a fringe of tassels and bells; along the bottom a cresting of fleurs-de-lys. There are narrow side-borders of conventional leaf ornament.

Museum acquisition. 375–1906. Given by Sir J.C. Robinson.

Literature
Ackerman, P., *The Rockefeller McCormick Tapestries: Three Early 16th Century Tapestries*, New York, 1932

Asselberghs, J.P., *La tapisserie tournaisienne au XVIe siècle*, Exhibition catalogue, Tournai, 1968, Nos. 3–8

Boettiger, J., 'En Vasco da Gama-tapet i National-museum' in *Nationalmusei Årsbok*, Stockholm, 1921, vol.III, I

Caramulo, *Relação de obras de arte*, Museu do Caramulo, Fundação Abel de Lacerda, Caramulo, 1964, pls.47–8

Farcy, L. de, 'Tapisserie tournaisienne de 1502–4' in *Les arts anciens de Flandre*, vol. VI, 1913, pp.105–11

Göbel, H., *Wandteppiche I. Die Niederlande*, Leipzig, 1923, pt.ii, pls.226, 227

Jarry, M., 'L'Homme Sauvage' in *L'Oeil*, no.183, March 1970, pp.14–21

Kendrick, A.F., *Victoria and Albert Museum Catalogue of Tapestries*, 2nd ed., London, 1924

Paris, *Exhibition 1973–4*, see Souchal, G.

Ricci, Seymour de, *Catalogue of Twenty Renaissance Tapestries from the J. Pierpont Morgan Collection*, Paris, 1913

Salzman, L.F., *English Trade in the Middle Ages*, Oxford, 1931, p.436

Souchal, G., *Chefs-d'œuvre de la tapisserie du XIVe au XVIe siècle*, Exhibition Catalogue, Paris, 1973–4, No. 53

Tournai, *Exhibition 1968*, see Asselberghs, J.P.

Nos. 19–20 (pls.30–33)
Two Tapestries with
Woodland Scenes and Peasants

FLEMISH; early 16th century.

Rustic scenes in woodland and forest were in great demand throughout the 15th and 16th centuries. Foresters cutting trees, shepherds at work and play, sometimes with sportsmen emerging from the woods with arquebus and hound, are commonly mentioned in the inventories and quite a few of these tapestries, varying in quality, have survived. In a study made in 1907 A. Warburg showed that the Courts of Italy, as well as Burgundy and France, liked these 'vulgar' and playful scenes as a foil to their classical paintings and sculpture. They are found referred to as 'Chambre de Verdure avec personnages de paysans et bûcherons' (Philip the Good, bought of Guillaume au Vaissel of Arras, 1446); 'Chambre de tapisserie à personnages de bûcherons' (bought by Philip from Pasquier Grenier, 1466, to present to his niece, the Duchess of Gelderland). One of the finest to survive from this earlier period (Paris, Arts Décoratifs) bears the armorial device of three keys on the collar of one of the greyhounds; this probably identifies the owner of the tapestry as Chancellor Rolin, the patron of Rogier Van der Weyden and founder of the great Hospital at Beaune. H. Göbel (*I*, i, p.282) associates it with tapestries delivered by Grenier, 'Toute emplye de bosquaille et de verdure et partout esdites pièces sont plusieurs grans personnaiges come gens paysans et bocherons lesquels font manière de ouvrer et labourer audit bois par diverses façons'. A similar but rather later tapestry of the same date as ours is also in the Musée des Arts Décoratifs (Göbel, *I*, ii, pl.234; Asselberghs, Tournai, *Tapisseries héraldiques*, no.33).

A comparable genre of rustic subject for tapestry, which was also in great demand from the early years of the 16th century, was *The Egyptians* (sometimes referred to as 'Carrabara'). Gipsies in strange costumes with Saracenic patterns mingle with lords and ladies with their greyhounds and falcons; the same woodland scenes and foliage fill the fore and backgrounds. The gipsies had entered Western Europe a century earlier and were accepted by the end of the 15th century as a

colourful part of the less reputable scene. There is a set of four at the Château de Gaasbeck and one in the Burrell Collection with a typical bell and *fleur de lys* frieze border (see Asselberghs, Tournai, *La tapisserie tournaisienne au XVIe siècle*, 1968, no.2).

The two V & A tapestries were bought together in 1859 from the Soulages Collection for £25. They are of exceptionally good quality for this class of tapestry, colourful and lively. The equipment of the peasants, foresters and sportsmen is clearly shown and interesting. The question of provenance has been much debated, but evidence set out by Dr Schneebalg-Perelman points definitely to a Flemish centre, whether Tournai, Oudenarde, Bruges or even Brussels. She quotes Charles VIII's purchase in 1487 of 'huit tentures de tapisseries de Flandre à bergeries assises sur verdure'; from the Amboise inventory, tapestries 'de Flandres . . . à bûcherons', and 'de verdure à personnages'; and Philip the Fair's purchase of verdures with scenes of shepherds and woodcutters made in 1497 from Pieter van Aelst of Brussels. Merchants of Tournai are also known to have commissioned such tapestries from Oudenarde, to augment their own production.

No. 19 *(pls.30–31)*
La Main Chaude

H. 10ft 8½in. (3·26m.) W. 18ft 0½in. (5·5m.)
Wool and silk: 12 warp threads to inch (5 to cm.)

Condition. Good. Cleaned and repaired in the Tabard workshops, Aubusson, 1960–1.

Description. Shepherds and shepherdesses are playing the game of *la main chaude* in a woodland scene, with woodcutters at work in the background, where swine are routing; sheep in the middle ground and a dog. A finely dressed lady is with the peasants and a nobleman, hawk on fist, with a lady and an attendant bearing a flask, advance

from a drawbridge. It has been suggested that the characters are in fact gentry dressed up as peasants. The game of *la main chaude* is defined in Larousse exactly as played by the central pair here; when not a childrens' game it was obviously suggestive of elaboration as in the game of 'forfeits'. The shepherds' staves, with crook at one end and spade at the other for diking, have been studied by L.F. Salzmann who illustrates shepherds with 'staves with weeding spuds for digging up roots' in his *English Life in the Middle Ages*, p.53; their French name is *houlette*. A variety of implements and containers hang at the peasants' waists.

Museum acquisition. 5668–1859. Bought with 5668A from the Soulages Collection £25.

No. 20 *(pls.32–33)*
Rustic Sports

H. 11ft 2in. (3·41m.) W. 11ft 3in. (3·43m.).
Wool and silk: 12 warp threads to inch (5 to the cm.).

Condition. Good. Cleaned and repaired in the Tabard workshops at Aubusson, 1962–3.

Description. Peasants are washing their feet and disporting beside a stream. A nobleman stands on the right, holding a couple of greyhounds on leash with a horn hanging at his belt. Another (both carry swords) with hawk on fist, talks to a lady on a bridge in the middle ground; a lure can be seen in his pouch. On the left a man shoots at a duck in the river with a crossbow, a retriever by his side; on the right two woodsmen or hunters emerge from the forest with a pair of hounds. A mill, a house and peasants in the wooded background. For the shepherd's crook and implements carried by the peasants, see the previous tapestry.

Museum acquisition. 5668A–1859. Bought with 5668–1859 from the Soulages Collection (£25).

Further information. There are two rather similar tapestries, with peasants playing and hunting or hawking scenes in the background, in the Corcoran Gallery of Art, Washington D.C. (W.A. Clark Collection); they are listed as numbers three and four in M.C. Ross's article in the Corcoran *Bulletin*. The fourth comes from the same cartoon as the tapestry illustrated by H. Göbel (i, ii, pl.240), only the Corcoran tapestry has about one-third of the subject missing on the right side, and the Göbel piece is cut slightly at the top; the latter was formerly in the collection of Genevieve Garvan Brady, New York. The other two Corcoran pieces of the series are hunting tapestries. Among the tapestries brought together in the Tournai Exhibition of 1970, *Les Bûcherons* from the Paris Musée des Arts Décoratifs is nearest in date, but more archaic and summary in style. The Brussels (Cinquantenaire) *Sheepshearing* piece of a generation or more earlier (3rd quarter of 15th century) shows the pastoral genre at its best. Two tapestries with peasant scenes of approximately similar date, now in the Stockholm National Museum and Cleveland Museum of Art (illustrated by H. Göbel, *I*, ii, pl.241, 242) are not really comparable and are of coarser style and execution.

Literature
Asselberghs, J.P., *La tapisserie tournaisienne au XVIe siècle*, Exhibition Catalogue, Tournai, 1968, No. 2
Asselberghs, J.P., *Tapisseries héraldiques et de la vie quotidienne*, Exhibition Catalogue, Tournai, 1970, Nos.27, 28, 33
Göbel, H., *Wandteppiche I. Die Niederlande*, Leipzig, 1923, pt.i, pp.281–2; pt.ii, pls.234, 235, 236, 240–2
Kendrick, A.F., *Victoria and Albert Museum Catalogue of Tapestries*, London, 1924
Paris, Exhibition 1973–4, see Souchal, G.
Ross, M.C., 'Four Tournai Tapestries' in *Corcoran Gallery of Art. Bulletin*, Washington D.C., vol.9, no.2, November 1957
Salzmann, L.F., *English Life in the Middle Ages*, Oxford, 1927, p.53

Schneebalg-Perelman, S., 'Les sources de l'histoire de la tapisserie bruxelloise et la tapisserie en tant que source' in *Annales de la Société Royale d'Archéologie de Bruxelles*, Brussels, 1966, no.51, pp.279–337

Souchal, G., *Chefs-d'œuvre de la tapisserie du XIVe au XVIe siècle*, Paris, 1973–4, No. 53

Stockholm, *Foreningen Nationalmusei Vänner. Kontakt*, Stockholm, 1964, pp.6–12, figs.2 and 3

Warburg, A., 'Arbeitende Bauern auf Burgundischen Teppichen' in *Zeitschrift für Bildende Kunst*, vol.XVIII, Leipzig, 1906, pp.41–7

No. 21 (*pls.34–35*)
Pity Restraining Justice *from striking sinful Man*

BRUSSELS; first quarter of 16th century.
H. 9ft (2·74m.) W. 12ft 9in. (3·89m.).
Wool and silk: 14 warp threads to inch (5–6 to cm.).

Condition. Good, but with considerable restoration. Parts of the tapestry have been repaired with careful reweaving, which has now faded far more than the original fabric. The rewoven parts are: the whole landscape background; the folds of Jeremiah's robe at his back; a patch below the knee of Justice's dress; the robe of the right-hand Vice from her knee down (but not bottom folds). Also, the inner and outer guardstripes of the border on the left side, and part of the inner stripe at top left; the outer guardstripe on right. The rest of the border, though somewhat restored, is original.

From a series of tapestries on the theme of the *Redemption of Man*. This piece is a scene from the third tapestry in the series variously known as *The Virtues Intercede for Man*, or the *Seven Deadly Sins*. The complete hanging can be seen at Hampton Court and in the Metropolitan Museum, New York; the scene reproduced in our piece constitutes the foreground of the left half of the full tapestry.

The series of the *Redemption of Man* seems to have consisted of ten large hangings, each some twenty-five feet in length. They are clearly set out in A. Cavallo's *Catalogue of the Tapestries in the Museum of Fine Arts, Boston*, no.24 (pp.94–5), where the present location of the various tapestries is given, including variants and excerpted scenes as individual hangings. He lists them as follows:

1. *Creation and Fall of Man*
2. *The Tempter attacks Man*
3. *The Virtues intercede for Man*
4. *The Nativity*
5. *The Childhood of Christ*
6. *The Manhood of Christ*
7. *Battle of Virtues and Sins*
8. *The Resurrection*
9. *The Ascension*
10. *The Last Judgment*

The theme of this dramatised allegory of the popularised Christian account of man's life, torn between heaven and hell, virtue and vice, comes from the Miracle and Morality plays of medieval Europe. The exact sources for the designs as put together in the tapestries are disputed, but the allegory and drama are common to *Everyman*, *The Castle of Perseverance*, and, as Emile Mâle has pointed out, to the 'Trail of Paradise' theme inspired by Saint Bonaventura's *Meditations on the Life of Christ*. The dramatisation of virtues, vices and other qualities played a vigorous part in medieval mentality, witness such scenes as Margaret of Anjou welcomed to London in 1445 by Grace of God, Truth, Mercy, Justice and Peace; or the Twelve Virtues introduced by Grace of God to the *Banquet des voeux* in 1454. Such allegories continued well into the 16th century.

The dating of the various *Redemption* tapestries can be linked with a bequest by Don Juan Rodrigues de Fonseca, Bishop of Palencia (1504–14) and of Burgos (1514–24), of eight tapestries of the series divided between the two cathedral cities. The Metropolitan Museum tapestry (mentioned above) was one of these Burgos tapestries. As for the tapestry at Hampton Court, Cardinal Wolsey bought nine pieces of *The Seven Deadly Sins* from the London merchant-financier, Richard Gresham, in 1522. In style the *Redemption* tapestries are in a slightly earlier mode than that of the *Triumphs of Petrarch*, which superseded them. R. d'Hulst, in his study of one of the Palencia Cathedral tapestries (*Tapisseries flamandes*, no.15), has admirably described the composition of these great designs, arranged symmetrically with a prophet flanking the scene to left and right, and with a well-ordered foreground of large figures, which becomes densely packed with figured scenes in the upper planes: an impression of perspective is obtained where there is in fact none.

There is a copious literature on this cycle of tapestries, beginning with D.T.B. Wood's *Burlington Magazine* articles, published in 1911–12. More recently R. d'Hulst has discussed the subject with his usual lucidity, and A. Cavallo, in his Boston catalogue (no.24), has set out the facts and tabulated the known surviving pieces in a most helpful manner.

Description. Justice (Justicia) represented as a crowned female figure holding a drawn sword, threatens to strike a young man (Homo) who starts back in fear. Pity ('Mia' for Misericordia) restrains Justice from her purpose. The four female figures to the right typify the vices of the young man. On the left of the group sits the prophet Jeremiah (Jerimie) holding an inscribed scroll, which originally bore the words '*Asce(n)dit mors per fenestras*' ('Death is come up into our windows', Jer. IX, 21), but they have been wrongly restored. There is a border of vine stems, roses, pansies, daisies, and other flowers, tied by ribbons, on a dark green-blue ground.

Note. In the original composition, this scene was balanced on the right by Homo, seen with Misericordia, and offered a breastplate by Gratia Dei and a helmet by Pax; Moses seated on the right proclaims: 'I will render vengeance to mine enemies' (Deut. 32, 41).

Further Information. There is another abridged version in the Burrell Collection, Glasgow, which came from Knole (and there was one formerly in the Schutz Collection, Paris). A Tournai tapestry at Strassburg (Coll. Simon Michaeloff) shows a quite different and more simply treated rendering of 'The Trial of Paradise' (Tournai Exhibition, 16th century, 1968, no.11).

Museum acquisition. 638–1890. Bought (£550). William Morris testified in favour of this purchase, praising the tapestry.

Literature

Asselberghs, J.P., *La tapisserie tournaisienne au XVIe siècle*, Exhibition Catalogue, Tournai, 1968, no.11

Cavallo, A., *Catalogue of the Tapestries in the Museum of Fine Arts*, Boston, 1967, no.24, pp.94–5

Forsyth, W.H., 'A Tapestry from Burgos Cathedral' in *Metropolitan Museum Bulletin*, vol.XXXIII, New York, 1938, pp.148–52

Hulst, R.A.d', *Tapisseries flamandes du XIVe au XVIIIe siècle*, Brussels, 1960, no.15

Kendrick, A.F., *Victoria and Albert Museum Catalogue of Tapestries*, 2nd ed., London, 1924, no.18

Mâle, E., *L'Art religieux de la fin du Moyen-Âge en France*, Paris, 1908

Marillier, H.C., *The Tapestries at Hampton Court Palace*, London, 1962, pp.12–19

Tournai, Exhibition 1968, see Asselberghs, J.P.

Wood, D.T.B., 'The Tapestries of the Seven Deadly Sins' in *Burlington Magazine*, vol. XX, 1911–12, p.210

Nos. 22–24 (*pls.36–43B*)
The Triumphs of Petrarch

BRUSSELS; 1500–1510.
Woven in wool and silk: 16 warp threads to the inch (6–7 to cm.).

Three of a set of six tapestries based on Petrarch's poem *I Trionfi*. This poem was begun soon after 1352 and finished by 1374. Laura's name, identified with Chastity, is inscribed in the first tapestry.

I Trionfi is a series of allegorical visions, similar to those of the Provençal poets, written in the metre of the *Divine Comedy*. It provided the inspiration for a host of Triumphs in all branches of art; the theme was elaborated during the 14th to 16th centuries with variations. For example, Petrarch gave a chariot only to Love, but in the 14th century the miniaturists added a car for Fame, and in the 15th century each figure had a chariot, with different teams. Chastity is drawn by unicorns, Death by buffaloes, Fame by elephants (rarely by horses), Time by stags and Eternity by the Evangelistic Beasts. Petrarch gave four white horses to the car of Love.

In painting there are very many Triumphs, examples being the frescoes of the school of Botticelli in the Oratory of Sant' Ansano near Fiesole, the series by Lorenzo Costa at Bologna, and paintings by Mantegna, Bernardino Campi, Bonifacio da Verona. They were a favourite subject on *cassoni*, such as the 15th century Florentine *cassone* in the Museum (4639–1858) and also on *deschi da parto* or birth trays (V & A M 44–1869, 398–1890; National Gallery No. 3898 on loan to this Museum), although the latter were confined to the Triumph of Love. The Triumph of Fame is found on a magnificent Castel Durante dish painted by Giovanni Maria, c.1490 (V & A M, *Catalogue of Italian Maiolica*, by Bernard Rackham, 1940, No. 519, pl.81). Triumphs are frequent in miniatures, especially Florentine miniatures of the 15th century. They appear in engravings, for instance a set of Florentine Broad Manner prints (c.1470) in the Albertina, and a set of Fine Manner prints in the British Museum. There were sets by Marten van Heemskerck, Georg Pencz, Jost Amman. Book illustrators took up the idea in the *Hypnerotomachia Poliphili* of 1499 (Aldus Manutius, Venice), but although the 'Songes de Polyphile' were once listed as the subject of tapestries, none are now known. Triumphs appeared all over Italy, France, Germany and Flanders and were staged as Triumphal processions and Triumphal entries of Princes, frequently designed by leading artists.

These tapestries, and four others at Hampton Court, date from the first two decades of the 16th century. There was a brief interest in Petrarch and Italian literature at the Court of Henry VIII; *I Trionfi* was translated into English by Lord Morley and presented to Henry VIII; the sonnets were translated by Wyatt and Surrey (all published two or three decades later). It is not surprising that Petrarch's Triumphs are found on the imposing scale of tapestry hangings. The subjects of the six tapestries were:

1. *The Triumph of Love*
2. *The Triumph of Chastity over Love*
3. *The Triumph of Death over Chastity*
4. *The Triumph of Fame over Death*
5. *The Triumph of Time over Fame*
6. *The Triumph of Eternity over Time*

The Museum has the second, third and fourth. The figures in the tapestries are drawn from classical and medieval sources. The verses along the top and lower edges describe the theme in Latin and French, but they are not taken from the original poem. The four tapestries at Hampton Court were bought (eight pieces at the time) by Cardinal Wolsey in 1523 from the executors of the Bishop of Durham; they are numbers (2) and (3) and (5) above [plus a duplicate of (2)]. Skelton's poem *Colin Cloute* lampooning Wolsey's ostentation, has an undoubted reference to these tapestries (it was written in this same year, 1523).

The tapestries are designed as large scale dramatic compositions in the most advanced style of the early years of the 16th century; there is a unity of composition centred on the two chariots and leading from one to the other, hitherto not favoured in tapestry design. The artist is unknown: the circle of the Van Orleys at Brussels is still the closest reasonable attribution. They are woven in the low-warp technique of Brussels, used for the

finest tapestries of this period. *The Triumph of Chastity* has two dates inscribed, 1507 and 1510; both may have been in the original cartoon (or cartoons) or the latter may have been inserted by the workshop.

No. 22 (*pls.36, 37, 42A*)
The Triumph of Chastity over Love

H. 14ft 8in. (4·47m.) W. 27ft (8·23m.).

Condition. Good; there is some inevitable fading, particularly of the lighter tones; some wear in places and small patches of repair.

The second in the series of six. Inscribed: 'Second Triu(m)phe de Chastete'. Also inscribed (right side under the statue of Diana) '1507' and on roof (top right) '1510' (the third digit cannot be correctly read as a seven).

Description. On the left Cupid is pulled down from his chariot by Chastity 'LAURA POUR RAISON'. She is attended by Honour (HONESTETE), Modesty (HONTE), and Goodwill (BON VOULOIR). Above this group and a little to the right is a scroll inscribed 'HAULX PENSERS ET ESLEVEES CO(N)-SIDERACOV(N)S'. Round the chariot are grouped celebrated victims of Love, for instance Julius Caesar and Cleopatra. Chastity rides in triumph in the centre of the tapestry with Cupid bound at her feet. Lucretia, Virginia and others stand by her chariot. On the right is a temple honouring Diana, the Virgin huntress.

A scroll in the centre of the top border is inscribed: 'SECOND TRIU(M)PHE DE CHASTETE'.

In the top border are the verses:

Larc cupido a este surmonte
Par les armes de dame chastete
Qui ce seigneur co(n)culque e(t) tie(nt) en presse
Et ses membres trop rebella(n)s oppresse

Car es delices de cypre lopule(n)te
Ne es fluers souefues dide amour nest pas le(n)te
Mais par heres [sic] et thetis refrenee
Est folle amour et challeur forcenee

In the lower border:

Arma pudicicie supera(n)do cupidinis arcu(m)
Et d(omi)n(u)m calca(n)t et sua me(m)bra
 premunt
Nec pingui cipre nec mollis florib(us) ide
in herere [sic] et theti suppeditatur amor

The inscriptions have been completed by comparing them with those on the tapestries at Hampton Court.

Translation of inscriptions: The bow of Cupid has been overcome by the arms of Lady Chastity who subdues this Lord and keeps him closely confined, binding his too rebellious limbs. For it is not the delights of abundant Cyprus nor its sweet flowers that hold back the god of Love, but by Ceres and Thetis wild love is curbed and passion subdued.

The bow of Cupid being overcome by the arms of Chastity, this lord is vanquished and his limbs bound; Love is not held back by abundant Cyprus nor its sweet flowers, but is subdued by Ceres and Thetis.

No. 23 (*pls.38, 39, 42B*)
The Triumph of Death over Chastity

H. 14ft 7½in. (4·46m.) W. 22ft 5in. (6·83m.).

Condition. Cut at the right side, with added made-up border. Otherwise condition as No. 22.

Death is represented by the Three Fates. The third of the series. Inscribed: 'le tiers Triu(m)phe de la mort'. The missing part of the right side can be seen in the Hampton Court piece.

Description. On the left Chastity, riding in her chariot with Cupid bound at her feet, is stopped by the Fates (Atropos, or Death, stabs Chastity with a spear, Cloto holds a distaff, Lachesis rides behind the other Fates). Lucrece stands in the foreground with a banner on which is an ermine, an emblem of Chastity. Venus lies prostrate near her; in the background rides Scipio Africanus. The chariot of the Fates in which Chastity lies vanquished, occupies the centre of the tapestry. To the right of Lucretia is a warrior Debile carrying a spear 'GREVANCE' and on his shoulder clubs 'CONSOMACION' and 'P(ER)-SECUCION'. The scroll above their chariot carries the words 'LE TIERS TRIU(M)PHE DE LA MORT'. On the far side of the chariot is the companion of Debile, 'ACCIDENT', carrying a club 'FOR-TUDIO' and spear 'MALHEUR'.

In the top border are the verses:

Co(m)bien que l(h)o(m)me soit chaste (et) tout
 pudi(que)
Les seurs fatalles par leur loy aute(n)tique
Tra(n)che(n)t les nerfs et fillets de la vie
A cela la mort tous les vivans aonie [for 'convie']

Le chaste au fort plus saineme(n)t peult vivre
Qui (se treuve de gra(n)s vices delivre)
Mais a la fin il ny a roy ne pape
Gra(n)t (ne petit qui de ses las eschappe)

In the lower border:

Celibis absci(n)du(n)t nervos et fila sorores
Nec durat fragili vita pudica solo
Sanior ac lo(n)geva poterit valitudi(n) ecelebs
Esse sed heu tamde(m) singula cadu(n)t

Part of the right hand side of the tapestry is missing.

Translation of inscription: However chaste and completely virtuous a man may be, the fatal sisters by their inexorable law cut the nerves and threads of life. To this death brings all living beings. At the most the chaste, who are spared from

great vices, can live a better life, but in the end there is neither king nor pope, neither great nor small who escapes its toils.

No. 24 (*pls.40, 41, 43A & B*)
The Triumph of Fame over Death

H. 14ft 5in. (4·39m.) W. 26ft 11in. (8·21m.).

Condition. Rather more uneven than Nos. 22 and 23. There is wear and discoloration of the oxen pulling the second chariot, with some re-weaving on the legs of the central horse. The tapestry has a vertical cut left of the centre, with a patch cut out and restored to the left of this at the bottom; there is a small restored patch (about 4in. wide) on the right side from the border to the elephants' trunks. A section of border at the left bottom is a replacement from (apparently) another piece of this set.

The fourth of the series. Inscribed: 'le IIIIe Triu(m)phe de bon(n)e Renom(m)ee'.

Description. On the upper left hand side Fame (RENOMEE) dislodges Atropos with a blast of her trumpet. A number of legendary mortals and heroes rise from their graves; Paris, Tristram, Charlemagne, etc. On the right, Fame rides in a chariot drawn by four elephants. Below her sits Atropos. A procession of famous men and women advances from the buildings, among them Julius Caesar, Alexander the Great, Nero, etc. The scroll in the centre of the top border is inscribed: 'LE IIIIe TRIU(M)PHE DE BON(N)E RENOM(M)EE'.

The verses in the top border are:

La mort mord tout mais clere reno(m)mee
Sur mort (triumphe et) la tie(n)t deprimee
Dessoubs ses pieds mais apres ses effors
Fame sus (cite les hau)lx fais de gens morts

Qui par virtu ont meritee gloire
Quapres leur mort de leurs fais soit memoire
Inclite fame neust jamais congnoisa(n)ce
De letheus le grant lac doubliance

In the lower border:

Omnia mors mordet s(uper) morte fama
 t(ri)u(m)phat
Cetera morde(n)te(m) sub pede fama premit
Egregiu(m) facin(us) post morte(m) suscitat ipsa
Nec scit letheos inclita fama lacus

Translation of inscriptions: Death strikes all, but bright Fame triumphs over Death and keeps it trampled underfoot; after her victory Fame proclaims the great deeds of the dead, so that the actions of those, who by their greatness have deserved glory, shall be remembered after their death. Renowned Fame has never known Lethe, the great lake of forgetfulness.

Additional information. The four Hampton Court tapestries were probably woven in the same Brussels workshops as ours from the same designs and cartoons. (The latter were often altered in minor details for different weavings). A slightly later, but similar weaving of the *Triumph of Fame* is in the Rijksmuseum, Amsterdam. It appears to be one of four which were once at the Château de Malesherbes (Comte de Mirepoix); the crouching figure of a mahout riding on the foremost elephant (an innovation) is drawn in a Raphaelesque manner, with knee raised and body and head turned vigorously back. The large portion of a *Triumph of Love* at the Cinquantenaire Museum, Brussels, is of interest because this subject is otherwise missing. It is attributed to Tournai by J.P. Asselberghs 'en raison de sa texture grossière et de ses vives couleurs' (see Tournai Exhibition of 16th century Tapestries, 1968, p.21), although its affiliation to the finer Brussels set is clear. A fragment of the *Triumph of Time* at the Bowes Museum, Barnard Castle (c. 6ft 10in. × 5ft 9in.) bears the

arms of Philip of Cleves (1456–1528). Other fragments are known, such as inscriptions from the *Triumph of Chastity* (private collection in England), which may come from Wolsey's piece, missing from Hampton Court and once in the Tower of London; and the figure of Chastity (top portion) from this *Triumph*, now in the Rijksmuseum.

An entirely different and stylistically earlier set of Petrarch *Triumphs* is at Vienna. The Museum possesses a small portion of a similar piece; this is discussed under the next entry. Another earlier set is referred to under *The Three Fates*, No. 26; it is associated with a purchase for Isabella the Catholic in 1504. The *Three Fates* tapestry is itself probably an excerpt from the grand Petrarch theme used for decorative tapestry.

Several later editions of Petrarch's *Triumphs*, from different cartoons, or much simplified and of inferior quality, are to be found. It is sufficient to enumerate four at Barcelona (Palacio Generalidad); five in the Spanish Patrimony, which were woven at Oudenarde by Martin Cordier in the latter part of the 16th century; and three formerly in the Berlin Schlossmuseum (old Imperial collections). As late as 1609 the top-ranking workshop of Martin Reymbouts at Brussels commenced weaving a set of Petrarch's *Triumphs*. The 'mise en scène' of *Triumphs* in this manner was applied to various subjects throughout the 16th century in tapestry: Prudence, Fortitude, Peace, Victory, etc. The theme culminated in Rubens' great set of *Triumphus Ecclesiae*, designed in 1625 for the Archduchess Isabella, who gave the original set, woven by Jan Raes, to the Convent of the Descalzas Reales, Madrid, where it still is.

Museum acquisition. No. 22 *Chastity:* 440–1883. No. 23 *Fame:* 439–1883. No. 24 *Death:* 441–1883. Purchased from E. Lowengard, Paris, for £1,000, £1,000 and £775 0s. 6d., respectively.

Related Pieces. The Table* summarises the most closely related pieces of the six tapestries of this set:

1. *The Triumph of Love*
 (a) Fragmentary portion: Brussels, Musées royaux d'art and d'histoire (Cinquantenaire)
2. *The Triumph of Chastity over Love*
 (a) Victoria and Albert Museum, No. 22, 440–1883
 (b) Fragment: Rijksmuseum, Amsterdam, representing CHASTITY, with two attendant putti
 (c) Fragment, the figure of PENELOPE BREAKING THE BOW. Sold at Sotheby's, 1967
3. *The Triumph of Death over Chastity*
 (a) Hampton Court Palace, No. 1031
 (b) Hampton Court Palace, No. 1094
 (c) Victoria and Albert Museum, No. 24, 441–1883
4. *The Triumph of Fame over Death*
 (a) Hampton Court Palace, No. 1032
 (b) Victoria and Albert Museum, No. 23, 439–1883
 (c) Rijksmuseum, ex-Château de Malesherbes
5. *The Triumph of Time over Fame*
 (a) Hampton Court Palace, No. 1033
 (b) Fragment: Bowes Museum, Barnard Castle, with arms of Philip of Cleves (1456–1528)
 (c) Fragments formerly in collection of Comtes de Mirepoix, Château de Malesherbes
 (d) Fragment formerly in collection of H.D. MacLaren
6. *The Triumph of Eternity over Time*
 (a) Fragment(s) formerly in collection of Comtes de Mirepoix, Château de Malesherbes

Literature
Amsterdam, *Wandtapijten I*, see Erkelens, A.M.L.
Asselberghs, J.P., *La tapisserie tournaisienne au XVIe siècle*, Catalogue of the exhibition, Tournai, 1968, No. 13
Chartrou, J., *Les Entrées Solennelles et Triomphales de la Renaissance*, Paris, 1928
Crick-Kuntziger, M., *Musées royaux d'art et d'histoire.*

*This Table is based on Hilary Wayment's more complicated table in *Oud-Holland*, 1968, p.71.

Catalogue des Tapisseries, Brussels, 1956, Nos. 22, 23; pls.30, 31
Erkelens, A.M.L., *Wandtapijten I. Late Gotiek en Vroege Renaissance*, Rijksmuseum, Amsterdam, 1962, Nos. 18–25
Essling, Prince d', and Müntz, E., *Pétrarque*, Paris, 1902
Göbel, H., *Wandteppiche I. Die Niederlande*, Leipzig, 1923, pt.i, pp.103–5, 111–12, 411–12
Kendrick, A.F., *Victoria and Albert Museum Catalogue of Tapestries*, London, 1924, Nos. 15–17
Law, E., *New Authorised Historical Catalogue of the Pictures and Tapestries at Hampton Court*, London, 1911
Marillier, H.C., *The Tapestries at Hampton Court*, London, H.M.S.O., 1962, pp.19–23
Mumford, I.L., 'Petrarchism in early Tudor England' in *Italian Studies*, vol.XIX, 1964
Rackham, B., *Victoria and Albert Museum Catalogue of Italian Maiolica*, London, 1940, vol.I, No. 519; vol.II, pl.81
Scheicher, E., 'Die Trionfi: eine Tapisserienfolge des Kunsthistorischen Museums in Wien' in *Jahrbuch der Kunsthistorischen Sammlungen in Wien*, vol.67, Vienna, 1971, pp.8–46
Wayment, H., 'A Rediscovered Master II. Adrian van den Houte as a Tapestry Designer' in *Oud-Holland*, Amsterdam, 1968, vol.LXXXIII, pt.I, p.71
Venturi, A., 'Les Triomphes de Pétrarque dans l'Art Représentatif' in *Revue de l'art, ancien et moderne*, vol.XX, 1906

No. 25 (*pl.44*)
The Triumph of Eternity over Time (*Portion*)

FRENCH or FLEMISH; early 16th century.
H. 10ft 9½in. (3·29m.) W. 5ft 9in. (1·75m.).
Wool: 12–13 warp threads to inch (5 to cm.).

Condition. Reasonably good. The blues, pinkish reds, and greens are fairly fresh, but the faces and hands have faded to buff.

This strip comes from the left side of the sixth piece of the *Triumphs of Petrarch*; the complete set is in the Kunsthistorisches Museum, Vienna. The style of these *Triumphs* is quite different from the V and A and Hampton Court Brussels series (see nos.22–24); lacking the dramatic and spatial qualities of the latter, they look medieval by comparison and their distinctive soft colouring and texture suggests a different weaving centre. They have inscriptions in French and are woven without borders. A late 16th century set of engravings published by Charles le Vigoureux in Paris show the same designs as in these tapestries, with only minor points of difference. It is usually assumed that the engravings derive from earlier prototypes.

There has been a good deal of discussion on the origin of the Vienna *Triumphs* and of pieces associated with them in the Metropolitan Museum, at Brussels, Seattle, and our piece. At one time they were considered to be French because of their stylistic similarity with a wide group of tapestries associated by Guiffrey with the Tours and Loire district. M. Crick-Kuntziger argued for the Flemish (Bruges) origin of the *Triumph of Fame* in the Cinquantenaire (which is basically the same design as the Vienna *Fame*, but woven in subdued verdure-like colouring) (M. Crick-Kuntziger, Brussels Catalogue, no. 22). Elizabeth Scheicher has published a study of the Vienna tapestries with a careful analysis of their iconography (Vienna, *Jahrbuch*, 1971). Her conclusions are that the set of six tapestries constitute a humanistic interpretation of the Triumph theme, which shows strong affiliations with the French Court of Louis XII, and she looks there for the intellectual scheme of the cycle (possibly Guillaume Budé) and the designer (possibly Jean Pérreal). According to Elizabeth Scheicher the figure of Pandora with her box, who leads the triumphal car of Death (4th tapestry) with its oxen, shows a new humanist interpretation of Pandora

as a harbinger of evil (carrying a pyxis) and a disseminator of diseases and death, which was first stated by Erasmus of Rotterdam with the publication of *Adagiorum chiliades tres* in 1508 (reference to E. Panofsky, *Pandora's Box*, 1956). If this 'terminus ante' is correct, the Vienna *Triumphs* are contemporary with the V and A (Nos. 22–4) and Hampton Court set, despite their archaic appearance. (Scheicher attempts to date them 1508–10.)

Description. The left-hand portion of a large tapestry showing the Triumph of Eternity over Time. In the centre stands St Gregory wearing the mitre and cope and holding a crozier and an open book. On his left, a little below him, stands St Jerome with a closed book. Both figures have inscriptions identifying them. The panel includes the back wheel of the chariot of Eternity. Crushed beneath it are two female figures, 'Lachesis' and 'Clotho', two of the Fates, and on the lower right-hand side is the head of another figure. On the left-hand side of the panel is a tree bearing fruit and on the right is part of an aureole of clouds with cherubim. At the foot of the panel are flowers scattered in rather sparse clumps. The colouring of the tapestry is predominantly dark, mid and light blue and pinkish-red. There are some pale green tints remaining in the leaves of the tree. The faces and hands of the figures have faded to shades of buff.

The tapestry is part of the sixth in the series. A complete version of the *Triumph of Eternity over Time* exists in Vienna, and is illustrated in Ludwig Baldass, *Die Wiener Gobelinssammlung*, 1920; E. Scheicher, Vienna Kunsthistorisches Museum *Jahrbuch*, 1971, fig.6.

Further information. This portion of the *Triumph of Eternity* belongs to a group (quite distinct from nos.22–4), represented by the complete set of six at Vienna, two pieces in the Metropolitan Museum, *Fame* and *Time*, the Brussels Museum *Fame* (illustrated, E. Scheicher, *Jahrbuch*, figs.1–6, 30, 36, 37), the figure of Virgil from *Fame* at Seattle Museum

of Art, and our piece. In her study of the Vienna set E. Scheicher infers that there may have been an earlier weaving than the one preserved, that the New York pieces are slightly inferior in detail, that the Brussels tapestry is coarser, and that the V and A piece, which is again the relic of another set, shows deterioration in the expression and volume of the figures and the rather clumsy rendering of the clouds (E. Scheicher p.46).

Museum acquisition. T.148–1959. Purchased at Sotheby & Co.: £250. Sale 22 May 1959, lot 90.

Literature

Asselberghs, J.P., *La tapisserie tournaisienne au XVIe siècle*, Catalogue of the Exhibition, Tournai, 1968, no.13

Baldass, L., *Die Wiener Gobelinssammlung*, Vienna, 1920–1, vol.1, no.6, pl.6

Crick-Kuntziger, M., *Musées royaux d'art et d'histoire. Catalogue des tapisseries*, Brussels, 1956, no.22; pl.30

Heinz, D., *Europäische Wandteppiche*, vol.1, Braunschweig, 1963, p.101

Panofsky, E., *Pandora's Box: the changing aspects of a mythical symbol*, London, 1956

Scheicher, E., 'Die Trionfi: eine tapisserienfolge des Kunsthistorischen Museums in Wien' in *Jahrbuch der Kunsthistorischen Sammlungen in Wien*, Vienna, 1971, vol.67, pp.4–46

No.26 (*pls.45 A&B*)
The Three Fates
or The Triumph of Death over Chastity

FLEMISH; early 16th century.
H. 10ft 1in. (3·07m.) W. 8ft 8in. (2·64m.).
Wool and silk: 12 warp threads to inch (5 to cm.).

Condition. Good.

This colourful and decorative piece has always been a favourite in the collections. The theme is definitely connected with the *Triumphs of Petrarch*, which inspired a multitude of designs for over two centuries. In the Bibliothèque de l'Arsenal, Paris, are three manuscripts which include drawings of Petrarch's Triumphs. MS. 5066 has four drawings in ink, lightly washed, of the Triumphs of Love, Chastity, Death and Fame. The Triumph of Death is shown as here with three Fates standing over a recumbent maiden with the thread severed; her branch is a rose, not a lily. The design is very close to our tapestry (reversed), but the costume and hair styles are Italianate and suggest a date around 1520–30; there is a lightly suggested landscape in the background. The French metrical inscription below the figures (there is a Latin verse above) corresponds with that in the great *Triumph of Death* tapestry in the Museum. The model for our tapestry seems to be connected with the Arsenal drawing at some remove. Eugene Müntz has pointed out that earlier 15th century versions of the theme use a skeleton with scythe for Death (often seen on *cassoni*), rather than the Fates.

A tapestry in the French State Collections and now at the Château d'Azay-le-Rideau, together with a duplicate piece formerly at Rufford Abbey and now in the Burrell Collection, Glasgow, show the three Fates with distaff and spindle surrounded with falling and prostrate figures; above fly Time (a woman with a scythe) and Death (pale and emaciated). The composition is contained within a Gothic arcade. These two tapestries are of more sophisticated draftsmanship and composition than our piece, and J.P. Asselberghs has shown that they can be closely connected with a set of Petrarch *Triumphs* bought for Isabella the Catholic from a Flemish merchant, Matis de Guirla (or, van Gierle), in 1504, (Asselberghs, Cats. of Exhibitions at the Château de Culan, and at Louvain, both in 1971). Four other pieces from the set are known, though it is not claimed that any of them are from the original set which belonged to Isabella. This leaves the dating of our less princely piece open within the first quarter of the 16th century.

The vigorous handling and 'mille-fleurs' background show how effective wall hangings with such decorative conceptions, based on a well-known theme, can be. The weaving, although not particularly fine, is very skilful.

Description. The three Fates stand upon the prostrate body of a young woman, by whose side lies a broken lily. Clotho holds a distaff, Lachesis draws the thread, which is held by Atropos in her left hand, but her right is empty and the thread severed; the spindle has fallen to the ground beside the maiden's head. The names of the Fates are inscribed beside them. The blue background is covered with flowering plants, with birds above and a rabbit, a monkey and lizards, and a frog below. The tapestry has been cut down to its present size and is now surrounded with a blue galloon border.

Additional information. A fragment of a *Triumph of Love* at the Detroit Institute of Art, with Eros shown standing and blindfold, is closely related to another of the Bibliothèque de l'Arsenal drawings (mentioned above). It appears to be part of the set represented by three tapestries at Cleveland Museum of Art, which came from the Château de Chaumont: the *Triumph of Eternity* (the Virgin), of *Youth*, and of *Time*. These distinguished tapestries, in their courtly manner, are as medieval in feeling and treatment as our *Three Fates*. They have been extensively studied in the Cleveland *Bulletin* (vol. 48, no.7, 1961).

E. Scheicher, in a study of the Vienna Museum *Triumphs* (Kunsthistoriches Museum *Jahrbuch*, 1971, p.40), suggests that the *Three Fates* tapestry comes from an interpretation of the Triumph theme earlier than the Vienna series and allied pieces.

Other examples in tapestry of the three Fates, apart from the great Petrarchian *Triumphs*, are also known. For example, the *Three Fates* winding a chain round a female figure (Cluny Museum, Paris); a winged *Fame* trampling on the three Fates

(inscribed), an angel above with scroll, and inscribed heroes (Joseph, Virgil, etc.) (Barcelona Exhibition, 1888; Ackerman, *Apollo*, 1931; ascribed to Brussels early 16th century).

Museum acquisition. 65–1866. Bought (£24). An enlarged photograph of the tapestry was coloured by hand for the Museum in 1886 (cost £45).

Restoration. Cleaned and restored in 1964–5 in Tabard's workshops in Aubusson, when the old (later) border was removed and the galloon woven on.

Literature
Ackerman, Phyllis, 'The Final Solution of Maître Philippe' in *Apollo*, August 1931, pp.83–7
Asselberghs, J.P., *Chefs-d'œuvre de la tapisserie flamande*, Catalogue of the exhibition, Culan, 1971, No.4, pl.4
Asselberghs, J.P., *Aspekten van de Laatgotiek in Brabant*, Catalogue of the exhibition, Louvain, 1971
Barcelona, *Exposition Universelle*, 1888
Essling, Prince d', and Müntz, E., *Pétrarque*, Paris, 1902, pp.235, 237, 271–2
Kendrick, A.F., *Victoria and Albert Museum Catalogue of Tapestries*, London, 1924, No.14
Martin, H., and Lauer, P., *Les principaux manuscrits de la Bibliothèque de l'Arsenal à Paris*, Paris, 1929. vol.v, pp.33–4
Scheicher, E., 'Die Trionfi: eine Tapisserienfolge des Kunsthistorischen Museums in Wien' in *Jahrbuch der Kunsthistorischen Sammlungen in Wien*, Vienna, vol. 67, 1971
Shepherd, D., 'Three Tapestries from Chaumont' in *Museum of Art Bulletin*, vol.48, no.7, Cleveland, September 1961, pp.159–76

No. 27 (pls.46–47)
The Adoration of the Infant Saviour

BRUSSELS; around 1500.
H. 5ft 0in. (1·52m.) W. 6ft 6½in. (1·99m.).

Wool and silk enriched with gold and silver thread: 28 warp threads to the inch (11 to cm.).

Condition. No longer fresh.

A small tapestry of great fineness and richness, such as was used particularly in chapels by princes of the Church and State. Many of these devotional tapestries have survived from this period. Two in the Vatican may be mentioned; one shows the *Virgin and St Anne with the Infant* holding a bunch of grapes, the other an *Adoration of the Shepherds*: in both, attendant angels, the flowers and rich materials, and the general air of sweetness, are similar to the V & A *Adoration*.

The style of one of the Brussels schools of painting of the first years of the 16th century is evident in the design, but an exact attribution is probably not possible. A decree of the Brussels Magistrates in 1476 gave the Painter's Guild the monopoly of drawing the figures for tapestry; *patronschilder* (artists who composed cartoons) became a profession and whether they worked from a design (*petit patron*) by a chosen master, or not, they interpreted the style of the current Brussels schools. The composition and draftsmanship are of a high order, but anonymous, and the weavers have understood exactly how to interpret their cartoon because of their close association with the *patronschilder*.

At first sight the types of the angels, shepherds, Madonna, Child and Joseph in the *Adoration* could be from the workshop of Hugo van der Goes; but the formal composition and rather inept rendering of space are alien to the powerful manner of Van der Goes. Friedländer's description of the style of Colijn de Coter could be applied to the artist of the tapestry: 'he strives for a lofty, ecclesiastical style, a sombre dignity . . . He was little concerned with spatial depth and landscape, placing his characters in the foremost level and filling the foreground with a dense wall of figures.' Colijn de Coter 'of Brussels' as he signed his paintings, was active there around 1500, the approximate date of the tapestry. His few

surviving paintings contain many parallels with the *Adoration*: in the long, solemn faces of the angels and their monumental forms, the features of the Madonna, and details of drapery. Above all, the lack of concern with effects of space, noted by Friedländer, is apparent in the uncertain relationship between the wall of the *hortus conclusus* in the tapestry, the angels, who are meant to be in front of it, and the shepherds who look in from outside.

Two features are not to be found in de Coter's surviving work: the figure of Joseph with mouth open in an expression of adoration and the figure of the Christ Child with small head in semi-profile. De Coter's portrayal of the Child was usually full-face with a rather large, misshapen head. It is possible, however, that he borrowed Joseph, the Child and perhaps the shepherds too from paintings by Roger van der Weyden and the Master of Flémalle, just as he did with other figures in his surviving works. As an artist he was essentially a traditionalist and a reinterpreter.

In her monograph on Colijn de Coter, Jeanne Maquet-Tòmbu speculated that the artist was likely to have designed tapestries and suggested a number of pieces which she considered to approximate to his style. With one of these, the late 15th century *Credo* in the Boston Museum of Fine Arts, the name of De Coter was also linked by Mme Crick-Kuntziger in the introduction to the tapestry section of the Brussels Exhibition of 1935. The types of Joseph and the Christ Child in the Nativity scene of the *Credo* are similar to those in the *Adoration* tapestry.

Description. In the centre is the Virgin, seated on a faldstool, her hands joined in prayer, and the naked Babe on her lap. On her right kneels St Joseph, and on her left kneels an angel wearing a cope with embroidered orphreys. Behind St Joseph are the midwife and nurse (Zelemia and Salome) of the Apocryphal Gospels; behind the kneeling angel are two others in adoration. In the background, behind the Virgin, is a group of four shepherds, one playing the bagpipe. On the left of this group three angels are playing musical instruments, and on the right three angels stand singing round a lectern, on which lies a book. The ground is covered with flowers, and at the feet of the Virgin a Book of Hours lies open. The group is enclosed by a low parapet, and in the distance are glimpses of a hilly landscape. The border is composed of rose stems on a gold ground; the rectangular outer strip is shaped at the four corners. The weave is very fine and the colours cool, except for the beautiful rose-red.

Further Information. We do not know if the design for the *Adoration* was woven more than once, but the cartoon must have remained in the tapestry workshop, as figures from it recur in later tapestries. The heads of the angels grouped by threes in the upper corners are re-used in a tapestry of the *Virgin and Child with a Concert of Angels* formerly in the San Donato Collection, Florence, and in a copy named *The Three Marys* by Phyllis Ackerman (*A Mirror of Civilisation*, pl.18). The folds of the cope worn by the angel kneeling at the right in the *Adoration* are reproduced exactly, though with different orphreys, in the *Nativity* of the Trento *Life of Christ* and its duplicate tapestry in Budapest. This copying of insignificant detail argues one workshop for the Victoria and Albert Museum *Adoration* and for the *Life of Christ* which carries the name of Pieter van Aelst, the leading tapestry-maker in Brussels during the first twenty years of the 16th century.

Museum acquisition. 1–1889. Purchased from the Castellani collection, Rome (£1,176). Sir Frederick Leighton, J. Henry Middleton and William Morris were consulted about this expensive purchase and wrote letters of recommendation. In view of the craftsman's taste generally associated with William Morris, it is interesting to quote from his letter: 'The composition is remarkably beautiful, the drawing refined and elegant, the faces particularly dignified: the details of the costume etc. of very great beauty, and the colour very harmonious in a pure key.' (See also his recommendation of No. 19).

Literature

Ackerman, P., *Tapestry, the Mirror of Civilisation*, New York, 1933, p.94, pl.18

Crick-Kuntziger, M., *Cinq siècles d'art, Mémorial de l'Exposition de Bruxelles 1935*, vol.II, *Tapisserie*, 1936, p.7

Florence, Catalogue of the sale at the Palais de San Donato, 15 March 1880, No.398, pp.95–6 and plate

Friedländer, M.J., *Early Netherlandish Painting*, vol.IV, Leyden, 1969, pp.65–6, pls.84–94

Göbel, H., *Wandteppiche I. Die Niederlande*, Leipzig, 1923, pt.i, p.411

Maquet-Tòmbu, J., *Colyn de Coter, peintre bruxellois*, Brussels, 1937

No. 28 (*pls.48, 49A–B*)
The Resurrection

Probably BRUSSELS; c. 1520–25.
H. 8ft 4½in. (2·55m.) W. 7ft 7½in. (2·33m.).
Wool and silk enriched with gold and silver thread: 16–17 warp threads to inch (6–7 to cm.).

Condition. Very good.

The relationship between this design and two pictures, which both probably derive from an original by Dieric Bouts, has been pointed out by Dr Johanna M. Diehl, formerly of the Haarlem Tapestry Repair Workshops. One is a Resurrection (the Ehningen Altar), now in the Stuttgart Staatsgalerie (Brussels Cat. No.84, p.182); the other, a Resurrection by Dieric's son, Albert, in the Mauritshuis, The Hague (Brussels Cat. No.61, p.141). A similar tapestry, from the Somzée collection, is in the Metropolitan Museum, New York (illustrated, H. Göbel, *I*, ii, pl.141). Except for the rather different Christ with right arm bent and

different stance, and variant details in the foliage and no inscription, the two tapestries are duplicates. The borders are not the same. The floating Christ is more like an Ascension, but the rest fits better with a Resurrection.

Description. Christ rises from the rock-hewn tomb, his right hand held out in blessing, his left holding a jewelled cross on a staff, to which a pennon is attached. The letters of an inscription run up one side of the tomb door. Below are the soldiers waking in alarm. In the landscape background on the right the three Holy Women are approaching the Sepulchre, and on the left Christ is appearing in the garden to Mary Magdalene. The border is composed of fruit with copious bunches of grapes, foliage, masks and gadrooned bowls, with some roses, richly woven in metal thread and coloured silks on a deep blue ground. The colour tones are hot with red and sepia predominating on a rather pale landscape ground. The weave is very tight.

Inscription. On the tomb face, various letters are inscribed, only a few of which are complete: one can read 'O B A M', presumably random letters suggesting an inscription.

Further Information. The border of this tapestry is to be found on two other tapestries with scenes from the life of Christ. One is *The Three Marys* or *The Concert of Angels* owned by the Norton Simon Foundation, mentioned above in connection with No.27, *The Adoration*. The dimensions of this piece are 8ft 6in. (2·59m.) × 9ft 8 in. (2·95.m) and it was woven, like *The Resurrection*, with metal thread. The other tapestry with the same border is a double panel of *The Nativity and the Adoration of the Magi*, the scenes divided by an ornate pillar, which is in the Virginia Museum of Fine Arts, Richmond, U.S.A. Metal thread is used in this weaving too; the ground of the border, as in *The Resurrection*, is dark blue and the height 8ft 11in. is close to that of *The Resurrection*. The figures of the Magi in the one

tapestry and the soldiers around the tomb in the other are similar in their fantastic dress and awkward posture. One soldier and one of the Magi virtually share the same profile, and a feature of the masculine faces in both tapestries is a long, high-bridged nose with bulbous tip.

The pose of the Virgin and the three angels behind her in the *Richmond Nativity* are copied from the Trento *Nativity*, which in turn has taken the folds of a cope from the Victoria and Albert Museum *Adoration*. The angels in *The Three Marys* are also taken from the *Adoration*. And the floating figure of Christ above the soldiers in the *Resurrection*, dividing the background from the two smaller scenes, is a concept taken from the Trento *Resurrection*. These links suggest the possibility of a common workshop, which from the inscription on the Trento *Life of Christ* would be that of Pieter van Aelst. The awkwardness of the three later pieces compared with the better known tapestries from this famous workshop would seem to result from the lesser skill of the designer, as they are finely woven.

Museum acquisition. T.139–1921. Bequeathed by David M. Currie. This tapestry was in the Lafaulotte sale, Paris, Hôtel Drouot, April 1886, lot 1032.

Literature
Brussels, '*Dieric Bouts*', Catalogue of the exhibition, Palais des Beaux Arts, 1957–8, Nos.61, 84. Also Delft, Stedelijk Museum Het Prinsenhof
Diehl, Dr J.M., Letter in Textiles Department records
Göbel, H., *Wandteppiche I. Die Niederlande*, Leipzig, 1923, pt.ii, pl.141
Kendrick, A.F., *Victoria and Albert Museum Catalogue of Tapestries*, London, 1924, No.23a, p.38

Nos. 29–30 (*pls.50–51*)
The Story of Esther

The Old Testament *Book of Esther* was a story which

was reproduced in sets of tapestries throughout the centuries, not least in the 15th and 16th. The Museum has two pieces of similar style and date and with closely similar borders, but they are more likely to come from two contemporary sets than from one and the same set. Both pieces are of good quality, sensitively drawn and woven in the quietly restrained style of the period, with emphasis on perpendicular lines.

No. 29 (*pl.50*)
Esther hearing of Haman's Plot

BRUSSELS; first quarter of 16th century.
H. 11ft 2½in. (3·42m.)　W. 13ft 1½in. (4·00m.).
Wool and silk: 18 warp threads to inch (7 to cm.).

Condition. Reasonably good.

Description. Haman, the King's favourite minister, enraged with Mordecai the Jew, has persuaded King Ahasuerus to issue a decree 'to destroy, to kill, to cause to perish, all Jews, both young and old', throughout his lands.

The tapestry shows Hatach the chamberlain bringing to Esther a copy of the King's decree. The Queen (Esther) has risen from a chair placed on a platform and stands and looks upwards in consternation, her hands clasped. Groups of courtiers and ladies in waiting, one holding a lute, are standing in the foreground. In the background, copies of the decree are sent to the governors of the provinces, and Esther with her maids is seen in lamentation.

There is a narrow border tightly packed with flowers and leaves on wavy stems, on a dark blue ground.

Museum acquisition. 5669–1859. Bought (Soulages Collection; £25).

Repaired at the Conservation Centre, Hampton Court (Mrs Finch), 1973–5.

No. 30 (*pl.*51).
Esther approaching Ahasuerus

BRUSSELS; first quarter of 16th century.
H. 10ft (3·04m.) W. 12ft 9½in. (3·9m.).
Silk and wool: 17 warp threads to inch (7 to cm.).

Condition. Good.

Description. Mordecai, Esther's uncle, has instructed her as Queen and chief concubine to appear before Ahasuerus and plead the Jews' cause, although to approach unsummoned was at risk of death, 'except such to whom the King shall hold out the golden sceptre'.

In the tapestry this dramatic moment is shown. Ahasuerus is seated on a throne under a canopy hung with rich brocades, surrounded by courtiers. He extends the sceptre to Esther, who kneels before him. In the upper corner to the left Esther is again represented wearing a crown and received by the King who advances towards her. On the right (above) the King and Queen are seen enthroned, listening to the music of a harp.

The border is again narrow and tightly packed with floral and leafy stems; the turning of the corners is a little differently arranged to the other Esther tapestry.

Museum acquisition. 338–1866. Bought (Caveletti of Madrid; £9 9s 5d).
Repaired by Mrs Karen Finch, London, 1970–1.

Additional information. The Esther tapestry nearest to these two in style and date is perhaps the one in the Isabella Stewart Gardner Museum, Boston, and a pair at Lerida Cathedral, all with similar borders. The borders of a smaller piece formerly in the Figdor Collection (Kurth, pl.81) are analogous in style but arranged in rectangular compartments. Going back to the 15th century, a fragment in the Louvre (Albert Bossy gift), with Vashti (Ahasuerus' former queen), enthroned and refusing the King's summons, two pieces at Nancy (Musée Lorrain), and another at the Minneapolis Institute of Arts with Esther's invitation of the King to her feast, have been associated with a set delivered by Pasquier Grenier in 1462 to Philip the Good; but these pieces date from around 1480, and the above connection, if tenable, must be at some remove. At La Seo, Saragossa, is the grandest extant set (three pieces), dating from about 1470, given by Ferdinand the Catholic to his son, Don Alphonso of Aragon, who gave them to the Archbishop of Saragossa.

The subject was very popular in the 16th century. Cardinal Wolsey and Henry VIII had Esther sets (Henry VIII Inventory); and there is at St John's College, Oxford, a fine small silk and gold piece woven at Antwerp in the middle of the century (Antwerp Exhibition, 1973). A grand piece in the Bernard van Orley style is recorded (Berlin Lichtbildstelle). In German tapestries the subject is common.

It may be mentioned that the Coronation of Esther figures as a sub-scene in the famous Sens *Coronation of the Virgin*; and also in the cartoons for the *Glorification of Christ*, which appear with variations in the 'Mazarin Tapestry' (Washington), at the Cloisters (New York), at Brussels Cinquantenaire, and at Saragossa.

Literature
Antwerp, *Wandtapijten*, Catalogue of the exhibition, 1973, No.23, pl.11
Asselberghs, J.P., Catalogue of the exhibition *La tapisserie tournaisienne au XVe siècle*, Tournai, 1967, Nos.19–22
Göbel, H., *Wandteppiche I. Die Niederlande*, Leipzig, 1923, pt.ii, pl.222
Heinz, D., *Europäische Wandteppiche*, vol.1, Braunschweig, 1963, p.81, pl.49
Hunter, G.L., *The Practical Book of Tapestries*, Philadelphia and London, 1925, pp.56–7
Kendrick, A.F., *Victoria and Albert Museum Catalogue of Tapestries*, London, 1924, Nos.20, 22; pl.xvii
Kurth, B., *Gotische Bildteppiche aus Frankreich und Flandern*, Munich, 1923
Madrid, *Exposiciòn Històrico-Europea* 1892–1893, Madrid, 1893, Room X, No.58
Marillier, H.C., 'Tapestries at St. John's College, Oxford' in *Burlington Magazine*, vol.XLII, November 1926, p.205
Salet, F., and Souchal, G., Catalogue of the exhibition *Chefs-d'œuvre de la tapisserie du XIVe au XVIe siècle*, Paris, 1973–4, No.76

No. 31 (*pls.*52A & B)
David and Bathsheba (*four fragments*)

BRUSSELS; first quarter of 16th century.
H. 6ft 10in. (2·08m.) W. 2ft 6½in. (0·77m.) (within the applied borders), and three small fragments sewn together.
Wool and silk: 16–17 warp threads to the inch (6–7 to the cm.).

Condition. Fragmentary and with the silk in poor condition.

These four fragments of tapestry come from one piece, or at least from one set, of the story of David and Bathsheba. The borders on these fragments are attached and seem to come from two different tapestries.

Description. The largest piece shows Bathsheba seated in front of a fountain, with a bowl of water at her feet. Her name is written on her gown, 'bersabe'. In her hand she holds the summons from King David, sealed with the impression of a harp. She looks to the left, as though to the messenger. At her right stands a female attendant; behind the fountain are two more women. The lower ends of garments at the top of the fragment indicate that there was a smaller scene in the upper register.

The three small fragments joined together show figures on three different scales from different parts

of the tapestry. From the foreground comes the lower part of a man kneeling towards the right on one knee, his hat in his hand. A neat row of flowers beneath him show that his position was at the bottom of the tapestry, and his attitude suggests that he is the messenger to Bathsheba. On a smaller scale are two male figures cut to the right by a fold of drapery belonging to a figure in the foreground. Smaller still is a scene which probably comes from the upper right corner of the tapestry (perhaps balanced on the left by David sending his messenger or watching from his palace) with David standing beside a bed where Bathsheba is lying, her name on the coverlet.

Further Information. This tapestry is from a cartoon inferior to the finest contemporary sets of the same subject, such as the tapestries in the Cluny Museum and in the Spanish State Collection, but the weave is fine and typical of good Brussels tapestries of the early 16th century.

Museum acquisition. Circ.493 and 494–1919. Purchased from Harold Wallis as part of a large collection of textiles. See also Nos.32 and 33.

No. 32 (*pl.53B*)
Court scene (*fragment*)

BRUSSELS; first quarter of 16th century.
H. 3ft 10in. (1·17m.) W. 7ft 7in. (2·31m.).
Wool and silk: 16 warp threads to the inch (6–7 to the cm.).

Condition. Rather worn. The dark outlines and silk have deteriorated. The piece has been cut in two and joined along the right side of the pole bearing the banner.

This fragment comes from the upper register of a tapestry which, owing to the loss of the main scene, cannot be identified with any certainty. The tips of

spears and helmet plumes and the banner that protrudes into the upper register suggest a military or ceremonial scene. The association of this tapestry, through its previous owner, with the *David and Bathsheba* fragments (No.31) tempts identification of the missing troops with those of Uriah departing for battle. The letters on the banner could be read as 'U R . . .' in reverse. But although the fragmentary nature of these pieces and their poor condition make any stylistic comparison difficult, the difference in the treatment of water spilling from the fountain in each fragment suggests that even if they by chance share a subject they are probably not from the same set.

Description. At the left two men and two women make music in a landscape setting. To the right of a woman playing a lute is a long pole with a fluttering banner, borne by some lost figure from the scene below. A plumed helmet and the tops of spears are also to be seen at the lower edge of the fragment. At the right is a fountain and a pair of lovers, the woman making a chaplet for the man. Behind them are two servants with fruit and wine.

Museum acquisition. T.812–1919. Purchased from Harold Wallis as part of a large collection of textiles. See also Nos.31 and 33.

No. 33 (*pls.53A, C & D*)
Hunting scenes (*three fragments*)

BRUSSELS; first quarter of 16th century.
(1) H. 4ft 1in. (1·24m.) W. 5ft 5¾in. (1·67m.).
(2) H. 4ft (1·22m.) W. 5ft 6in. (1·68m.).
(3) H. 3ft 7½in. (1·10m.) W. 4ft 2½in. (1·28m.).
Wool and silk: 16–18 warp threads to the inch (7–8 to the cm.).

Condition. Silk deteriorating but colour still good, except for purples, yellows and greens.

These three fragments from the upper register of a tapestry probably come from the same set. The costume worn by the men is similar, plain garments with decorative edgings and hats bound beneath the chin to secure them. The landscape shows the conventional forms of grass and leaves seen in Brussels tapestries of the early 16th century. The loss of the main subject has prevented the identification of these fragments.

Description.
(1) At the right of the landscape with a number of trees is a group of mounted horsemen, one blowing a horn, and two hunting dogs. Two men with poles over their shoulders walk off in the distance.
(2) In a similar setting three men on foot with hunting horns and a hound are hastening towards the right. At the bottom left of this fragment is the top of an ornate fountain with a seated putto playing on a pipe. At the right is part of an oak tree with the hind-quarters of a dog disappearing behind it.
(3) Part of an oak tree and the nose of a dog at the left suggest that this may be a continuation of fragment (2). A young monarch on a white horse rides towards the right, where a stag standing in a pool turns its head to look at him.

Museum acquisition. (1) T.813–1919. (2) T.814–1919. (3) Circ.492–1919. Purchased from Harold Wallis as part of a large collection of textiles. See also Nos.31 and 32.

No. 34 (*pls.54–55A*)
Court scene

FLEMISH (probably Brussels); first quarter of 16th century.
H. 13ft 4in. (4·06m.) W. 17ft 10in. (5·43m.).
Wool and silk: 15 warp threads to inch (6 to cm.).

Condition. Good. The lower border and the right side have been rewoven including the left lower corner; also the top left corner.

The subject represented has never been satisfactorily explained. That it was a popular one is shown by surviving related pieces. Vigevano Cathedral owns a tapestry which shows the scene at the right of the Victoria and Albert Museum piece, the ruler enthroned surrounded by courtiers, with variations of detail including full armour for the ruler (Viale, pl.26). Another version of this scene, with greater differences, including a chest on the steps of the throne in place of the boy with an arrow and an elderly man introduced at the right of the throne, was in a private collection on Long Island in 1935.

At Vigevano a second tapestry *en suite* shows the same ruler in armour standing surrounded by courtiers. A youth in armour is beside him, and in front of him is a young woman with a chest at her feet (Viale, pl.27).

Nothing in these tapestries provides an identification of the subject. The armour and tents suggest a military encampment, possibly a siege. The pagan altar suggests a story from classical history or mythology.

Two tapestries once at Knole in Kent perhaps provide an answer. The borrowing of figures from totally unrelated tapestries, such as the figure of Ceres from the Doria *Months* in the 'Royal Court' (No.36), was commonplace in the early 16th century. But the extensive duplication between these two groups of tapestries is not confined to single figures, such as the elderly man in the Long Island tapestry and the youth in armour in the second Vigevano tapestry which come from the two pieces at Knole, or the groups of courtiers which appear in one of the Knole pieces and in the Victoria and Albert Museum tapestry. The latter shares with the Knole tapestries the principal male character and the youth who accompanies him.

The significance of this lies in the fact that the Knole tapestries are not from the same set, but both clearly show the story of Aeneas from his landing in Africa to his meeting with Dido. If the same features were used for Aeneas in two different

sets of cartoons, why not in three? It is difficult to see where the second Vigevano tapestry fits into the story of Aeneas; but one of the Knole tapestries contains three scenes which follow Virgil's story closely and two scenes which cannot be identified. Yet another tapestry with the figure of Aeneas, formerly in the American art market, contains some inexplicable scenes in the background while the foreground shows Mercury commanding Aeneas to leave Carthage for Italy and the funeral games with which Aeneas commemorated his father's death. The border of this tapestry contains flowers identical with some sections of border on the Museum's tapestry.

The tapestry in the Victoria and Albert Museum could show Aeneas and the Trojans giving thanks for their survival and encamped in Africa, the third scene representing the Trojans before Dido. It would be an unusual representation of these scenes, however. The tapestry is more likely to show Aeneas in Italy, praying to Mars for victory in the war with Latium. According to the medieval romance additions to Virgil's story, Lavinia, Princess of Latium, fell in love with Aeneas and sent him a message of encouragement shot over the wall of the besieged city on an arrow. The two other scenes in the tapestry could show Lavinia giving instructions for the message to be sent and Aeneas receiving the arrow.

This is a strongly woven tapestry after a good cartoon, with well-drawn details; the hachures are finely constructed, but the texture is coarse rather than fine.

Description. There are three scenes. On the right, in a landscape with tents, is a king seated on a dais under a canopy, holding a sceptre in his left hand. Courtiers are grouped on either side, and before the king are seated four ladies, two on either side of a youth who holds a long feathered dart in his right hand. In the foreground to the left, the same king kneels before the image of an armed warrior placed on a short pillar resting on an altar.

Courtiers and attendants stand and kneel around. Behind this group is a third, in which a queenly figure with a sceptre and crown is seated, surrounded by other figures.

There is a narrow border of flowering stems and grape vine on a dark blue ground.

Further Information. The tapestries at Vigevano were given to the Cathedral in 1534 by Duke Francesco II Sforza, through Gerolamo Mazza, his procurator. They are identified (probably incorrectly) by Mercedes Viale as Esther subjects (Viale Nos.21, 22; pls.26, 27).

Museum acquisition. 811–1893. Purchased at Christie's (£315).

Literature
Kendrick, A.F., *Victoria and Albert Museum Catalogue of Tapestries*, 2nd ed., London, 1924, No.23
Viale, Mercedes and Vittorio, *Arazzi e tappeti antichi*, Turin, 1952, Nos.21, 22; pls.26, 27

No. 35 (*pl.55B*)
A Court scene

FLEMISH (probably Brussels); first quarter of 16th century.
H. 9ft 3in. (2·84m.) W. 6ft 7½in. (2·01m.).
Wool and silk; 16 warp threads to inch (6–7 to cm.).

Condition. Poor, repaired.

The subject has not been identified.

A portrait is to be seen in a tapestry at the Hermitage, Leningrad; it is held before a Queen and there it obviously refers to a suitor, as Cupid has fitted an arrow to his bow. The subject is unidentified, and in any case not otherwise analogous to the Museum tapestry. Since it was acquired with the *Esther* tapestry, No.30, the tapestry has for long

been linked erroneously with the Esther and Ahasuerus story.

Description. A lady kneels before a King enthroned. Soldiers and courtiers are grouped around. One on the left is completing a portrait of the King. The letter 'A' is inscribed on the lance held by the man in the foreground (right), and again on the hat of a man at the back (left).

There is a narrow border with flowers and leafy stems on a dark blue ground.

Museum acquisition. 339–1866. Purchased (Cavaletti, Madrid: £5 5s 2d).

Literature
Biryukova, N.Y., *The Hermitage, Leningrad: Gothic and Renaissance tapestries*, Leningrad, 1965, p.73
Kendrick, A.F., *Victoria and Albert Museum Catalogue of Tapestries*, 2nd ed., London, 1924, No.21

No. 36 (*pl.56*)
A Royal Court

FLEMISH (probably Brussels); c.1530.
H. 11ft 6in. (3·51m.) W. 13ft 4in. (4·06m.).
Wool and silk; 16 warp threads to inch (6–7 to cm.).

Condition. Much rewoven in the lower left corner.

A lively but rather mannered tapestry. The subject is so far unidentified.

Description. A King and Queen are giving audience; there is an open arcade at the back and a bed in an alcove on the right. A scribe is scrutinising books or ledgers at a table; two pages hold flaming torches, and a third picks up a large volume from among others on the floor. On a carpet before the royal pair sits a little girl, with a bird perched on her left hand and with a pet dog (the Queen holds another pet). There are numerous courtiers and

ladies and there seems to be a dispute with reference to the books.

The borders are filled with fruit, flowers and leaves, the top and bottom borders with swags, the side borders entwined with ribbons and rising from vases, on a dark blue ground. In each corner is a lion's mask, on a lighter blue ground.

Further Information. A pair of tapestries sold at the Marczell von Nemes sale at Amsterdam (Nov. 1928) give some clue to the subject of our tapestry. One of them seems to represent the meeting of Isaac and Rebecca, the other shows the same scene as ours with considerable variations, including the background, where there are statues of Justice and Pity, and two windows with glass roundels representing Moses and Samson. An Old Testament subject therefore seems to be indicated. The 'Royal Court' could just possibly be that of Solomon, with Bathsheba seated in the place of honour on the King's right hand.

A seated figure with plaited hair in the Von Nemes 'Court' piece is copied from a figure in *Remus taken captive* from the *Foundation of Rome* set in the Spanish State Collection. This figure does not appear in the Victoria and Albert Museum version of the scene: instead a standing figure with plaits has been borrowed from another tapestry, the figure of Ceres from *January*, one of the *Months* in the Palazzo Doria, Rome. The design of the border also owes something to the Doria *Months*.

The two tapestries once belonging to Marczell von Nemes are extremely close in style to the *Foundation of Rome* set and probably date from c.1525. The Victoria and Albert Museum *Royal Court*, with its weaker drawing and many borrowings from the Von Nemes piece, should be dated later, about the time of a tapestry of similar style dated 1530 in the Burrell Collection, Glasgow, which shows Bathsheba leading the newly crowned Solomon to mount King David's mule. This tapestry also has an echo from the *Foundation of Rome* – a striking building seen in the distance.

Museum acquisition. 88–1896. Purchased (Lowengard, Paris, £595).

Literature
Kendrick, A.F., *Victoria and Albert Museum Catalogue of Tapestries*, 2nd ed., London, 1924, No.24
Nemes, Marczell von, *Collection Marczell von Nemes*, Sale, F. Muller & Co., Amsterdam, 13, 14 November, 1928, Lots 70, 71

No. 37 (*pl.57*)
Tobias taking leave of his father-in-law (or possibly *The Departure of the Prodigal Son*)

FLEMISH; mid 16th century.
10ft 11in. (3·33m.) × 11ft 1in. (3·38m.).
Wool and silk on woollen warp; 13 warp threads to the inch (5 to the cm.).

Condition. Contains a number of old repairs, including a vertical rewoven strip, and patching with parts of a different border. The top border seems to be the bottom of some other tapestry and the right two-thirds of the bottom border is also alien.

It is difficult to determine the subject of this tapestry. It could represent the departure of Tobias from his father-in-law. The figures are not directly related to any other known Tobias sets, neither the slightly earlier designs of the Vienna and Spanish State Collection sets, nor the contemporary Tobias tapestries at Tarragona, Gaasbeeck, nor the set which was at Bisham Abbey. The Bisham Abbey pieces and some others portray the angel without wings, but he is usually shown in flowing robes.

Another possible subject is the departure of the Prodigal Son, though the presence of women among his servants would be unusual.

Description. In the centre a young man in armour shakes the hand of an elderly, bearded man wearing a turban and a long cloak. With them are another

young man, bareheaded, and a helmeted soldier, each holding a spear. To the left in the middle distance are a number of men and women departing with horses and camels. To the right in the middle distance is a group of two young men and a young woman, and further back a young man and two women stand on the steps of a large building.

The side borders have clusters of fruit and flowers upon a pole, with boys at the lower corners holding a similar swag of flowers along the bottom border. The boy at the right and most of the bottom border is missing, as is the top border.

Additional Information. The same side border, excluding the corners, is found on two other tapestries. One, a *Judgement of Solomon* at Hardwick Hall, Derbyshire, has on its upper galloon the mark of an unknown weaver. The other, in the Museo degli Arazzi, Fabriano, is an unidentified scene with a betrothal or marriage in the foreground and in the background an indoor scene with a couple in bed. The style of this tapestry is very close to our piece and is likely to be by the same artist.

Museum Acquisition. T.61–1909. Purchased from a dealer for £95.

No. 38 (*pls.58A & B*)
Verdure, with arms of Giovio of Como

Probably BRUGES; second quarter of 16th century.
H. 7ft 3in. (2·21m.) L. 22ft 5in. (6·83m.).
Wool and silk: 13–14 warp threads to inch (5–6 to cm.).

Condition. Excellent.

This long tapestry, only seven and a quarter feet high, was presumably intended to hang above wainscoting ('Sopra Spalliera'). The pair to it belongs to Prince Liechtenstein at Schloss Vaduz.

With three medallions, surrounded with garlands and bearing the arms and motto of Giovio of Como, on a mille-fleurs ground, enlivened with a variety of birds and animals, it is the finest example of its kind known, as Heinrich Göbel noted in his *Wandteppiche*, I, i, p.286. It is in excellent condition.

As here marshalled, the arms of Giovio, of Como, were first borne in the generation of the family represented by the famous historian, dilettante and collector, Paolo (b.1483, d.1552), and his brother Benedetto (d.1545). Paolo Giovio received from Pope Leo X a Knighthood and the Professorship of Rhetoric at the Roman University. The same Pope granted him, as augmentation to his arms, the Medici insignia as borne in quarters 1–4. In 1528 another Medici Pope, Clement VII, elected Paolo Giovio to the see of Nocera dei Pagani (Naples). The motto FATO PRUDENTIA MINOR ('Wisdom is weaker than fate') may be adapted from Virgil's *Georgics*, I, 415–16. Paolo Giovio had a famous Museum of antiquities at Como; in his *Dialogo dell'imprese militari et amorose* the above motto is said to be seen in his houses, his museum, and in 'every ornamental contrivance' of his home.

Armorial tapestries were designed in various ways in the 16th century. This type, with arms set on a mille-fleurs ground, has as its most splendid example the *Armorial* of Philip the Good, woven in Brussels by Jean le Haze to the Duke's order in 1466 (Historical Museum, Bern). Similar to our piece is the cut portion of tapestry, without borders, at the Fogg Art Museum, with a Cardinal's arms (see Asselberghs, Tournai Exhibition, 1970). Others of inferior quality to Giovio's, but about the same date, are in Angers Cathedral Museum; and another with the arms of Pozzo di Borgo (Corsica), in the USA. The frieze-shaped strips at Hampton Court with the arms of Cardinal Wolsey and Henry VIII are more Italianate in design, with Renaissance motifs and scroll-forms replacing the naturalistic floral and plant forms. About mid-way between the two is the frieze-panel with the arms of the Chaise-Dieu and putti with swag borders in

the Arts Décoratifs, Paris. By about 1540 another Imperial Armorial, that of Charles V, uses an elaborate leaf-foliage design on a much bolder scale, in keeping with the contemporary taste for large-leaf verdures (Vienna, Kunsthistorisches Museum, and Amsterdam, Rijksmuseum). Obviously a rustic effect was intended for the lively and charming tapestry with the arms of Giovio, in keeping with the landscape scenes, possibly depicting the country round Lake Como, within the medallions.

The borders of the Giovio tapestry are Italianate, with acanthus scrolls and grotesques with putti and masks and arms in the uprights, but less Italian than Bernard van Orley's design for the borders of the *Genealogy of the House of Nassau* (1520s) and as seen in the *Notre Dame de Sablon* tapestries (1518).

Borders of the type on the Giovio tapestry are found on other armorials with mille-fleurs. J.P. Asselberghs pointed out their connection with a fragment in the Gruuthuse Museum, Bruges, believed to have been made in that town. In a recent article J. Duverger and J. Versyp substantiated this belief, listing the tapestries with related borders:

(a) The Bruges mille-fleurs fragment attributed to Antoon Segon, c.1528–30
(b) The Victoria and Albert Museum and Liechtenstein pieces with the arms of Giovio
(c) Armorial of Cardinal Matthias Lang in Salzburg and in the Fogg Art Museum
(d) Tapestries with the arms of Italian families, scenes from the New Testament and saints on a mille-fleurs ground, at Murano

Of these, the Bruges Gruuthuse fragment is superior in the naturalism of its mille-fleurs. The others display grounds close in style to the Giovio tapestry: possibly they were an export quality.

Description. The tapestry is covered with small flowering plants of many kinds on a dark blue ground. Amidst these may be seen animals and birds including a lion, a stag, rabbits and pheas-

48

ants. Three circular medallions are disposed across the middle of the tapestry; each consists of a wreath of fruit, flowers, and foliage enclosing a landscape. From the top of the wreath a shield of arms is suspended in front of the landscape, and a scroll entwining the wreath bears the motto FATO PRVDENTIA MINOR. The shield and motto are those of the Giovio family of Como. The arms in the shield are as follows: quarterly: 1, 4, or three balls; 1 and 2, gules (Medici); 2, 3, a representation of an island azure, standing in water proper, thereupon a double-towered castle argent (Giovio); over all an escutcheon argent (for or) charged with an eagle displayed sable. There is a border gobony gules and argent to the outer edges (only) of quarters 2–3.

In the border are trophies of arms and armour, cornucopias, boys riding on grotesque dolphins, flowers and leaves, on a red ground; in each of the upper corners is a lion's mask, on a blue ground.

A full description of the Giovio arms and commentary by A. Van de Put, are set out in Appendix A of the 1924 V & A Museum Catalogue, pp.80–2.

Further Information. Similar pieces may be listed as follows:

(a) A pair to our tapestry belonging to Prince Liechtenstein at Castle Vaduz
(b) Portions of a tapestry with a Cardinal's arms (without borders) at the Fogg Art Museum, Harvard University
(c) A complete hanging with six roundels in two rows, but with Brussels type borders with lilies (Illustrated by Göbel, *I*, ii, pl.253)
(d) Angers Cathedral Museum: arms set on a mille-fleurs ground, but the flowers rather schematic and geometrically treated; a landscape frieze above. An upright hanging
(e) the arms of Pozzo di Borgo, Corsica, with bishop's mitre and crozier above, and somewhat coarsened floral ground, as at Angers; the arms are in an escutcheon, not a roundel.

A fragment only (from the Kermaingant Sale, now in USA)
(f) Bruges, Gruuthuse Museum, from the Salle échevinale de France; a fragmentary piece
(g) Arts Décoratifs, Paris; frieze-shaped hanging with Arms of the Chaise-Dieu supported by putti; mille-fleurs ground but some of the plants are increased in size; a border with swags and relatively large putti

Museum acquisition. 256–1895. Bought (£358 15s 8d). Formerly on loan (1890–91) from the Countess Lambertenghi, Rome. The tapestry is stated to have come from the Palazzo Giovio, Como.

Literature

Asselberghs, J.P., *Tapisseries héraldiques et de la vie quotidienne*, Catalogue of the exhibition, Tournai, 1970, Introduction and No.8
Connaissance des Arts, 'La Demeure féodale du Prince de Liechtenstein' in *Connaissance des Arts*, Paris, April 1957, p.40 illustration
Duverger, J., and Versyp, J., 'Brugs tapijtwerk in her Paleis van het Brugse Vrije en het belang ervan voor de kennis van de Brugse Tapijtkunst' in *Album Albert Schouteet*, 1973, pp.75–84
Hulst, R.A.d', *Tapisseries flamandes du XIVe au XVIIIe siècle*, Brussels, 1960, Nos.10, 22
Göbel, H., *Wandteppiche I. Die Niederlande*, Leipzig, 1923, pt.i, pp.286–7; pt.ii, pls.251–3
Kendrick, A.F., *Victoria and Albert Museum Catalogue of Tapestries*, London, 1924, No.25, pl.xviii; Appendix A
Marillier, H.C., *The Tapestries at Hampton Court Palace*, London, HMSO, 1962, p.12, pls.18, 19

No. 39 (*pl.59B*)
Mille-Fleurs tapestry cushion cover

FLEMISH; first half of the 16th century.
H. 22in. (0·56m.) W. 21¾in. (0·55m.).
Wool on a warp of bast fibre; 12 warp threads to the inch (5 to the cm.).

Condition. Much of the black ground is in poor condition, particularly at the edges. Colours have faded.

Enough remains of three edges of this piece of tapestry to show that it was woven as a cushion cover, the flowers coming to a definite end on a plain surround. It is rare for a cover of this age and type to have survived hard usage and the changes of fashion.

Description. On a black ground are stiff, stylised flowering plants stopping short at the edges at sides and top, the bottom edge being cut. The clumps of flowers are roughly rectangular, with a break between upward and downward turning leaves. Highlights are shown by circles of lighter colour and small double dashes. The design is not impoverished, however. Of the fifteen plants shown only one is repeated, and the weaving is in thirteen colours.

Further Information. This quality of verdure comes somewhere between the mille-fleurs of the *Arms of Giovio* (No.38) and the barely intelligible *verdure* of No.40. The cushion cover is close in style to the tapestry at Angers with arms hanging before a landscape in a wreath on a mille-fleurs ground with animals and birds, a crude version of the design with the arms of Giovio, which has in addition a landscape frieze at the top. Göbel (*I*, i., pp.286–7; ii, pl.251) ascribes this tapestry to Oudenarde in the second quarter of the 16th century. The same type of mille-fleurs can be seen, however, in paintings of Joos van Cleve thought to date from c.1515–20.

Museum acquisition. 1342–1864. Purchased from the Bock Collection with numbers of other textiles. This was one of the earliest purchases of tapestry made by the Museum.

Literature
Göbel, H., *Wandteppiche I. Die Niederlande*, Leipzig, 1923, pt.i, pp.286–7; pt.ii, pl.251.

No. 40 (*pl.59A*)
Mille-Fleurs verdure (*fragment*)

FLEMISH; 16th century.
H. 7ft 2in. (2·18m.) W. 5ft 4½in. (1·64m.).
Wool on linen warp. 8 warp threads to inch (3 to cm.).

Condition. Poor, patched.

This tapestry shows the same arrangement of animals and birds on a mille-fleurs ground, with birds towards the top and animals towards the bottom as in the piece at Angers illustrated in Göbel, *I*, pt.ii, pl.251. Like the Angers piece it may have finished at the top with a frieze of small hills and castles. The flowering plants here have reached the extreme of stylisation and the weave is coarse. This was probably one of the cheapest types of tapestry woven.

Description. Squared-off clumps of flowers cover the ground, which is enlivened by five small animals and five birds.

Museum acquisition. 35–1903. Purchased for £39 15s 8d. This is more than was paid fifty years earlier for either of the *Esther* tapestries (Nos. 29, 30), or for the Pastoral *La Main Chaude* (No. 19).

Literature
Göbel, H., *Wandteppiche I. Die Niederlande*, Leipzig, 1923, pt.ii, pl. 251

No. 41 (*pl.59C*)
Lectern cover

FLEMISH; first half of 16th century.
H. 30in. (0·76m.) W. 37in. (0·92m.).
Wool. 16 warp threads to inch (6–7 to cm.).

Condition. Faded; the bottom part is missing. Torn at the four corners.

Designed as an open missal with musical notation and the prayer: 'Ave Maria gratia plena dominus'. On an off-white and buff ground, with black lettering, the edge of the binding shows in green, with a maroon strip on the left side. The border design is in blue.

This appears to be a unique piece. A few rare vestments in tapestry are known. There is a cope and two dalmatics associated with Pope Clement VII (c.1595) shown in the Sala dei Paramenti at the Vatican. H. Göbel published a chasuble and dalmatic, woven about 1570 with the arms of Wys (of Utrecht) and Culenborg (of Gelders), which he ascribed to a Dutch weaving centre, probably Gouda (*Pantheon*, 1937). Göbel compares this pair of vestments with the chasuble in Uppsala Cathedral, published by Branting and Lindblom, which also has a ground imitating a velvet pattern; the Flemish inscription and the arms of Hertogenbosch in North Brabant point to a Flemish workshop and a date in the first half of the 16th century. Of these, the Uppsala chasuble alone makes use (sparingly) of silk.

Museum acquisition. T.1–1948. Bought from Acton Surgey Ltd (£175).

Literature
Branting, A. and Lindblom, A., *Medieval Embroideries and Textiles in Sweden*, Uppsala and Stockholm, 1932, vol.I, p.150; vol.II, pl.220
Göbel, H., 'Gewirkte Messgewänder aus Holland' in *Pantheon*, vol.XIX, Munich, April 1937, pp.122–5; figs.1a & b, 2a & b
Rome, *Museo Sacro III Itinerario*, Biblioteca Apostolica Vaticana, Città del Vaticano, 1938, pp.32–3; fig.20

Nos. 42–44 (*pls.60–64*)
The Story of Cupid and Psyche

(a) *Venus seeks vengeance on Psyche*

(b) *Venus admonishing Cupid*
(c) *Psyche in Venus' service; her punishment*

FLEMISH (probably Brussels); mid 16th century.
Wool and silk: 18–20 warp threads to inch (7–8 to cm.).

The story of Cupid's love for Psyche and her misfortunes is told by Apuleius as an allegory of the human spirit, in the story of *The Golden Ass*, which is part of his *Metamorphoses* (books 4–6). Psyche, the beautiful daughter of a King, aroused Venus' jealousy, but Cupid, betraying his mother, fell in love with Psyche; unfortunately the jealousy of Psyche's two sisters caused her to break Cupid's spell; after many misfortunes Psyche became a servant of Venus, who used her cruelly; eventually she achieved divinity and unity with her beloved Cupid. The Psyche story was a favourite pictorial theme at the Renaissance and was represented in tapestry (also with increasing popularity in the 17th and 18th centuries).

Three drawings connected with these tapestries have been published by Timothy Clifford (*Burlington Magazine*, April 1975, pp.234–8). He attributes the drawings to Giovanni Battista Castello (1509–69), known as 'Bergamesco', who went to Genoa in 1531 and worked extensively for Tobia Pallavicino, who was building his great palace between 1558–60. As head of the Pallavicino family, with its monopoly of tolfa alum (a mineral used for fixing textile dyes), he was one of the foremost of Genoa's wealthy citizens and patrons of art. The Pallavicino palace, with Bergamesco's contributions to its decorations, has been described by Raffaello Soprani (*Le Vite de' Pittori, Scultori e Architetti Genovesi*, 1647; see also Soprani-Ratti, 1768–9). Bergamesco was also employed by Tobia Pallavicino at his Villa Pallavicino Delle Peschiere, c.1560–2, where he was said to have acted as architect, painter and controller of its works. In the Pallavicino palace is a ceiling fresco of the Psyche story traditionally attributed to Bergamesco, which corresponds with

the design of a tapestry closely associated with the V & A pieces, *Psyche watching the Sleeping Cupid*, formerly in the Corcoran Gallery (see below). The drawings related to the Victoria and Albert Museum tapestries are *Venus seeking vengeance on Psyche*, which was at Messrs P. & D. Colanghi's in 1960, and *Venus admonishing Cupid* at The Scottish National Gallery. A third drawing, also attributed by Timothy Clifford to Bergamesco, is at Christ Church, Oxford, and relates to a tapestry in the Vaisse Sale (Paris 1885: see below); it represents *Psyche bringing the Phial to Venus and Psyche assisted by Jove's Eagle*.

The attribution of the design of these *Psyche* tapestries to Giovanni Battista Castello, 'il Bergamesco', and an original location in the Pallavicino Palace, brings into question four *Psyche* hangings with four overmantels in the Vaisse Sale in Paris (8 May 1885); they were said to have come from the Palazzo Ferretto, Genoa. The borders are identical with our tapestries and Clifford suggests they were part of the Pallavicino set and were passed to the smaller and less distinguished Ferretto Palace in the 19th century. Five *Psyche* tapestries with the same borders belonged to the Corcoran Gallery, Washington D.C. They show: (1) *The Toilet of Psyche*, (2) *Her Banquet*, (3) *Psyche and the Sleeping Cupid*, (4) *Psyche and her two sisters*, (5) *Psyche in Hades*. Three pieces of the Corcoran tapestries were bought in 1970 by the Monuments Historiques and are to be shown at the Château D'Oiron (Bourbonnais), France.

No. 42 (*pls.62–63*)
Venus seeks Vengeance on Psyche. T.772–1950

H. 11ft 10½in. (3·62m.) W. 10ft 5½in. (3·18m.).

Condition. Somewhat worn and restored. The right and left borders are 19th century.

Description. Venus solicits the aid of Juno and Ceres in her schemes against Psyche; her turtle doves and Juno's peacock are visible, and the scene takes place just beyond a marble balustrade and portico in an Italian landscape. In the sky Venus is shown in her car imploring the help of Jupiter, who dispatches Mercury with a proclamation. The drapery of the gods and goddesses is light in tone against the blue-greens of the landscape.

The grotesque borders are lightly touched in red and blue (mostly pale) on a cream silk ground, with red ribbon-bands.

No. 43 (*pls.60–61*)
Venus admonishing Cupid. T.770–1950

H. 12ft (3·66m.) W. 10ft 5in. (3·175m.).

Condition. Somewhat worn.

Description. Venus upbraids Cupid for his love of Psyche. Cupid lies on a red couch and the drapery of the bed is a full blue, as are the pilasters on either side. The floor is marbled and Venus' doves appear again.

No. 44 (*pl.64*)
Psyche in Venus' service; her punishment. T.771–1950

H. 11ft 11in. (3·63m.) W. 8ft 4in. (2·54m.).

Condition. Much of the silk highlights are re-woven.

Description. Psyche before Venus' temple implores the help of Juno. In the background she is dragged before Venus by three females representing Habit, Drudgery and Sorrow, who beat her. Juno's overmantle is red, worked with gold, and the banners of the temple are red. Psyche's gown is palely shot with red and her skirt is shot with pale blue.

Museum acquisition. T.772, T.770, T.771–1950. Given by Dowager Viscountess Harcourt, G.B.E. Except for minor instances, the repair work was done before the tapestries came to the Museum, probably before 1914.

Literature
Apuleius, *The Golden Ass, Metamorphoses*, Book IV
Clifford, T., 'G.B. Castello's designs for the Cupid and Psyche tapestries' in *Burlington Magazine*, April 1975, pp.234–238
Fenaille, M., 'Histoire de Psyché' in *État général des tapisseries de la manufacture des Gobelins depuis son origine jusqu'à nos jours 1600–1900*, vol.1, Paris, 1923, pp.287–92
Marillier, H.C., *Subject Catalogue of Tapestries*, Victoria and Albert Museum, Department of Textiles, Ms., n.d.
Schneebalg-Perelman, S., 'Richesses du Garde-Meuble Parisien de François Ier. Inventaires inédits de 1542 et 1551' in *Gazette des beaux-arts*, vol.LXXVIII, November 1971, pp.253–304
Soprani, Raffaello, *Le Vite de' Pittori, Scultori e Architetti Genovesi*, Genoa, 1647
Soprani, Raffaello, and Ratti, Carlo, *Delle Vite de' Pittori, Scultori e Architetti Genovesi*, Genoa, 1768–9
Vaisse, *Catalogue des Objets . . . Collection de M.E. Vaisse*, Catalogue of the sale, Hôtel Drouot, Paris, 5–8 May, 1885, lots 371–8

No. 45 (*pl.65*)
Grotesque with Ceres

BRUSSELS; mid 16th century.
H. 11ft 5in. (3·48m.) W. 9ft 8in. (2·95m.).
Wool and silk: 16 warp threads to inch (6–7 to cm.).

Condition. Worn and faded.

This tapestry is in the Italian style of grotesque which derives from the school of Raphael. The

name *grotesque* and the impetus for this style of decoration is due to the discovery in about 1493 of Nero's Domus Aurea as subterranean rooms beneath the Baths of Titus: hence *grotte, alla grottesca*, and the French *grotesques*. Raphael had furnished the borders of the *Acts of the Apostles* with grotesque designs. The tapestry hangings by Italian designers of the first half of the 16th century in this mode are much less crowded and overwrought than became fashionable in the Netherlands with Cornelius Floris, Cornelius Bos, Vredeman de Vries and others from the middle of the century (see Nos.46 and 47).

The *Ceres Grotesque* is related to seven other grotesque tapestries with somewhat similar borders, as Louisa Erkelens has shown in relation to the Amsterdam *Hercules* (*Rijksmuseum Bulletin*, 1962, no.4). These eight tapestries (of which seven are preserved) derive from, or at least reflect, a set of four made for the Doria Palazzo Bianco in Genoa; *Minerva* in the Metropolitan Museum, New York (and possibly *Neptune*), are the only known survivors; *Minerva* bears the Doria arms, and also a Brussels mark. *Neptune* was published by Müntz, Guiffrey and Pinchart, 1878–84, fig.98, and was lot 782 (illustrated) in the Emile Gavet sale in Paris, the sale in which our *Ceres* was also sold in 1897; it carried the Doria arms in the four corners of the borders. In all these tapestries the disposition of the subject and motifs vary with each piece but are fairly consistent in style, and the borders are similar except for a hexagonal compartment with the head of a wind-god, which is prominent in the Amsterdam *Hercules* and two others (Erkelens, figs. 4 and 6). This feature is also to be seen on two *grotesque* tapestries at Windsor Castle, the one with *Hercules*, the other with *Bacchus*, but the main field is arranged in three tiers. Erkelens is probably right in seeing in these two tapestries an echo of the lost *Grotesques* (disappeared in 1767), ordered by Pope Leo X from Pieter van Aelst of Brussels in about 1520; Vasari attributed their designs to Giovanni da Udine. The eight subjects recorded in the Vati-

can inventory of 1544 were: (1) Venus, (2) Hercules, (3) Fortune, (4) Seven Muses, (5) Seven Virtues, (6) Mars, (7) Bacchus, (8) Liberal Arts. Venus, Hercules, Mars and Bacchus recur in the various tapestries mentioned above. But it seems wrong to see the Museum tapestry as *Fortune*, since Ceres is clearly depicted with cornucopia, whilst baskets and vases are laden with fruit, and cereals sprout all over the tapestry. The suggested affiliation of our piece and the Doria and Windsor series is indicative; but the proliferation of grotesque designs for tapestry already in the first half of the 16th century should be borne in mind: many related sets must have been woven. And there were others, such as the lovely Bacchiacca *grotesques* produced in Florence c.1550, and the Fontainebleau *grotesques* (deriving from Androuet du Cerceau's engravings).

Description. A light architectural structure enshrines a figure of Ceres holding two cornucopiae and is supported by a figure of Pan, crouching, with hooved feet placed on two tortoises. On each side is an elaborate candelabrum decked with fruit and ears of corn. The whole subject may perhaps symbolise the season of Autumn. The background is dark blue. The side borders have standing cupids with fanciful tiers of candelabra, scrolls and figures; the top and bottom borders are filled with open scrolls, with a central cartouche supported by winged lions. There are blank shields at the four corners and the central cartouches are also blank. The borders have a faded brown ground.

Further information. The *Hercules Grotesque* in the Rijksmuseum is fairly close to our tapestry and is also on a blue ground; the borders have certain features in common, but *Hercules* has the wind-god face in the centre of each side, as does the Genoa *Mars* (without the Doria arms) and *Diana of Ephesus* in Stockholm, also the Windsor pair. Louisa Erkelens suggests the names of Pierino del

Vaga and Amico Aspertini as authors of the designs (op. cit). Another three *Grotesques*, still strongly Italianate in style, are those in the Philadelphia Museum of Art and in Miami, and the one illustrated by Göbel (*II, ii*, pl.357) and attributed by him to the Ferrara looms; each has one of the labours of Hercules in a large central medallion within a floral frame.

Museum acquistion. 650–1897. Bought from the Emile Gavet Sale, Paris 1897 (£144 8s 10d).

Literature

Amsterdam, *Rijksmuseum Bulletin*, 1962, see Erkelens, A.M. Louise

Amsterdam, *Wandtapijten II. Renaissance, Manerisme en Barok*, Rijksmuseum, 1971, fig.5

Erkelens, A.M. Louise, 'Rafaëleske grotesken op enige Brusselse wandtapijt series' in *Rijksmuseum Bulletin*, no.4, Amsterdam, 1962, p.119, p.136 note 6; figs.4 & 6

Göbel, H., *Wandteppiche II. Die Romanischen Länder*, Leipzig, 1928, pt.i, pp.372–3; pt.ii, pl.357

Guiffrey, J.J., *Histoire de la tapisserie en France. Histoire générale de la tapisserie*, Paris, 1878–85

Kendrick, A.F., *Victoria and Albert Museum Catalogue of Tapestries*, 2nd ed., London, 1924, No.29, pl.XIX

Müntz, E., *Histoire de la tapisserie en Italie. Histoire générale de la tapisserie*, Paris, 1878–85

Paris, *Emile Gavet Sale*, Galerie Georges Petit, June 1897, Cat. No.784, illustration of No.782

Pinchart, A., *Histoire de la tapisserie dans les Flandres. Histoire générale de la tapisserie*, Paris, 1878–85

Schele, Sune, 'Cornelius Bos' in *Stockholm Studies in History of Art*, no.x, Stockholm, 1965

Woldbye, V., 'Tapestries for the workshops of Michael Wauters in Antwerp at Rosenborg Castle in Copenhagen' in *Artes Textiles*, vol.vi, 1965

No. 46 (*pl.66*)
Grotesque with Arms of Herbert

FLEMISH; 1548–51.
H. 12ft 10in. (3·91m.) W. 7ft 8in. (2·32m.)
Wool and silk: 15 warp threads to inch. (6 to cm.).

Condition. The bottom strip (about 9in. deep) is re-woven, also a strip at the right edge (15–17in. wide), joining up with a short section at the right top (about 21in. deep) which includes the right bascule. Cut on the left side and at top. This fragmentary piece is worn and rather faded with a good deal of repair.

Sir William Herbert, first Earl of Pembroke (created 1551), was brother-in-law to Henry VIII when the latter married Katherine Parr in 1543, Sir William having married Anne, daughter of Sir Thomas Parr in, or before, 1534. This stylish tapestry, although now only a large fragment, would have been a special order and its date is significant for the first period of Flemish grotesque design, which was then being developed by Cornelius Floris, Cornelius Bos, Vredeman de Vries and others. A. Van de Put has argued that the insignia exemplifies Sir William Herbert after he had received the Order of the Garter in 1548 and before his elevation to the Peerage in 1551, there being no coronet; and that it is Sir William (d.1570) rather than his successor, Henry (elected K.G. in 1574, d.1601). Moreover, under each large medallion is a cartouche with the initial 'W' (on left) and 'H' (on right). Above the shield is the motto: 'UNG IE SERVIREY'. Two badges of the Herbert family appear in the tapestry, the green wyvern with a hand in its jaws (centre bottom), and a bascule with a crescent (top, that on right re-woven).

It was customary for the English aristocracy to buy tapestries in Flanders and also sometimes to order them there with their coats of arms, or specifically as armorial hangings. (The native

Sheldon workshops at Barcheston and Bordesley were a small private establishment of provincial standing only.) Apart from tapestries with the Royal arms of Henry VII or VIII at Winchester College and Haddon Hall (Duke of Rutland), notable examples are as follows: the splendid armorial of Lord (John) Dynham (d.1501) at the Cloisters, New York; the tapestry table-carpet with the arms of Sir Andrew Luttrell of Dunster, c.1520–30, in the Burrell Collection, Glasgow; another table-carpet with the Lewknor arms, from Chawton House, near Alton, (with which Jane Austen must have been familiar) dated 1564 (Metropolitan Museum, New York); the rich armorials of Robert Dudley, Earl of Leicester, from Drayton House and now in the Burrell Collection. The list could be extended through the 17th century.

Description. In the middle is a shield of arms encircled by the Garter-band and ensigned by a closed helmet in profile, above which is the motto: 'UNG IE SERVIREY.' The green wyvern with a hand in its jaws (repeated twice, at bottom), and the bascule with a crescent (twice, at top) are badges of Sir William Herbert. The subject in the large medallion to the right of the shield, with a gentleman and lady seated on a couch, may represent *Lust;* that to the left, a seated female holding a spear with a turkey-cock beside her, may represent *Pride.* Beneath the medallions is a cartouche with the initial 'W' on the left and 'H' on the right. The medallions are overhung with arches of flowers and fruit, and flanked on the outer sides by vases filled with tall leafy stems, under arched trellises and resting on the heads of female terminal figures. Beyond these, at each end, is a seated woman with cross and book (*Faith?*) under a square canopy which supports a vase of flowers. In each of the lower corners is a marine deity, half-human and half-quadruped, blowing a horn and holding a fish. The grotesque is made up with fruit, swags, figures and other devices.

Note on the Arms by A. Van de Put (from the 1924 *Catalogue*). Arms, encircled by the Garter-band and ensigned by a closed helmet in profile, above which is the motto: UNG IE SERVIREY:—
Quarterly of 7:
1. Per pale azure and gules three lions rampant, 2 and 1, argent, a bordure gobony or and gules, on each pane of the last a bezant (Herbert)
2. Sable a chevron between three spearheads argent (Blethyn ap Maynarch)
3. Argent three cocks, 2 and 1, combed and wattled or (Einion Sais)
4. Argent a lion rampant sable crowned or (. . . .)[1]
5. Azure semy of cross-crosslets and three boars' heads, 2 and 1, argent (Craddock)
6. Bendy engrailed argent and gules a canton or (Horton)
7. Gules three leopards' heads, 2 and 1, jessant de lys or (Cantelupe)
Supporters: (dexter) a panther guardant argent, spotted or and azure, gorged or; (sinister) a lion rampant argent gorged gules.
Badges: (At top of the tapestry) a bascule charged with a crescent azure; (below) a dragon vert holding in its jaw a hand couped gules.

The insignia exemplify Sir William Herbert, first Earl of Pembroke of the 1551 creation, after he had received the Order of the Garter in 1548 (1 December), possibly even before his peerage creations, by the style of Lord Herbert of Cardiff, 10 October 1551, and, on the day following, Earl of Pembroke. He died in 1570.

As identifying the arms more particularly with this Earl of Pembroke (rather than with his successor Henry, elected K.G. in 1574, and d.1601), especially within the period 1548 (December) to

[1]. The identity of this quartering, possibly for Gam, to which family the great-grandmother of Sir William Herbert belonged, is altogether uncertain; for this, and the identification of the quarterings generally, see Octavius Morgan, *Some account of the Ancient Monuments in the Priory Church of Abergavenny*, 1872, pp.46–7

1551, there may be noted the absence of a coronet, which ensign of dignity figured above the seven-quartered shield upon the Earl's tomb in Old St Paul's;[1] and further, the conflicting evidence with regard to the use of a bordure gobony with the Herbert Arms by the second earl, Henry.[2] Finally, upon a cartouche beneath the figure composition to the dexter of the arms, is the initial 'W' and in the corresponding feature on the opposite side is the initial 'H'.

Further information. If Van de Put's assessment of the arms is correct, the date 1548–51 puts this tapestry at the beginning of the great vogue for grotesques in the Netherlands, which was taken up in every form of decoration from printed books to plaster work and sculpture. In tapestry, after the Italianate grotesques (see No.45, *Ceres Grotesque*), Brussels produced many series. A set of twelve *Grotesque Months* on a red ground was sold to the Duc de Lorraine in 1574/5 and is now in Vienna, whilst another was listed in the French Crown inventory in 1661.

This style of grotesque is very imposing, but is crammed to over-flowing, and rather heavy with its landscape medallions and overweighted borders. Another variety, with monkeys and birds, belongs to the Spanish Patrimony. The famous *Baldachin* with *Pluto and Proserpine* at Vienna has Vredeman de Vries' signature (presumed to refer to the architectural structure only) and the date 1566; it also bears the Brussels mark. Pope Gregory XIII ordered a set of *Grotesques with Gods* at Brussels in about 1575, now in the Mobilier National. Later, in the 17th century, this grandiose manner was transformed by Bérain and Claude Audran II into an altogether lighter vein, but the earlier Italianate style was reproduced by the Wauters

[1]. Dugdale, *History of St. Paul's Cathedral*, 1658, p.88.
[2]. G.E.C., *Complete Peerage*, vol.vi, 1895, p.218, note d., resumes this question.

of Antwerp, as V. Woldbye has shown in a study of the *Grotesque* tapestries at Rosenborg Castle, Copenhagen (*Artes Textiles*, vol.vi, 1965). This can sometimes lead to confusion; the Wauters had a big export trade to England and many other countries.

Museum acquisition. T.213–1911. Bought (£500). As an assessor, Walter Crane wrote: 'A very desirable acquisition for the Museum … the treatment in detail is characteristically English.' The tapestry was bought as English, Sheldon.

Literature

Barnard, E.A.B., and Wace, A.J.B., *The Sheldon Tapestry Weavers and Their Work*, Society of Antiquaries, Oxford, 1928. Also published in *Archaeologia*, 1928, vol.LXXVIII, pp.255–314
Glasgow, *Gothic Tapestries*, The Burrell Collection, Art Gallery and Museum, 1960
Göbel, H., *Wandteppiche I. Die Niederlande*, Leipzig, 1923, pt.ii, pl.157
Hulst, R.A.d; *Tapisseries flamandes du XIVe au XVIIIe siècle*, Brussels, 1960, Nos.27, 29
Kendrick, A.F., *Victoria and Albert Museum Catalogue of Tapestries*, London, 1924, No.1 and Appendix A
Kendrick, A.F., 'Some Barcheston Tapestries' in *Walpole Society*, vol.xiv, 1925–6, p.39, pl.XXXII
Marillier, H.C., *Subject Catalogue of Tapestries*, Victoria and Albert Museum, Department of Textiles, Ms., n.d.
Schele, Sune, 'Cornelius Bos' in *Stockholm Studies in History of Art*, Stockholm, 1965, no.x
Thomson, W.G., *A History of Tapestry*, London, 1973, p.267
Van de Put, A., Appendix A in *Victoria and Albert Museum Catalogue of Tapestries*, London, 1924
Woldbye, V., 'Tapestries for the workshops of Michael Wauters in Antwerp at Rosenborg Castle' in *Artes Textiles*, vol.vi, 1965
Ysselsteyn, G.T. van, *Geschiedenis der Tapijtweverijen in de Noordelijke Nederlanden*, Leiden, 1936

No. 47 (*pl.67*)
Grotesque with Pride and Avarice

OUDENARDE; late 16th century. Mark: a pink heart (unidentified).
H. 9ft 7in. (2·921m.) W. 17ft 6in. (5·338m.).
Wool and silk: 12 warp threads to inch (5 to cm.).

Condition. Good but somewhat faded.

This *Grotesque* is similar to a small group of tapestries in English houses. The medallions containing Pride and Avarice, with their tentlike over-mantling, recall the *Grotesque with Arms of Herbert* (No.46), as do some of the figures in the grotesque, but the foliage has become more massive and the treatment is clumsier than in the earlier piece. The same borders with trophies of arms appear in a tapestry at Compton Wynyates, which shows the vice of *Envy* under the same type of canopied medallion and could be from the same set as *Pride and Avarice*. The tapestries have a weaver's mark in common, a pink heart, which has never been identified. H. Göbel considered that the present tapestry came from the Dutch-German frontier district, but pointed out that these borders are found in an Oudenarde piece with figure subjects (belonging to the Berlin dealer, Margraf, in 1931) and suggested the possibility of an Oudenarde weaver who had migrated to East Friesland (letter in the Department of Textiles). Margraf also had a tapestry of *The Submission of the Kings to Alexander* with a heart-shaped mark in conjuction with the mark of Oudenarde, and borders with grotesques similar in style to those on the hunting scene (No.59), also attributed to Oudenarde, and to the grotesque tapestries themselves.

Other related sets include three tapestries at Chastleton Manor with *Planetary Gods* on grotesque grounds of the same type and with trophy borders only slightly different from those of the *Vices*. These tapestries also have the heart-shaped mark. A grotesque in the same style and in the same borders as the Chastleton set, with *Fortuna* in a medallion,

probably belonged to the *Planetary Gods*. Two other related *grotesques* in different borders, *Mars* and *Saturn*, were sold at Christie's on 26 July 1935, lot 160.

Description. In the field are two medallions with canopies and elaborate borders. The left one contains a woman with a mirror and a peacock, personifying Pride, and the right, a woman with bags and a chest of money, Avarice. These medallions hang in a kind of framework of fantastic architecture and strapwork among which satyrs, witches, caryatids and similar figures occur. The intervals are filled with fruit and flowers. There is a fairly wide border with arms, armour, banners and similar military trophies.

Museum acquisition. T.124–1931. Bequeathed by Mrs Alfred W. Hearn.

Literature

Marillier, H.C., *Subject Catalogue of Tapestries*, Victoria and Albert Museum, Department of Textiles, Ms., n.d., vol. 'Arabesques', p.75

Thomson, W.G., *A History of Tapestry*, London, 1930

Ysselsteyn, G.T., van, *Geschiedenis der Tapijtweverijen in de Noordelijke Nederlanden*, Leiden, 1936

Nos. 48–50 (*pls.68–72*)
Group of Large-leaf Verdures

A new style of Verdure tapestry came to the fore in the second and third decades of the 16th century and remained in vogue till it gave place to a type of landscape tapestry with woods and parks in the 17th and 18th centuries. The large-leaf designs are sometimes the main motif ('verdures' proper), sometimes they are used as the background to set off coats of arms, or for rustic and pastoral scenes – just as was the case with the earlier mille-fleurs group.

The large or giant-sized leaves of these complex designs are sometimes serrated and dentated, some-times great rounded shapes predominate; the leaves are interspersed and intertwined with flowers such as foxgloves, King Solomon's seal, convolvulus and many others, sometimes imaginary or composite. In this jungle of foliage there are often birds and animals, sometimes realistic, sometimes grotesque or mythological and usually half hidden, or peering out of the thickets. In contemporary inventories these tapestries are referred to as verdures, forest-work, 'verdours of the brode blome' (Henry VIII's inventory, at Greenwich, Otelands, etc.). In French they were known as 'feuillage renversé', 'verdure à grande feuillage'. Nos.48–50 are typical of two styles among the many variations on this 16th century verdure theme.

The new style, whatever its exact origins (which is controversial and still largely unwritten), undoubtedly reflected the new naturalism and the study of botany. For this was the period when the great botanical gardens were first being developed and new plants were being introduced to Europe from Asia and the New World. Botanising was becoming an intellectual cult. Floral designs of a new kind, excellently drawn with great detail, were used for the backgrounds of Margaret of Austria's *Armorials* of 1528–9 (Budapest Museum of Decorative Art) and those of the Emperor Charles V (Vienna, Kunsthistorisches Museum; Amsterdam, Rijksmuseum; see d'Hulst, No.22), and many of the finest of these verdures were produced by the leading Brussels workshop of Willem de Pannemaker (1535–78). The flowering plants in these armorials are relatively large, particularly in the latter, and are seen also in an important tapestry with *Saint Veronica* of about 1540 (Madrid, private collection, shown in the 'Tapisseries flamandes d'Espagne' exhibition at Ghent, 1959). They are closely related to the large-leaf verdures. For, although they existed in all qualities, they were also among the favourite hangings of the leading Houses of Europe. Henry VIII's inventory at the Tower shows: '9 peces of riche verdoure the grounde or

fielde of golde' (W.G. Thomson, p.245). Charles V retired to Yuste at the end of his life with six tapestry-landscapes, seven tapestries with animals and landscape, twelve foliage verdures, five coverings for seats with foliage – these besides his rich religious tapestries woven with gold and silver.

The origins and development of the new verdure style have been discussed by H. Göbel and by R.A. d'Hulst. Göbel connects them with garden and particularly fountain scenes, quoting the 1615 inventory of the Château de Turenne (Limousin) 'faictes en façon de fontaine et de grands feuilhiages et de bestes sauvages' (among other similar entries), and a 1572 inventory entry, 'à feuillage d'eaue . . . lions, liepures . . . ' (Göbel, *Die Niederlande*, I, i, pp.176–9). There was a great variety of types of composition. Those with great straggling stems and leaves and with a profusion of beasts and birds, suggesting savage disorder, are connected with the group where a park or *hortus conclusus* is the principal theme (see P. Ackerman, *The Rockefeller McCormick Tapestries*, 1932; Rijksmuseum, Amsterdam, *Wandtapijten I*, figs.16, 17; Asselberghs, Tournai Exhibition, 1970, No.12). These are quite different in feeling to the rhythmic order of Nos. 48–50 and the thistle verdures, which appear to have been an early, but all-too-rare group of great beauty. The thistles are designed as rows of giant plants, complete in themselves and with clouds above. Charles V had thistle tapestries from Pieter van Aelst of Brussels in 1518 (S. Schneebalg-Perelman, 'Pieter van Aelst', p.304), and an earlier order of Pierre II Duke of Bourbon (d.1503) commemorating his ancestor Louis II of Bourbon goes back to about 1500 (B. Kurth). There are extant examples in the Burrell Collection and at Copenhagen (Kunstindustrimuseet); these are woven entirely in blue, with touches of white.

It is most unlikely that the large-leaf verdures were made exclusively in any one centre, or even country: Göbel, Crick-Kuntziger, d'Hulst and other leading authorities agree on this. Two well-

known series at Vienna bear the marks, the one of Grammont (there is another Grammont-marked piece at Hamburg), the other of Enghien, and it has become common practice to refer to large leaf verdures in general after these localities, which is quite incorrect; both were centres of minor importance among many others. Crick-Kuntziger points out that the borders of these verdures are often Brussels borders of known type: many of the best may have come from there. But they were doubtless made also at Oudenarde and elsewhere and in the Northern Netherlands. Göbel has quoted French inventories to show that they were undoubtedly also made in the La Marche district (Aubusson and Felletin): Château de Motte-Feuilly, 1514, 'feuillage renversé d'Auvergne'; given to Bourges Cathedral in 1537, 'pièces de tapisserie de verdure à grand feuillage'; Château de Saumur, 1615, '8 tapisseries de la Marche avec grands feuillages et bestes sauvages' (Göbel, *Die Niederlande*, I, i, p.178). A set of large-leaf verdures with birds, giraffes, a monkey, lion, fabulous animals and hounds, and with a frieze of landscape (castle, villages, trees) at the top, come from the Presbytère d'Anglard de Salers; they bear the arms of Montclar of Auvergne. They probably date from the late 16th century and were somewhat coarse and rustic. (A technical analysis has been made of this set showing the use of twenty-eight colours, in eight scales of three tonalities each; M. Dayras, *Cahiers de la tapisserie*, 1961).

It is also worth mentioning that from about the year 1600 comes a set of seven large-leaf verdures which combine a grotesque design, or 'ferronnerie' in the manner of Cornelius Bos, with 'playing boys' themes; two of them have the Enghien mark (Enghien, *Trésors d'art d'Enghien*, 1964, pls.2 and 3).

No. 48 (*pl.68*)
Giant-leaf Verdure, with deer

FLEMISH; second half of 16th century.
H. 8ft 10in. (2·69m.) W. 10ft 7in. (3·23m.).

Wool with some silk: 11–12 warp threads to inch (4–5 to cm.).

Condition. Worn.

Description. The flowering plants with large curved leaves fill the whole field; in the foreground a stag and a hind. Birds in the foliage. The foliage border with fruit and flowers, entwined with ribbons, on a dark blue ground.

Further information. H. Göbel illustrates analogous pieces with similar rather plain borders (*Niederlande*, I, ii, pls.442, 456, 474), the two latter with a frieze of landscape at the top.

Museum acquisition. 243–1894. *Purchased* (£87 15s 3d).

No. 49 (*pls.69–71*)
Giant-leaf Verdures

FLEMISH (Brussels?); mid to second half of 16th century. Weaver's mark unidentified.
Seven cut pieces from an unknown number of tapestries:–

862 –1894	5ft. 7¾in. × 11ft. 0in.
	(1·72m. × 3·35m.)
862A–1894	7 ft. 10½in. × 1ft. 11in.
	(2·40m. × 0·58m.)
862B–1894	7ft. 11⅛in. × 4ft 4¾in.
	(2·42m. × 1·34m.)
862C–1894	6ft 11½in. × 6ft. 2in.
	(2·12m. × 1·88m.)
862D–1894	5ft 9½in. × 8ft 3in.
	(1·75m. × 2·51m.)
862E–1894	2ft 7in. × 2ft 9¾in.
	(0·79m. × 0·86m.)
862F–1894	3ft 0½in. × 6½in.
	(0·92m. × 0·16m.)

From putting together fragments 862 and 862B, which share part of the same pattern, it is possible

to estimate that this set of tapestries was about twelve feet high.
Wool and silk: 12 warp threads to inch (5 to cm.).

Condition. Cut and fragmentary; there are three sizeable portions, 862 and 862 (C), (D), and another with a section of the top and left side border (B); also a fragment of the right border (A). The texture is fairly well preserved but somewhat faded.

Description. The principal feature of the design is the dentate foliage on a large scale, which practically covers the whole surface. Stems of the vine and various flowers, including roses, foxgloves, and convolvulus, grow in and out amid this foliage, which also partly conceals a number of animals chasing one another. On one piece is seen a leopard and a wolf about to attack an ox (862); on another (D) is a lion seizing a horse, two deer and a monkey; a third (C) has two hounds chasing a stag. Birds, snails and insects are also seen amid the foliage. The fragments (E) and (F) are repeats, with minor variations, of parts of the stag and a dog in (C); while the left side of 862–1894 is almost duplicated in the tapestry with surviving left-hand border (B).

Part of the left and top borders is seen on (B), and of the right border on (A). The left border has a female figure supporting an object in the form of a candelabrum, decked with fruit and surmounted by a male warrior in armour. In the right border the supporting figure is a bearded man, and the upper figure is a female holding a lance. The two upper figures uphold the ends of a festoon loaded with fruit and flowers which would fill the top border. At the lower edge of (C) is a band which apparently marked the inner side of the bottom border. The ground of the border is yellow, shaded with brown. The factory mark, so far unknown, is in the top right hand corner, on fragment (A).

Further information. These pieces were found in 1893 under wallpaper in an old house known as the

Unwin Residence in the High Street, Huntingdon.

The border is more elaborate than the Vienna piece with the Grammont mark (Baldass 106) and more stylish than the Brussels tapestry (Crick-Kuntziger, Cat.40, pl.51c) which also has figures at the top and bottom corners. This border is excellently designed with caryatids supporting vases on their heads; the fruit is opulent and with the leaves spills over into the field. Two tapestries in the Boston Museum of Fine Arts represent this style, but with different borders (Cavallo, Cat. Nos.27, 28).

Museum acquisition. 862A–F–1894. Purchased from the Rev. A.A. Honey, Huntingdon (£150). The Museum records have a note reporting that Mr William Morris was shown these pieces 'and liked them very much' (Skinner, 10 January, 1895).

No. 50 (*pl.72*)
Fragment of Giant-leaf Verdure with Arcade

FLEMISH; second half of 16th century.
H. 5ft 6in. (1·68m.) W. 4ft 7in. (1·40m.).
Wool and silk: 15 warp threads to inch (6 to cm.).

Condition. Worn at edges, colours reasonably fresh.

Although only a fragment, this piece is of interest as it links this type of verdure with the Pergola and Garden tapestries. Like the rather later *Planets*, Nos.60 and 61, this may have been a long, low tapestry to hang above wainscoting.

Description. An arcade, of which three columns and two arches remain, supported on a balustrade. The field behind is filled with large curling leaves intertwined with stems, flowers and fruit. A female musician with triangle sits on the balustrade, a boy and dog beneath. A fox (with collar) is leaping along the balustrade; there are birds of different sizes in the foliage. The piece is cut at the top and sides.

Further information. The idea of an arcade or pergola as a framework for scenes which unroll beyond is found in three groups of tapestry, all originating in the middle of the 16th century or a little earlier. First, there was Jan Vermeyen's celebrated *Vertumnus and Pomona* (Baldass 146–54). Second, Battista Dossi's *Metamorphoses* woven by Jan Karcher at Ferrara, of which one is dated 1547 (Musée des Gobelins, Exhibition 1929, Nos.27–28; Viale, pl.XII). Third, the lovely garden tapestries woven for Cardinal Antoine Perrenot Granvella by Willem de Pannemaker, with porticos and pergolas and gardens receding into the distance behind the front arcade, where there are animals, birds and foliage showing something of the feeling prevalent in these verdures (Baldass 140–45). These three were all the grandest of tapestries, but pergola and garden tapestries enjoyed a great vogue varying in quality from those at the Isabella Stewart Gardner Museum, Boston, to quite humble pieces; sometimes large pots of shrubs stand in the arcade (Spanish Patrimony, Göbel, I, ii, pl.156).

The V and A fragment must come from a set of reasonably common quality. Other pieces of giant-leaf verdure with a low, curved balustrade are known, with birds on the balustrade and one with a boy (as here; Marillier Catalogue). But this exact combination of arcade and verdure seems rare.

Museum acquisition. T.24–1924. Given by Mrs Morton Dexter.

Literature

Ackerman, P., *The Rockefeller McCormick Tapestries. Three Early 16th Century Tapestries*, New York, 1932.
Amsterdam, *Wandtapijten I*, see Erkelens, A.M.L.
Asselberghs, J.P., 'La Tapisserie d'Enghien', Catalogue of the exhibition *Trésors d'Enghien*, Enghien, 1964, No.8; pl.IV
Asselberghs, J.P., *Tapisseries héraldiques et de la vie quotidienne*, Catalogue of the exhibition Tournai, 1970, Nos.12, 13

Baldass, L., *Die Wiener Gobelinssammlung*, Vienna, 1920–1, vol.I, Nos.102–108; vol.II, Nos.140–154
Cavallo, A., *Catalogue of Tapestries in the Museum of Fine Arts*, Boston, 1967, Nos.27, 28
Crick-Kuntziger, M., *Musées royaux d'art et d'histoire. Catalogue des Tapisseries*, Brussels, 1956, Nos.40, 41; pls.50b, 51a, 51c
Dayras, M., 'Les tapisseries du Presbytère d'Anglard de Salers' in *Cahiers de la Tapisserie*, Galerie d'Aubusson, Paris, April, 1961, No.3, pp.22–6
Duverger, J., *Tapisseries flamandes d'Espagne*, Catalogue of the exhibition, Ghent, 1959, No.13
Enghien, *Trésors d'art d'Enghien*, Catalogue of the exhibition, 1964, pls.2, 3
Erkelens, A.M.L., *Wandtapijten I. Late Gotiek en Vroege Renaissance*, Rijksmuseum, Amsterdam, 1962, figs.16, 17, 30
Ghent, *Tapisseries flamandes d'Espagne*, Catalogue of the exhibition, 1959, No.13
Göbel, H., *Wandteppiche I. Die Niederlande*, Leipzig, 1923, pt.i, pp.176–9; pt.ii, pls.156, 442, 456, 471, 474
Hulst, R.A.d', *Tapisseries flamandes du XIVe au XVIII siècle*, Brussels, 1960, Nos.22, 30
Kurth, B., *Kunstmuseets Aarsskrift*, Copenhagen, 1940, vol.XXVII, p.48
Marillier, H.C., *Subject Catalogue of Tapestries*, Victoria and Albert Museum, Department of Textiles, Ms., n.d.
Paris, *Tapisseries de la Renaissance*, Catalogue of the exhibition, Musée des Gobelins, 1929, Nos.27, 28
Schneebalg-Perelman, S., 'Un grand tapissier bruxellois: Pierre d'Enghien dit Pierre van Aelst' in *International Colloque 1961. L'Âge d'Or de la tapisserie flamande*, Brussels, 1969, pp.279–323
Thomson, W.G., *A History of Tapestry*, London, 1930, pp.245, 247, 251–2
Viale, M. Ferrero, *Arazzi italiani*, Milan, 1961, pl.XII.
Ysselsteyn, G.T. van, *Geschiedenis der Tapijtweverijen in de Noordelijke Nederlanden*, vol. II, Leiden, 1936, pl.82

No. 51 (*pl.73*)
The Rape of Proserpina

FLEMISH (OUDENARDE?); late 16th–early 17th century.
H. 8ft 9in. (2·67m.) W. 17ft 8in. (5·38m.).
Wool and silk: 13 warp threads to inch (5 to cm.).

Condition. Rather worn and faded.

Pluto's seizure of Proserpina is enacted in a landscape where wild and fabulous animals roam, seen through an arcade, as it were from a terrace. A column of the same design as is used for the arcade occurs, with similar masks in the spandrels of the arches, in a tapestry tentatively attributed to Kassel by Göbel (*Wandteppiche III*, ii, pl.29). This tapestry also has wild beasts in the foreground: in the background men are killing a lion, and in the centre is a seated woman with three women running away to the left. Two of these figures, the seated woman with hands held to her head and the figure immediately to the left are the same in the 'Kassel' tapestry and in our *Rape of Proserpina*. The other two running women in the Proserpina tapestry are similar in pose to figures in an animated frieze on the architrave supported by the columns in the 'Kassel' tapestry.

No.50, a large-leaf verdure seen though an arcade of closely similar columns, is related to these two tapestries. The place of origin seems more likely to have been a Flemish town rather than one in Germany. Figures and foliage seem quite consistent with the output of Oudenarde in this period. But since many Flemish workers emigrated it is not possible to be certain of an attribution without further evidence.

Description. In the foreground is an arcade of seven arches, through which is seen the representation of the story. Proserpina has been seized by Pluto and placed in his chariot; her companions are in attitudes of grief and terror; before them on the ground lie the baskets of flowers they have been gathering. The chariot is drawn by horses through the water towards the infernal regions, which are represented on the right by a pile of masonry and two flaming urns. In the foreground are a dragon, a griffin, a unicorn and peacocks. At each side of the tapestry the columns are replaced by a pillar with apertures through which figures are chasing one another, as they do along an arcade at the bottom of the tapestry. Above, festoons of drapery and fruit with trophies of arms are supported by figures and masks in the spandrels. There is a narrow border of blossoms and interlaced ribbons on a yellow ground.

Museum acquisition. 2029–1899. Purchased from a dealer (£65).

Literature
Göbel, H., *Wandteppiche III. Die Germanischen und Slawischen Länder*, pt.ii, Berlin, 1934, pl.29

Nos. 52–58
Landscapes with Gardens, Parks and Sports

These were favoured themes for tapestries in the last third of the 16th century, and the taste for them was still strong in the 17th century. The Museum tapestries, five with the arms of the Contarini (a distinguished patrician family of Venice) and two other pieces, have formal gardens with arcaded walls, pavilions, canals and fountains and also park and forest scenes with hunting and archery; courting couples and music, or an incident taken from mythology, further enliven them. In the foreground of the Contarini hangings there are animals and birds and the garden and woodland scenes alternate in the series. All these are typical features of a large group of tapestries to which these belong. With their leafy foliage and vistas of landscape they are extremely pleasant to see on the wall, giving a sense of recession; their animal figure subjects, though on a small scale, provide plenty of interest, as do the borders, which are full of playful allegory and illusion.

Dr Dora Heinz has summarised the vogue for garden tapestries which developed in the middle of the 16th century (p.213), and Dr Heinrich Göbel has made a detailed study of the gardens represented, which were those of France and Northern Europe with a special love for ornate pavilions, canals and fountains (see later). The Brussels workshops of Frans Geubel and his widow were prolific in producing them, also landscape tapestries, but so were other workshops in Brussels, Antwerp, Oudenarde and the Northern Netherlands (Delft). The Contarini set comes from a Brussels atelier; the cipher J.V.H. is either that of Joost van Herzeele, or the Van den Hecke family (probably Jan).

The idea of a garden glimpsed through an imposing portico or arcade goes back to Battista Dosso's designs for the *Metamorphoses of Ovid*, woven at Ferrara in about 1545 (Louvre); also to the famous *Vertumnus and Pomona* set, attributed to Jan Vermeyen, woven in Brussels for the Emperor Charles V (Vienna, Madrid). Then came the *Garden Tapestries* for Cardinal Antoine Perrenot Granvella, furnished by Willem de Pannemaker (Vienna). From these princely orders two different types of garden tapestry developed. First, those with colonnades and great vases of flowers, sometimes known as 'à pergola', or 'à portique', represented at Brussels, at Holyrood Palace and elsewhere, but not in the Museum collection. Secondly, gardens viewed from the verge of a park or forest; along with these went the woodland and forest tapestries animated with hunting and other scenes of sport. A tapestry in the Hôtel de Ville at Brussels shows a scene very similar in general disposition to the third Contarini piece, but it has an accurate topographical view of the city of Brussels in the third quarter of the 16th century, showing the Old Palace of the Dukes of Brabant (burnt in 1731); the view is taken from a corner of the old park (Forest

of Soignes). It corresponds to the Louvre drawing by Bernard van Orley for the *Hunts of Maximilian*, month of *March*, the drawing having been altered subsequently. The alteration includes the Chapel of the Palace, which was only completed in 1551 and which is shown in the Hôtel de Ville tapestry. It also shows other interesting topographical details, such as the tower of St Nicholas (fell 1714), the part of the Palace towards the park including the 'deduit de la Chasse', the tournament ground, a pond, the garden and labyrinth. But it is the composition of the tapestry which interests us here. In the park are riders, kennel-men and woodsmen, with greyhounds and other hunting dogs assembling for a day's sport; in the foreground are the great trees with their foliage and, close up, a magnificent peacock and peahen; in the distance are the Palace with its gardens and grounds, and the city. All this corresponds with the general disposition typical of this group of tapestries, only here it represents a topographically accurate scene. The borders have allegorical figures, grotesques and foliage in the usual manner.

The connection of this genre of tapestry with one historical set in particular should be noted. The *Valois Tapestries* at Florence show a series of festivities in which Catherine de Medici, Henri III of France and his brother François, duc d'Anjou, figure. They are based on drawings for festivals and masquerades by Antoine Caron and Lucas de Heere of different dates, but can reasonably be assumed to have been woven by the year 1582. With their courtly personages in the foreground and the festivities before arcades and pavilions, lakes and gardens, and a palace sometimes seen in the background, they are likely to have had an influence on the group of tapestries under discussion.

H. Göbel has written at some length on this French and North European style of garden, with its waterways and canals, suitable to the old moated castles, which were being transformed into more Italianate ways in the 16th century. The *Valois Tapestries* show all the typical features, and Göbel

suggests that the garden scenes of romance, carnival and intrigue, described in literature from the *Decamerone* onwards, can be better seen and imagined in the Valois and others of this large group of tapestries, than anywhere else (Göbel, *Wandteppiche I*, pt.i, pp.173–76). In studying the gardens common to the tapestries, Göbel illustrates a piece belonging to the Spanish Patrimony; also an engraving from Furttenbach's *Architectura Civilis*, 1628, and a Frankfurter Burgermeister's garden (pls.152–4). The geometrically arranged flower gardens, the vegetable gardens and orchards, the 'pleached alleys', arcades, pavilions, gazebos and fountains, often with labyrinths and 'ruina' – all somewhat detached from the house or palace and divided off from the wild woodland country beyond by a sunk fence – are typical of North European taste of the time. French accounts for the gardens of Blois and Amboise include the work of carpenters for the 'accoudoirs' and for elaborately carved pavilions and aviaries with caryatids and herms (mostly in wood). This was before the vogue for Italian gardens and Le Nôtre.

Two other influences may be seen in these garden and landscape tapestries – influences which indeed sprang from the leading interests of the intelligentsia of the day – namely, zoology and topography. From about 1555–65 Sigismund Augustus I, King of Poland, was completing his immense order at Brussels for tapestries to furnish his palace-castle of Wawel at Cracow. Among the most original and attractive of these were the forty-four pieces with *Animals and Birds in Landscapes*. The beautifully rendered park and woodland landscapes have their foreground dominated by exaggeratedly large animals and birds, mostly (but not always) exotic, and sometimes semi-mythological. In a study of these Wawel tapestries Maria Hennel-Bernasikowa attributes the designs to Peter Coecke van Aelst, who was influential in Antwerp at that time as a designer of tapestries and founder of a school of cartoonists. The influence of the work of the engravers Matthew and

Jerome Coecke is also indicated; whilst the zoological interest coincides with the publication in Zurich during the 1550s of Conrad Gesner's *Historia Animalium*. Animals and birds, exotic and indigenous, continue to figure in the later landscape and park tapestries, often treated as sort of zoological portraits in the foreground.

The Contarini tapestries, which are superior in quality to the other two in the Museum, bear the Brussels mark and the cipher I. (or J.)V.H. The question is to whom this cipher refers. At the exhibition of Antwerp Tapestries (Antwerp, 1973), Dr Erik Duverger attributed several tapestries with analogous ciphers made in the 16th century, to Joost van Herzeele, who worked both in Brussels and Antwerp. In a study of a set of *Romans and Sabines* (two in the Metropolitan Museum) Edith A. Standen accepted this attribution for a variant I.V.H. cipher on one of them and suggested that the monogram N.V.O., to be seen on a shield in the *Battle Scene*, can be identified with the designer, Nicolas van Orley (died between 1586–91, nephew of Bernard van Orley). These *Romans and Sabines* tapestries have the same borders as on the Contarini set, which suggests a common workshop. The I. (or J.)V.H. cipher is also found on an *Alexander* series in Vienna, on a *Moses* set, and on some tapestries with hunting scenes at Petworth. The V.H. cipher was certainly used by the van den Hecke family, one of the oldest Brussels families of tapestry-weavers; Jan died in 1633/4 as a doyen of the guild; Frans (1650–65) and his successors flourished through the 17th century well into the middle of the 18th. If J.V.H. refers to Jan van den Hecke, the Contarini tapestries would be two or three decades later than the Valois tapestries, and the Brussels Hôtel de Ville piece may pre-date the latter by a decade or two. But this style of tapestry was in demand and woven over at least fifty to seventy-five years, as was common with tapestry styles. No less exalted personages than the Archduke Albert and Isabella, Governors of the Netherlands, ordered in 1611 and 1614 a repeat of *Vertumnus and*

Pomona from the weaver Martin Reymbouts, over sixty years after the originals were made (Crick-Kuntziger, Brussels Cat. No.50); and the four *Garden Tapestries* 'à portique' in the Isabella Stewart Gardner Museum, which were based on the Granvella tapestries, have two pieces signed by Jacques Geubels (active 1585–1605) and two supplied by Raphael de la Planche of Paris (active 1633–61).

Nos. 52–56 (*pls.74–77B*)
The Contarini Landscapes with Gardens
With the Arms of the Contarini family of Venice.

BRUSSELS; late 16th–early 17th century. Cipher: J.V.H. attributed to Joost van Herzeele or Jan van den Hecke (d. 1633/4). Brussels mark.

1.	H. 7ft 11in.	W. 14ft 6in.	
	(2·41m.)	(4·42m.)	(127–1869)
2.	7ft 9in.	13ft 2in.	
	(2·36m.)	(4·01m.)	(128–1869)
3.	7ft 9in.	13ft 3in.	
	(2·36m.)	(4·04m.)	(129–1869)
4.	7ft 8in.	7ft 9in.	
	(2·335m.)	(2·36m.)	(130–1869)
5. (entre-fenêtre)	7ft 8in.	4ft 6in.	
	(2·335m.)	(1·37m.)	(130a–1869)

Wool and silk: 14 warp threads to inch (5–6 to cm.).

Condition. Good but somewhat yellowed and faded.

Description.
1. A wooded landscape with men practising archery. In the foreground a large goat and a snake (left) and an otter with a snake in its jaws (right). Vistas and a rustic pavilion in the background. (J.V.H. cipher, lower right galloon).
2. A wooded landscape with a wild boar brought to bay; hunting dogs, equestrian and running figures. A large wolfhound or alaunt, with protective coat, in foreground; also an owl in a tree (left). (J.V.H. cipher, lower right galloon).
3. A canal or lake with gardens, arcades, covered walks and pavilions beside a palace – all viewed from a woodland park with hills in the distance, a river or lake, and the sun low in the sky (left). Boating, people at leisure in a pavilion in the middle of the lake, women gathering flowers or herbs in baskets. In the foreground two large peahens and a rabbit; trees and foliage. (J.V.H. cipher, lower right galloon).
4. Boating on a river beside a palace overlooked by pavilions, a pergola, and a tower behind. A lute is being played in one boat and spectators look on from the balustrade. A chesnut tree in foreground (left). (J.V.H. cipher, lower right galloon).
5. Entre-fenêtre, inner border-stripes only on either side. A woodland glade with a man galloping with drawn sword; another horseman on right crossing a small bridge over a brook; in middle distance archery practice at a target on a tall pole. Two large chestnut trees in foreground. (J.V.H. cipher, lower right galloon).

The borders have the Contarini arms, one of the twenty varieties given in Vincenzo M. Coronelli's *Blasone Veneto* (1702), in the centre (top). Allegorical figures at the sides and beneath (Ceres, Flora, Arithmetic), standing, seated and reclining, amidst floral and fruit-laden branches with trophies. In excellent style on a white (now yellowed) ground with inner and outer guard-stripes with arabesque design punctuated with masks and lozenges. As well as the cipher, four of the tapestries have the Brussels mark (lower galloon, left).

The Contarini Family. The Contarini were one of the most distinguished patrician families of Venice. From the early Middle Ages they were connected with the Oriental trade and a branch of the family settled in Syria. No less than eight Contarinis were Doges, five of them in the 17th century, and the family played a leading part in Venetian politics, diplomacy and letters through the centuries; in the first half of the 16th century Gaspar Contarini was a Cardinal known for his learning and wisdom (*Grand Dictionnaire Historique de Louis Moréri*, Paris, 1759). It has unfortunately not proved possible to identify a particular member of the Contarini family from the coat of arms displayed on the tapestries.

Museum acquisition. 127 to 130 & a–1869. Bought (as German) from Signor Gagliardi for £20.

No. 57 (*pl.78*)
A Park with Courtiers and Hunting scene

FLEMISH; last quarter of 16th century.
H. 10ft 10in. (3·30m.) W. 12ft 4in. (3·76m.).
Wool and silk: 14 warp threads to inch (5–6 to cm.).

Condition. Worn and faded; restored.

Description. On the left in the foreground are a lady and a gentleman standing together, the lady holding a mirror; on the right another elegantly dressed couple are sitting side by side, the gentleman playing a lute. In the countryside round about the two couples is a hunting party on foot and on horseback, brandishing weapons and blowing horns, etc. In the centre of the middle distance a bull is attacked by hounds and men. There are tall trees to right and left and among them are small birds and animals, such as a fox, etc. In the foreground are a cluster of irises and other naturalistically drawn flowers. In the background is a large country house with a walled formal garden and wooded hills behind. Only a very narrow strip of sky is visible.

The wide borders contain vases of fruit and flowers with grotesques and masks separating each decorative group. There are allegorical figures; those from mythology include Hercules and the Nemean lion, Diana and Cupid.

Museum acquisition. T.269–1958. Given by Mrs Edgar Seligman in memory of the late Edgar Seligman.

No. 58 (*pl.79*)
Landscape with Europa and The Bull

FLEMISH; late 16th–17th century.
H. 9ft 5in. (2·87m.) W. 8ft 1in. (2·46m.).
Wool and silk: 20 warp threads to inch (8 to the cm.).

Condition. Worn and faded. The border may not belong as the tapestry is cut at the sides and the border is seamed at top and bottom.

Description. Maidens gather flowers in a verdant landscape: on the extreme left two of them are garlanding the Bull. In the right middle distance the Bull is swimming away with Europa on his back. In the background are farmyard animals, horses and a man playing bagpipes with a great house behind. There is a border of mythological characters in chariots and under pavilions, also vases of flowers and medallions containing country scenes.

Museum acquisition. T.773–1950. Given by the Dowager Viscountess Harcourt, G.B.E.

Further Information. At Warwick Castle there is a *Garden* tapestry of this type signed by Francis Spierincx of Delft and dated 1604; the borders, however, are quite different (floral scroll). The Merchant Taylors' Company, London, have a fine *Garden* tapestry, similar in style and quality to the third Contarini piece (with large birds in foreground) but it is made up with borders as a table-carpet; it bears the cipher of Frans Geubel of Brussels and the excellent borders are typical of his work. This tapestry carpet was purchased for the Company from a Mrs Prokter, presumably the widow or relative of the Prokter who was Master of the Company in 1593, as noted in the 1618 inventory (A.F. Kendrick, *Burlington Magazine*, Oct. 1927). Dr E. Duverger has published a study of Frans Geubel's workshops, where he discusses these *Garden and Landscape* tapestries and their borders, illustrating among others one at Burgos Cathedral where Trajan's Column is seen in a park beside a formal garden. J. Versyp has published six *Garden and Landscape* tapestries, similar to ours, in the Palazzo di Venezia, Rome, bearing the arms of the Vidoni family ('Tour de la Vigne'); they are compared with four others at the Château de Laarne, near Ghent, and one in the M.H. De Young Museum. He quotes the poet Ronsard on two points of view, for and against hunting in the forests in the 16th century. The Marillier Catalogue lists numerous other examples of these popular tapestries, including one at Castle Drogo, Devonshire. Two with the mark of Antwerp, with hunting scenes, are in the Landesmuseum, Stuttgart, and were in the Antwerp Exhibition, 1973.

Literature

Antwerp *Wandtapijten*, Catalogue of the exhibition 1973, Nos.24, 25; pls.12, 13

Baldass, L., *Die Wiener Gobelinssammlung*, Vienna, 1920–1, vol.II, Nos.140–5

Crick-Kuntziger, M., *Les tapisseries de L'Hôtel de Ville de Bruxelles*, Antwerp, 1941, pp.21–3; pl.12

Crick-Kuntziger, M., *Musées royaux d'art et d'histoire. Catalogue des Tapisseries*, Brussels, 1956, No.50

Duverger, E., 'Tapijtwerk uit het atelier van Frans Geubels' in *International Colloque 1961. L'Âge d'Or de la tapisserie flamande*, Brussels, 1969, pp.91–204

Duverger, E., *Antwerpe Wandtapijten*, Exhibition Catalogue, Antwerp (Deurne), June to September 1973

Enciclopedia Italiana, 'Contarini Family', vol.XI, Milan, 1961

Göbel, H., *Wandteppiche I. Die Niederlande*, Leipzig, 1923, pt.i, pp.173–76; pt.ii, pls.152–4

Heinz, D., *Europäische Wandteppiche*, Braunschweig, 1963, pp.213, 261

Hennel-Bernasikowa, M., 'Verdures with Animals' in *The Flemish Tapestries at Wawel Castle in Cracow*, ed. by J. Szablowski, Antwerp, 1972, chap.III, pp.235–86

Kendrick, A.F., 'A Tapestry at the Merchant Taylor's Hall' in *Burlington Magazine*, vol.LI, October 1927

Marillier, H.C., *Subject Catalogue of Tapestries*, Victoria and Albert Museum, Department of Textiles, Ms., n.d.

Paris, Exhibition 1965–8 – see Viatte, G.

Standen, Edith A., 'Romans & Sabines, a 16th century set of Flemish Tapestries' in *Metropolitan Museum Journal*, vol.9, New York, 1974, pp.211–28

Thomson, W.G., *A History of Tapestry*, London, 1930, pp.390–1

Versyp, J., 'Zestiende-Eeuwse Jachttapijten met hen wapen van de Vidoni en Aanverwante Stukken' in *Artes Textiles*, vol.VII, Ghent, 1971, pp.23–46

Viatte, G., *Le Seizième Siècle Européen. Tapisseries.* Catalogue of the exhibition, Mobilier National, Paris, 1965–6, No.36

Yates, F.A., 'The Valois Tapestries' in *Warburg Institute, Studies*, XXIII, London, 1959

No. 59 (*pl.80*)
Landscape with a hunt
(*Fragment*)

FLEMISH (OUDENARDE); late 16th century or early 17th century.
H. 4ft 9in. (1·45m.) W. 7ft 4in. (2·24m.).
Woven in wool: 12 warp threads to the inch (5 to the cm.).

Condition. Only the top right section of the tapestry remains, and it is in poor condition, with old repairs.

Two tapestries in the same border, one illustrated in the catalogue of *Chefs-d'œuvre de la tapisserie flamande*, Château de Culan, June-Sept. 1971, Cat. No.15, the other sold at the Lempertz sale, Cologne, 8–10 May 1969, lot 1161, show that this tapestry had a foreground filled with large animals in thick undergrowth. The border at the bottom once contained a large architectural feature which projected into the picture space and contained an enthroned Virtue. Jean-Paul Asselberghs attributed these tapestries to Oudenarde on the evidence of their colouring and weave.

Description. The landscape shows a semi-tropical forest with palm trees. A dromedary, an elephant, stags and other animals appear between the trees. Men, some on horseback, are hunting a bull. On the right is water, a bridge, a church and other distant buildings. In the top border is a cartouche of irregular shape containing a reclining woman holding a pair of scales: grotesques, fruit, flowers and a standing figure in armour fill what is left of the border.

Museum acquisition. T.22–1924. Given by Mrs Morton Dexter.

Literature

Asselberghs, J.P., *Chefs-d'œuvre de la tapisserie flamande*, Catalogue of the exhibition, Château de Culan, 1971, No.15

Lempertz, *Catalogue of the sale* at Kunsthaus Lempertz, Cologne, 8–10 May 1969, lot 1161 and plate

Nos. 60–61 (*pls. 81–89*)
The Planets

No.60. **Mars, Jupiter, Saturn, Fortuna**
No.61 **Luna, Mercury, Venus, Sol, Time**
OUDENARDE; dates inscribed 1591, 1601.
No.60: H. 5ft 6in. (1·68m.) L. 26ft 8½in. (8·14m.).

No.61: H. 5ft 7½in. (1·71m.) W. 31ft (9·45m.).
Wool and silk; 20 warp threads to inch (8 to cm.).

Condition. Good but a number of patches and a lot of clumsy oversewing.

These two long panels of tapestry, probably intended for hanging above wainscoting, depict the seven Planets and their influences on mankind, to which *Time* and *Fortuna* are added (making nine scenes in all). There are two dates (on *Jupiter* and *Fortuna*) and the second panel has two stars in the upper selvedge. This star is found on the four Verdure tapestries with *Hercules* scenes in the Louvre, which also have the city mark of Oudenarde: it is also on another large-leaf verdure tapestry which can be ascribed to Oudenarde, at Chicago.[1]

From the seven planets are derived the names for the days of the week, beginning with Sol and Luna (with gods from Northern mythology substituted). The Planets and their influences were a favourite theme in the late Middle Ages, as Emile Mâle has described (*L'Art religieux de la fin du Moyen-Age*). The planets, it was held, influence the tendencies of human and other terrestrial behaviour and hence the psycho-somatic type at birth: sanguine, choleric, melancholic, phlegmatic. The way of presenting the subject goes back to Italy in the early 15th century, and particularly to Baccio Baldini's engravings (mid-15th century) where each planet rides as a god in a chariot in the sky, drawn by appropriate beasts or birds, with two signs of the Zodiac shown on either side. Below, in the world, men and women are shown at their labours or leisure under the ruling influence of the particular planet. Apart from the frescoes of Perugia and the Vatican, the theme was carried north by engravings, which proliferated in the 16th and 17th

centuries. In tapestry the Planets became a popular subject. A magnificent set (seven pieces) at Munich woven with additional gold and silver thread, has been studied by R.A. d'Hulst (*Tapisseries flamandes*, No.28); it has the Brussels mark and was woven in the last third of the 16th century. One of the *Seven Planets*, *Mercury*, from the château of Chaumont-sur-Loire, woven by Martin Reymbouts at Brussels (active 1570–90), was shown at the Paris exhibition, *Le Seizième Siècle* (1965–6 Mobilier National); it is contemporary with, or perhaps a few years earlier than ours. There are *Planet* tapestries at Hardwick, Holyrood, and a splendid 17th century set in Vienna.

D'Hulst has pointed out the Italianate feeling usual in the treatment of this subject. This is perhaps true for the borders of the Museum pieces, with their delicate arabesque design and lion-masks and the Corinthian columns with their carved lower portions, which are like those in the Munich *Mercury*. The narrowness of the borders is customary with frieze-tapestries (cf. the Como *Verdures* with the arms of Giovio, No.38). The terrestrial scenes, conceived on a meticulously detailed scale, derive from engravings.

The figures in the *Planets* come, in the main, from two series of engravings. The gods in their chariots and some of the figures of their 'children', the men and women under their influence, are taken from a set of the Seven Planets engraved by Herman Muller after designs by Marten van Heemskerck. A preliminary drawing of *Mars* in the Albertina, Vienna, is dated 1568. The other engravings are dated 1569 and are by Jan Saenredam after Hendrick Goltzius. In these the planetary gods stand on pedestals and only the figures of the people they influence are borrowed for the tapestries. Figures after Goltzius occur mostly in the foregrounds of *Saturn, Venus, Mercury, Luna* and *Jupiter*, the latter including groups of figures from both the *Jupiter* and the *Sol* of Goltzius. Groups after Heemskerck appear in *Mercury, Luna, Sol, Jupiter* and *Saturn*. On the scale in which

1. Dr J.P. Asselberghs kindly pointed out this identification of the star mark.

they are used in the tapestry the different groups blend quite happily and no one without the aid of the engravings would suspect that under *Luna* the two men in one boat and the three fishermen in another come from different sources. Where the designer of the tapestries disliked the figures available from these two series he drew on other engravings of related subjects. Background figures and buildings from the sack of a town under *Mars* are taken from an engraving entitled TYPUS BELLICAE CALAMITATIS EXACTISSIMUS, dated 1587, by Gerard de Jode.

No. 60 (*pls. 81–84*)

Description. A long, narrow panel divided into four scenes by Corinthian columns. The upper parts of the columns are fluted: the lower parts are covered with acanthus leaves, against which is represented a female figure in classical dress with winged sandals and a winged helmet. There is a tall ornamental base on a square plinth. All round the panel is a border with conventional ornamentation of a Renaissance type based on classical palmette designs.

In the upper selvedge above the extreme right-hand scene are two star marks in white, workshop marks connected with Oudenarde.

The scenes from left to right are:–

Mars in full armour in a chariot drawn by wolves in the middle of the sky, with the signs of the Ram and the Scorpion. Below are scenes of war, with troops mounted and on foot driving people across a field in the foreground and an engagement with muskets between two detachments in the background.

Jupiter above in the sky in a chariot drawn by peacocks, carrying a thunderbolt and with an eagle. Signs of the Fish and Sagittarius. Below are, on the left, a Pope crowning a King or Emperor, and in the foreground an astronomer with astrolabe and other instruments; in the centre a King is consulting with his councillors; on the right a King on

his throne is receiving a petitioner or messenger. In the background in the centre a man is reading a royal declaration from a balcony to a crowd; over the door beneath the balcony is a date, which appears to be 1601. In the background on the right is an ecclesiastical procession going to a church, and behind, a King on horseback with a canopy over him moving towards another church in the distance.

Saturn, eating his children, sits in a chariot drawn through the clouds by griffins. The signs of the Zodiac are Aquarius and Capricorn. Below are peasants reaping and ploughing. On the right are monks distributing bread and provisions to beggars and cripples, with a similar scene in the background in front of a church. In one place a priest is apparently comforting a man in the stocks outside a gaol. The significance of these scenes lies not in the acts of charity but in the lives of those misfortunates influenced by Saturn.

Fortuna: seated on a globe in clouds in the centre of the sky is the winged figure of Fortune holding in her right hand a veil or sail in a large curve over her head, and in her left hand a covered cup. On the left in the sky is Saturn, holding a scythe and eating one of his children. He presides over scenes of disaster; a city burning, a ship wrecked in harbour. On the right is a figure of Mercury with a winged helmet, holding a purse in one hand, and in the other various objects, one of which is a tablet with the date 1591 and underneath the letters 'ME(?)N.' Beneath him are scenes of good fortune and prosperity.

No. 61 (*pls. 85–89*)

The lower border has been patched with two similar borders from the right-hand end, and the right-hand end portion has been added on, so that in these two panels we have four right-hand end borders.

The scenes in this panel from left to right are as follows:–

Luna: Diana (holding in her left hand a horn and in her right a crescent and carrying a quiver) is being drawn by two nymphs in a chariot in the clouds in the centre of the sky. With her is the sign of Cancer. Below, the main scene represents men fishing with nets in a pool apparently cut off from the sea by a sluice gate. Men and women on the bank are carrying fish in baskets. Beyond the sluice is a quay where more men are fishing, and fishing boats are on the open sea.

Mercury, wearing a winged hat and sandals, carries his caduceus in his right hand and is being drawn through the clouds in the centre of the sky in a chariot to which cocks are harnessed. Nearby are two signs of the Zodiac; Virgo and Gemini. Below on the left are ships, with merchandise being loaded and unloaded, and in the foreground are men discussing business. At a table on a balcony in the centre foreground are seated men, apparently bankers and astronomers. On the right is a woman playing an organ, and behind her are seen at work a painter and a sculptor.

Venus carries an arrow in her left hand. Accompanied by Cupid, she is drawn through the clouds in a chariot to which a pair of doves is harnessed. The signs of the Zodiac, Taurus and Libra, are nearby. On the banks of a river in a wooded landscape, just outside a town, men and women picnicking or listening to music. Here and there are pairs of lovers.

Sol: he is represented as a King with crown and sceptre, seated in a chariot drawn through the clouds by a pair of horses. The sign of the Zodiac is Leo. Below are men engaged in all manner of sports – tilting, fighting with broad-swords and scimitars, boys standing on their heads, acrobats, men playing bowls, wrestling and something like a cock-shy. In the background on the right a King and Queen watch from a balcony hung with tapestries.

Time is represented by a big bearded figure with wings flying through the clouds with a scythe in his hands and an hour-glass on his head. Below are

Mars and Venus symbolising War and Peace and, probably by their heavenly conjunction brought about by Time, their daughter Harmony. Mars holds a sword; Venus caresses Cupid. Behind Mars is a pile of military equipment, and in the background soldiers are encamped before the walls of a city. Behind Venus is a pile of various objects, including a mask, a mitre, a crown and other jewels. In the background is a 16th century house with a porch approached by a flight of steps on each side.

Further information. H. Göbel in his *Wandteppiche,* *I,* i, pages 163–8, has summarised some useful information on ideas about the seven Planets with their twelve Houses, related to the seven Ages of Man and the twelve months. He gives the doctrines about the 'humours', disease and blood-letting, and the planets' influence in general, which were still current in the 16th century, tracing them back to the Salerno school of medicine, Galen and Hippocrates. He also gives a useful analysis of two of the Doria *Months* (p.164) and sets out in connection with the *Lucas Months* the correlation of the months with their planets and zodiacal signs, influences, and appropriate labours and pastimes (pp.167–8).

With reference to the star mark of Oudenarde, three of the large-leaf *Verdures* with Hercules scenes, which have this mark, were shown in Amsterdam in 1955 (nos.280–82, pl.60) and one, *Hercules and the Lernaean Hydra,* was at the Paris *Seizième Siècle* exhibition in 1965–6 (Mobilier National, No.32).

Museum acquisition. T.168, 169–1931. Bequeathed by E.H. Littledale, Wick Hall House, Bracknell, Berkshire. Said to have been acquired in Poland by Mrs C. St G. Littledale.

Literature
Amsterdam, *Le Triomphe du Manérisme européen de Michel-Ange au Gréco,* Catalogue of the exhibition, Rijksmuseum, 1955, Nos.280–2; pl.60

Göbel, H., *Wandteppiche I. Die Niederlande,* Leipzig, 1923, pt.i, pp.163–8; pt.ii, pls.499, 507
Heinz, D., *Europaïsche Wandteppiche,* Braunschweig, 1963, p.223; figs.155, 156
Hulst, R.A.d', *Tapisseries flamandes du XIVe au XVIIIe siècle,* Brussels, 1960, No.28
Mâle, E., *L'art religieux de la fin du Moyen-age en France,* Paris, 1908, pt.2, ch.1, sections 1 & 2
Paris, *Le Seizième Siècle Européen. Peintures et dessins dans les collections publiques françaises,* Catalogue of the exhibition, Petit Palais, 1965–6, no.164 drawing by Heemskerck for *Luna*
Viatte, G., *Le Seizième Siècle Européen. Tapisseries,* Catalogue of the exhibition, Paris, Mobilier National, 1965–6, Nos.32, 33

No. 62 (*pls.90A–F, 101A*)
Set of Six cushion-covers
The Story of the Prodigal Son

FLEMISH; last third of 16th century.
21 inches square, each (0·53m.).
Wool and silk with gold and silver thread: 22–23 warp threads to inch (9 to cm.).

Condition. Good.

This is a particularly pleasing set of cushions with colours still fresh. The clearness of the red, blue and yellow tones, the free handling of the design, and the evenness of texture distinguish this weaving from Sheldon's. Although given in the earlier Museum catalogue (*Tapestries,* 1914 and 1924 editions) as English, Wace rejected this attribution (Barnard and Wace, p.304). The figures are larger and better drawn than the Barcheston-Bordesley cushions and the borders are typically Flemish (compare the single Sheldon *Prodigal Son* cushion, Cat. No.71A). The borders with Sol and Luna reclining on chariots in the lower corners, and with grotesque devices and fruit can be seen with variations and with other mythological figures on

tapestries from Brussels, Enghien, etc., of the latter half of the 16th century. See, for instance, the *Contarini Landscapes* in this Museum (Cat. Nos.52–6); an *Alexander* tapestry in the Boston Museum of Fine Art, and a *Verdure with animals* (from the Frans Geubels workshops; Duverger, Brussels *Colloque* 1961, p.157, fig.16; p.183, fig.22); the *Fall of Phaeton* in the Germanisches Museum, Nuremberg (*Trésors d'art d'Enghien,* 1964, No.9, pl.5; see also Göbel, *I,* ii, pl.398).

Description.
(1) Departure of the Prodigal. Holding a plumed cap, a sword slung from his waist, he stands grasping the hand of his father, who is sitting at a table on which are a book and some coins. The elder brother stands on the far side of the table. In the landscape background the Prodigal is seen departing on horseback.
(2) Riotous living. The Prodigal is seated at a table spread for a feast before an inn. Beside him is a young woman. There are two other women, one bringing food, the other chalking up the reckoning.
(3) The Prodigal is driven out of doors by three women, one, who is kicking him, swinging a bunch of keys, and another a broom. In the background the Prodigal approaches a cottage, at the door of which stands a woman.
(4) The Prodigal, with hands folded, kneels on one knee beneath a tree. About him are tusked swine, some feeding from a trough. In the background is a landscape with buildings, and two men conversing.
(5) The return. The Prodigal kneels, clothed in rags. His father hastens to embrace him. Behind the father is a building, on the terrace of which a man is killing the fatted calf, while another man brings out the robe and the ring. The elder brother approaches from the right.
(6) The Prodigal, his father and brother sit at a feast. A woman approaches from the left. In the background is a building from which a man advances to meet another (the expostulation of the elder brother).

The borders with pale yellow ground are similar on all six. At the upper corners are two male figures blowing horns. At the bottom corners are Diana or Luna, on the left, and Apollo or Sol, on the right. Each is seated in a two-wheeled chariot inscribed with the letters LV and SOL. Diana holds a bow, and Apollo a sceptre with a top resembling a rayed face. The rest of the border is filled with strap and scroll-ornament hung with fruit, flowers and foliage.

Museum acquisition. T.278 to 283–1913. Bequeathed by Edward Salmon Clarke.

Literature

Asselberghs, J.P., 'La tapisserie d'Enghien' in *Trésors d'art d'Enghien*, Catalogue of the exhibition, Enghien, 1964, No.9, pl.15

Barnard, A.E.B., and Wace, A.J.B., *The Sheldon Tapestry Weavers and their Work*, Society of Antiquaries, Oxford, 1928. Also published in *Archaeologia*, vol.LXXVIII, 1928, p.304

Brussels, *L'Âge d'Or de la tapisserie flamande, Colloque International 1961*, see Duverger, E.

Duverger, E., 'Tapisseries de l'atelier de Frans Geubels' in *L'Âge d'Or de la tapisserie flamande, Colloque International 1961*, Brussels, 1969, p.157, fig.16; p.183, fig.22

Enghien, *Trésors d'art d'Enghien*, Exhibition, 1964, see Asselberghs, J.P.

Göbel, H., *Wandteppiche I. Die Niederlande*, Leipzig, 1923, pt.ii, pl.398

Kendrick, A.F., *Victoria and Albert Museum Catalogue of Tapestries*, London, 1924, No.1B, frontispiece

No. 63 *(pls.91–92)*
Set of Six cushion-covers; The story of Jacob

FLEMISH; late 16th – early 17th century.
(1) 19½ × 16½in. (0·48m. × 0·42m.);
(2) 20 × 18in. (0·51m. × 0·46m.);
(3) 20 × 18in. (0·51m. × 0·46m.);
(4) 20 × 18in. (0·51m. × 0·46m.);
(5) 22 × 38in. (0·56m. × 0·96m.);
(6) 20 × 18in. (0·51m. × 0·46m.).
Silk, silver and silver-gilt thread, and wool: 22 warp threads to inch (9 to cm.).

Condition. Excellent; the colours are fresh.

These cushions, superior in quality and drawing to most contemporary work attributed to English looms, were nevertheless thought to be Sheldon by Wace. Wace admitted they were 'different in plan' to most of the other sets, but compared the treatment of the main scenes to *Judith* (Cat. No.71B) and the four sets of *Virtues* (Wace, p.298, N; see M and L). He pointed out that the borders were in keeping with Sheldon's style and noted that the 'diamond-shaped devices uniting the bunches of fruit and flowers' had a close parallel in the long cushion with the arms of Walter Jones and Eleanor Pope (Wace, F.). He placed them relatively early in the Sheldon work that has come down to us (Wace, p.309, Chronology). Wace claimed that the inscription on the long cushion with *Jacob at the Well*, 'JACOB.29.CH' is in English. 'Jacob', however, could be short for 'Jacobus', or could even be Flemish, while the so-called H of CH is split in two by the turned-over end of the scroll and appears to have a cross-bar at the bottom of the upright as well as in the middle.

The long cover is in odd contrast to the more sophisticated design of the other pieces in the set. In the small cushions the scenes within the lobed medallions show detailed landscape: in the long cover there are a few stylised plants and a plain, awkward horizon. The lobed medallion, too, has not been adapted to the different shape of the cover. In a sale at Christie's in December 1932 there was a long cushion cover of the same basic field and border design with a scene (different from No. 3 of this set) of *Isaac blessing Jacob*. The lobed medallion here is roughly oval in shape, showing a bed in the extension to the right, Esau setting out to hunt on the left. In the spandrels are leaves, fruit and flowers matching those on the small cushion covers. In the long cover with the scene of *Jacob at the Well* the large area outside the unadapted medallion is filled with stylised plants and long-stemmed dishes of fruit. Weave and dyes, however, seem to be consistent in this and in the small covers, and the way the landscape is depicted in these smaller pieces suggests a Flemish origin for the sets of this design.

The set in this Museum may well be incomplete. The subject of *Jacob wooing Rachel*, in matching medallion and surround, exists in a private collection, and the latter part of the story of Jacob, from 'Jacob fleeing Laban' to 'Jacob reconciled with Esau', is omitted from the present set.

The same surrounds and borders, containing the *Story of Abraham*, are on a set of cushion covers in the Metropolitan Museum of Art, New York.

Description.
(1) *Esau selling his birthright*
Esau on the right dressed as a huntsman shakes hands with Jacob on the left dressed in flowing robes. The background is a wood, and on the left is seen a huntsman. The scene is set in a diamond-shaped frame with lion masks at the angles, and the whole is placed in a square border of floral devices. The spandrels between the frame and the border are filled with bunches of fruit. At each angle of the border is a bunch of fruit and flowers, and next comes a device resembling a Maltese cross. In the centre of the top and bottom borders is a bunch of fruit and flowers from under which a mask peeps out. In the centres of the side borders are caryatids of legless female figures. The borders have a white ground throughout.
(2) *Rebecca disguising Jacob*
Rebecca, on the left, is putting a long hairy robe on Jacob, who stands on the right. Jacob also wears a kind of turban, and has a cloth in his raised left hand. Behind Rebecca stands a handmaiden,

and the whole scene is set in a wooded landscape with a pond on the right in which swims a swan.

Frame and border similar throughout the set.

(3) *The deception of Isaac*

Isaac sits on the left under a canopy and raises his right hand to bless Jacob, who stands before him on the right. Jacob, bareheaded, is clad in a long hairy robe and carries his turban in his left hand. His right hand is held by Isaac's left. Behind Jacob stands Rebecca and there is a wooded background. Before Isaac is a low table with a cloth and a platter of food and a goblet. A flagon stands on the ground.

Frame and borders are as previously described, except that there are no masks under the bunches of fruit, etc., in the centres of the top and bottom corners.

(4) *Jacob's dream*

In the foreground Jacob sleeps with his head to the left resting on his right hand. He is wrapped in a red robe shot with gold. His head and shoulders rest on a large rectangular slab. On the right is a sloping ladder resting against the sky, and on it are two angels ascending. Behind on the right are trees, and on the left Jacob is seen lifting the rectangular slab to make an altar.

(5) *Jacob at the well (a long cushion)*

On the left is Jacob lifting with both hands a large square slab off a circular well top. On the right is a young shepherd, and in the centre on either side of the well are two bearded shepherds, one facing, the other with his back to the spectator. Two sheep are seen in front, and in the background are more sheep and a wooden fence. On either side of the central scene is a blue (for silver?) vase with a large bunch of fruit and flowers. There are pomegranates, grapes, gourds, wild strawberries, cherries, iris, lilies of the valley, carnations, columbines, pansies, etc., among them, and the composition of the bunches though symmetrical is not identical.

The border resembles that previously described, but there are three central bunches of flowers and fruit in the top and bottom borders, and on the

central bunch of the top border is a tablet inscribed 'IACOB 29 C[?]'.

The left vase and foremost sheep are slightly worn.

(6) *Jacob meeting Rachel*

Jacob, bareheaded and in his voluminous cloak, advances from the left towards Rachel, who stands on the right with her left hand upraised. Between them, facing the spectator stands a handmaiden (or Leah?). The scene takes place before a wooded background.

Museum acquisition. T.180 to 185-1925. Bought under the bequest of Captain H.B. Murray from Basil Dighton for £1,500.

Literature

Barnard, A.E.B., and Wace, A.J.B., *The Sheldon Tapestry Weavers and their Work*, Society of Antiquaries, Oxford, 1928. Also published in *Archaeologia*, vol.LXXVIII, 1928, p.304

Christie's, Catalogue of the Sale 15 Dec. 1932, Lot 98

No. 64 (*pl.93*)
Orpheus and the Nine Muses

FRENCH; mid-16th century.
H. 9ft 7½in. (2·94m.) W. 10ft 8in. (3·25m.).
Wool and silk; 13–14 warp threads to inch (5–6 to cm.).

Condition. Good but faded. Restored.

This tapestry has the clear and rather pale colouring characteristic of certain French tapestries of the 16th century, where the new Renaissance style is in predominance. An example is *The Life of Saint Mammès*, ordered in 1543, with Jean Cousin the elder responsible for the cartoons, for the Bishop of Langres (now at Langres Cathedral and the Louvre). But these are much more sophisticated

(with their elaborate borders) than is Orpheus. A closer comparison seems to be the *Kings of Gaul* series given to Beauvais Cathedral in 1530; the simplification of the landscape with labelled place-names and sparsely branched fruit trees, with armorial shields tied to their trunks, recalls the style of the *Orpheus* tapestry, although the *Kings* may be a decade or two earlier. The provincial style of *Orpheus* has a close parallel in the *St Stephen* tapestries ordered by the Metropolitan Chapter of Saint-Etienne de Toulouse and woven in Toulouse between 1531–35 (one is dated 1532). Commenting on the *History of St Stephen*, Germain Viatte has pointed out affiliations with the Felletin weavers in La Marche and also a strong Italian influence in the designs, including the use of hemp in the manufacture (1965–6, Paris, Mobilier National Exhibition, No.6). Madame Jarry has commented on some close comparisons between *Orpheus* and a fragment of the series showing the *Birth of St Stephen*, especially the treatment of faces, hair, and the landscape behind with its hills and sparse and summary trees, and particularly the pebbles (seen in the right foreground of *Orpheus*).[1]

The two coats of arms in the field of the tapestry are those of two Gascon houses, Tersac de Montberault and La Fontaine, which adds interest to the Toulouse comparison. The words 'ORPHEVS' and 'LES IX MVSES' are inscribed, the letters on a banderole on the central tree above the group of figures.

Description. Orpheus is seated under a tree playing a harp. The nine Muses stand around him singing and playing on various musical instruments. The figures are placed in a hilly landscape, with trees and buildings. The name ORPHEVS is inscribed beneath the principal figure, and a scroll wreathed round the tree in the middle of the group bears the inscription 'LES IX MVSES'. Near the upper left-

1. Communication from Madame Madeleine Jarry, files of Textiles Department, V & A Museum.

hand corner is a shield of arms: tierced in fesse azure, or and gules, in chief three fleurs-de-lys or; for Tersac de Montberault. Slightly lower down on the right is another shield: Bendy of six or and azure, on a chief argent three ermine-tails sable; for Fontaines (?). There is no border.

Arms. The arms, despite certain inaccuracies, exemplify two Gascon houses:–

a. Tersac de Montberault, and b. Fontaines (?), respectively:–

(a) In the dexter top corner: tierced in fesse azure, or and gules in chief three fleurs-de-lys or; for Tersac de Montberault.

(b) In the sinister corner: bendy of six or and azure, on a chief argent three ermine tails sable; for Fontaines.

The house of Tersac de Montberault derived its name from seignories in the marches of Western Languedoc and Comminges (Haute Garonne Department), and appears as Lord of Montberault, near Cazères, in the County of Nébouzan, in 1215.

But scanty information is forthcoming as to the alliances of this family, of which unfortunately no pedigree would appear to exist. Bends or and azure were borne by families named La Fontaine or Fontaines, with chiefs charged with ermine tails or with helmets (Languedoc), and with bezants (Lorraine).

Pierre Paillot's *La vraye et parfaite science des armoiries*, printed in 1660, assigns to Tersac de Montberault the arms of Tersac[1] quartering: azure three bends or and a chief ermine. The following data drawn from what appears to be the only printed account[2] of the family in existence, testifies to, if it does not explain, the connection here

1. The coat of Tersac, with its three horizontal compartments is variously blazoned: a chief with lilies, supported by a device (Rietstap); a fesse and a chief (contiguous) charged with lilies (Carsalade du Pont); and a fesse with lilies in chief (Palliot).
2. 'François de Tersac' by the Abbé J. Carsalade du Pont, in the *Revue de Gascogne*, vol.XII, p.141, Auch, 1871. The

exemplified between Tersac de Montberault and Fontaines in the 16th century.

Gaspard de Tersac (d.1509) left, by his wife, Marie Beatrix de Benque a son Jean, Lord of Montberault, who is recorded to have obtained from Pope Julius III, in the year 1550, a bull dispensing him, his family and also Jean Jacques de Fontaines, of the diocese of Rieux, from the Jubiliary pilgrimage to Rome. François de Tersac, his son (b. about 1550), by Jeanne de Nubias (or Loubias) of the house of Misclas, was a principal partisan of the League in the south, and Captain of Rieux. After the accession of Henry IV, he was assigned a pension and the court appointment of 'gentilhomme ordinaire'; he married Catherine de Lambès de Savinhiac, and was buried in the church of the Dominican order at Rieux, where an imposing monument was erected to his memory. This François de Tersac is styled Lord and Baron of 'Montberault, Fontaines, et autres lieux', he is also designated 'François de Tersac de Fontenes, seigneur de Montberault'.

Museum acquisition. 336–1903. Bought from Messrs Martin van Straaten for £250. Restored by Tabard Frères et Soeurs at Aubusson, 1967.

Literature

Carsalade du Pont, Abbé J. de, 'François de Tersac' in *Revue de Gascogne, Bulletin*, vol.XII, Auch, 1871, p.141

Espagnat, E., *Notes historiques et archéologiques sur Cazères (Hte-Gne.)*, Toulouse, 1911

Jarry, M., 'Unknown tapestries at the Mobilier National' in *Burlington Magazine*, vol.CVIII, no.754, January 1966, pp.16–20

monograph by E. Espagnat, *Notes historiques et archéologiques sur Cazères (Hte. Gne)*, Toulouse, 1911, gives, besides a view of the château de Tersac, in its present condition, illustrations of the château and church of Cazères, establishing a general resemblance between the architecture of the region and that figured in the tapestry.

Viatte, G., *Le seizième siècle européen. Tapisseries*, Catalogue of the exhibition, Mobilier National, Paris 1965–6, No.6

Weigert, R.A., *French Tapestry*, London, 1962, p.88

Wescher, H., 'Textile Art in 16th century France' in *C.I.B.A. Review*, Basel, no.69, July 1948, pp.2540, 2542

No. 65 *(pl.94A)*
St. Antoninus, Archbishop of Florence
(b. 1389, d. 1459, canonised 1523)

ITALIAN, probably FERRARA; 2nd half of 15th century.

H. 5ft 10in. (1·78m.) W. 2ft 6in. (0·76m.).

Wool and silk: 14 warp threads to inch (5–6 to cm.).

Condition. Faded; a bright green in the flowers and floral border, and pink, golden yellow and pale blue in the halo and mitre, can be seen on the reverse of the tapestry. Repaired; there are numerous patches of repair, particularly in the borders.

This isolated panel of an Archbishop is unusual; it was probably woven by Flemish weavers, perhaps working in Italy at Ferrara. Although not canonised till 1523, Antoninus Pierozzi, Archbishop of Florence (1446–59), was represented as a saint in paintings of the 15th century. The inscriptions in the upper and lower borders are later restorations, but they seem to identify correctly this Dominican archbishop bearing the halo of a Beatus. They read: 'MCCCCLX; Antoninus A F' (for Archiepiscopus Florentiae). The head of the figure, which is unlikely to have any value as a portrait, is in the style of Cosimo Tura, who from 1457–80 supplied drawings and cartoons to the Flemish tapestry weavers at Ferrara (for instance, the *Deposition*, c.1475, in the Cleveland Museum, Ohio). The inscriptions on the robe and crozier staff of the

saint are later additions painted on to the tapestry, not woven into it, and have no bearing on its origin. Legible words are (on staff) 'Lorenza Micheliai'; (on robe) 'Roma'.

Description. The Archbishop is standing; he wears the Dominican habit, the pallium, gloves, and mitre. In his left hand he holds a book and a pastoral staff, and his right hand is raised in the act of blessing. The ground beneath is covered with flowering plants; the border is plain at the top and bottom, and has a hanging garland of fruit and leaves on each side. The background of both subject and border is shaded, in dark blue at the top, light blue in the middle, and brown below.

Museum acquisition. 846–1884. Bought (£96).

Literature
Kendrick, A.F., *Victoria and Albert Museum Catalogue of Tapestries*, London, 1924, No.57; pl.xxx
Viale, M.F., *Arazzi italiani*, Milan, 1961, p.13; pl.4

No. 66 (*pls.94B–95*)
Boys at play
(Giuochi di Putti)

ITALIAN (FERRARA, or possibly Mantua); c.1540.
H. 11ft 4in (3·46m.) W. 10ft 1in. (3·07m.)
Wool and silk: 16 warp threads to inch (6–7 to cm.).

Condition. A strip at the bottom has been rewoven and small repairs were probably done when the Flemish borders were woven on, including the inner guard-stripes.

Tapestries with boys at play, or winged cupids, amidst a pergola of vines trained on trees, known as *Giuochi di Putti*, were first woven for Cardinal Ercole Gonzaga, after designs by Giulio Romano in workshops in Ferrara (or possibly Mantua). Six drawings exist to establish the identity of the artist responsible for these delightful fantasies. A set of four tapestries, with two additional entre-fenêtres, with Cardinal Gonzaga's arms, are in the Calouste Gulbenkian Foundation at Lisbon, and another four pieces (same subjects, also with Gonzaga arms) are in the Vatican. The tapestries are woven with gold and silver and are without borders. The Museum piece (like a tapestry at Compton Wynyates and a fragment in Milan) would appear to come from another Italian set based on the same models (it is without additional gold and silver). Our tapestry has been furnished with Flemish borders and carefully repaired, but judging from a drawing in the Nottingham Museum it may have lost little or nothing of its original size and shape. Vasari in his *Lives* records under Giulio Romano: 'For the Duke of Ferrara Giulio prepared many designs for Arras, afterwards executed by Maestro Nicolo and Giovanni Battista Mantovani (Ghisi) . . . ' (The engravings have never been traced). However Frederick Hartt in discussing the kindred drawing of the *Erotes of Philostratus* suggests that the designs may have been for murals in a room near the secret garden in the Palazzo del Tè, on the strength of a payment to Pagni (Giulio's assistant) 'for painting putti in a room . . . with vine leaves on a blue ground', and another payment to Rinaldo (another assistant) 'for having painted half the putti and the verdure . . . in the centre of this room'. The date was January and February 1532. The murals no longer exist, but this is perhaps the more likely explanation of the original purpose of these designs, which later would have served as models for tapestries for Duke Federico's successor. (Cardinal Ercole Gonzaga became guardian of his children and the Duchy in 1540). The full design can be seen in the Ellesmere drawing, which is nearly one metre long: there are five pergola arches, those flanking the centre being lower, with the putti and the stag (as in our tapestry) occupying the centre (Sotheby Cat., No.58). This model is based on a combination of the Museum drawing (Hartt 257) (centre and right half) and the Nottingham drawing (left half); it is not considered to be by Giulio's hand, as are the other two. Clearly, it is the model for a decorative scheme and a mural would seem more in keeping with its long proportions, rather than a tapestry, as will be discussed later.

Viale describes the masterly effect of the designs as seen in the tapestries conceived without borders, giving a frieze of romping putti beneath and around a pergola, with glimpses of landscape seen beyond – a verdure effect combining animated figures with massed foliage and yet a sense of distance, 'simile ad un magico giardino, intessuto di seta, d'oro, e argento'.

A drawing in the Museum (which together with the tapestry belonged to George Salting) shows the design for the tapestry and several (but not all) details exactly: namely, the putti with stag, the two seen pick-a-back behind the fence, recumbent putto, arms linked over head, and his mate, and one swarming up a tree and another recumbent in the pergola above; the trees with apples, vines, and trellised fence are all there, but the tapestry is reversed. If the Nottingham drawing is placed on the left of the Salting drawing we have the Ellesmere modello with five arches complete. A drawing in the British Museum gives us the original sketch. The Nottingham Museum drawing is of interest, because it gives the composition and proportions of our tapestry, with one high and one low arch. The composition of the Salting drawing appears in a tapestry at Compton Wynyates (also with the Gonzaga arms) (A.F. Kendrick, *Collector*, vol.11), with three arches and four pairs of trees (if one allows for the left of the drawing being slightly cut); also, there can be seen the putti riding a tortoise and one with a shell from the Salting drawing. The disposition of these two tapestries goes back, therefore, beyond the Ellesmere modello to the original drawing; but the Gulbenkian and Vatican

sets show the fuller, more balanced composition, as well as additional scenes.

The Este started tapestry workshops at Ferrara under Giovanni and Niccolo Karcher in the early 1530s and one of the Karchers is known to have worked in Mantua for the Gonzagas; together with Giovanni Rost and their other Flemish compatriots they established more permanent workshops for the Medici at Florence in 1545. The high quality and originality of their work at Ferrara is witnessed in surviving tapestries after Italian painters, such as Dosso and Battista Dossi and Garofalo.

Giulio Romano's *Giuochi di Putti* were copied in Brussels after the middle of the century, three tapestries (with a duplicate fourth), woven by William Pannemaker belonging to the Spanish Patrimony; they are said to have come from Cardinal Granvella, a great amateur of tapestries, at Besançon. The Brussels *Boys at Play* have lost something of the gaiety, airiness and fantasy of the originals. The trees have become more solid, the foliage dense, the trellised fence has disappeared together with the poetry of the glimpsed landscape. Also the putti are wingless, as became common in the next century. The tapestries now have borders of vine-scrolls and bacchanalian masks. Playing Boy subjects were to proliferate in tapestry in the 17th century at Paris, at Mortlake and at Antwerp, whilst for the Gobelins Lebrun designed the engaging *Enfants Jardiniers*.

It should be remembered that there was an earlier *Giuochi di Putti* series in the Raphaelesque manner, but of different character, woven at Brussels after Giovanni da Udine's designs for Pope Leo X in about 1520; it was excessively costly and celebrated in its day.

Description. A central pair of apple trees entwined with a vine forming a pergola above, the vine dipping in a swag on the right below the clustering branches; a boy (or winged cupid) on the central stem above picking grapes, with another reclined above (left) munching from a bunch. A trellised fence runs behind the central trees with two disposed to the left and one to the right; a lake or estuary with ships is seen between the fence and overhanging branches and vines. On the right two cupids playing with a stag recumbent, on which one sits. To the left three cupids are playing, one swarms up a tree, and two appear above the fence looking on, one on the shoulders of the other. All the boys are winged. The border is composed of large flowers, fruit and grapes, rising from a vase with mask above at the sides, and cornucopiæ at the ends of the horizontal sections above and below. The borders have been woven onto this tapestry, probably in the last century.

Further information. The leading extant tapestries connected with the Giulio Romano drawings, apart from the Museum's, are a set of four with two additional narrow pieces (entre-fenêtres) in the Calouste Gulbenkian Foundation, Lisbon; these appear to be identical with Mme A. Cahen's (of Antwerp) pieces sold in Paris in 1920 (Georges Petit, 14 May), which had previously belonged to Lord Pirbright in England and to Baron Worms. The subjects are: (1) Boys playing with apples, (2) Playing with grapes, (3) A boat crammed with putti, with Venus in the bows, (4) Boys in a roundelay dance, watched by Venus with a harp. The composition of the first two resembles the Salting drawing but the incidents and figures are different. The tapestries bear the arms of Cardinal Gonzaga, as does a similar set of four at the Vatican with the same subjects. Another with the Gonzaga arms is at Compton Wynyates, belonging to the Marquis of Northampton; composed like the Salting drawing, it has two details from it: the cupids with a tortoise and with a shell. It has a narrow guilloche border with tassels below. There is another cut-down piece, of excellent quality, again with the Gonzaga arms, in the Poldi Pezzoli, Milan. All these were presumably woven by the Karcher brothers for the Gonzaga Cardinal at Ferrara (or possibly Mantua). Göbel states (*Romanischen Lander*, pt.i, p.406) that in the Gonzaga inventory of 1563 there are *Giuochi di Putti* tapestries and again in 1661 and 1668, where ten are listed; but since they are ascribed to Giovanni da Udine in the earliest inventory, the ten pieces may have come from two different sets (Giovanni's and Giulio's).

At one remove from these are the tapestries woven in Brussels in the third quarter of the 16th century. They are more crowded and heavy, as previously stated, the cupids are now wingless boys, and the trellised fence has disappeared; they are woven with borders. The set of three (plus duplicate) in the Spanish Patrimony bear William Pannemaker's mark, as does a set of four also woven with gold and silver thread belonging to Count Doria Dalle Rose, Venice (Brussels Exhibition 1935, No.648, pl.CLIX). Others are recorded: one in the Dollfus sale (Paris, 1912, April 12), with boys dancing in front of the opening to a pergola, or covered avenue, has groups reversed from the Pannemaker version as well as certain different features (landscape, caryatids in avenue); it may be one of the earlier Italian pieces.

Giulio Romano's drawings are discussed by Peter Ward-Jackson in his *Catalogue of the Italian Drawings* in this Museum, Cat.No.151. The Ellesmere drawing (now in the collection of Miss Jacqueline Pouncey), a school model or copy, which is nearly one metre long, shows the full design consisting of a pergola of vines climbing trees with five arches, with the putti and stag (as in the Museum drawing and tapestry) in the centre. The Museum and Nottingham drawings taken together are reproduced in this model. The British Museum sketch (*Cat. of Italian Drawings*, No.89) has been developed in the two drawings cited above and finally in the Ellesmere modello, presumably by Giulio's assistants for the large-scale work. Since none of the ten known complete tapestries (not counting the Milan fragment) are anything like the proportions of the Ellesmere modello, which would be most inconvenient for tapestry, it seems it was intended for a mural. It

was in connection with the Chatsworth drawing, the *Erotes of Philostratus*, that Frederick Hartt suggested that the Giulio drawings were for murals in the Palazzo del Tè, as stated above. The affinity of this drawing to the other *Giuochi di Putti* is apparent with the winged cupids in apple trees, wrestling and playing in various ways, and in a boat in the distance. Another drawing of *Giuochi di Putti* in Copenhagen, published by Michael Jaffé, was in Rubens' collection and has been overpainted in places, perhaps by him: the cupids no longer have wings. Since the Museum (Salting), Nottingham, Chatsworth and Copenhagen drawings are accepted as by Giulio himself (as well as the B.M. preliminary sketch), they may conceivably have served both as models for murals and (later) tapestries. A drawing in the Albertina, Vienna (Invent. No. 14188) is designed on the same pattern as the Copenhagen drawing; it does not correspond with any part of the Ellesmere-Pouncey composition. But this design is reproduced (*not* reversed) on a Mortlake tapestry (c.1640s) at Holyrood Palace, which has the 'picture-frame' borders as on the Tapestry Map of Worcestershire, No. 69. Judging from the tapestries which have survived, there must once have been a considerably larger series of these superbly decorative drawings. In tapestry Giulio Romano's fame has rested on the ten designs for the *Story of Scipio* for Francis I of France (especially the *Triumph* and *Banquet*), the other twelve designs coming from Gianfrancesco Penni for a set of twenty-two pieces (destroyed in 1797); eighteen of the designs remain (Louvre, Windsor, Chantilly, Ashmolean). Secondly, on his *Fructus Belli*, for which there are three cartoons in the Louvre and tapestries at Vienna (Kunsthistorisches Museum). Less grandiose, but more original and pleasing, are the *Giuochi di Putti*, whose influence runs into the 18th century; the chain of reproduction has been admirably sketched by Mme Jarry in *L'Oeil* (Dec. 1971).

Inventories show that boys were a popular subject in Gothic tapestries. But Leo X's *Playing Boys* ordered in 1520 for the Constantine room at the Vatican was a new departure. Vasari ascribes the designs to his friend Giovanni da Udine; Tommaso Vincidor was sent to Brussels to supervise the cartoons and weaving in Pieter van Aelst's workshop. Vincidor's letters from Brussels have confused the issue of the designer, but it would be normal in the tapestry workshops at Brussels for a great deal of work to go into the translation of the artist's designs into cartoons, for which Vincidor was presumably responsible. The original set, woven with masses of gold and silver and more expensive than *The Acts*, disappeared after 1790, but it is known from a single piece, woven in the 1530s at Ferrara, preserved in Milan cathedral, and from 17th century versions from the Barberini workshops in Rome (Louvre, Budapest). The design is quite unlike Giulio Romano's, with large putti and heavy swags laden with Medici emblems (ostrich feathers, peacocks, lions, bees, the yoke, etc.). Though both these two themes were reproduced in later tapestries, Giulio's had by far the greater influence.

Museum acquisition. T.405-1910. Bequeathed by George Salting (No. 2122). From the Bandini Sale, Christie's, 1899.

Literature

British Museum, Department of Prints and Drawings, *Italian Drawings in the Department–Raphael and His Circle*, by P. Pouncey and J. Gere, London, 1962, p.678, No.89

Brussels, Exhibition 1935, see Crick-Kuntziger, M.

Cahen, *Collection de Madame A. Cahen*, Galerie Georges Petit, Paris, 14 May 1920, Nos.43-8

Crick-Kuntziger, M., *Cinq siècles d'art, Mémorial de l'Exposition*, Memorial volumes to the Brussels International Exhibition 1935, Brussels, 1936, vol.II, pl.CLIX

Dollfus, *Collection de M. Jean Dollfus*, Galerie Georges Petit, Paris, 2 April 1912, pt.III, No. 193

Duverger, J., *Tapisseries flamandes d'Espagne*, Catalogue of the exhibition, Musée des Beaux Arts, Ghent, 1959, pls.22-3

Ellesmere, *The Ellesmere Collection Part II. Drawings by Giulio Romano*, Sotheby & Co., 5 December, 1972, lot 58

Ghent, Exhibition 1959, see Duverger, J.

Göbel, H., *Wandteppiche I. Die Niederlande*, Leipzig, 1923, pt.ii, pls.100, 101

Göbel, H., *Wandteppiche II. Die Romanischen Länder*, Leipzig, 1928, pt.i, p.406; pt.ii, pls.358, 359

Guerreiro, G., 'Tapecarias da Colecção Calouste Gulbenkian' in *Colóquio*, no.41, December 1966, pp.8-11

Guerreiro, G., 'Some European Tapestries in the Calouste Gulbenkian Collection in Lisbon' in *Connoisseur*, CLXXIII, April 1970

Hartt, F., *Giulio Romano*, New Haven, U.S.A., 1958, vol.I, p.159 and nos.217, 255-7; vol.II, figs.354, 516

Heinz, D., *Europäische Wandteppiche*, Braunschweig, 1963, pp.178-80, 264, fig.183

Jaffé, M., 'Rubens as a Collector' in *Master Drawings*, New York, 1964, vol.II, p.390; pls.17 and 18

Jarry, M., 'Jeux d'amours, jeux d'enfants' in *L'Oeil*, December 1971, pp.2-9

Kendrick, A.F., *Victoria and Albert Museum Catalogue of Tapestries*, London, 1924, No.56, pl.XXIX

Kendrick, A.F., 'Art Notes' in *Collector*, vol.XI, 1930, pp.216-19

Müntz, E., *Histoire générale de la tapisserie en Italie*, Paris, 1878-84

Pouncey, P., and Gere, J., see British Museum

Thomson, W.G., *A History of Tapestry*, London, 1930, p.231

Tormo y Monzó, E., and Sánchez Cánton, F.J., *Los Tapices de la Casa del Rey N.S.*, Madrid, 1919, pp.107-8; pl.37

Viale, M. Ferrero, *Arazzi italiani*, Milan, 1961, pp.21, 24, 25; pls.14, 15, 22

Ward-Jackson, P., *Victoria and Albert Museum Catalogues, Italian Drawings*, vol.I, *14th–16th century*, London, H.M.S.O., *in press*, No.151

No. 67 (*pl.96*)
Manhood *from The Life of Man*

ITALIAN (FLORENCE, BENEDETTO SQUILLI); c. 1560.
H. 15ft 4in. (4·67m.) W. 14ft 5in. (4·40m.).
Wool and silk: 19 warp threads to the inch (7–8 to the cm.).

Condition. The silk going in places. Some fading; otherwise good.

In the records of the Medici tapestry workshops detailed by Cosimo Conti (pp.51–2) an entry of 21 October 1560 notes that 'Giovanni della Strada Fiammingo' was credited with the cartoons of the *Life of Man*, made to the instructions and designs of Giorgio Vasari and woven as tapestries by Squilli. At this time Vasari was deeply involved in the decoration of the Palazzo Vecchio, where since 1555 he and numbers of assisting artists, Stradanus among them, had been translating into visual terms the complicated iconographic programmes suggested by Vasari's friends Vincenzo Borghini and Cosimo Bartoli. The decoration involved large numbers of tapestries, for, as Vasari explained, the subjects depicted in each room were planned in such a way that 'All that could not be included on the ceilings was placed in the friezes of each room, or has been placed in the arras-tapestries that the Lord Duke has caused to be woven for each room from my cartoons, corresponding to the pictures high up on the walls.' The translator of this passage should have written of Vasari's 'designs' rather than 'cartoons', since Vasari always gave credit for the cartoons to Stradanus: 'the principal task of this man is to make cartoons for various arras-tapestries . . . in accordance with the stories . . .

painted by Vasari in the Palace . . . to the end that the embellishment of tapestries below may correspond to the pictures above . . . he has made very beautiful cartoons for . . . ten pieces of tapestry in a hall in which is the Life of Man' (Vasari, 'Of the Academicians . . .', trans. vol.x, p.18).

Of these ten tapestries there has since been no trace. No drawing or engraving has been associated with them, and no tapestry identified as belonging to the series. Two surviving tapestries, however, can be so identified. The tapestry in this Museum shows Man midway in his pilgrimage of life, ascending the mountain of salvation in the company of two female figures and a winged child. Two other women await them half-way up the mountain. One of the women in the foreground carries a golden bowl from which two wings protrude. This symbol formed part of a conceit on the 'Life of Man' sent to Vasari in 1552 by Cosimo Bartoli (*Lo Zibaldone*, p.151). Unfortunately only the final part survives; the 'same man' accompanied by 'the four women' takes the path to the summit of the mountain towards the altar, and ascends into heaven to kneel before the throne of Jove. Having placed the bowl with the two wings at the foot of the throne, Man is stripped of his garments by the women, who throw them down into the world below, leaving him naked face to face with Jove.

The theme was used by Vasari in 1555 for the programme of frescoes for the house front of Almeni Sforza in the Via de' Servi, Florence, painted by Christoforo Gherardi and Vasari. In his Life of Gherardi (pp.132–7) Vasari describes these frescoes in great detail, being fearful, with reason, that they would not survive weathering. Bartoli's allegory was altered slightly. Vasari depicted the 'Life of Man' in seven scenes. The fifth, *Virility*, showed 'a mature man standing between Memory and Will who hold before him a golden bowl in which are two wings and point out to him the way of salvation leading to a mountain'. The sixth, *Old Age*, showed 'an elderly man dressed as a priest who kneels before an altar on which is placed the

golden bowl with the two wings'. The seventh, *Decrepitude*, depicted a naked man received in heaven by Jove while Felicity and Immortality cast his clothes down into the world.

The bowl with wings, placed before the throne of Jove or offered on an altar, is presumably symbolic of the 'Life of Man', the wings perhaps representing the Active and the Contemplative Life,[1] further aspects of which figured prominently in another part of Vasari's fresco. There can be little doubt that any Florentine tapestry stylistically consistent with a date around 1560 and containing this symbol must be a surviving piece from the Vasari-Stradanus *Life of Man* tapestries. Consequently a companion piece in the Musée des Gobelins, Paris, with borders and scene related to the V & A Museum tapestry, also belongs to this set. It shows the same man with the same two women and winged child, one woman carrying a covered bowl, all looking towards a light falling from heaven on a mountain.

To confirm the identification of these two tapestries, their figures appear again in a series of six prints of the 'Life of Man' after Stradanus engraved by Furnius in 1570. The scenes of the two tapestries are shown as one in the background of the fifth print. Man, with the winged child and two women, one carrying a covered bowl, walks towards a mountain on which a light shines from heaven and where two women wait for him. The text beneath this engraving explains that he is led by Faith and Innocence towards the mountain, where Religion and Piety urge him to ascend.

In this series of engravings, which like the frescoes links the Ages of Man with the Pilgrimage of Life, Youth is given the choice between the World, the Flesh and the Devil and the Path of Virtue. Manhood is assisted by the four Cardinal Virtues. The conclusion of the series shows Man, as in the

[1]. C. Landino in his dialogue on the Active and the Contemplative Life (1508) compared 'iustitia' and 'religio' the principles of action and contemplation, to two wings which 'carry the soul to higher spheres' (E. Panofsky, p.139).

fresco, dressed as a priest and offering the bowl with the wings upon an altar. Then Religion and Piety lead him up to Heaven, where he kneels naked before God. It seems likely that these engravings reflect the designs of the eight lost tapestries, linked still to humanistic themes but given a more specifically Christian context than Vasari's neo-platonic frescoes.

Description. In the foreground, seen in profile or from the back, walk a middle-aged man in a short tunic flanked by two women. The woman to his right, by whom walks a small winged child, is probably a personification of Faith accompanied by Divine Love. The woman to his left, who carries a golden bowl from which two wings protrude, is a personification of Innocence, holding a symbol of the Life of Man. They walk through a rocky landscape with ruins of some classical buildings on the left. Before them the ground rises, and at the foot of a mount in the distance are the small figures of two more women, Religion and Piety.

The wide border contains thick strapwork and human figures, pairs of men and women of varying ages seated in the corners, children climbing through the strapwork. At the sides are male herms bound with draperies, with gorgon and man-lion masks beneath them. The scrolling strapwork in the corners has goat-satyr masks. In the centre of the upper border large satyr masks, a swag of fruit between them, flank a cartouche in which two linked female herms raise smaller masks. In the centre of the lower border a female holds a basket of fruit on her head.

Each tapestry in the set may have had a different though related border design. The tapestry in the Musée des Gobelins, Paris, is narrower and so omits the adult figures in the corners, replacing them with more children. Only one figure of a child is the same in both tapestries. The herms in the Paris side borders are not full-face but look inwards towards the source of light in the scene beneath them.

The colours are mostly fresh yellows and greens with blues and pale browns. There is very little red, but the tapestry is enlivened by touches of sharp pink.

Further information. Vasari's designs for the *Life of Man* tapestries do not figure in his records of work done and payments made. Possibly he did not himself design or paint the frescoes in the hall 'wherein is the Life of Man': all notes of other work on tapestries are tacked on as an afterthought to the records of his paintings for the palace. It is, however, possible to date the designs with fair certainty to 1559–60 from the speed with which the other tapestries recorded in the Medici workshops followed the documented designs: for example, tapestries for the room of the Goddess Ops were designed and woven in 1557; the Triumph of Saturn with the Three Fates, designed in 1558, was delivered in 1559. By the same argument, though the delivery of the *Life of Man* tapestries is not recorded, it probably followed hard upon the note crediting Stradanus with the cartoons, or was even contemporary with it. In the following year, 1561, the workshop records noted the work of Stradanus on the cartoons of the *Story of David* and the work of Squilli on the tapestries of *David* under the same date.

The first part of Vasari's *Ragionamenti*, the explanation, room by room, of the iconography in the Palazzo Vecchio, was published in 1557, covering only the room with the Elements, various gods and goddesses and Hercules. The second part, published in 1563, dealt exclusively with the series of rooms dedicated to the lives of the Medici. The part of the palace not described in detail was that which contained the rooms of the Duchess, with those of the Duke below. As the room with the 'Life of Man' was also not described in detail it presumably lay in this section of the palace; a supposition strengthened by Vasari's description of the work of Stradanus, mentioning the 'Life of Man' between the tapestries made for these two

sets of rooms. A record of 1562 noted that the cartoons were for tapestries for the room 'where his Excellency eats in winter' (Orbaan, p.48).

The majority of tapestries for the Palazzo Vecchio were woven in the workshop of Benedetto Squilli, established with ducal patronage in the 1550s and lasting until Squilli's death in 1587.

Museum acquisition. T.110–1975. Purchased from a dealer for £4,500. The tapestry was put up for sale at Sotheby's on 21 June 1974, lot 9.

Literature

Chew, S.C., *The Pilgrimage of Life*, New Haven and London, 1962

Conti, C., *Richerche storiche sull'arte degli arazzi in Firenze*, Florence, 1875

Göbel, H., *Wandteppiche II. Die Romanischen Länder*, Leipzig, 1928, pt.i, p.389

Orbaan, J.A.F., *Stradanus te Florence*, Rotterdam, 1903

Panofsky, E., 'The Neoplatonic movement in Florence and Northern Italy' in *Studies in Iconology*, Oxford, 1939

Vasari, G., *Le Opere di Giorgio Vasari*, G. Milanesi, 1878–82. *Giovanni Stradano*: vol.vii, pp.617–18; *Cristofero Gherardi*: vol.vi, pp.231–37; *I ragionamenti*: vol.viii, p.882

Vere, Gaston du C. de, Translation of *Le Opere*, Medici Society, 1912–15

Vita, A. del, 'Lo Zibaldone di Giorgio Vasari' in *R. Instituto d'Archeologia e Storia dell'Arte*, Rome, 1938, p.151

England. William Sheldon (Nos. 68–73)
(*pls.97–108*)

There are many references to arras-makers in 15th–16th century England (W.G. Thomson, chs.3 & 8) but it has never been established that there was a manufactory of any standing before William Sheldon set up workshops under Richard Hyckes

(or Hickes as the name was later spelt) at Barcheston in Warwickshire and Bordesley in Worcestershire. Undoubtedly the greater part of the references are to tapestry weavers engaged basically in repair and maintenance work and many of them must have been capable of weaving coats of arms to apply to hangings. With the coming of the Protestant émigrés from the Netherlands in the 16th century it would be strange if no small individual workshops had appeared, in Norwich, Sandwich and elsewhere, such as those which perhaps produced the knotted pile carpets, which are undoubtedly English (the Verulam carpet dated 1570, the Duke of Buccleuch's carpets, two dated 1584 and 1585; see Tattersall, *British Carpets*), but a tapestry workshop needed considerable capital and patronage. Possibly the tapestry table-carpet with the arms of Sir Andrew Luttrell and Margaret Wyndham and several allied families was produced in such a way, although its excellent quality and difficult design seem to make this extremely doubtful (Göbel, *III*, ii, p.153); it dates from the middle years of the 16th century and is now in the Burrell Collection (W. Wells, *Scottish Art Review*, vol.XI, 1963, no.3, pp.14–18). Dr H. Göbel accepts the declaration in William Sheldon's will that Richard Hickes introduced the art into England as showing that by 1570 there was no memory of a tapestry manufacture of consequence in this country.

William Sheldon's long and detailed will of 1569/70, with a codicil written in September 1570, gives solid ground for understanding the nature of the enterprise which he successfully set up. The Sheldons had long been established in Worcestershire as rich country squires. They had worked for Thomas Cromwell in the dissolution of the monasteries and William Sheldon was Receiver for the King in 1546–7; he was Member of Parliament for Worcester in 1545 and 1554–5; he enlarged his estates and became increasingly prosperous in the two following decades. His will shows that he had established and confirmed Richard Hickes, whom

he refers to as 'the only author and beginner of this art within this realm, ... in the mansion house at Barcheston, with the myll, orchards, and gardens and pastures, without paying any rent in money, chiefly in respect of the Mayntenance of making tapestry, arras ...' (other cloths are mentioned). Barcheston had been acquired in 1561 and there is a record of an order for tapestry in 1568. The will is quoted by John Humphreys (*Elizabethan Sheldon Tapestry*, pp.11–12) and has been more fully quoted and analysed by E.A.B. Barnard (Barnard and Wace, pp.256–8). It is clear that Sheldon had set up workshops near his two country seats, at Bordesley near Bewley in Worcestershire, and at Barcheston near Weston Park in Warwickshire, and was providing for their financial maintenance in securing rent-free premises and lands out of his estates. Besides Richard Hickes, William Dowler and Thomas Chaunce (or Chance) are mentioned. Barnard has shown that all three, particularly Hickes, were men of property and must be regarded as managers employing artisans for much of the weaving. It is true that Francis Hickes, Richard's son, is described as the son of an arras-worker, but he was sent up to Oxford in 1579 (at the age of thirteen) and although he too was an 'arras-worker' and on the Lord Chamberlain's payroll as such, he was also something of a scholar as *his* son later took pains to make known, publishing his *Dialogues of Lucian*. Richard and Francis Hickes' long connection with the Great Wardrobe, as Royal arras-workers, seems to imply a profitable position, not that of an artisan, as is clear from later examples of men of means on the payroll at a few pence a week, but enjoying other benefits and influence.

The name of only one of the foreign artisans who worked for Richard Hickes has survived, Peter the Dutchman, who was buried at Barcheston in 1590. Sheldon's will makes it clear that part of his aim was economic, both to provide tapestries which would otherwise have to be bought abroad, and particularly to teach the trade to local people in

Worcestershire, Warwickshire, Gloucestershire, Oxfordshire, Berkshire and neighbouring regions. H. Göbel in his account of Sheldon stresses this aspect, but he believes a number of Flemish or Dutch artisans must originally have been employed and if only one can be found mentioned in the local records, it is because the others returned home before they died (Göbel, *III*, ii, pp.156–57). It is certain that Robert Dudley, Earl of Leicester, thought in this way when, in 1571, he was solicited by the Town of Warwick for aid for the poverty there, replying: 'I marvaile you do not devise some ways amongst you, to have some speciall trade to kepe your poore on woork as such as Sheldon of Beolye which me thinkith should not only be very profitable, but also a meanes to kepe your poore from Idelnes' (Humphreys, p.12).

The Sheldons and the Hickes seem to have well gauged the capacities of their two small workshops in producing useful and appropriate hangings, bed-curtains and cushion-covers for the use of the prosperous houses of rural Elizabethan England. To the not inconsiderable number of pieces which can fairly be assigned to them, as has been done by A.J.B. Wace (Barnard and Wace), there are written records of some orders of which no trace of the tapestries themselves has survived – enough to give a fair impression of this small country industry. To enumerate the latter briefly: William Sheldon speaks of 'the hangings of Tapestrye & Arras which I do will shall remain at Bewley from heyre to heyre' (his Will of 1570, see Humphreys, p.12; Barnard, pp.261–2) – presumably from his own looms in the same way that Weston was furnished with tapestry Maps. In 1568 hangings with the Talbot arms were supplied to John Talbot for Grafton Manor (Humphreys, p.13), and a set of tapestries to Sir George Calveley in 1571. In 1591 the Countess of Shrewsbury (Bess of Hardwick) 'Paid Mr Sheldon's man for seventeen armses to set upon hangings xxxs iiid., and also ten shillings to hang the tapestries' (Barnard, pp.279–80). In 1605 Thomas Hoerd of London,

who had lent money to Ralph Sheldon (the elder) claimed for delivery of 'certain hangings of Tapistrie for the furniture of two chambers, and one bed throughlie furnished . . .' (Humphreys, p.15; Barnard, p.280).

In order to understand the Museum's group of Sheldon tapestries, some further information about the Sheldon and Hickes families may be outlined (see the Genealogical Table below). William Sheldon married (first) Mary Willington, elder daughter of a wealthy wool-merchant, who lived at Barcheston and owned large estates there (see Map, Barnard and Wace, p.260). William, on inheriting from his father, lived at Beoley, which he emparked. In 1534 he bought Weston House, near Barcheston (see Barnard, p.255; *not* in 1545 as Humphreys states, p.11) and obtained a license for a 300 acre park. In 1561 he obtained Barcheston, which William Willington had left to a Barnes cousin, and it was there that he installed Richard Hickes and the looms (with another workshop at Bordesley). He died in 1570–1 and the memorial in Bewley Church, placed there by his son Ralph (the elder), records: ' . . . such was his patriotism that he introduced the art of tapestry-weaving into England at his own expense and bequeathed sums of money in his will towards the maintenance of craftsmen of that kind . . .' (Nash, *History of Worcestershire*, vol.I, p.69; see Barnard, p.259). Ralph Sheldon married (first) Anne Throckmorton in 1557 at the age of twenty. On his Memorial tablet, also in Bewley Church, his foreign travels are mentioned before his going to Court and his marriage, and it has been suggested that these travels may have had something to do with Richard Hickes' weaving apprenticeship in the Netherlands. In 1588 Ralph Sheldon began the rebuilding of Weston Park, borrowing in 1605 £24,000 from Thomas Hoerd, and leaving Weston one of the grand mansions of the country. He died in 1613.

To turn now to the Hickes family. Richard was born about 1524; he was supplying tapestry from Barcheston ('Barston' as then often called) in 1568, and in 1584–5 (aged sixty) his name heads the list of Royal arras-workers in the Lord Chamberlain's accounts (Barnard, pp.264–73). In about 1587 he returned to Barcheston and, since one of the Maps woven for the new Weston Park has the date 1588, it is conjectural that this was the reason for his return. Meanwhile his son Francis continued at the Great Wardrobe and his name is placed at the head of the payroll to the Royal arras-workers. From 1584–1606 materials were yearly supplied from Barcheston to the Royal arras-workers. In 1603 Francis returned to Barcheston; his father was already old, though he did not die till 1621 aged about 97. Apart from the Sheldon will, the principal reference to Richard Hickes as a weaver is found in the later diaries of Anthony Wood of Oxford, antiquary (1632–1695); 'The first Rich. Hycks here mentioned was bound prentice to a Dutch arras weaver in Holland by Ralph Sheldon (who built the great house at Weston in Com.Warw. in 1588) and being out of his time settled at Barcheston a mannor yt belongs to the Sheldons, and made and weaved those fair hangings yt are in ye dining roome at Weston' (see Barnard, p.259, note 2). It is doubtful how accurate this record is, but it reflects some factual information. Francis Hickes, the son, died in 1630 aged sixty-four.

The later members of the Sheldon family can best be seen in the abbreviated Genealogical Table, given here. Ralph Sheldon the younger, who made a name as an antiquarian and lived in style at Weston Park until 1684, was the great-grand-son of

Genealogical Table (*abbreviated from J. Humphreys*)

A	William Sheldon of Beoley; (*?* – d.1570)	*married*	(1) Mary, daughter of William Willington County Warwick, d.1553
			(2) Margaret, daughter of Sir Richard Brooke
B	Ralph Sheldon (the Elder) of Weston; (1537–1613) (1)	*married*	(1) Anne, daughter of Sir Robert Throckmorton of Coughton, d.1603
			(2) Jane, daughter of William West, Lord Delaware
C	Edward Sheldon of Beoley & Weston: (1558–1643) (2)	*married*	Elizabeth, daughter of Thomas Markham, Co. Notts
D	William Sheldon, (1589–1659)	*married*	Elizabeth, daughter of William, second Lord Petrie
E	Ralph Sheldon (the Younger), (1624–1683) (3)	*married*	Henrietta Maria, daughter of Savage, Viscount Rocksavage
	(see *Dictionary of National Biography*; this Ralph Sheldon was known as an Antiquarian)		

(1) Arms on 16th century screen-panel from *Map of Oxfordshire and Berkshire* and in 17th century version of *Map of Worcestershire*.
(2) Arms on 17th century version of *Map of Warwickshire* (+ Markham).
(3) Arms on 17th century version of *Map of Oxfordshire and Berkshire* (+ Savage).

Ralph the elder. Apart from the names of Richard and Francis Hickes, which are found on the tapestry Maps, the arms of William Sheldon (the elder) and Willington appear on *Worcestershire*, Edward Sheldon and Markham also on *Worcestershire*, and Ralph Sheldon the younger and Savage on *Oxfordshire and Berkshire* – in each case on the 17th century versions, but presumably copied from the 16th century originals. The arms of Ralph Sheldon the elder are to be seen on one of the two-fold screen panels of 16th century date from Weston Park and Strawberry Hill, and now in this Museum, No.68 (bequeathed by Mrs McKnight Franchot). As for the English artisans, trained as tapestry-weavers, these were almost certainly not absorbed by Mortlake (founded 1619) but some of them may have found employment at the Great Wardrobe.

Literature

Antiquaries, Society of, *Proceedings*, vol.XXVI, 1914, pp.236–38

Barnard, E.A.B., and Wace, A.J.B., *The Sheldon Tapestry Weavers and their Work*, Society of Antiquaries, Oxford, 1928. Also published in *Archaeologia*, vol.LXXVIII, 1928, pp.255–314

Bodleian Library, *Rawl MS*. D.807

Clark, Andrew, see Wood, Anthony

Cunningham, P., ed., *The Letters of Horace Walpole, Earl of Orford*, London, 1866, vol.VIII

Digby, G. Wingfield, *Elizabethan Embroidery*, London, 1963

Göbel, H., *Wandteppiche I. Die Niederlande*, Leipzig, 1923, pt.i, p.539; pt.ii, pl.490

Göbel, H., *Wandteppiche II. Die Romanischen Länder*, Leipzig, 1928, pt.i, p.208

Göbel, H., *Wandteppiche III. Die Germanischen und Slawischen Länder*, Berlin, 1933–34, pt.ii, pp.153, 155–7, 161–8; pls.123–8

Heinz, D., *Europäische Wandteppiche I*, Braunschweig, 1963

Humphreys, J., *Elizabethan Sheldon Tapestries*, London, 1929

Kendrick, A.F., *Victoria and Albert Museum Catalogue of Tapestries*, London, 1924

Nash, T.R., *Collections for the History of Worcestershire*, London, 1781–82

Nichols, J., *Literary Anecdotes of the 18th century*, London, 1812–15, vol.VI, p.326

Strawberry Hill, *A Catalogue of the Contents of Strawberry Hill*, 25 April–21 May, 1842, Lot 59

Tattersall, C.E.C., *A History of British Carpets*, Leigh-on-Sea, 1966

Thomson, W.G., *Tapestry Weaving in England*, London, 1914

Victoria and Albert Museum, *Portfolios. Tapestries Part III. Tapestry Maps*, London, H.M.S.O., 1915

Wells, W., 'The Luttrell Table Carpet' in *Scottish Art Review*, vol.XI, no.3, 1968, pp.14–18

Wood, Anthony, *The Life and Times of Anthony Wood, antiquary of Oxford, 1632–1695, described by himself. Collected from his Diaries and other Papers by Andrew Clark*, Oxford Historical Society, 1891, vol.I, 1632–1663, p.477n

No. 68 (*pls.97A & B*)
Two Panels
from the Map of Oxfordshire and Berkshire

ENGLISH, SHELDON LOOMS, c.1588
H. 4ft 1¾in. (1·26m.) W. 2ft 1¾in. (0·65m.) each.
Wool and silk: 16–17 warp threads to inch (6–7 to cm.).

Condition. Cut and formerly mounted as a two-fold screen. Preservation excellent.

These two panels, cut out of the large tapestry map of Oxfordshire and Berkshire, were mounted as a two-fold screen and bought in this form at the Weston Park sale in Warwickshire in 1781 by Horace Walpole, who kept them at Strawberry Hill. Because of their excellent condition and freshness of colour they are of exceptional importance, showing as they do the quality and texture of the original Sheldon tapestry maps; taken together with the large, though fragmentary portions of the Bodleian *Map of Worcestershire* (on loan to the Victoria and Albert Museum), they give a remarkable impression of the original hangings with their lively borders, inscriptions and armorial devices.

At the Strawberry Hill sale in 1842 under lot 59 the screen-panels are described as follows and were bought by R. Strong of Bristol for twelve guineas:

'59 *A Folding Mahogany Screen*, mounted with rare and curious specimens of ancient needlework, representing on one side a coat of arms, with a Wild Boar beneath, and on the other a Map of parts of the Counties of Surrey and Middlesex, and Anthony and Cleopatra represented beneath.

The screen is covered with part of the first tapestry that was wrought in England, it came from Weston, in Warwickshire, the seat of Ralph Sheldon, Esq., whose ancestor brought the art into England; the remainder of this tapestry is now at the seat of the Earl of Harcourt, Nuneham, in Oxfordshire, 1784.

The complete suite of hangings was purchased by Horace Walpole, and presented by him to the Earl of Harcourt. This specimen has never been hung up.'

Hitherto the screen had been wrongly identified with the panels in the possession of Henry Birkbeck, later owned by Viscount Ednam, and more recently by Mr E. Guinness. The screen was bequeathed by Mrs Louisa Griswold to the grandfather of Mrs McKnight Franchot (Mr Charles Scott McKnight of New York) sometime before 1875.

Description. Part of the lower edge of the tapestry map of Oxfordshire and Berkshire, showing a portion of Surrey, Middlesex and a short stretch of the River Thames, enclosing approximately an area between Shepperton and Kingston in the North, and Woking and Leatherhead in the South. Kingston-on-Thames with its bridge, Hampton Court, Otelands, Effingham and other historic places are shown. Part of the border of the map is

visible, with a female figure (Temperance?) seated beneath a canopy and pouring water from an ewer into a goblet. On her left the advancing figure of Mercury. (According to the Strawberry Hill Catalogue, these figures were identified as Anthony and Cleopatra).

The second panel has the lower right-hand corner from the same map with the coat of arms of Ralph Sheldon senior (1537–1613) and the family motto 'OPTIMUM PATI'. In the border the Erymanthean Boar and the tip of Hercules' club (which is visible in the right border). The Ralph Sheldon exemplified in the arms was the son of the original William Sheldon and great-grandfather of Ralph Sheldon the younger.

Further Information. The fragmentary remains of Oxfordshire and Berkshire belonging to the Bodleian Library, Oxford (on loan to this Museum), carry an inscription paraphrased from the account of Oxford in Camden's *Britannia*, published in 1586 (see Victoria and Albert Museum Portfolio).

Museum acquisition. T.61 & A–1954. Given by Mrs McKnight Franchot of Cambridge, Massachusetts.

No. 69 (*pls.98–99*)
Map of Worcestershire

ENGLISH, WOVEN FROM THE SHELDON CARTOONS; mid-17th century.
H. 13ft (3·96m.) W. 19ft 11in. (6·7m.).
Wool & silk: 22 warp threads to inch (9 to cm.).

Condition. Faded, particularly the yellows and greens; the names (in black) worn, otherwise condition good.

This is one of the three large tapestry *Maps* with plain 'picture-frame' borders, one of which (*Oxfordshire and Berkshire*) has the arms of Ralph Sheldon the younger (1623–1684), which came from the sale of Weston Park in Warwickshire in 1781; at the same time three older, but by then fragmentary tapestry *Maps* were also sold there. Weston House (before it was emparked) had been acquired by William Sheldon, the founder of the tapestry looms, in 1534 (it was close to Barcheston, the home of his wife, Mary Willington) and William's son Ralph the elder had started rebuilding Weston as a great mansion in 1588. William Sheldon was the friend and patron of Richard Hickes (or Hyckes), who with his son Francis and others conducted the two Sheldon tapestry workshops at Barcheston (the house was acquired by William Sheldon in 1561), and at Bordesley near Beoley, the Sheldon seat in Worcestershire. The earlier set of tapestry *Maps*, which was fragmentary by the time of the Weston sale in the 18th century, bore the date 1588, the name of Richard Hickes, and the royal Tudor arms; presumably the *Maps* were specially woven for the new Weston Park. The later set of three *Maps*, to which the present piece belongs, has the arms of Ralph Sheldon the younger and his wife Henrietta Maria, daughter of Viscount Rocksavage, on the *Oxfordshire and Berkshire* map; they married in 1647. Although these later tapestries retain the main features (and some names and arms) copied from the older series, they must be regarded as replacements woven for the antiquarian great-grandson of the elder Ralph. Anthony Wood, the Oxford antiquary (1632–95), records in his Diaries that tapestry *Maps* hung in the Dining room at Weston Park (see Barnard and Wace, p.259, note 2). Apart from the Sheldon and Savage arms on one of the pieces, the borders on all three are incompatible with an earlier date, and the weaving and colouring are much less lively than in the Elizabethan tapestries. We shall return to consider the original set in relation to the later *Map of Worcester* presently.

Description. Map of Worcestershire and parts of neighbouring counties. In the centre of the top border is an oval shield flanked by putti with fruit, in the lower border Neptune with a trident. On the lower left of the tapestry is a pair of dividers marking a scale of miles and the inscription (as on the earlier map) WIGHORN COMI LOCUPLETATA RIC HYCKES ('the County of Worcester enriched by Richard Hyckes'). The map extends from the Golden Vale in Herefordshire on the West to Somerton, a village on the Cherwell in the East, and from Dudley Castle in Staffordshire in the North to Sudeley Castle in Gloucestershire in the South. Thus as well as Worcester the map includes part of the counties of Warwick, Oxford, Gloucester, Hereford, Shropshire and Stafford.

The 'Redston Passag' across the Severn is illustrated adjoining the hermitage near Stourport. This was the direct route from Wales to Worcester.

In the left top corner are the arms of Sheldon and Willington, referring to William Sheldon (d. 1570) and his first wife. On the right are the 'modern' arms of the City of Worcester.

The borders are of the type modelled on carved picture-frames with a cartouche at the centre top and centre bottom, the latter with Neptune reclining, trident in hand, by a windy sea.

The 1588 Tapestry Maps. The original Sheldon *Maps* are based on Christopher Saxton's surveys of the counties of England, a series of maps published between 1574–79, but the tapestries include many additional features. Thus, although Saxton's map of *Worcestershire* (No.4) covers the same area, no details are given of the surrounding counties and no roads are marked, although roads appear on the tapestries. The first printed map showing roads was not published till five years after the probable date of the tapestries (1588, on *Warwickshire*, presumably copied from original weaving) (see Barnard and Wace, pp.289–90, 307). The *Worcestershire* map has a picture of the celebrated beacon in the Lickey Hills, a large iron tripod supporting an upright bar with five steps for ascent, and on the summit a cresset from which flames are emerging. Not far away is the Bell Inn, the only inn repre-

sented in the *Maps*. Lower down in Herefordshire between Yalton and Kynaston, appears the curious inscription 'which was dryven down by the removying of the ground' (see Victoria and Albert Museum Portfolio; Barnard & Wace, pp.289–90).

Of the three original *Maps*, only portions and fragmentary parts have survived: (1) *Worcestershire*: there is a major lower portion (cut on right side) with border on left side and beneath, and an isolated strip above. (2) *Oxfordshire & Berkshire*: small fragments with two slightly larger portions tenuously connected. (3) *Gloucestershire* is in four fragments. These fragmentary remains were bought by the antiquary Richard Gough for one guinea and bequeathed by him in 1809 to the Bodleian Library, Oxford. His manuscript note in the Bodleian states: 'I purchast for £1.1.0 three fragments of these maps containing the inland counties of Hereford, Salop, Stafford, Worcester, Warwick, Gloucester and Oxford and part of Berkshire' (see Victoria and Albert Museum Portfolio). They have been on loan to this Museum since 1913. Two fragments of *Gloucestershire* came into the possession of Henry Birkbeck, whence they passed to Viscount Ednam and now belong to Mr E. Guinness. Two other pieces, of *Oxford and Berkshire*, mounted as a two-fold screen, were acquired at the Weston Sale of 1781 by Horace Walpole and remained at Strawberry Hill till 1842; they are now in this Museum (see No.68).

The 17th century Tapestry Maps. To return to the later *Maps, Oxford and Berkshire, Warwickshire,* and *Worcestershire* (the last now in this Museum) which were bought by Horace Walpole for £30 at the Weston Park Sale. In a letter dated 12 September 1781 he wrote to the Countess of Ossory, 'I have made some purchases, too, at Mr Sheldon's, very cheap indeed, and shall go down on Friday to see them' (Horace Walpole's *Letters*, edited by Cunningham, vol.VIII, p.81). He gave the three hangings to Lady Harcourt, who built a special room at Nuneham for them (Victoria and Albert Museum Portfolio). In a letter to Richard Gough, the antiquary, answering an enquiry of the latter of 21 November 1783, Lord Harcourt writes: 'The very valuable Maps in Tapestry, made in the reign of Queen Elizabeth, brought from Mr Sheldon's, are now in my possession. I have had them repaired and cleaned, and they are as fresh as when first out of the loom. They are not yet hung up; but I mean to erect a Gothic tower on purpose to receive that magnificent mark of the friendship of Mr Walpole, who gave them to me' (Nichol's *Anecdotes*, vol.VI, p.326; the further remarks on pages 329–30 confuse these *Maps* with those bought by Richard Gough and given to the Bodleian). In 1831 Archbishop Harcourt presented these three *Maps* to the Yorkshire Philosophical Society. After being on loan in this Museum since 1914, when all the Sheldon *Maps* then known were exhibited here, they were sold by the Society at Sotheby in 1960. *Worcestershire* was bought by this Museum. *Warwickshire*, the piece which bears the crucial date 1588 (presumably taken from the original tapestry) and also the Tudor arms and the arms of Edward Sheldon (son of Ralph the elder) and Elizabeth Markham (married c.1588), was bought by Messrs Courtauld, who have loaned it to the Warwick City Museum. On it can be seen Beoley House with its double park, Stratford-on-Avon, and Sir Thomas Lucy's Charlecote Park near the Avon and paled in on the East (it was not emparked till 1615). *Oxfordshire and Berkshire* was bought by a private owner, who has loaned it to Oxburgh Hall (National Trust); it bears Richard Hickes' name, but the arms of Ralph Sheldon the younger and Henrietta Maria Savage (married 1647). With its topographical picture of London with old St Paul's, also of Oxford, it has a special interest.

The question remains where these four mid-17th century *Maps* were woven. As Wace pointed out, very similar frame-like borders are found on the set of *Playing Boys* in the Royal Collections (Holyrood Palace) (see Thomson, fig.14); indeed the borders are identical except for an additional inner guard-stripe on the *Maps*. Wace suggested the *Maps* were probably woven at Mortlake (Barnard and Wace, pp.307–8), but the texture, colouring and flatness of the effect is so unlike Mortlake work before the Restoration period, that one is led to think rather of the Royal arras-workers at the Great Wardrobe, executing a private commission.

Further information. Maps as tapestry hangings are unusual but obviously appropriate for the walls of a country house. If Ralph Sheldon or Richard Hickes conceived the idea for Weston Park, Walter Jones (who completed the new Chastleton House some four miles away in 1614), seems to have gone along with the idea. An inventory taken on 14 May 1633, after his death, records in the great gallery 'fower large Quarter maps' (which may have been tapestry maps) and 'arras hangings' in Mr Sheldon's chamber, which had the Sheldon arms carved on the chimney-piece (Humphreys, p.17). A topographical map appears in the record woven in tapestry of the Palatine Count Otto Henry's *Pilgrimage to the Holy Land*, which is dated 1541 and was designed by Mathias Gerung of Nördlingen (Munich, National Bayerisches Museum; Heinz, p.223). A map scheme also appears on one of the *Kings of Gaul* series in Beauvais Cathedral, woven about 1530 (Göbel, *II*, i, p.208). The late 16th century *Victories of the Duke of Alba* rendered battle scenes and campaigns with considerable detail and topographical accuracy (Heinz, p.223; figs.155, 156). Wace has suggested that the tapestry *Map* which commemorates the *Relief of Leiden* from the Spanish siege in 1574 (ordered by the Town Council of Leiden from the weaver Landraert of Delft in 1587), may have given Hickes the idea for the county maps, especially in view of his traditional connections with Holland and tutelage there in weaving (Barnard and Wace, p.290; Göbel, *I*, i, p.539; ii, pl.490).

Coats of Arms; Sheldon and Willington. Quarterly: 1–4, sable a fesse between three sheldrakes argent

(Sheldon); 2, argent on a bend between two lions rampant sable a wyvern of the field (Ruding); 3, or a saltire vair (Willington). The arms are ensigned by a closed helmet, to the sinister, with mantling the torse surmounted by the Sheldon crest: a sheldrake argent. Worcester. Argent a fesse between three pears sable.

Museum acquisition. T.261–1960. Bought Messrs Sothebys Ltd (£2,000).

No. 70 (*pl.100*)
Verdure with The Judgement of Paris

ENGLISH, SHELDON LOOMS: c.1595.
H. 10ft 8in. (3·25m.) W. 11ft 10in. (3·60m.).
Wool and silk: 14 warp threads to inch (5–6 to cm.).

Condition. Somewhat faded; the ground repaired in places.

This came from Chastleton House, in the north-west corner of Oxfordshire, along with a set of four similarly designed verdures with the *Story of Judah* in the central cartouche. The four *Judah* tapestries are inscribed with references to *Genesis*, chapter 38, and short quotations in English identifying the subjects; the quotations are adapted from the Geneva Bible of 1560. The first of the series bears the date 1595 and each has the initials 'W.I' & 'E.I', which are generally accepted as referring to Walter Jones and his wife Eleanor Jones, who lived at Witney House, Oxfordshire, but bought Chastleton in 1602 and rebuilt it from 1603–14. The Jones were friends of the Sheldons, and Chastleton was close to Weston (about 12 miles distant) and nearby Barcheston, where the tapestry looms were at work (less than 10 miles distant). The *Judgement of Paris* tapestry is inscribed in English with a reference to Ovid and has the initials 'H.I'; Henry Jones was the son of Walter and Eleanor. This group of five similar tapestries

is therefore closely identified with the Sheldon enterprise; A.J.B. Wace lists it immediately after the group of tapestry maps, along with three cushion-covers from Chastleton House, in his re-construction of Sheldon's work (Wace, pp.291–2, pl.39; Göbel, *III*, ii, pp.161–2; pl.123b).

The *Verdure* with the Paris episode is a practical piece of furnishing tapestry, medium coarse, simple in composition and colouring, with a cartouche in the fashionable taste of late Elizabethan England, set amongst a medley of floral forms, with a suitable border in a style familiar at the time as a gilt leather pattern and with guilloche-ribbon guard-stripes – in all a pleasant hanging for the walls of a country house. Like the tapestry *Maps*, it shows a standard of work quite comparable with the pro-duction of Aubusson-Felletin and the coarser Oudenarde pieces, but not with their best work. Wace has pointed out that Sheldon, or rather Richard and Francis Hickes, who were the managers of the looms, had the good sense to keep the figure subjects small, and that the cartouches in all this group are roughly the size of the cushions which they wove. The cushions were in great de-mand for the oak benches and window seats in country houses.

Description. Paris, seated and holding a long staff, offers an apple to Venus. One of the other two Goddesses in the myth, Juno or Minerva, is seated near Venus in a folding-chair. The scene is set in a landscape within a cartouche. This is outlined with strap-work and hung with tassels and fringed nar-row bands. From each end of its sides rises a large lantern supported by a pedestal. On the lower part of the strap-work edging, within a roundel, are the initials 'H.I.' for Henry Jones (d.1656), son of the first owner of the present Chastleton House, Walter Jones. On the upper part of the strap-work edging are the words: 'EPESTELS OUT OF OVID IX CHAPTER', and on the lower: 'WHEN PARESE GAVE THE GOLDENE APPEL'. The rest of the tapestry is filled with flowers. There is a wide

border of flowers and fruit with an inner and outer guilloche edging.

Further information. Chastleton House, near Moreton-in-Marsh, was formerly owned by Robert Catesby, the prime conspirator in the Gunpowder Plot. In 1602 he sold the estate to Walter Jones, a woollen merchant of Witney, for £4,000, to pay a fine of £3,000 levied on him for his share in the Essex rebellion. In the same year Walter Jones obtained a grant of arms; he was one of the two members of Parliament for the City of Worcester in 1584, 1586–8, and 1593. His wife Eleanor, née Pope, was a maid of honour to Queen Elizabeth; her father was the Queen's jeweller (John Humph-reys, pp.17–18). Chastleton was rebuilt as a fine Jacobean house (1603–14) and the inventory of 1633 describes a bedroom as 'Mr Sheldon's Chamber'; a chimney-piece carved with the Sheldon arms is still to be seen there.

The first of the four tapestries with the Story of Judah, which is dated 1595, belonged to Mrs Gubbay, as did the fourth; they are at Trent Park, Cockfosters (London). The second was acquired by the Birmingham Art Gallery & Museum.

A long cushion-cover with the arms of Walter Jones and Eleanor Pope and the motto 'Dulci periculum sequi Deum' (Wace, pl.40, fig.1) was in the possession of Colonel Howard.

Museum acquisition. T.310–1920. Bought at Sotheby, £1,000 (lot 129, 12 Nov. 1920). Sold from Chastle-ton House by Mrs Whitmore Jones with the four *Story of Judah* tapestries.

Sheldon's Tapestry Cushions

In the age of oak furniture and when benches and stools were commoner than chairs, cushions played an important part in the furnishing of English country houses, as contemporary inventories show. Made of tapestry, also of needlework on canvas,

or on silk or velvet, often beautifully embroidered and furnished with rich fringes and tassels, they were needed for window seats and in chapel stalls (see Digby, *Elizabethan Embroidery*, pp.108–17). In England they were usually either roughly square, or longer than high, and the old loom-width of 19–21 inches largely controlled their size and shape (see Wace, pp.311–13). Although perhaps English needlework and embroidered cushions of the Elizabethan and Jacobean period are the best known and most fully documented owing to the survival of the great country houses relatively intact into the present century, tapestry cushions were used in most north European countries and were made in Flemish, Dutch, North German and other weaving centres.

In his communication to the Society of Antiquaries of 1928 Professor A.J.B. Wace, who was then Keeper of the Department of Textiles at the Victoria and Albert Museum, set out with considerable acumen a reconstruction of what he and other scholars had been able to collect of the surviving work from the Sheldon looms. This paper was published with E.A.B. Barnard's meticulous study of the archival and literary sources for Sheldon's work in a separately bound volume, *The Sheldon Tapestry Weavers and their work* (1928); it reassessed the previous studies of A.F. Kendrick, J. Humphreys, and W.G. Thomson. Since the tapestry hangings which have survived from the Barcheston and Bordesley looms are relatively rare, Wace gave much of his attention to the rather larger number of cushions, distinguishing them as a corpus from their Flemish, Dutch and Schleswig-Holstein counterparts. Dr H. Göbel published his account of English tapestries some five years after Wace's work and relied much on Wace's excellent judgement (Göbel, *III*, ii, pp.162–68; pls.124–28); since then there has been no major contribution in this field. The brief discussion and enumeration of the tapestry cushions which follows is therefore closely linked with Wace's publication and the preparatory notes which he left in this Museum.

The characteristics of the Sheldon cushions were summarised by Wace as follows: (1) Borders with hunting scenes, as found on later Jacobean needle-work boxes; (2) the use of flowers and flowering plants, both as ground in the field and borders of cushions, recalling Elizabethan and Jacobean embroidery; (3) the use of arcades to frame the scenes; (4) masks and herm-like figures in the borders; (5) inscriptions in English; (6) the insertion of initials (of the owners); (7) narrow 'barber-pole' stripes as inner border-edgings or to mark divisions (Wace, pp.298–9). From the point of view of determining the English-Sheldon origin of the cushions, inscriptions in English (5) and initials (6) are of prime importance; the other points of style connect many of the cushions with a few which can be more closely determined as Sheldon's work, because of their historical origins or coats of arms, etc. The hunting scenes (1), it should be noted, are rather summary and naïve, and probably derive from current book-illustrations or engravings, suitably simplified.

With regard to the chronology of Sheldon's extant work, Wace is cautious (pp.308–11, table on p.309). Even so it is possible that the time-scale has been unduly shortened and that some of the earlier cushions go back to the 1560s and '70s, when Richard Hyckes and his men were active. A small tapestry cover with the date 1565 and inscription, 'Walk in the fere of the Lord', and the initials 'A E W', is in the possession of the Walker-Heneage family at Coker Court, Somerset; it bears the arms of Anthony Walker.

Literature: see under England: William Sheldon (Cat. Nos.68–73)

No. 71a (*pl.101A*)
Cushion-cover: The Prodigal Son

ENGLISH, SHELDON LOOMS; early 17th century. 19in. square (0·48m.).

Silk and wool: 22–23 warp threads to inch (9 to cm.).

Condition. Good with fresh colours.

This represents the first of six scenes illustrating the parable of the *Prodigal Son*, copied from a set of Flemish cushion covers (see No.62). The borders are identical to those on a long cushion in the Burrell collection with the *Virtues*, Faith, Charity and Hope in a triple arcade; the same side borders are to be seen in the Lady Lever Art Gallery cushions with *Virtues* (Wace, pp.296, 297, pls.47, 50). The *Virtue* cushions can be reasonably attributed to Sheldon because of English inscriptions and initials in the manner of the Chastleton tapestries. The arcading which frames the scene occurs on the Museum's *Flight into Egypt* cushion (No.71d) and several others.

Other English *Prodigal Son* cushions are known. One very similar to this in colour, condition, etc., belonged to Mr F. Mallet and represents the Prodigal's return to his father. The Mallet and Museum cushions may both be from the same set. General Goldburn had a short cushion with the same subject as the Museum's, and also a long cushion with three scenes under a triple arch: the Prodigal's riotous living, the Prodigal turned out by his companions, and the Prodigal herding swine. General Goldburn's cushions have the same type of borders but are in poor condition, having been used to upholster furniture.

Description. The Prodigal is taking leave of his father, who hands him a share of the inheritance. The father is seated on an ornamental chair beside a table on which is an inkstand and some money. A steward, or perhaps the elder brother, stands in the background. There is a tiled floor. The Prodigal is dressed in a 16th century style. In the background there is a country scene of fields and trees, and the Prodigal is seen riding off in the distance.

The scene is framed by an arch which has floral designs in the spandrels. Round it is a hunting scene with a fox carrying off a goose. Both these scenes have landscape backgrounds showing trees, manor houses, etc. The side borders each contain a vase holding flowers and foliage. From this springs a caryatid of the upper half of a female figure which supports on its head a basket of leaves and flowers. The ground of the side borders is brilliant crimson.

The top angles have tassels, and at the bottom is a dark-green fringe. These must have been added in Victorian times, when it must have been used as a banner–screen, or mantel bracket.

Museum acquisition. T.1–1933. Given by Mrs F.H. Cook of Barnet Hill, Guildford.

No. 71b (*pl.102A*)
Cushion-cover: Judith

ENGLISH, SHELDON LOOMS; second half of 16th century.
19in. square (0·48m.)
Silk and wool: 20 warp threads to inch (8 to cm.).

Condition. Good but somewhat faded; frayed at the edges.

Description. In the centre stands Judith, in her right hand an uplifted sword, in her left the head of Holofernes. She wears a short-sleeved gown over a blue petticoat and has a red cloak on her shoulders. On her left is her handmaid in a blue gown. Around and behind them is a background of floral sprays, foxglove, honeysuckle, rose, wild strawberry, carnation, cornflower, etc. Between the central panel and the border is a narrow barberpole edging. There is a border of flowers set on a wavy line on which 'S's are linked; the ground is red.

A square cushion which Wace compares with a set of one long and two square cushions in the Royal Scottish Museum (Wace, p.297, M., see L IV and pl.51); but the background of flowers is much less crowded and the figures themselves have more space. This cushion seems to be earlier than the Royal Scottish *Virtues* cushions and the Sudeley Castle pieces (Wace, pl.55); also than the Burrell and Port Sunlight cushions with *Virtues*, where the figures are set in arcades and seen against a landscape background (Wace, pls.47, 50). The borders are unlike those of other Sheldon cushions, but the 'barber's pole' stripe is familiar.

Judith and her maid appear with slight variations on at least six Sheldon cushion covers, besides the Sudeley Castle pieces. The closest to the V & A piece is a long cover in Sleaford Church, which shows Judith in exactly the same billowing cloak and with the maid standing close behind, half-hidden, a bag hanging from her left arm. They stand on a flowery mound, in front of a landscape with the tents of the enemy, enclosed in an arch. To either side of the arch are flowers similar to those on the V & A *Judith* and the Sudeley Castle tapestry. The majority of covers with Judith and her maid, including the pieces in the Burrell Collection, Glasgow, and the Metropolitan Museum of Art, New York, set the figures in a wider landscape with swans on some water and in the background the city to which Judith returns, with Holofernes' head stuck on a pole from the battlements.

Museum acquisition. T.273–1927. Bought under the Murray bequest from Messrs W. Burford of Exeter for £140.

No. 71c (*pl.102C*)
Cushion-cover with the Arms of Sacheverell

ENGLISH, SHELDON LOOMS; early 17th century.
L. 18½in. (0·46m.) H. 19in. (0·48m.).
Silk and wool with silver and silver-gilt for the arms: 20 warp threads to inch (8 to cm.).

Condition. Worn in places; rather faded.

This square cushion was formerly at Wolles Hall, the seat of the Harford family, and is said to have come from the Winter family, Robert and Thomas Winter being implicated in the Gunpowder Plot (Letter of 2 Jan. 1916 from Miss A. Harford Flood). Wace accepts it as Sheldon work but says: 'Its crudity would suggest that it was woven by a not over-skilled weaver in his home' (Wace, p.298, O). It seems to belong to the later Sheldon group; the borders with their masks resemble the Royal Scottish Museum *Virtues* (see Wace, pl.51). The half-figures in the border are borrowed from a Flemish set such as *Jacob* (No.63). The arms are those of the Sacheverells, and it has been thought that the initials H.S.P. stand for Henricus Sacheverell Primogenitus and refer to Henry Sacheverell of Rearsby, who died in 1581. Henry, however, was a common name in the family, and there is nothing to show that the Rearsby branch, who were cadets, used the Snitterton quartering which appears on this cushion. Henry Sacheverell of Morley, elder son of Jacinth Sacheverell, might equally well be intended, especially since that elder line used the Snitterton quartering. Jacinth Sacheverell died in 1656, aged 79, and his son Henry would up to that year have borne on his arms across the chief a label of three points gules as on this cushion, as was pointed out by Van de Put. Henry was married in 1638, and so was probably born early in the century. If the cushion was made for him as a child, such a date would suit its style, which, since no absolute certainty has yet been reached through the heraldry, is the best clue to its date.

A similar cover with the Arms of Sacheverell is in the Burrell Collection, Glasgow.

Description and Arms. The panel has a pattern of field flowers, larkspur, foxglove, pansy, rose, etc., with a shield of arms in the centre, showing the arms of Sacheverell; quarterly of six. (1) Argent,

on a saltire azure five water bougets or (Sacheverell). (2) Argent, a lion rampant sable crowned or, with a mullet for difference (Morley). (3) Gules, a pale lozengy argent (Statham). (4) Azure, a lion rampant argent (?). (5) Gules, a duck argent ducally gorged or (Snitterton). (6) Argent, three hares playing bag-pipes gules (Hopwell). Across the chief is a label of three points gules.

On each side of the shield is a brightly coloured bird.

The borders show in the corners baskets of fruit and flowers. In the middle of the top and bottom borders is an ornament of flowers and fruit connected by strapwork with a female figure and a lion's mask. In the middle of the side borders are figures connected by strapwork with lion's masks.

Museum acquisition. T.195–1914. Bought from the Reverend C.A. Thomas of Kermeston, Tewkesbury, for £50.

No. 71d (*pl.102D*)
Cushion-cover: The Flight into Egypt

ENGLISH, SHELDON LOOMS; c.1600.
L. 19in. (0·48m.) W. 18in. (0·46m.).
Silk and wool: 20 warp threads to inch (8 to cm.).

Condition. Good; the grey-brown thread used for the donkey has largely disappeared and been restored by darning.

A square cushion which Wace compares with a long cushion in a triple arcade which has the same borders (Wace, p.294, H. 1 and 2, pl.42 fig.1); the scenes of the latter are the *Annunciation*, the *Nativity*, and the *Adoration of the Magi*. The initials 'E I' at the top of the arcade (which could conceivably be read as 'T E I') recall the initials of the Jones family on the Chastleton tapestries. The scene with Joseph, carrying his carpenter's equipment, and the donkey is fairly close to the smaller *Flight into Egypt* cushion (No.71e).

Description. On the right is Joseph, wrapped in a cloak, wearing a hat with a feather and carrying his carpenter's tools, saw, mallet, etc., on his left shoulder. His right hand holds the leading rein of the ass on which rides the Virgin. She rides side-saddle, facing the spectator, and holds the Infant Christ in her left arm. There is a halo of rays round her head. A cow's head and shoulders appear just on the left. Behind is a mansion and a landscape with trees, with a tower in the distance.

The subject is set under an arch supported by two columns. The arch is filled with floral scrolls ending in spirals; in the centre is the monogram 'E.I.' There are flowers in the spandrels.

The top and lower borders contain hunting scenes. In the top a man with two hounds chase a large hare to the right. In the lower border a man stands blowing a horn on the right and a hound chases a fox to the left; the fox carries a goose over its back. On the extreme left is a building. At the corners are figures of men and women in contemporary dress and between them, in the side border on a red ground, are pedestals with fruit and flowers and two birds beneath. The green silk fringe is unlikely to be original.

Museum acquisition. T.191–1926. Bought from Basil Dighton for £165.

No. 71e (*pl.102B*)
Cushion-cover: The Flight into Egypt

ENGLISH, SHELDON LOOMS; late 16th century.
L. 11½in. (0·29m.) H. 8in. (0·20m.).
Silk, silver and silver-gilt thread: 24–25 warp threads to inch (10 to cm.).

Condition. Good; silver tarnished.

A.J.B. Wace links this little cushion with four others and associates the group in style with the *Judah* (Verdure) tapestries from Chastleton House, one of

which is dated 1595 (Barnard and Wace, p.293, G.1–4, pl.41). The Duke of Rutland's little cushion and another almost identical (Wace, G.1 and 1a) have closely similar borders with flowers and markings at the sides and an inscription top and bottom, all on a silver ground. But the inscription, instead of being in Latin, is in English, 'Have a stronge faith in God only / not this but my good will'; Wace points out that the latter half of this has the same meaning as the Latin inscription on our cushion ('non donum sed donantis animum'). The third cushion is inscribed 'Matthew the 2nd' (Wace, G.2), that is, also in English. An English origin for the group therefore seems certain. As well as the style, the disposition of the figures of Joseph, Mary and the ass links our cushion with Sheldon's workshops through another *Flight into Egypt* cushion, in this Museum, which has typically Sheldon borders (see No.71d).

Description. Joseph leads an ass which bears the Virgin and the Infant Jesus through a flowering meadow, with exaggeratedly large flowers. Beyond are trees and over the slopes a river (blue and silver) can be seen; also a distant building on a hill.

The borders have a silver ground and the inscription: 'Non donum sed donantis animum', with flowers, fruit, and a seated monkey with long tail and large ears at the sides.

Museum acquisition. T.85–1913. Bought with the next cushion, T.86–1913, for £100 from Messrs Harding Limited, 18 St James's Square, SW1.

No. 71f (*pl.103C*)
Cushion-cover: Christ and the Woman of Samaria

ENGLISH, SHELDON LOOMS; late 16th century.
L. 11½in. (0.29m.) H. 8¼in. (0.21m.).
Silk, silver and silver-gilt thread: 24–25 warp threads to inch (10 to cm.).

Condition. Good; frayed at the edges and without complete borders.

This little cushion belongs to the same group as the *Flight into Egypt* cushion (No.71e).

Description. Christ is seated at the well, from which the woman draws a bucket; a ewer stands in front. In the background three disciples and two Samaritans are approaching. The scene is set in a flowery meadow, with undulating hills and buildings in the distance. There is a narrow diagonally striped 'barber's pole' inner border-stripe on three sides.

Museum acquisition. T.86–1913. Bought (with T.85–1913) for £100 from Messrs Harding Limited, 18 St James's Square, London, SW1.

No. 72a–c (*pls. 103A, i & ii, B & D*)
Group of small Tapestry-woven objects

Small articles such as little cushions (used for devotional books), gloves, sweetbags and book covers, tapestry-woven in silk and metal thread, were obtainable from shops in London at this period. It is impossible to say where they, or their embroidered counterparts, were made, as the style and the taste for it was common to much of north-western Europe; but they, like the embroideries, were certainly made in professional workshops.

No. 72a (*pl.103B*). *Small Book Cushion*

L. 8in. (20cm.) H. 6¼in. (16cm.).
Silk and silver thread. (Slightly stained and worn).
26 warp threads to the inch (10–11 to the cm.).

In the middle is a two-handled vase, from which spring carnations, pansies and tulips. In each corner is a curved rose stem; the remaining space is filled with pairs of birds and butterflies, floral stems and strawberries. There is a narrow border of diagonal stripes in blue and white.

Museum acquisition. T.51–1914. Bought (£11-5-0).

No. 72b (*pls.103A, i & ii*). *Bible* (1614 edition).

(6¾ × 4½ × 1¾in.) (17 × 11 × 5cm.).
Silk, silver and silver-gilt thread (condition good but faded).
34 warp threads to the inch (13–14 to the cm.).

The tapestry is woven of silver thread with green, blue, brown, fawn and black silks. On the front is a square cartouche with Moses and the Burning Bush, with the presence of God indicated by the word DEUS in a cloud. A similar cartouche on the back represents the whale disgorging Jonah. On the spine is a gold star in a circular cloud. The remainder of the field and the narrow borders are powdered with flowers.

Museum acquisition. T.45–1954. Bequeathed by Sir Frederick Richmond, Bart.

No. 72c (*pl.103D*). *Pair of Gloves*

Greatest length 13in. (0·33m.); width with lace 7¾in. (0·19m.).
Tapestry woven in silk and metal thread (condition good but slightly faded).
33 warp threads to the inch (13 to the cm.).

The gloves are of white leather with tapestry-woven gauntlets in silk, silver and silver-gilt thread on woollen warp, trimmed with silver and silver-gilt bobbin lace and sequins (one thumb is missing).
 The gauntlets have a pattern of trees, floral sprigs (carnations, honeysuckle, etc.) and strawberries, with peacocks, parrots, owls and other birds.
 A similar pair of gloves is in the Metropolitan Museum, New York. Another was illustrated in *Embroidery* (December 1933, p.4). Wace studied the Museum gloves in some detail in the *Embroideress* (May 1932) and attributed the tapestry work to a Sheldon weaver, but the argument seems very tenuous.

Museum acquisition. T.145 & A–1931. Bought from Messrs Mallet of New Bond Street for £40 (ex-Sotheby sale, 28 May 1931, lot 94).

Literature
Digby, G. Wingfield, *Elizabethan Embroidery*, London, 1963, pt.I, ch.2
Embroidery, December 1933, illustration p.4
Morris, F., *Metropolitan Museum of Art Bulletin*, vol.xxIV, no.2, New York, February 1929, p.47, fig.3
Wace, A.J.B., 'A pair of gloves with tapestry-woven gauntlets' in *Embroideress*, no.42, 1932, pp.990–4; figs.1336, 1337, 1339

No. 73 (*pls.104–108*)
Valance with Hunting scenes

ENGLISH, SHELDON LOOMS; early 17th century. In three pieces, (1) 6ft 8in. long (2·03m.); (2) 4ft 2½in. long (1·28m.); (3) 6ft 8in. long (2·03m.). Height 10in. (0·25m.).
Silk and wool with some silver thread: 18–19 warp threads to inch (7–8 to cm.).

Condition. Excellent and unfaded.

This remarkable valance, still in prime condition with unfaded colours, is closely linked in style with many of the cushions which can be reasonably attributed to Sheldon; familiar features are the hunting scenes and the floral upper border with birds and terminal masks. Wace sees the valance, the Sudeley Castle panels, and the Hatfield *Seasons* as close in style and date (Wace, pp.303,

308; pls.54, 59); one of the *Seasons* is inscribed with the date 1611. The hunting and genre scenes on the valance recall the embroidered table carpet from the Earl of Bradford's collection, now in this Museum (Nevinson, *Catalogue of English Domestic Embroidery*, p.7, pl.3; Digby, *Elizabethan Embroidery*, pls.46, 47) but the embroidery is superior in style. The naivety of the frieze-like scenes is found frequently on Jacobean caskets (Nevinson, *Catalogue of English Domestic Embroidery*, p.54, pl.37). It was still common practice in the 16th century and a little later for tapestry workshops to supply bed curtains, with valances and sometimes coverlets. One recalls Thomas Hoerd of London's claim on Ralph Sheldon the elder for tapestry including 'one Bedd throughlie furnished' in 1605; Wace cites other examples of tapestry beds (Wace, pp.311–13).

When this valance was acquired for the Museum from Colonel Henry Howard, A.J.B. Wace made a careful study of its measurements and arrangement around a four-post bed. Whether the upper floral border was used with the main valance or separately, remains disputable. Wace describes it thus: 'The valance is composed of an upper floral border woven separately and sewn on to the valance proper below. The latter, with the delightful scenes of hunting (deer, wolf, boar, hare, bear, and fox), set against a landscape studded with country mansions of a castellated or château type, is made up of three parts. Two are 79¾in. long and one is 56½in. long. The former terminate with vases or baskets of fruit and flowers arranged in such a way that when the valance was put on a bed the vases would come against the posts at the head and the baskets against or over those at the foot. The vases are flanked by a squirrel and a seated animal, either a monkey or a cat, which closely resembles those in the side borders of the Duke of Rutland's panel (G.1), and the Flight into Egypt in the Victoria and Albert Museum (G.3). The whole is edged with a narrow barber-pole pattern. The measurements of the valance proper agree well with those of the sides and foot of the Corbet bed in the Victoria and Albert Museum which is dated 1593 and is 80in. along the sides and 48in. at the foot between the posts.

'The floral border at the top divides into four sections, two 38in. long and two 76in. long. They are arranged so that the two short sections come at the ends on the right and left and the two large in the middle, and the whole border thus made overlaps the valance proper by 6½in. on the left and 5½in. on the right. This was probably done so that the top border fastened on to the capitals of the posts at the head of the bed while the ends of the valance proper hung against the post immediately below.

'Of the four sections, one long and one short each ends with a lion mask on the left, and one long and one short each ends with a lion mask on the right. Since the short sections come at the head of the bed and the long sections run round the posts at the foot, two lion masks would appear side by side in the centre of the foot of the bed and one on each post at the head, while the joins between the long and short sections would come in the middles of the sides. The accuracy of the present arrangement is confirmed by the fact that one long and one short section are woven together in one continuous piece with a lion mask at each end of the whole, but none at the junction between the two sections. The lion masks are set in a frame of barber-pole pattern which also edges the whole valance. The only lack of symmetry is that there is no barber-pole edging to the woven join between the long and short strips on the left of the bed, though there is to the corresponding sewn join on the right.

'It is interesting to note that this division between the long and short strips of the floral border agrees with the widths and arrangements of crewel-work curtains of the later seventeenth century, which are in sets of four, two wide (76in. wide) and two narrow (38in. wide). The narrow hang against the head of the bed and half-way along the sides, the wide continue on from the narrow at the sides, go round or behind the posts at the foot, and meet one another at the middle of the foot of the bed. It is thus always possible that the two pieces of the valance were not originally meant to be together, but separate. The floral border may have been the upper valance of the bed to go along the edges of the tester, as its joins would correspond with those of the curtains. The valance proper then would have hung along the edge of the actual bedstead itself at the bottom of the curtains, and as it is narrow would have been well above the level of the floor' (quoted from Wace, pp.299–300).

Description. The valance is composed of a narrow floral border above a long strip with hunting scenes against landscape backgrounds. The border is in three pieces stitched together, 3ft 2in., 6ft 4in. and 9ft 6in. long (the latter has an uncut division 3ft 2in. from the selvedge). The valance is in three pieces, 6ft 8in., 4ft 2½in. and 6ft 8in. long.

On the extreme right the valance ends with a flower pot, with squirrel and monkey on either side, with silver thread. (1) *from right to left:* Men with lances and greyhounds pursue a wolf (or outsize fox); a scene with sheep, a shepherd and shepherdess, a lean-to hut and water; a bear hunt; flanked again with another flower pot. The scenes are divided with a 'barber-pole' stripe. (2) *continuing from right to left:* Men with spears and hounds pursue a hare; a scene of piping and dancing under a tree; a boar hunt, one of the men carries a rabbit over his back. (3) A terminal flower-pot; pursuit of a leopard; sheep with a shepherd piping and a man with a spade for dyking; hunting a stag, the men pursuing on foot, with one hound leaping on the deer. On the extreme left, a gentleman finely dressed with hawk on fist; terminal flower-pot with squirrel and monkey. Throughout there are trees, sheds, houses and castles in the background, sometimes the castle has a moat with water-fowl. The narrow band or border above has massed flowers with insects and birds; there are terminal

masks divided off with narrow 'barber-pole' stripes. The ground colour of the band is dark green.

Further information. There is a tapestry valance in the Burrell Collection with hunting scenes (c.5ft long, 10in. high) which Wace did not accept as Sheldon's work.

Museum acquisition. T.117–1934. Bought from the executors of Colonel Henry Howard for £1,400, of which £650 was contributed by the National Art-Collections Fund, and £50 by Sir Frederick Richmond.

Literature
Barnard, E.A.B., and Wace, A.J.B., *The Sheldon Tapestry Weavers and Their Work*, Society of Antiquaries, Oxford, 1928, pp.299–300, 303, 308, 311–13; pls.55–59. Also published in *Archaeologia*, 1928

Digby, G. Wingfield, *Elizabethan Embroidery*, London, 1963, pls.46, 47

Nevinson, J.L., *Victoria and Albert Museum Catalogue of English Domestic Embroidery of the 16th and 17th centuries*, London, 1938. pp.7, 54; pls.3, 37

See also the Literature for William Sheldon.

Concordance

PLATES

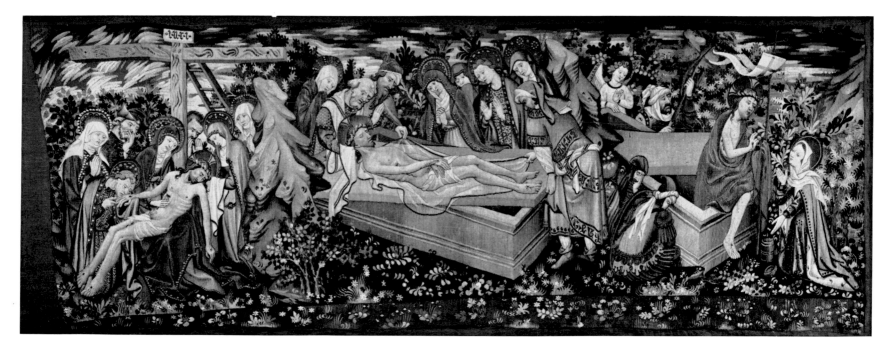

1A. The Descent from the Cross, Entombment and Resurrection; cat. no.1.

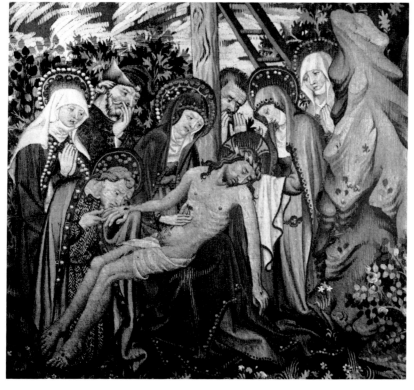

1B. The Descent from the Cross, Entombment
and Resurrection, detail; cat. no.1.

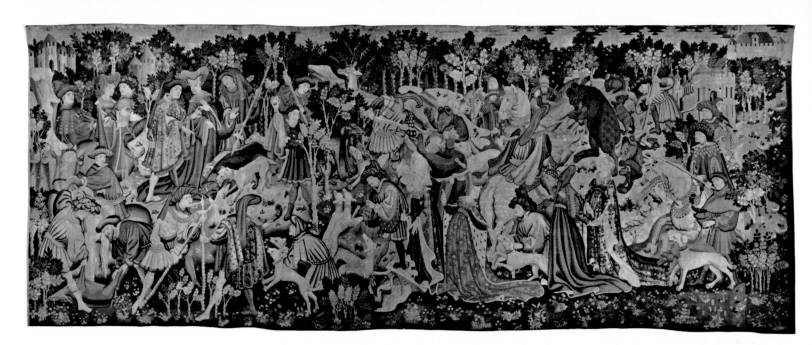

2A. Boar and Bear
 Hunt; cat. no.3.

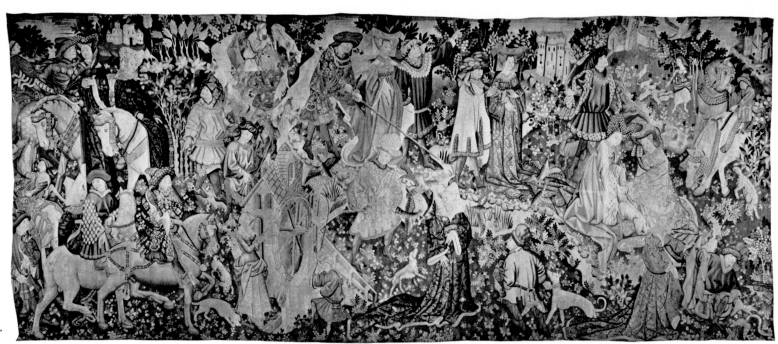

2B. Falconry; cat. no.4.

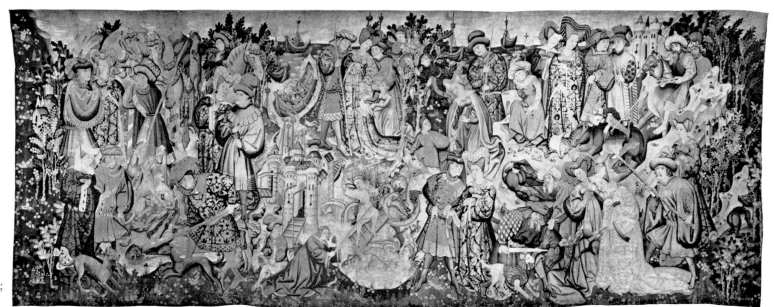

3A. Otter and Swan Hunt;
cat. no.5.

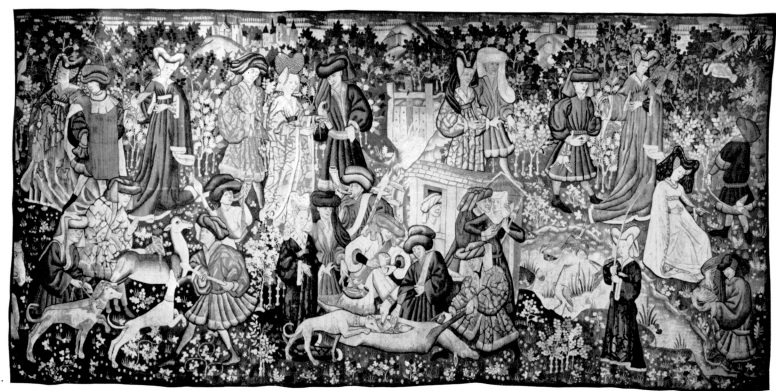

3B. Deer Hunt; cat. no.2.

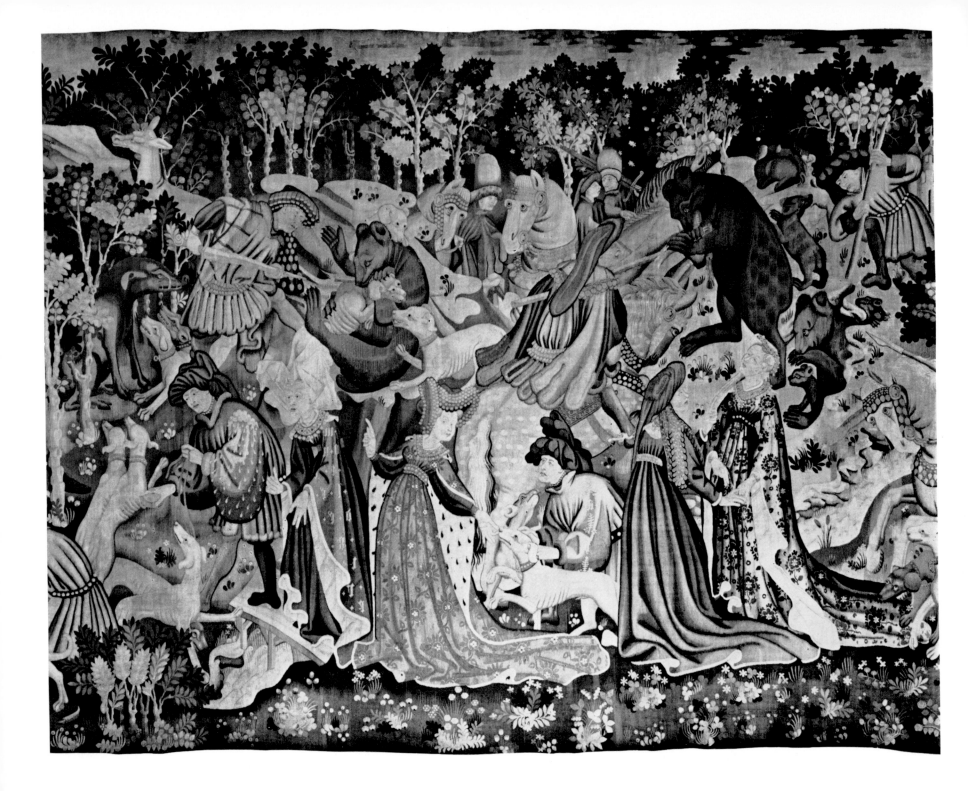

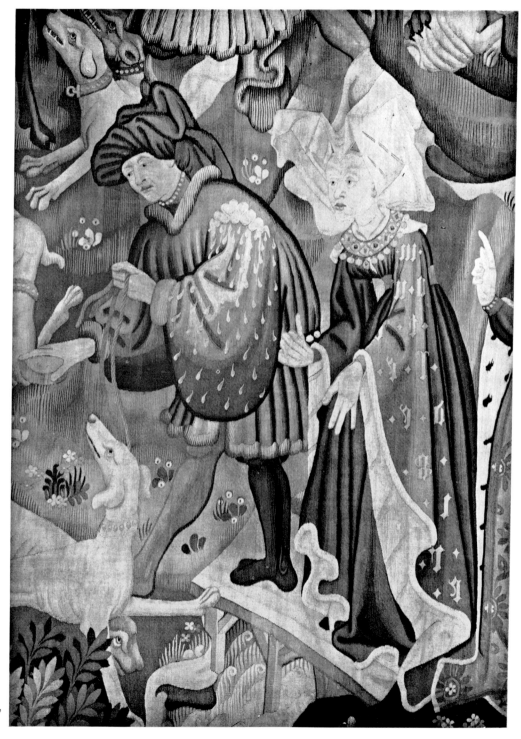

4. Boar and Bear Hunt, detail; cat. no.3. 5. Boar and Bear Hunt, detail; cat. no.3.

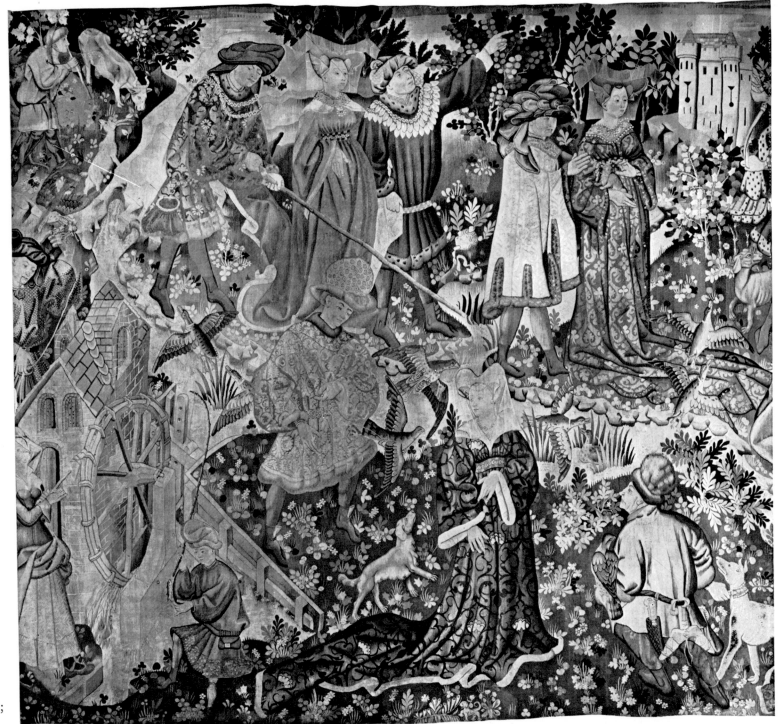

6. Falconry, detail; cat. no.4.

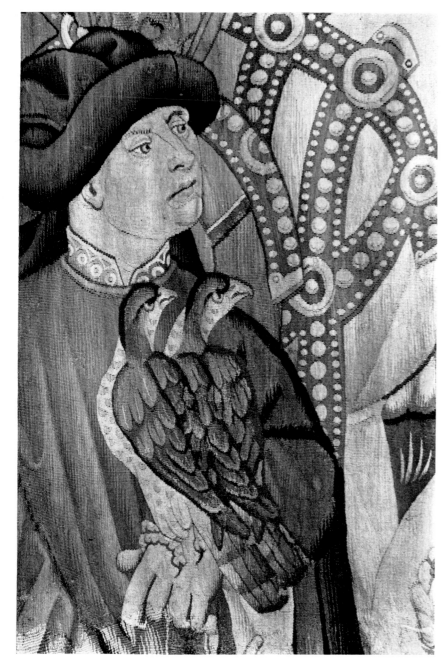

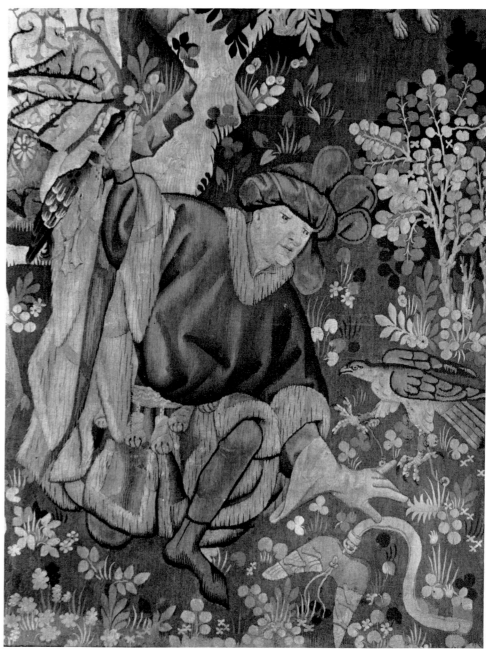

7A. Falconry, detail; cat. no.4.

7B. Falconry, detail; cat. no.4.

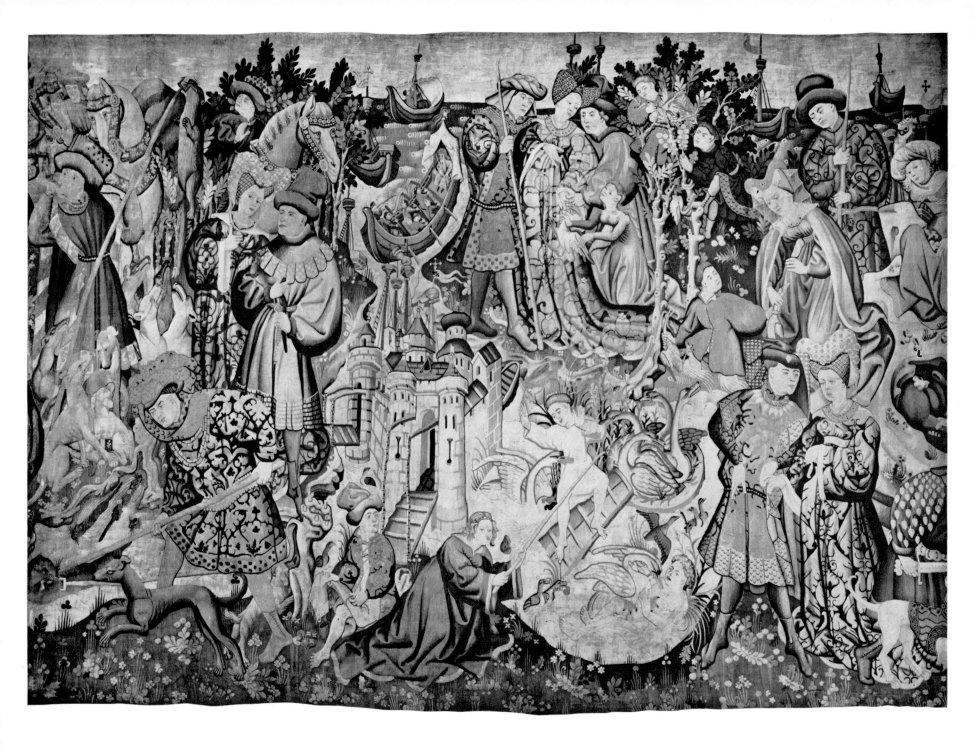

8. Otter and Swan Hunt, detail; cat. no.5.

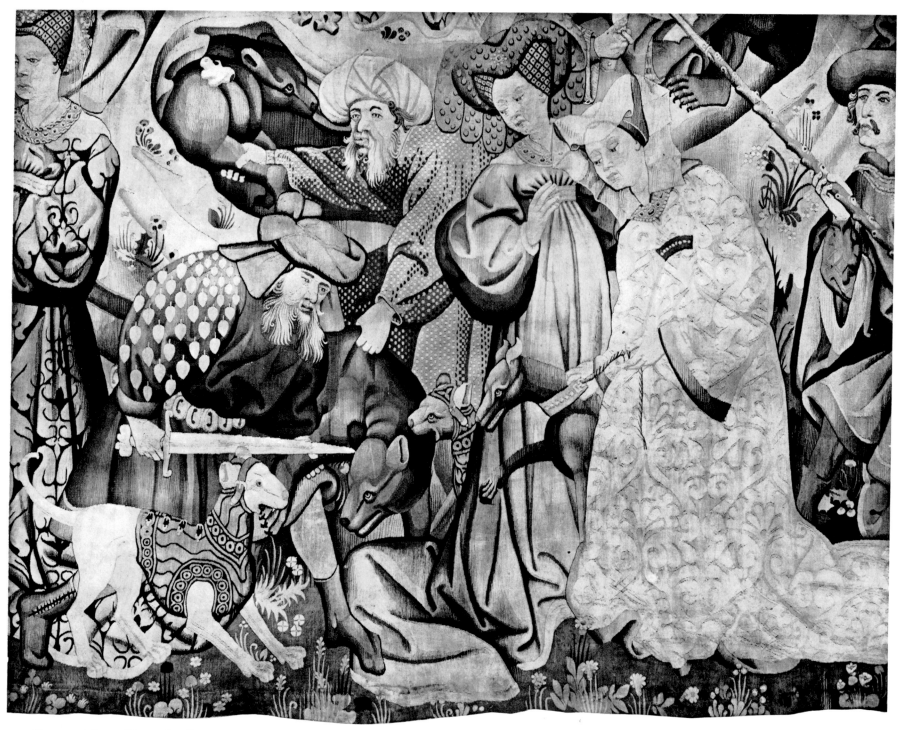

9. Otter and Swan Hunt, detail; cat. no.5.

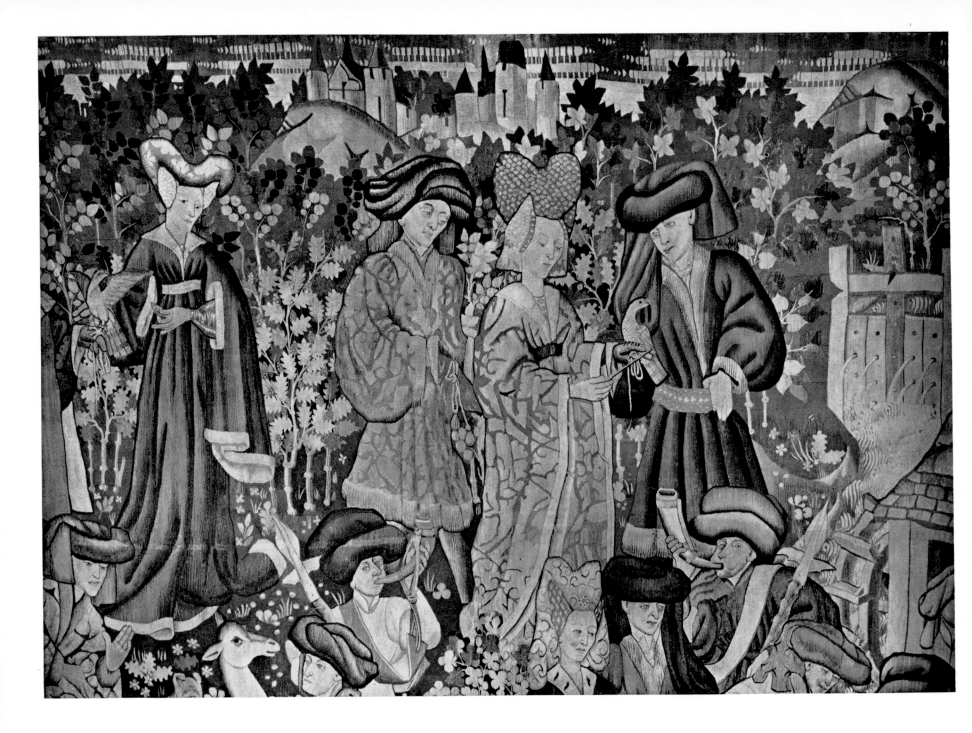

10. Deer Hunt, detail; cat. no.2.

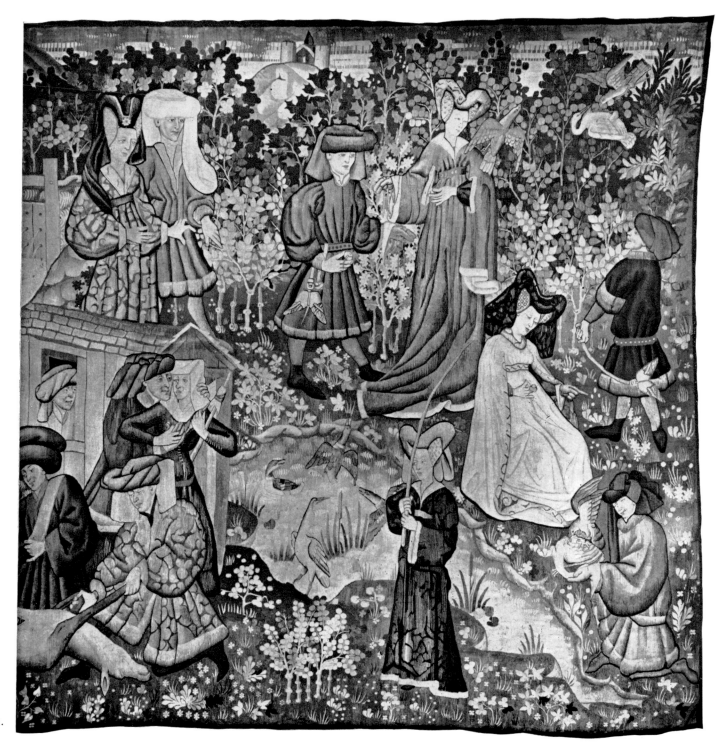

11. Deer Hunt, detail; cat. no.2.

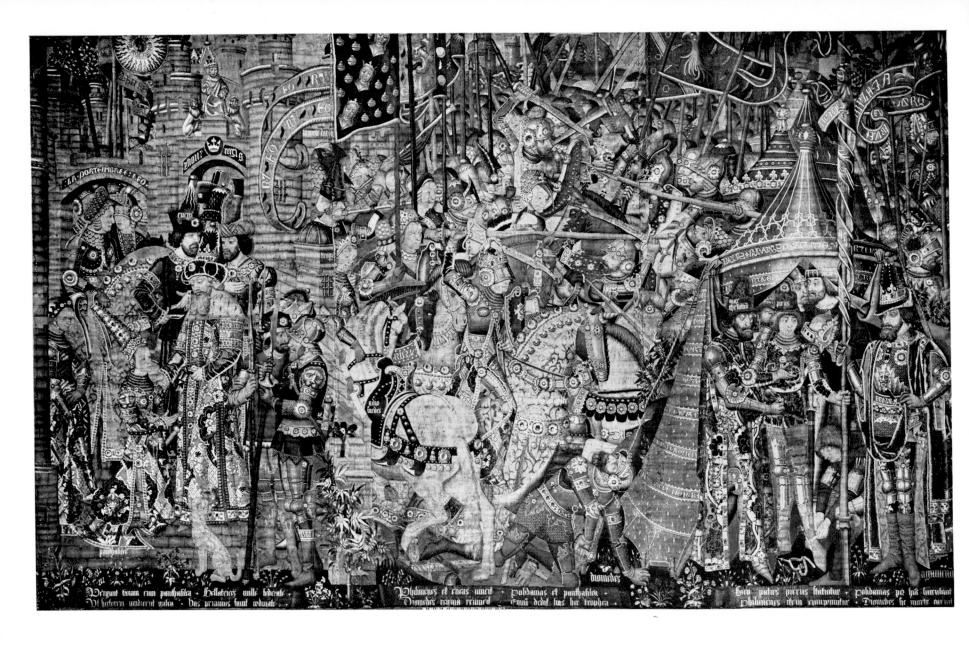

12. The War of Troy; cat. no.6.

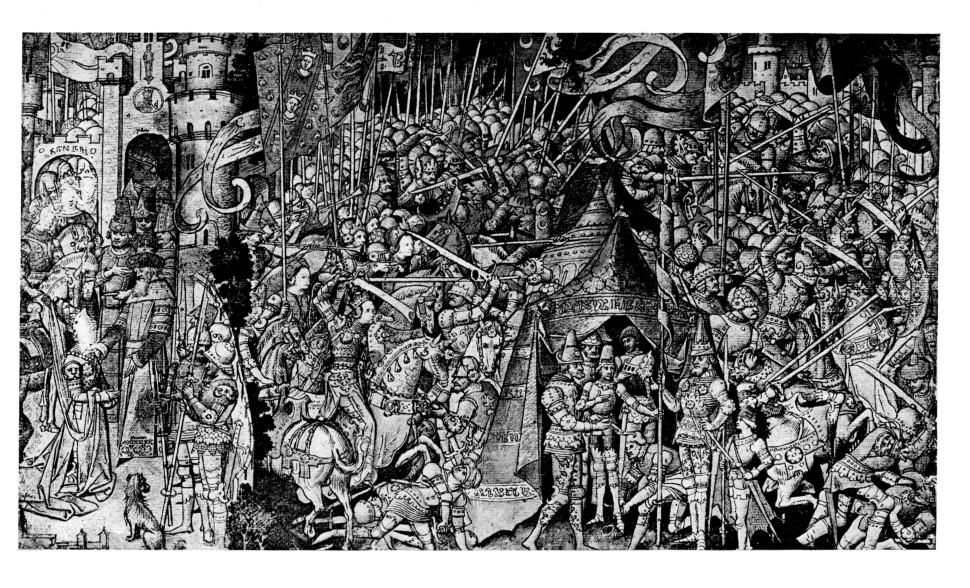

13. Original design in the Musée du Louvre, Paris, for the tapestry cat. no.6.

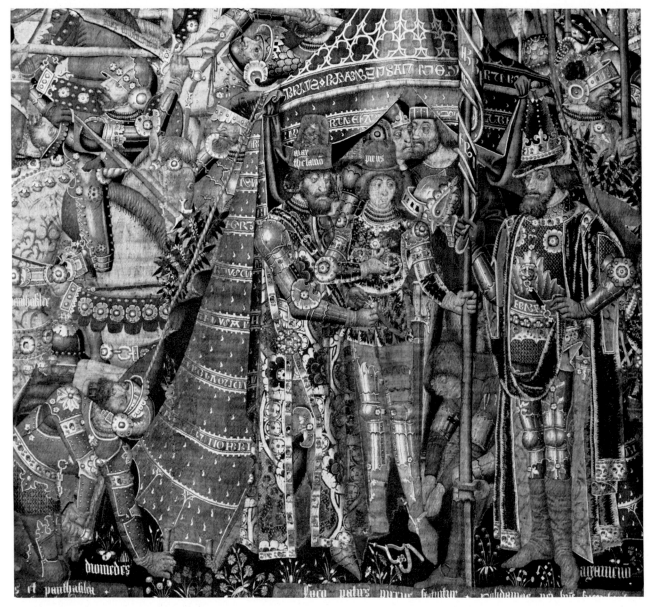

14. The War of Troy, detail; cat. no.6.

15. The Battle of Roncevaux; cat. no.7.

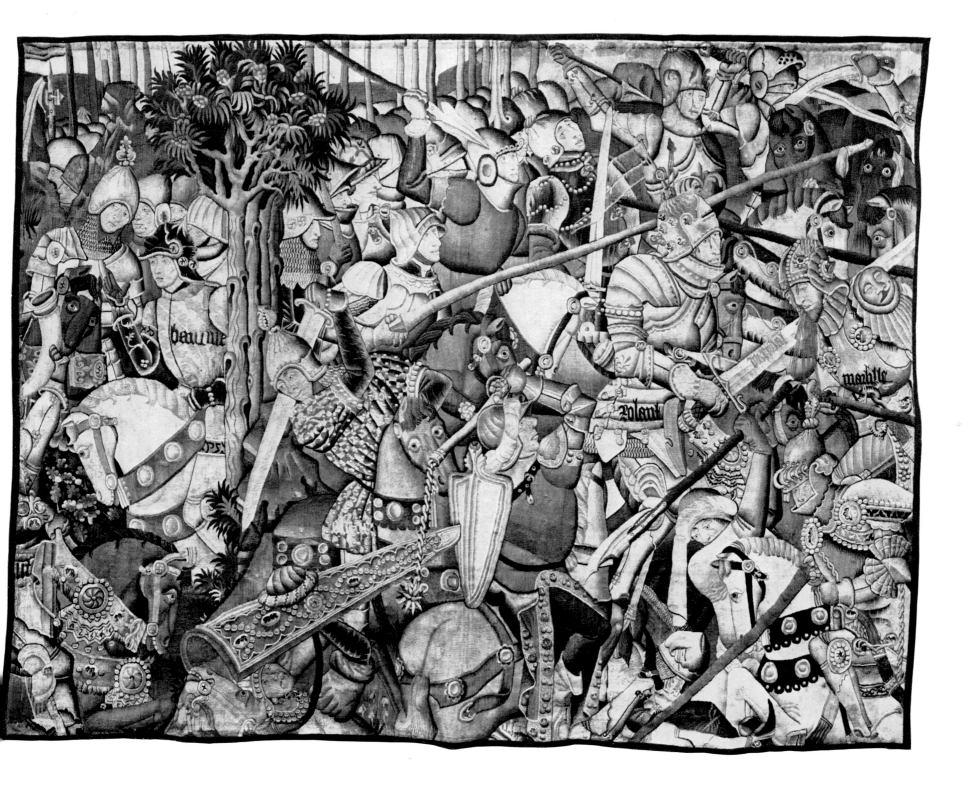

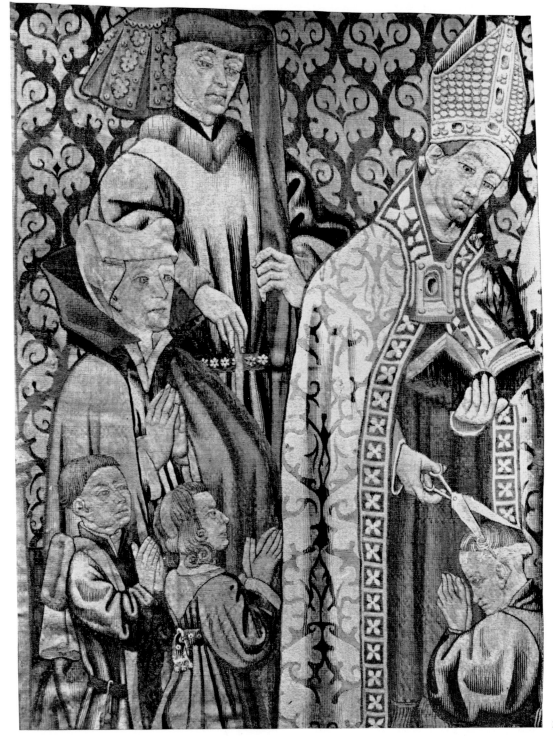

16. Confirmation, from the Seven Sacraments; cat. no 8.

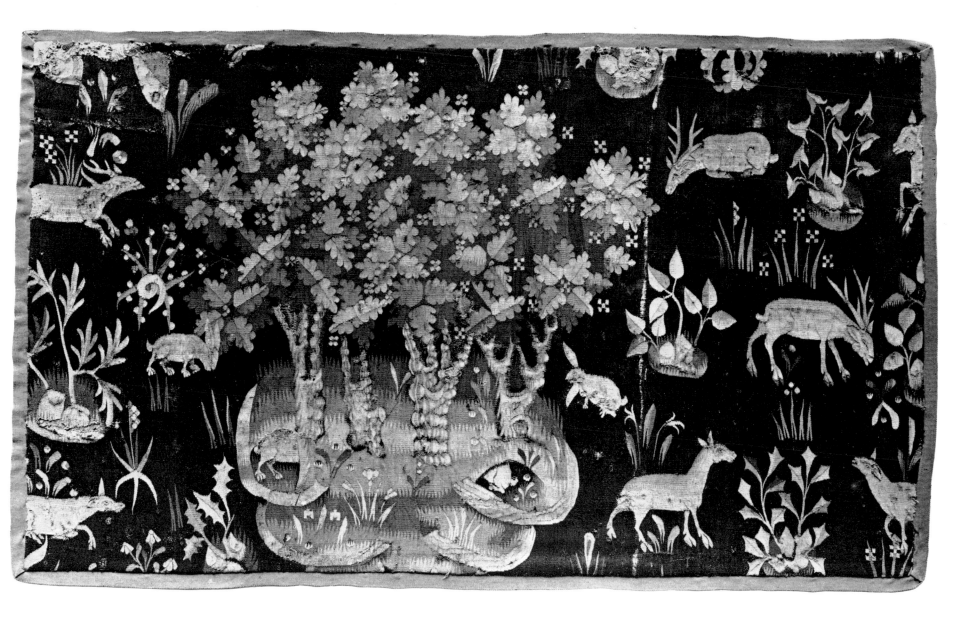

17. Verdure with a rabbit warren; cat. no.9.

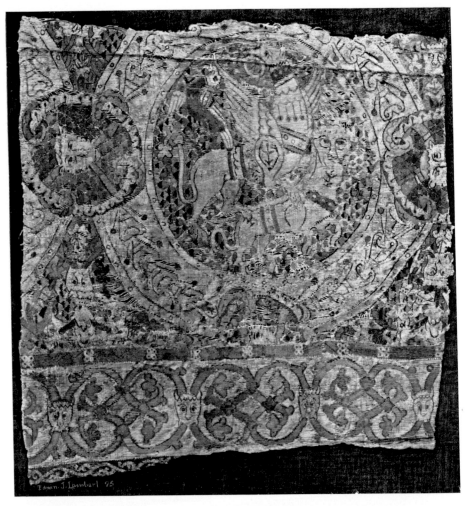

18A. Painted reconstruction of the tapestry from St Gereon's Church, Cologne;
see cat. no. 10.

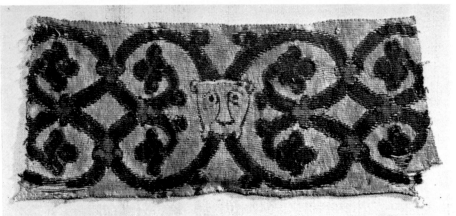

18B. Border of tapestry from St Gereon's Church, Cologne;
cat. no. 10.

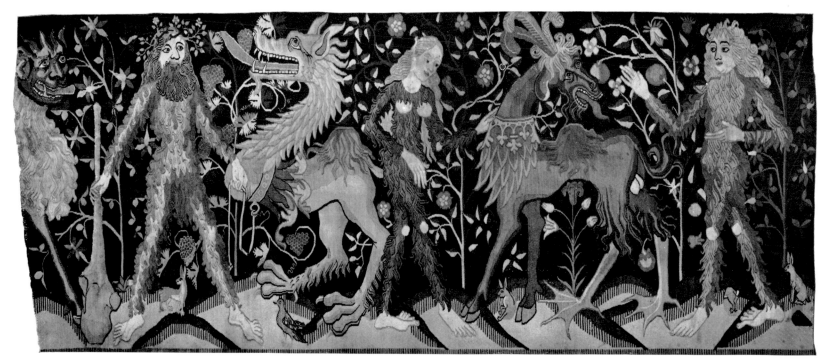

19A. Wild men with animals; cat. no.11.

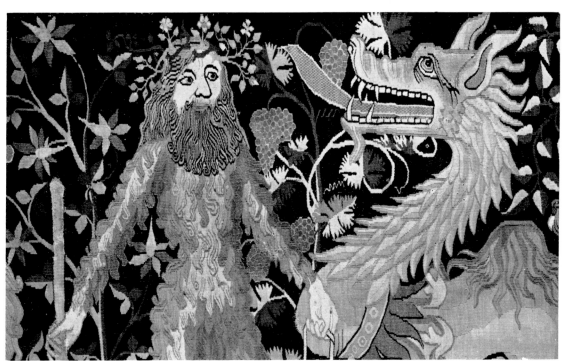

19B. Wild men with animals, detail; cat. no.11.

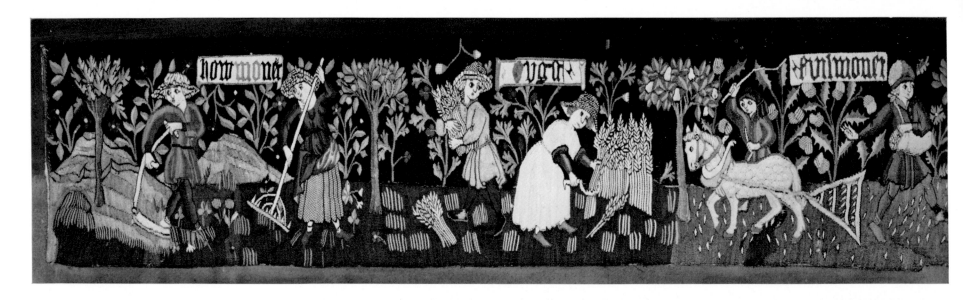

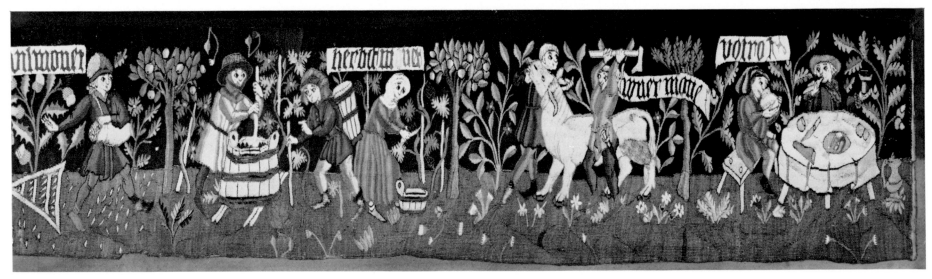

20A–B. Labours of the Months; cat. no.12.

21A & B. The Buzzard; cat. no.13.

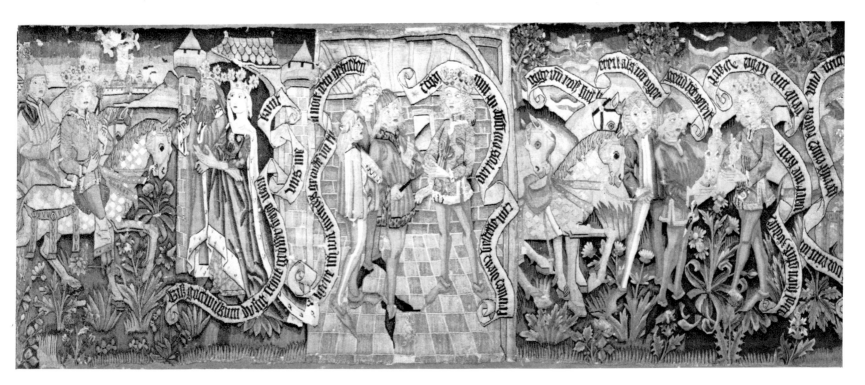

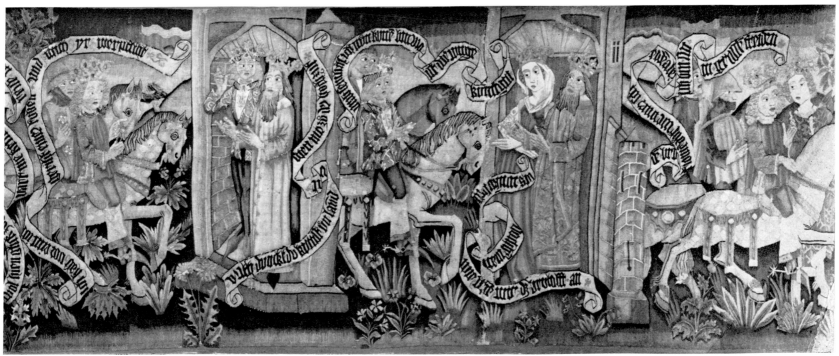

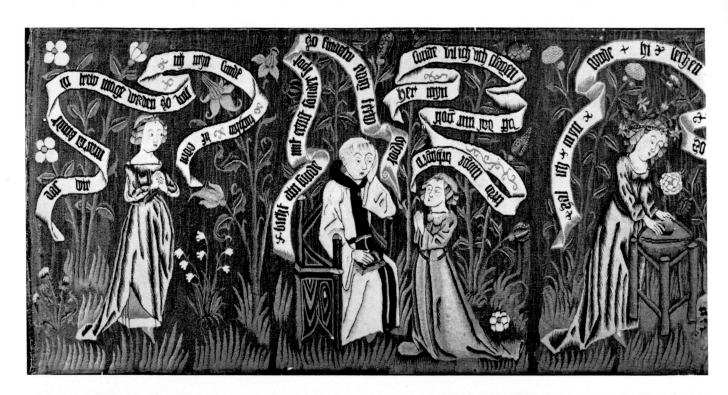

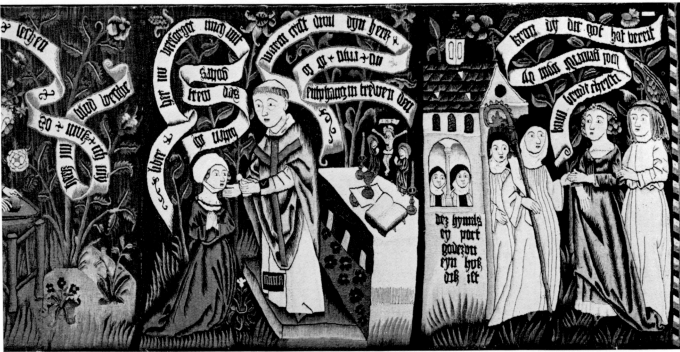

22A & B. The Search after Truth;
cat. no.14.

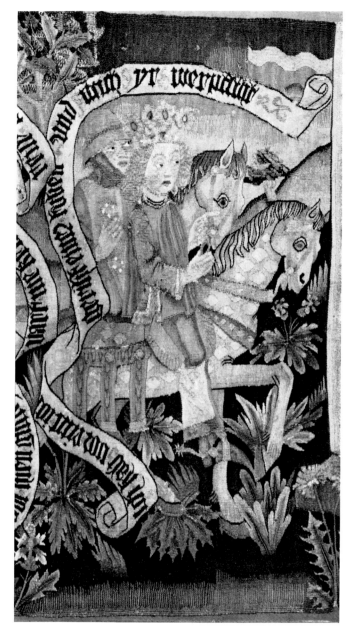

23B. The Buzzard, detail; cat. no.13.

23A. The Search after Truth, detail; cat. no.14.

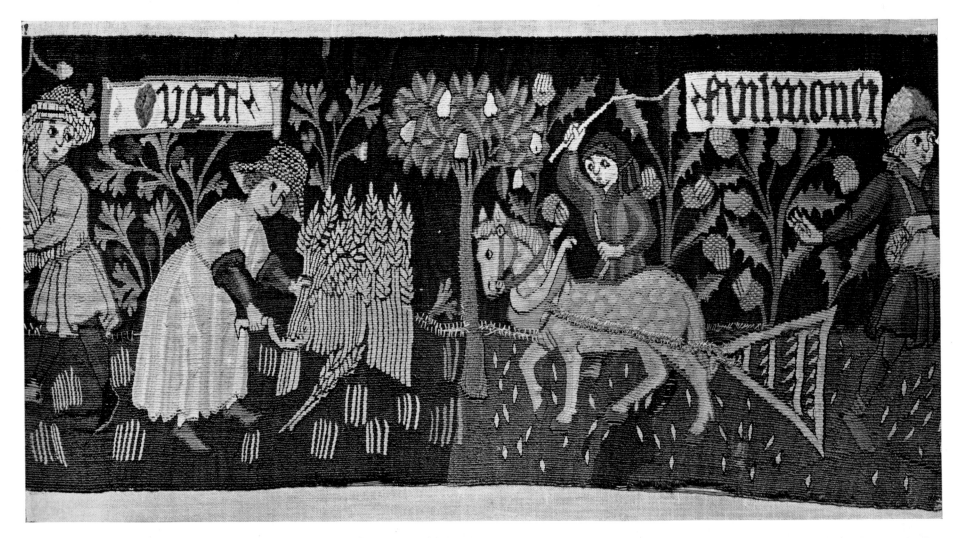

24A. The Labours of the
 Months, detail;
 cat. no.12.

24B. Part of a tapestry-woven
 super-frontal; cat. no.15.

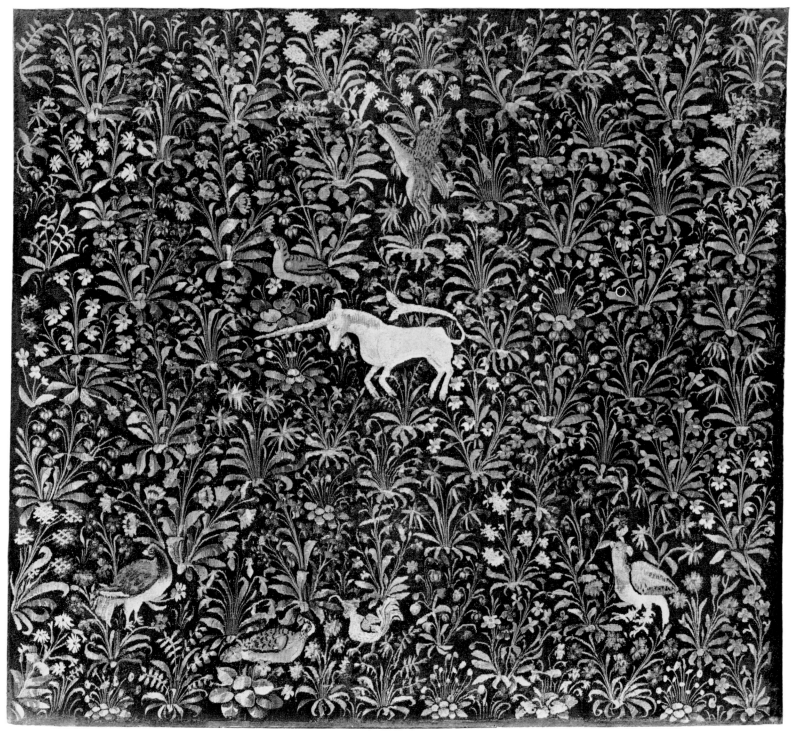

25. Verdure (fragment); cat. no.16.

26. Susanna and the Elders; cat. no.17.

27. Susanna and the Elders, detail; cat. no.17.

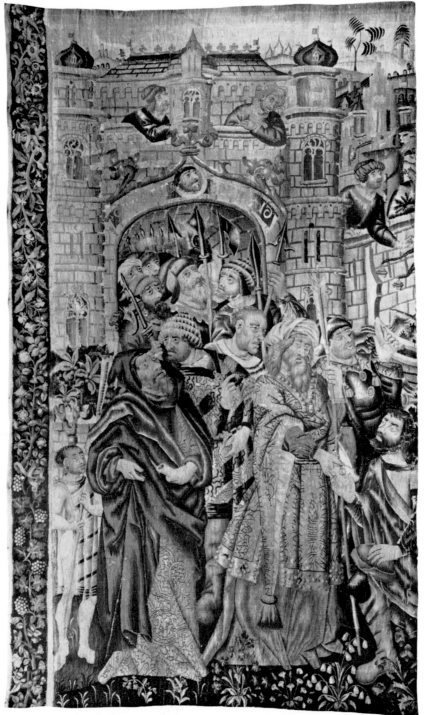

28A & B. The Landing at
Calcutta;
cat. no.18.

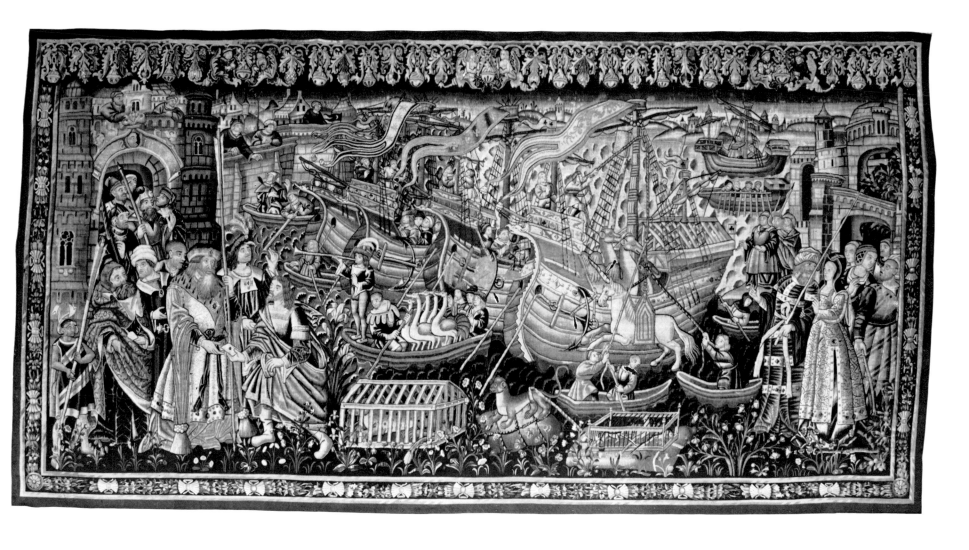

29. The Landing at Calcutta, tapestry belonging to the Banco Nacional Ultramarino, Lisbon.

30. La Main Chaude; cat. no. 19.

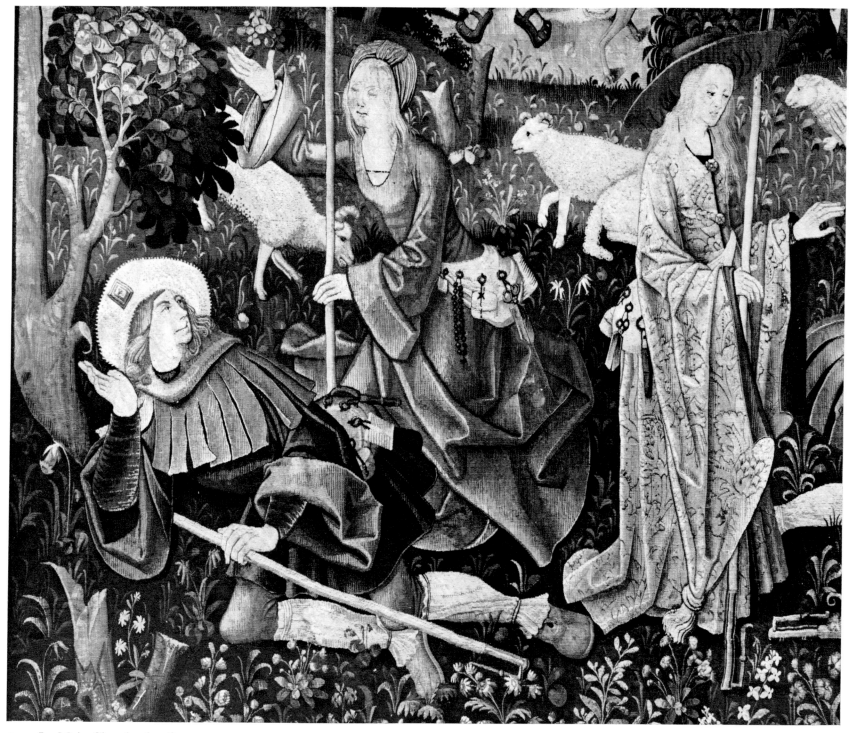

31. La Main Chaude, detail; cat. no. 19.

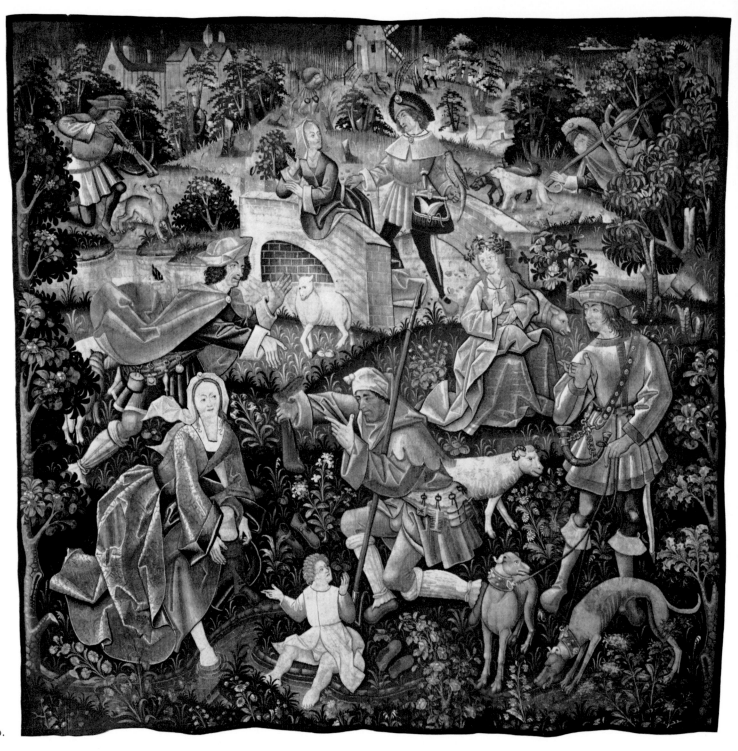

32. Rustic Sports; cat. no.20.

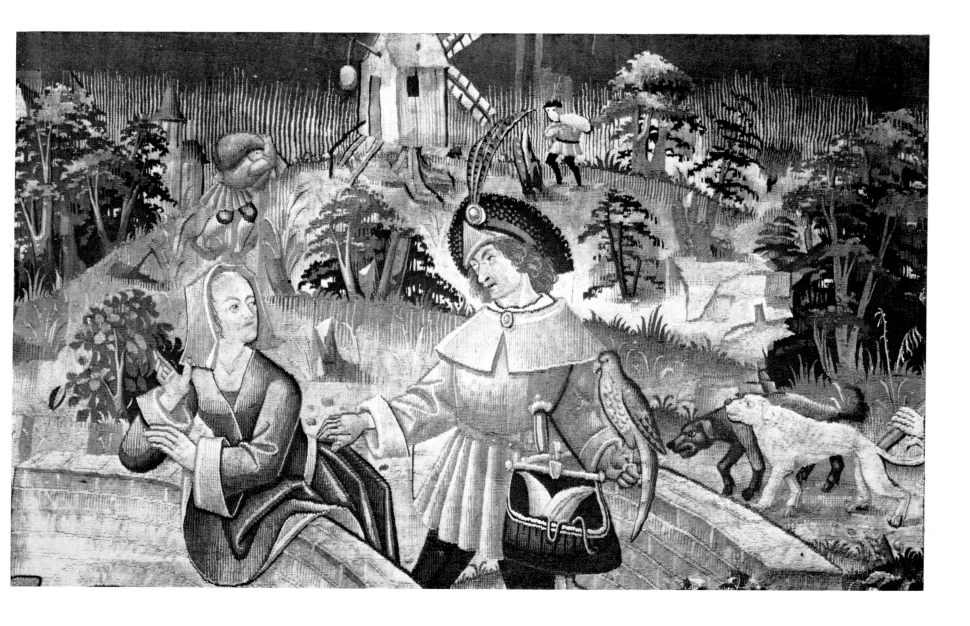

33. Rustic Sports, detail; cat. no.20.

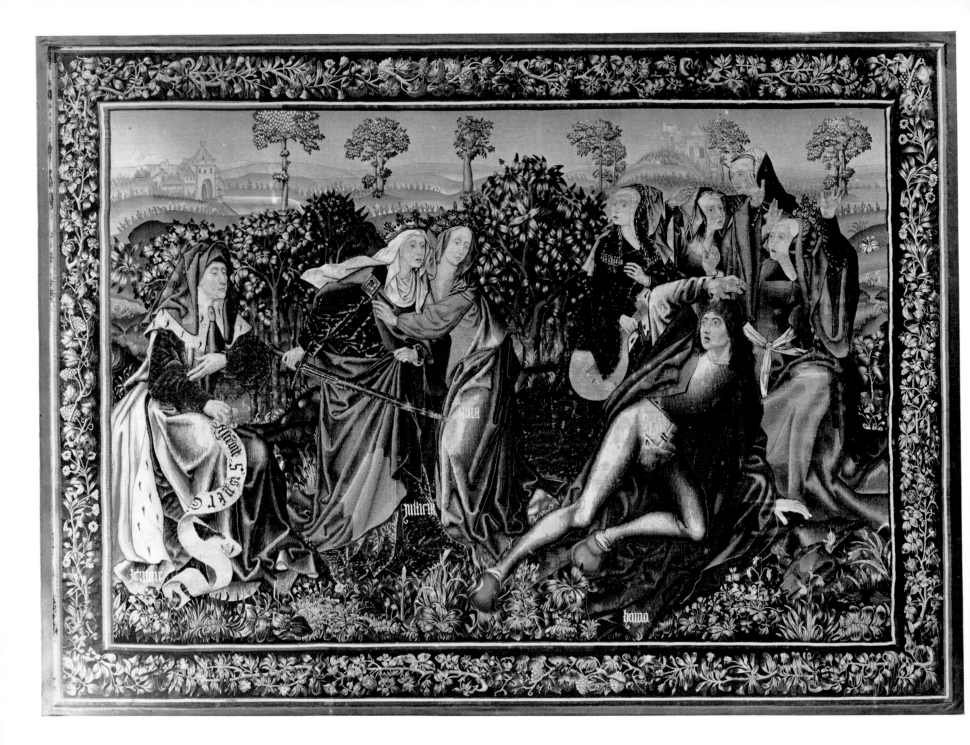

34. Pity restraining Justice (fragment); cat. no.21.

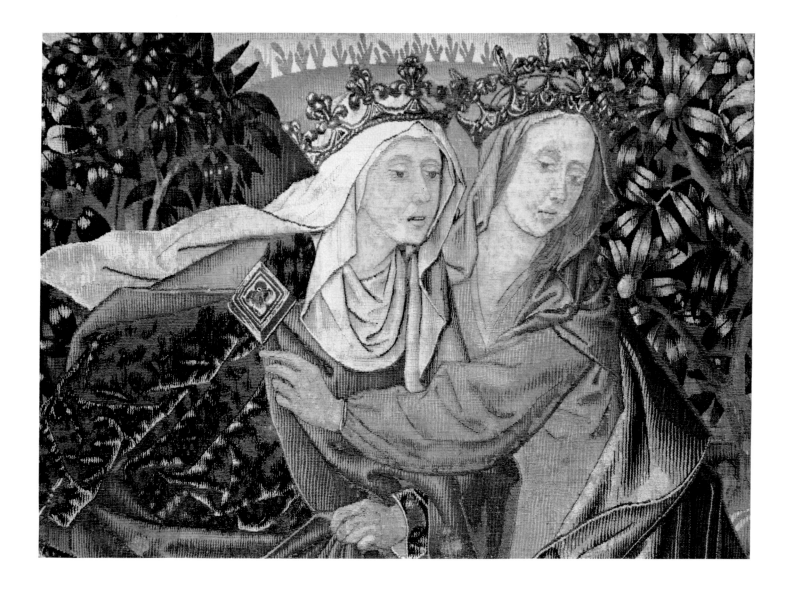

35. Pity restraining Justice, detail; cat. no.21.

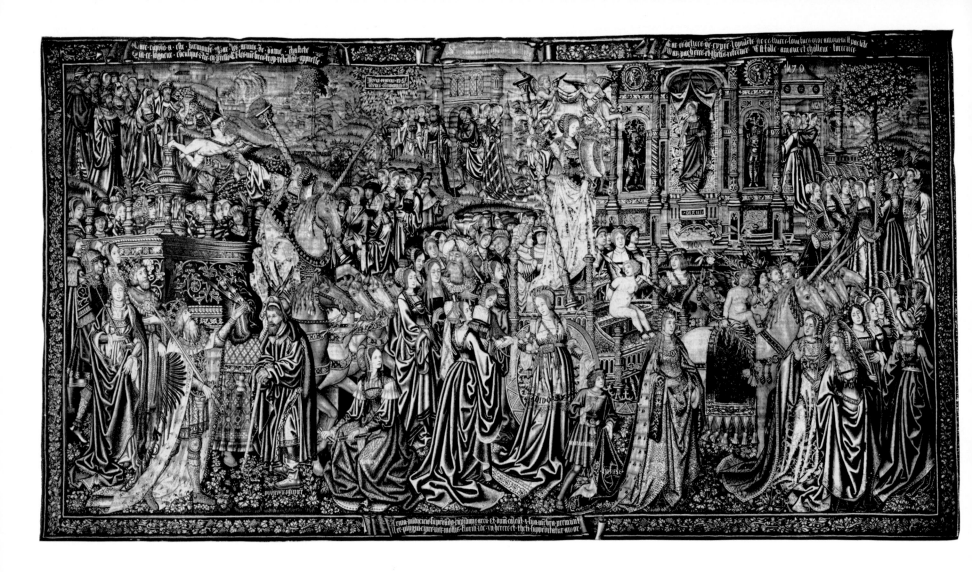

36. The Triumph of Chastity; cat. no.22.

37. The Triumph of Chastity, detail; cat. no.22.

38. The Triumph of Death; cat. no. 23.

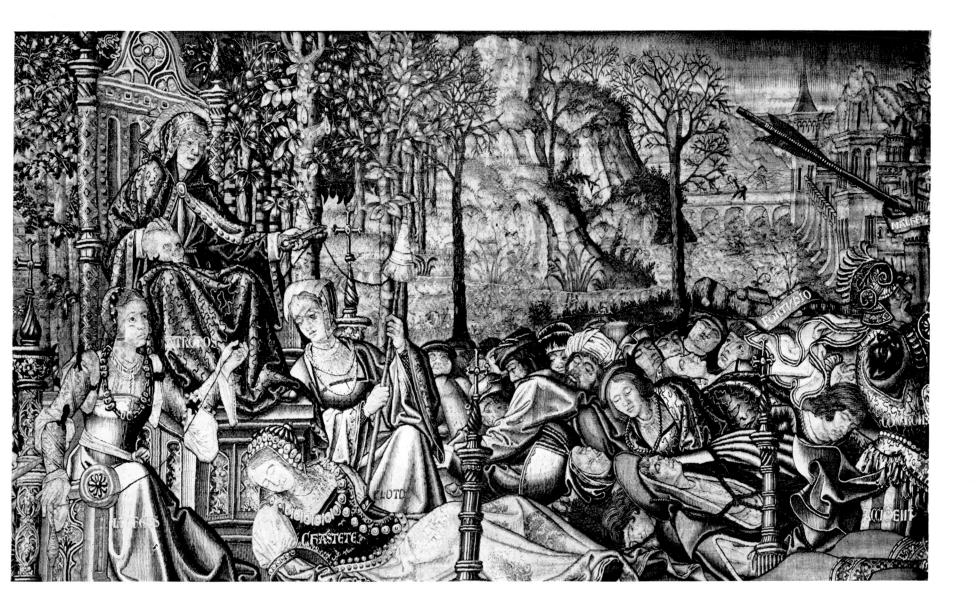

39. The Triumph of Death, detail; cat. no.23.

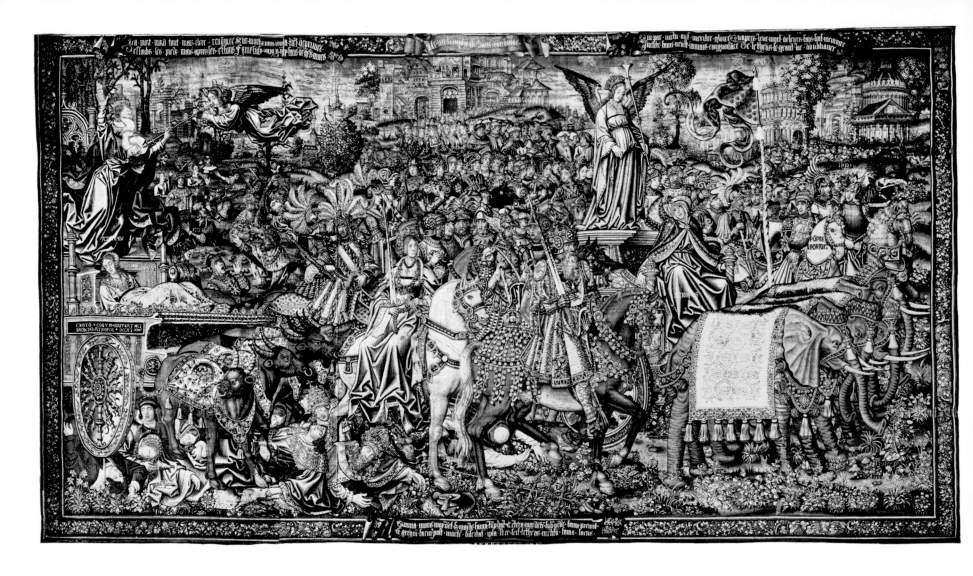

40. The Triumph of Fame; cat. no.24.

41. The Triumph of Fame, detail; cat. no.24.

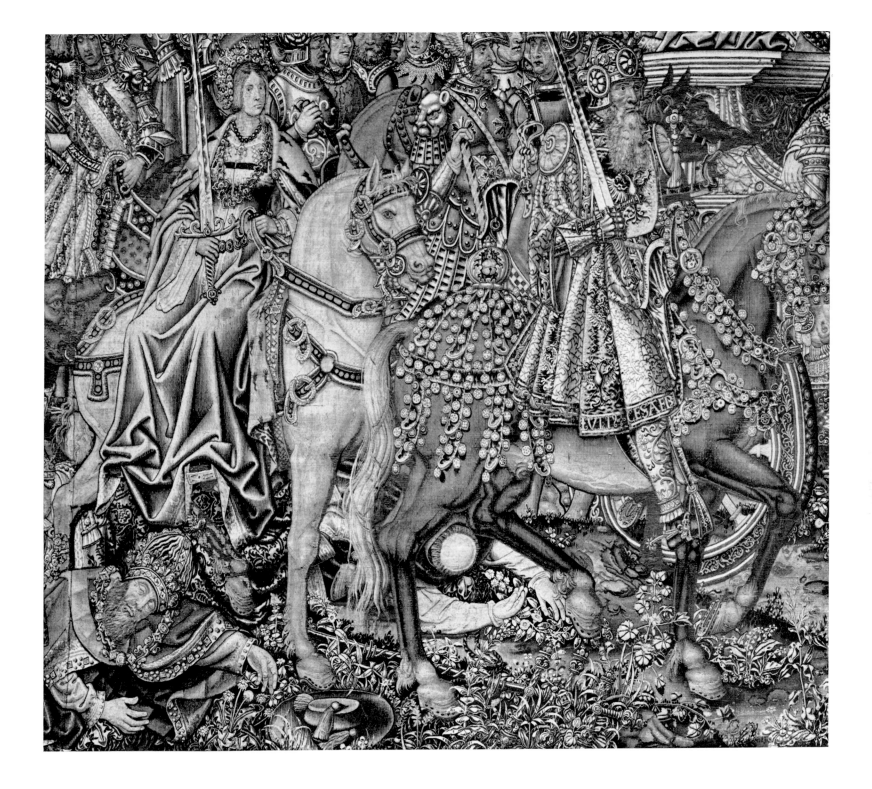

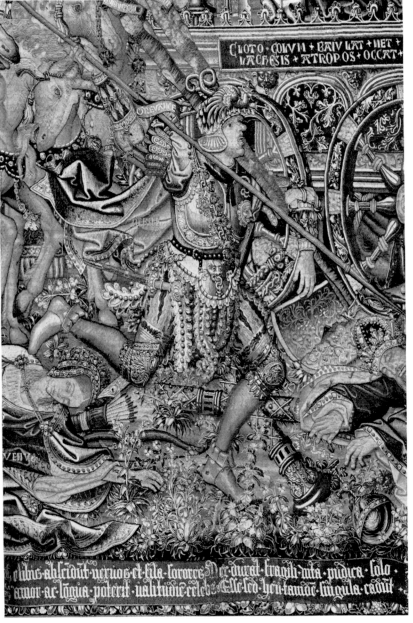

PENELOPE

CLOTO COLVM BAIVLAT NET LACHESIS ATROPOS OCCAT

42A. (*left*) The Triumph of Chastity, detail; cat. no.22.

42B. (*above*) The Triumph of Death; detail; cat. no.23.

43A. (*above*) The Triumph of Fame, detail; cat. no.24.

43B. (*right*) The Triumph of Fame, detail; cat. no.24.

44. The Triumph of Eternity (fragment); cat. no.25.

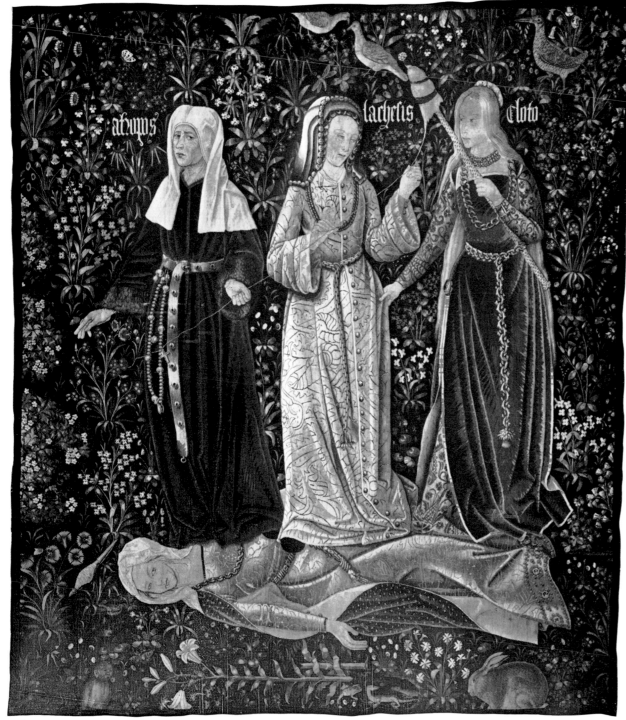

45A. The Three Fates; cat. no.26.

45B. The Three Fates, detail; cat. no.26.

46. The Adoration; cat. no.27.

47. The Adoration, detail; cat. no.27.

48. The Resurrection; cat. no.28.

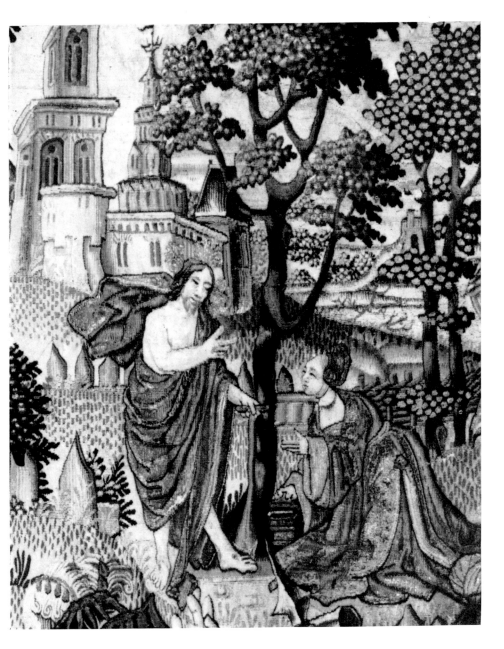

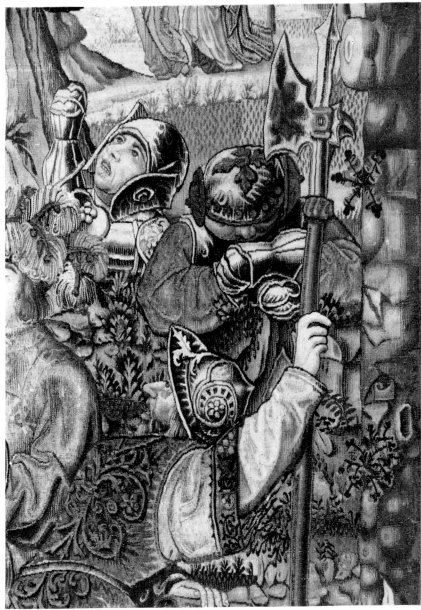

49A. The Resurrection, detail; cat. no.28.

49B. The Resurrection, detail; cat. no.28.

50. Esther hearing of
Haman's plot;
cat. no.29

51. Esther approaching Ahasuerus; cat. no.30.

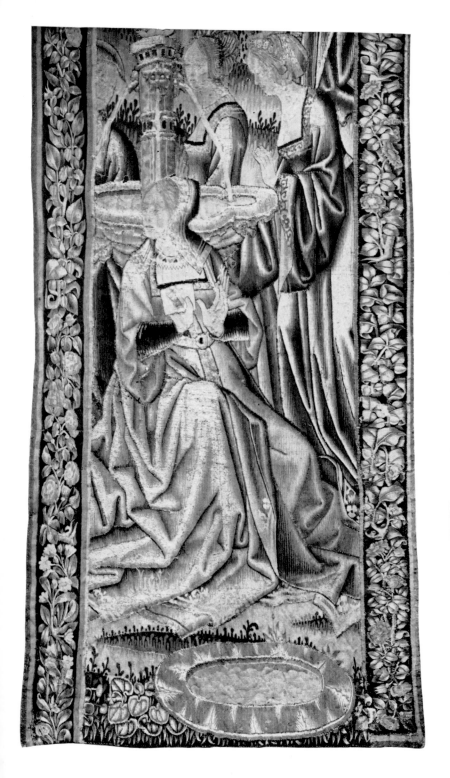

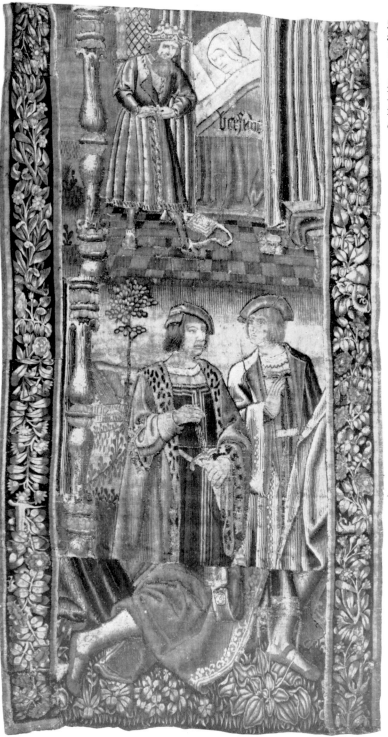

52A. (*far left*) David and Bathsheba (fragment); cat. no.31.

52B. (*left*) David and Bathsheba (three fragments); cat. no.31.

53A. (*opposite top left*) Hunting scene (fragment); cat. no.33.

53B. (*opposite top right*) Court scene (fragment); cat. no.32.

53C. (*opposite bottom left*) Hunting scene (fragment); cat. no.33.

53D. (*opposite bottom right*) Hunting scene (fragment); cat. no.33.

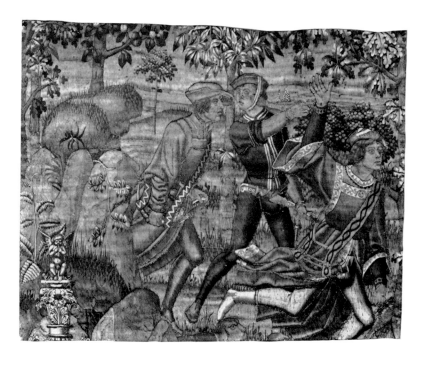

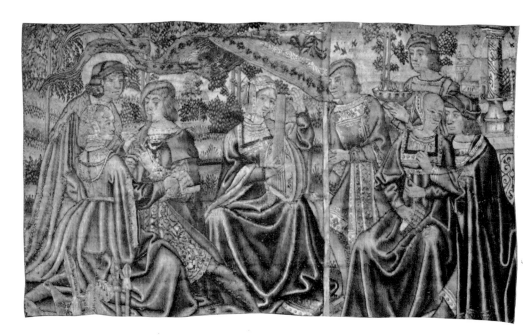

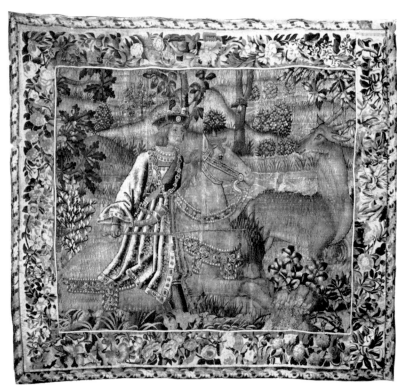

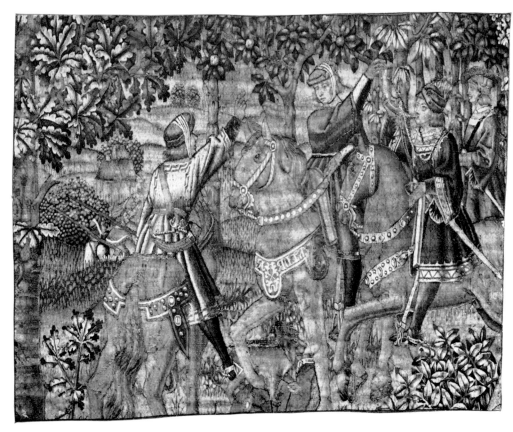

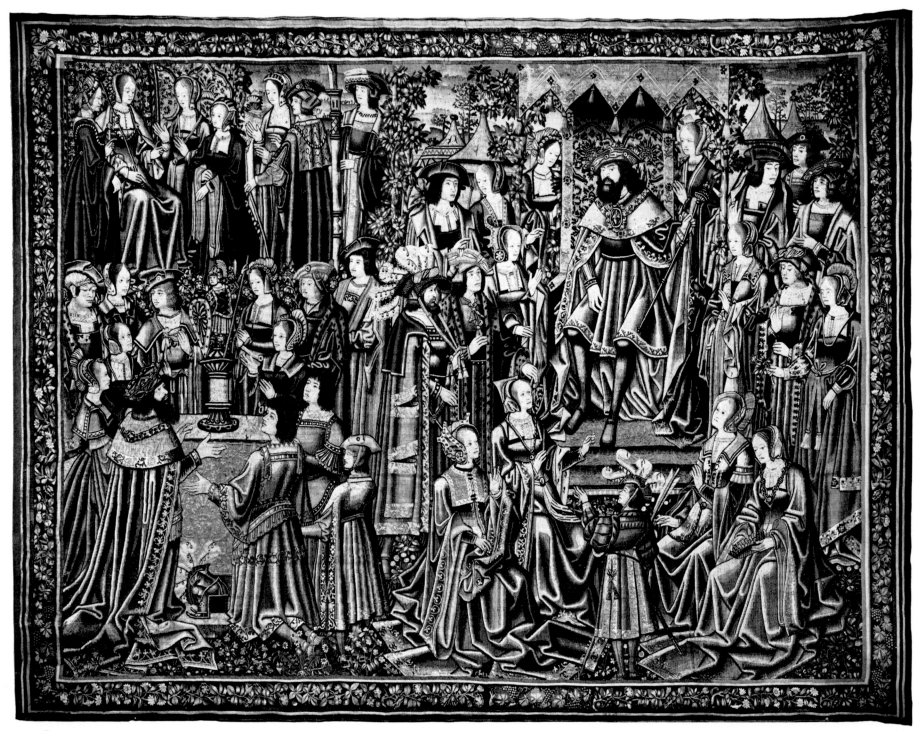

54. Court scenes; cat. no.34.

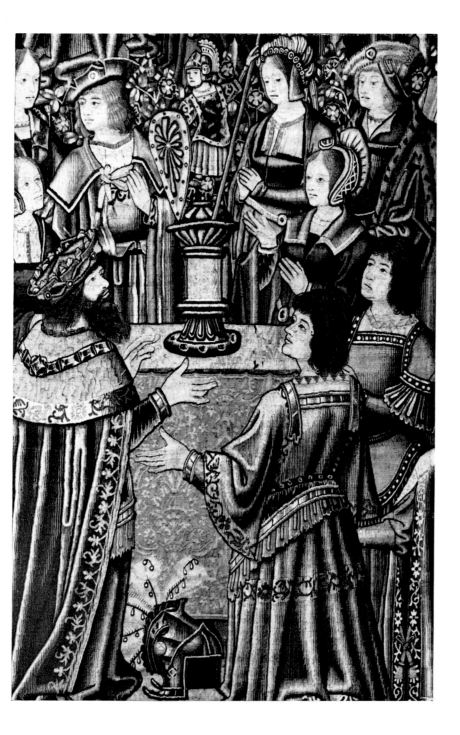

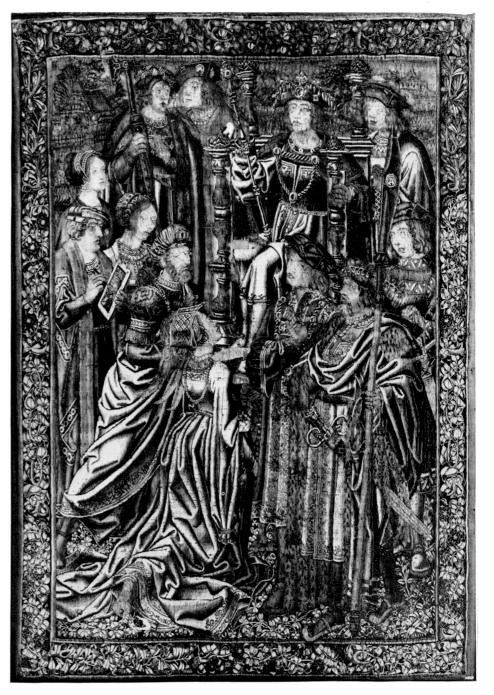

55A. Court scenes (detail); cat. no.34.

55B. Court scene; cat. no.35.

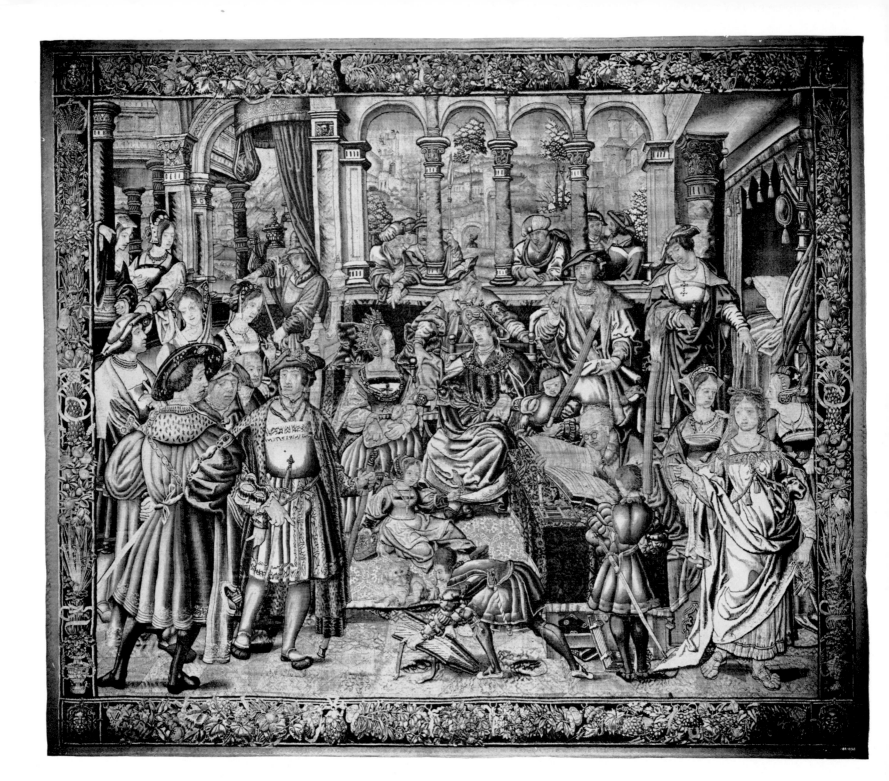

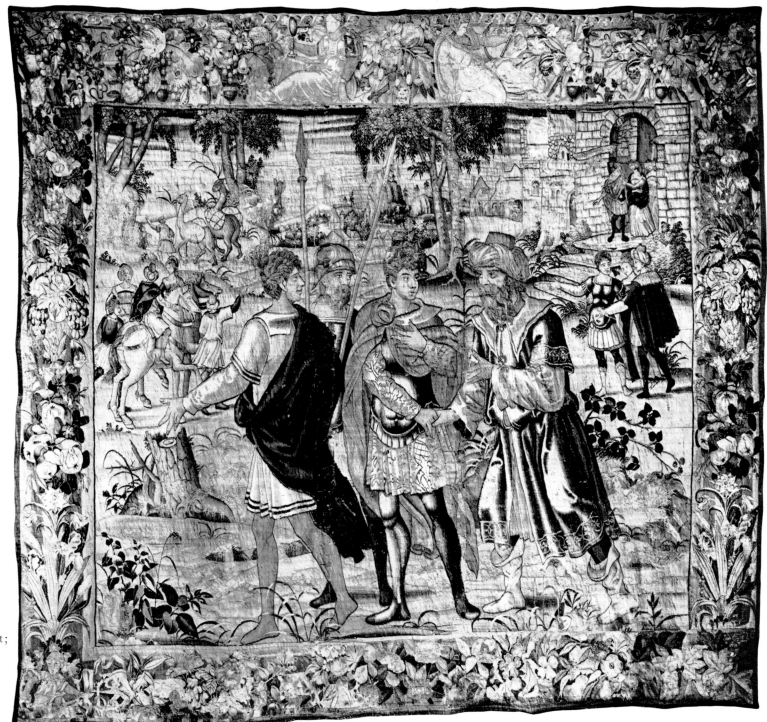

56. (*opposite*) A Royal Court; cat. no.36.

57. (*left*) Tobias or the Prodigal Son; cat. no.37.

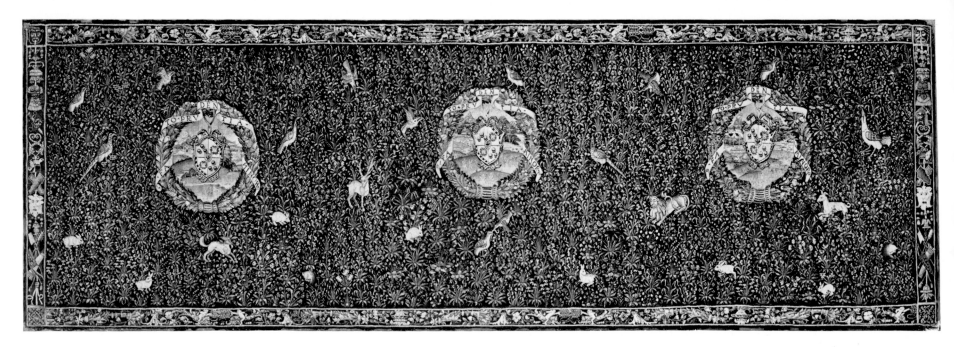

58A. Arms of Giovio; cat. no.38.

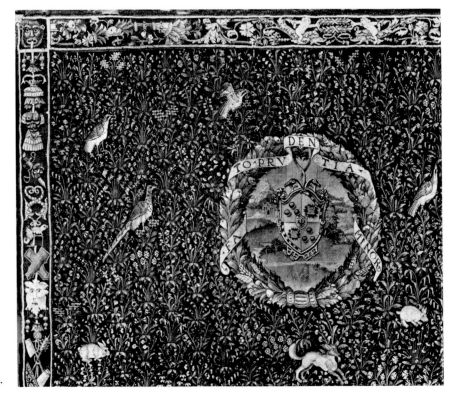

58B. Arms of Giovio, detail; cat. no.38.

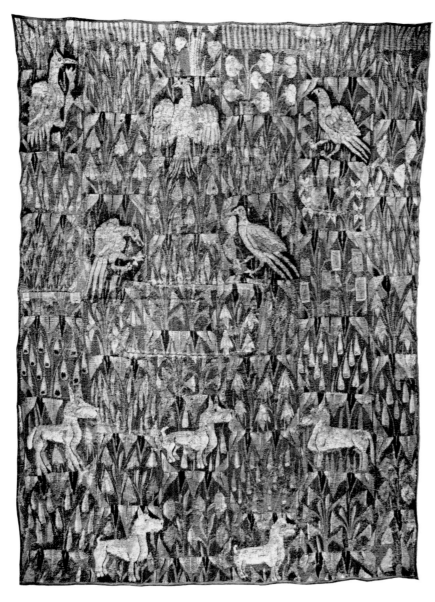

59A. Mille-fleurs verdure (fragment); cat. no.40.

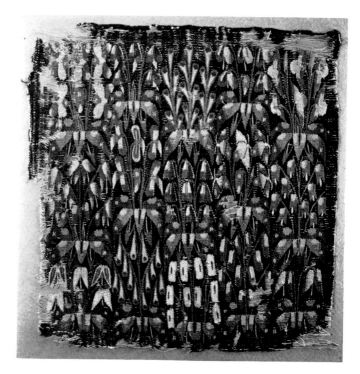

59B. Mille-fleurs cushion cover; cat. no.39.

59C. Lectern cover; cat; no.41.

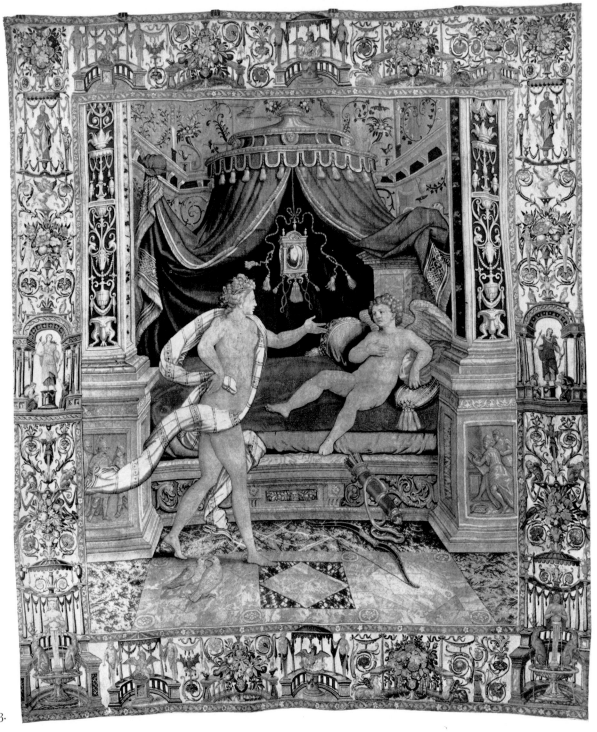

60. Venus admonishing Cupid; cat. no.43.

61. Drawing by Giovanni Battista Castello for
 tapestry cat. no.43, in the National Gallery of
 Scotland, Edinburgh.

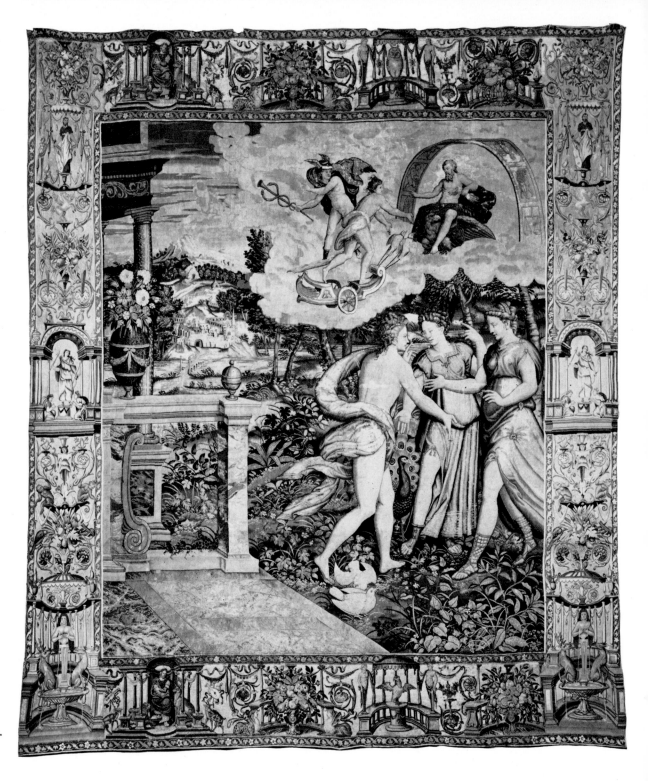

62. Venus seeks vengeance on Psyche; cat. no.42.

63. Drawing by Giovanni Battista Castello for
tapestry cat. no.42, formerly with P. & D.
Colnaghi & Co., Ltd.

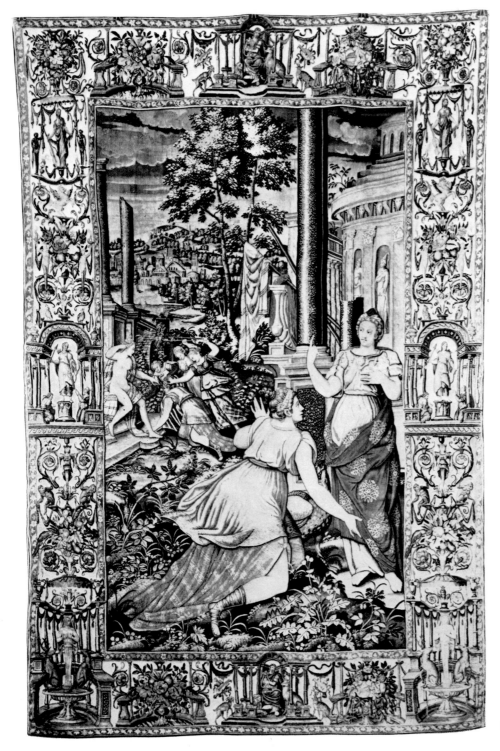

64. Psyche in Venus' service; cat. no.44.

65. Grotesque with Ceres; cat. no.45.

66. Grotesque with the Arms of Herbert; cat. no.46.

67. Grotesque with Pride and Avarice. cat. no.47.

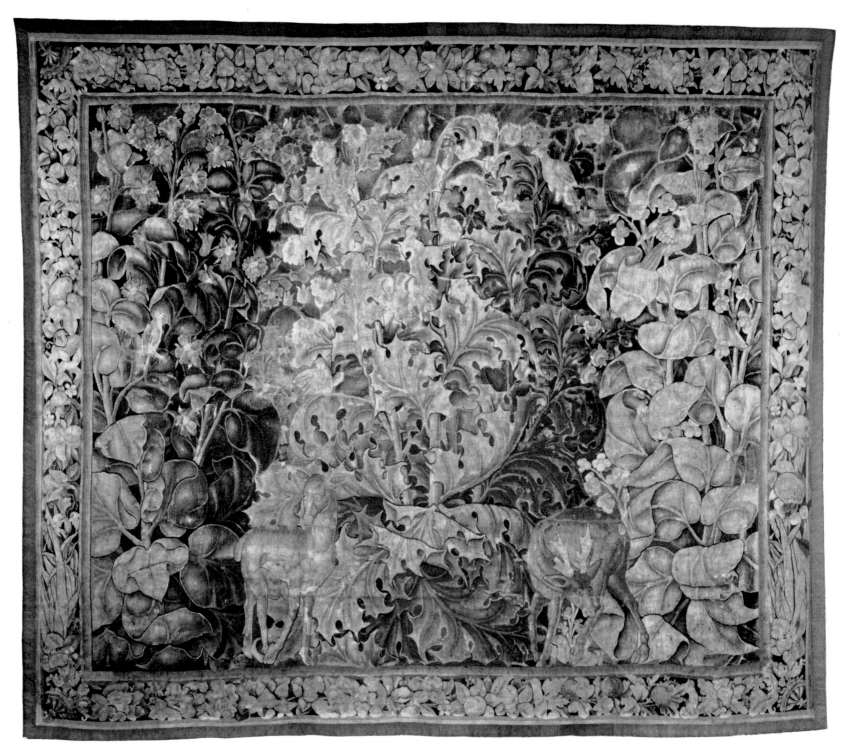

68. Verdure with deer. cat. no.48.

69A. Giant-leaf verdure (fragment); cat. no 49.

69B. Giant-leaf verdure (fragments of border); cat. no.49.

70. Giant-leaf verdure (fragment); cat. no.49.

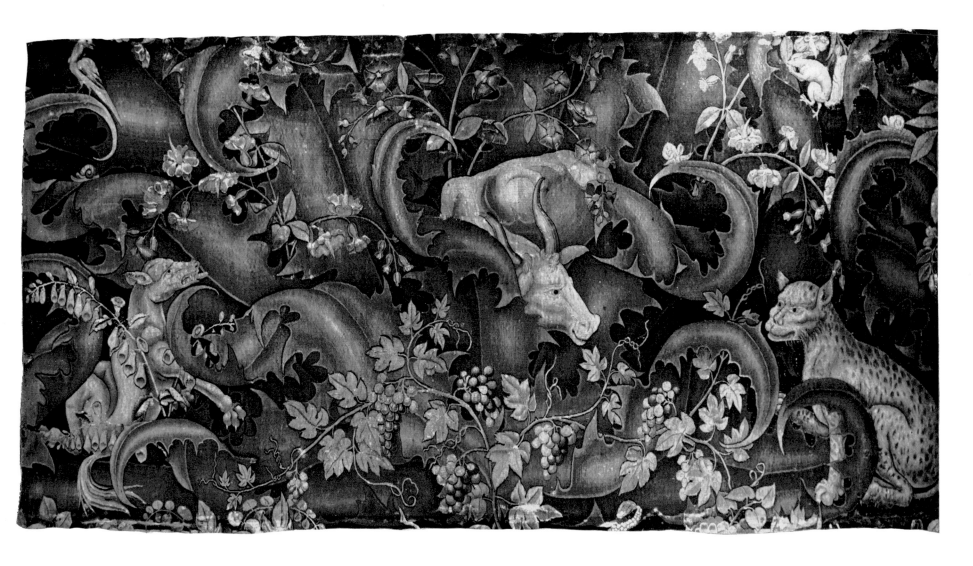

71. Giant-leaf verdure (fragment); cat. no.49.

72. Verdure with arcade; cat. no.50.

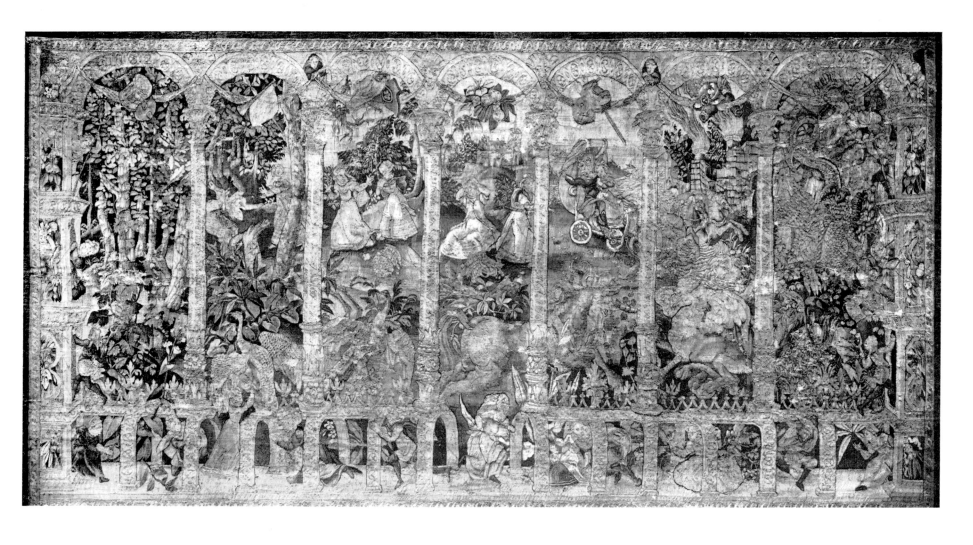

73. Rape of Proserpina; cat. no.51.

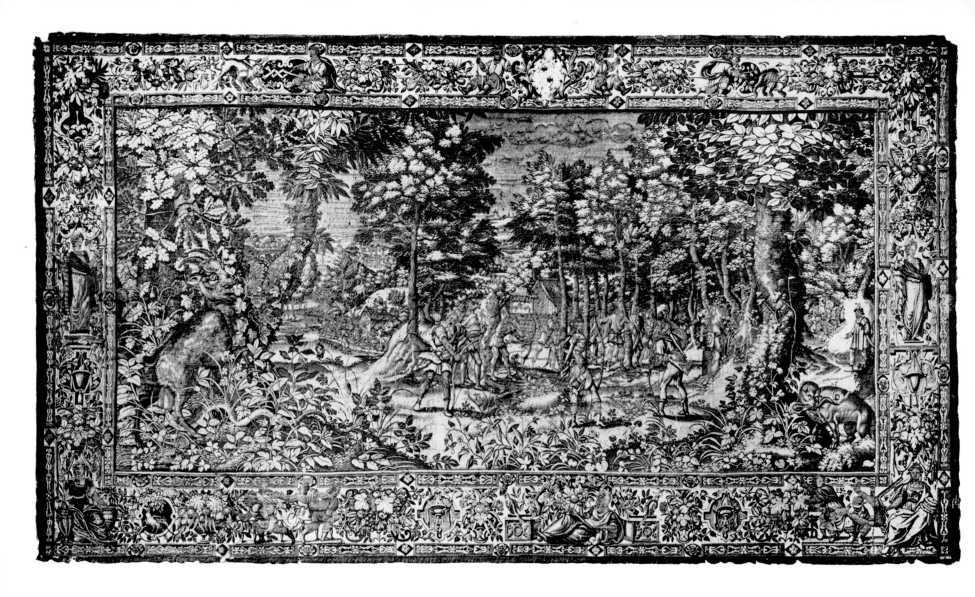

74. Landscape with the Arms of Contarini; cat. no.52.

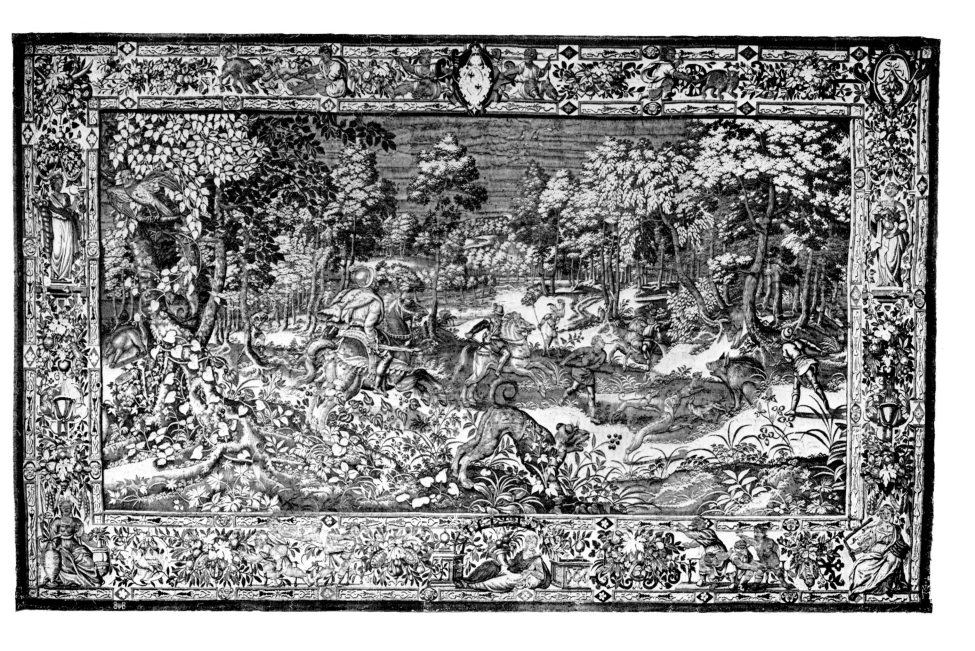

75. Landscape with the Arms of Contarini; cat. no.53.

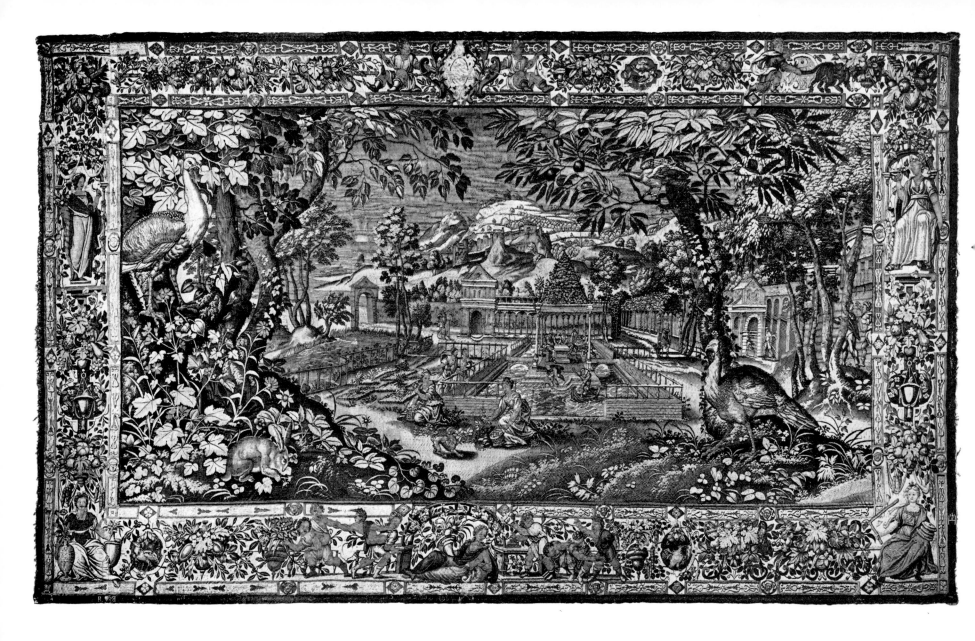

76. Landscape with the Arms of Contarini; cat. no.54.

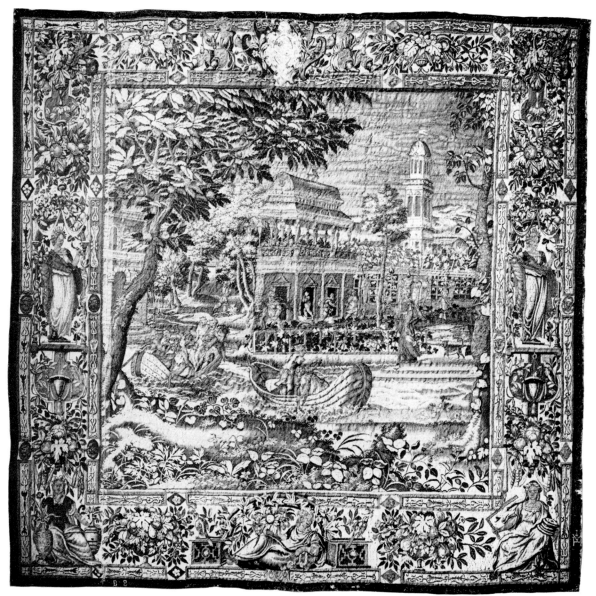

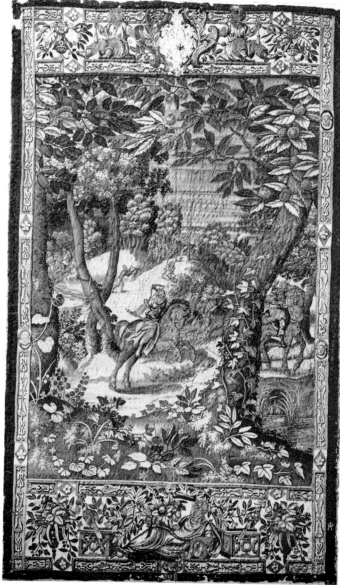

77A. Landscape with the Arms of Contarini; cat. no.55.

77B. Landscape with the Arms of Contarini; cat. no.56.

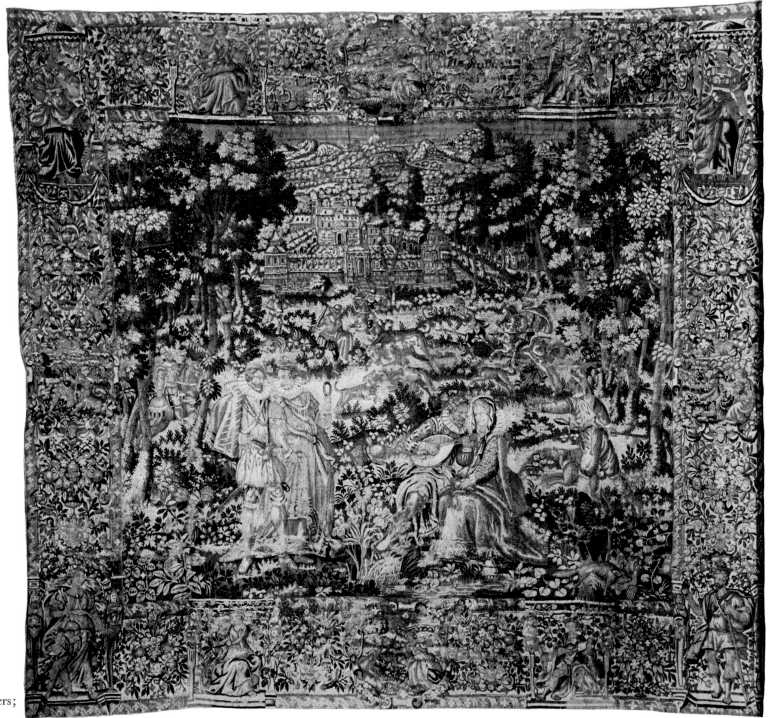

78. Park with courtiers;
 cat. no.57.

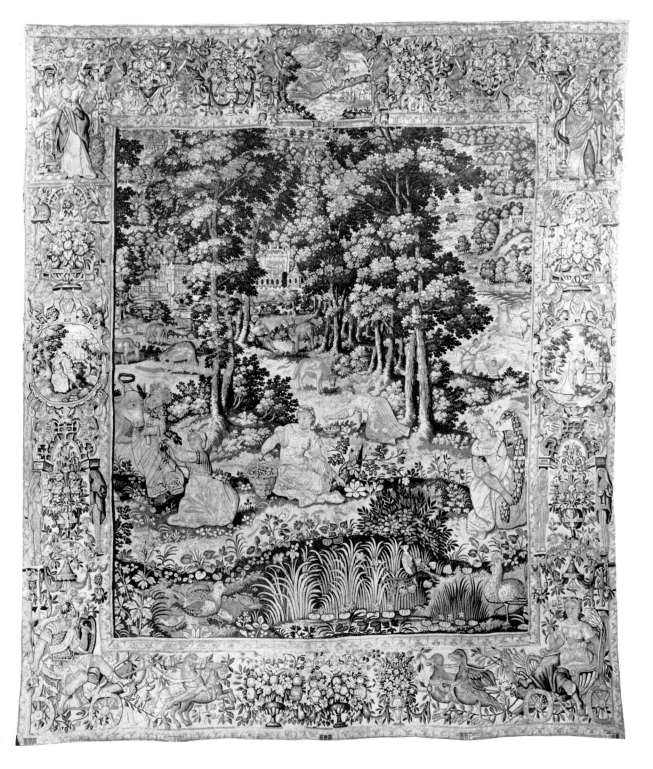

79. Europa and the Bull; cat. no.58.

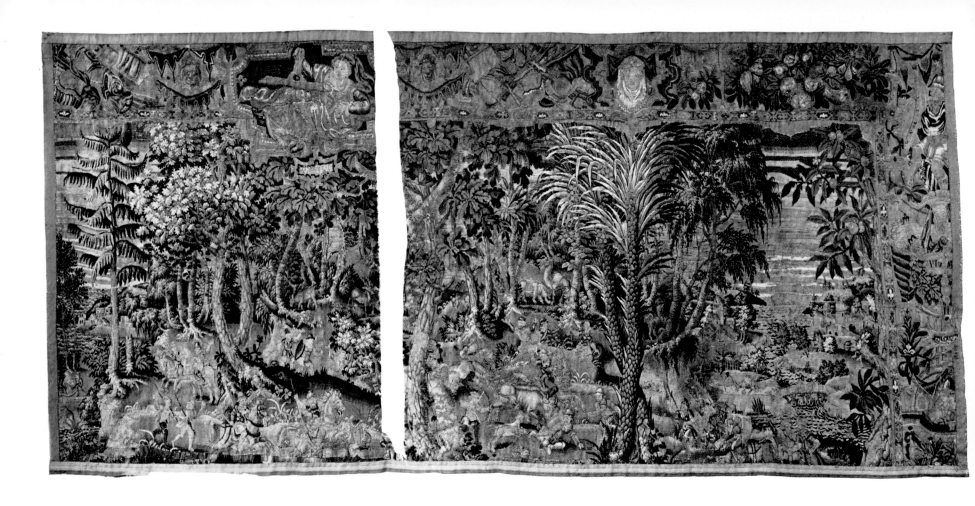

80. Landscape with a hunt (fragment); cat. no.59.

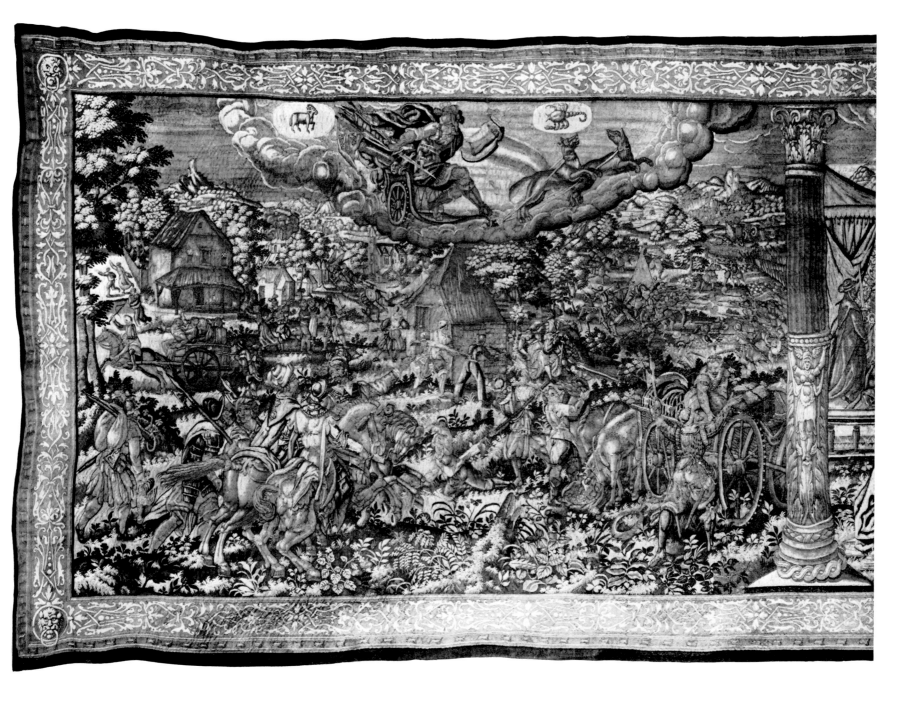

81. The Planets, Mars; cat. no.60.

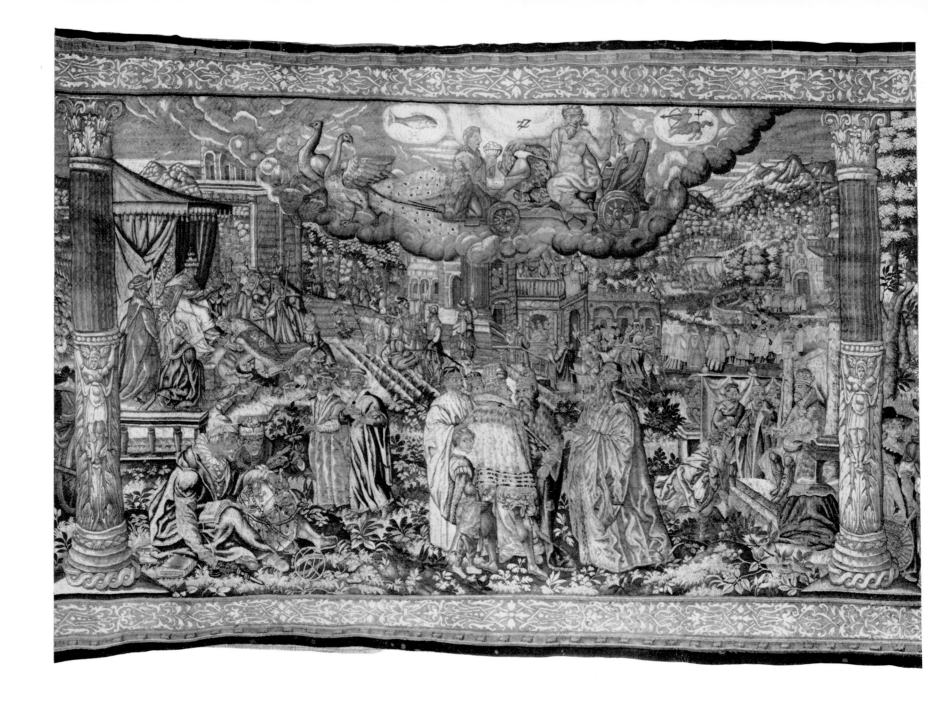

82. The Planets, Jupiter; cat. no.60.

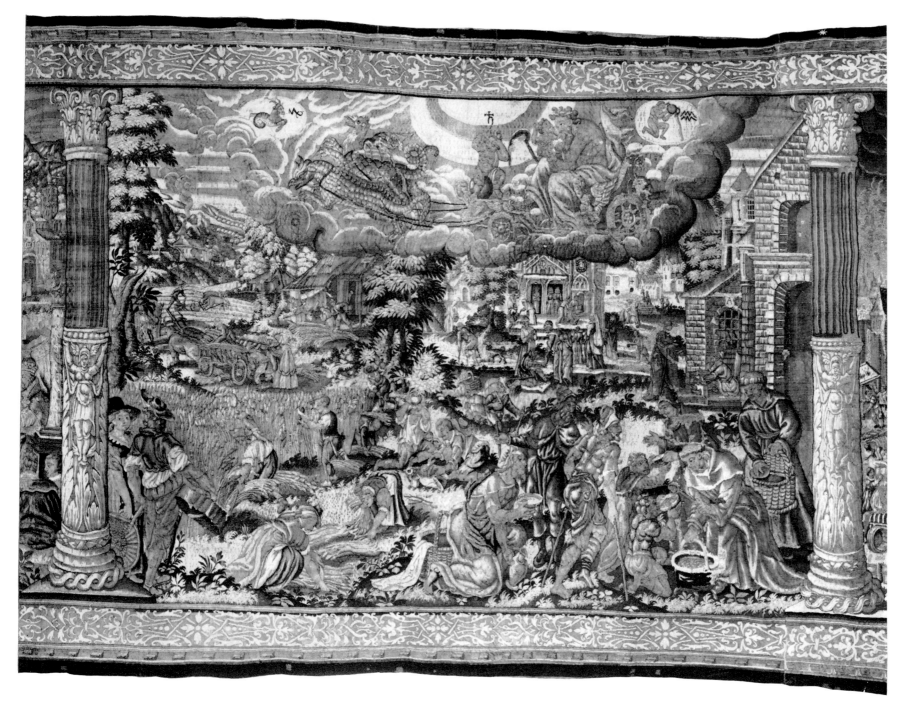

83. The Planets, Saturn; cat. no.60.

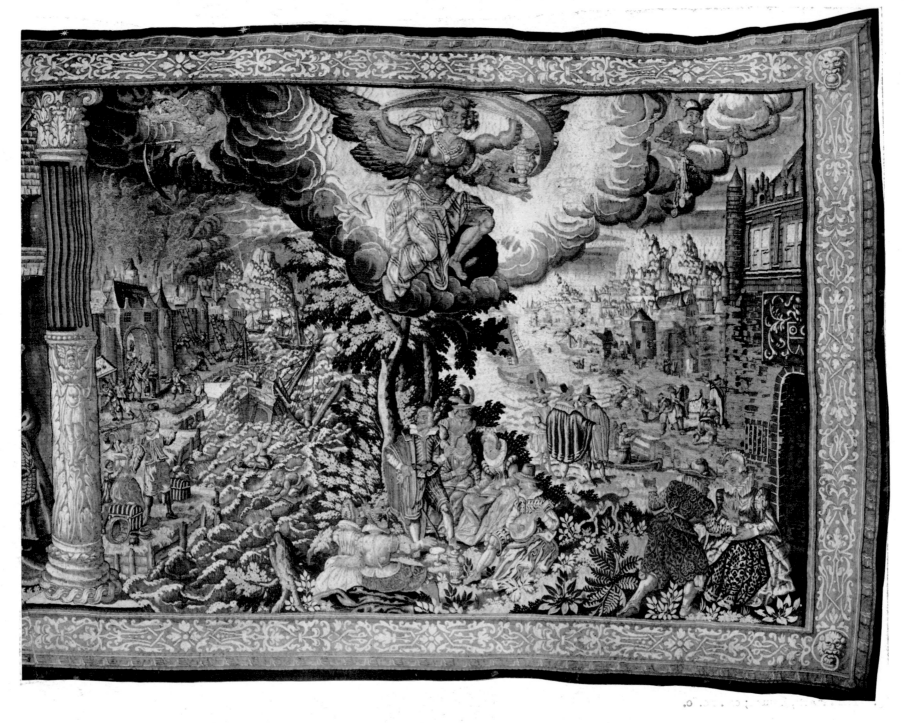

84. The Planets, Fortuna; cat. no.60.

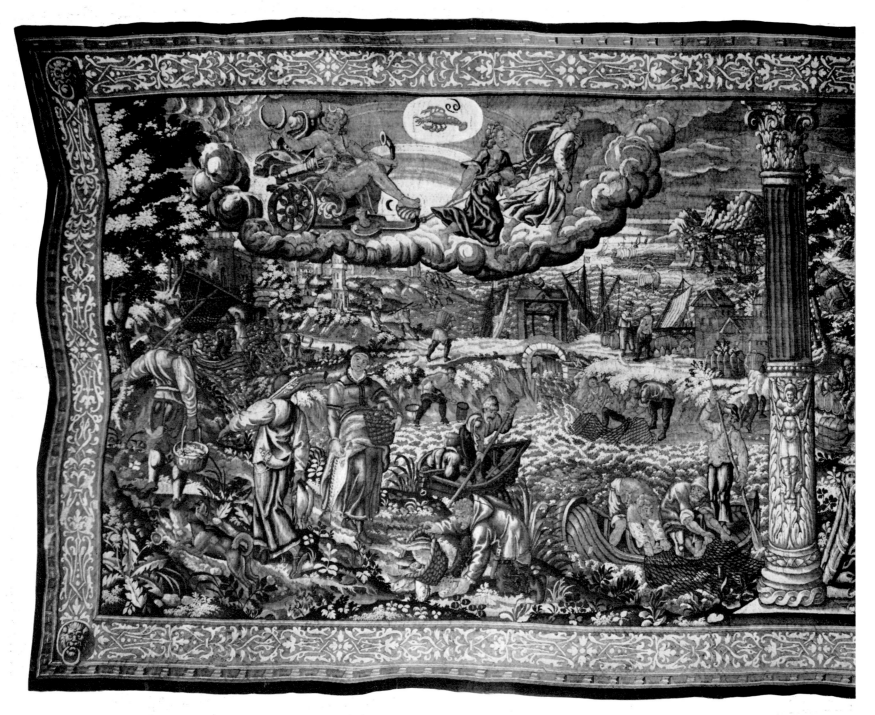

85. The Planets, Luna; cat. no.61.

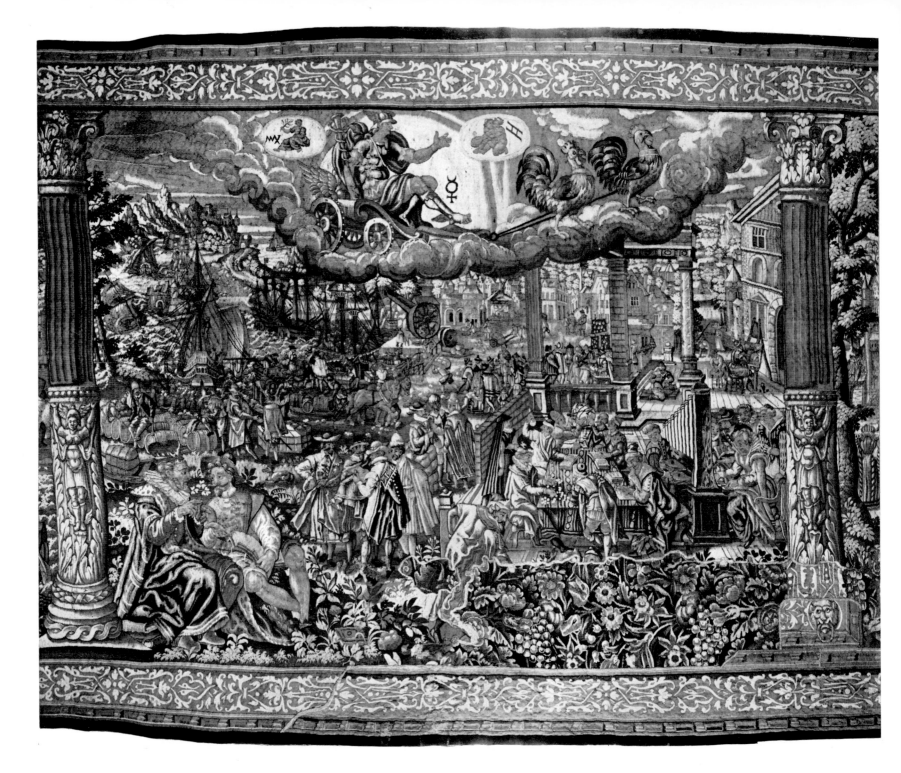

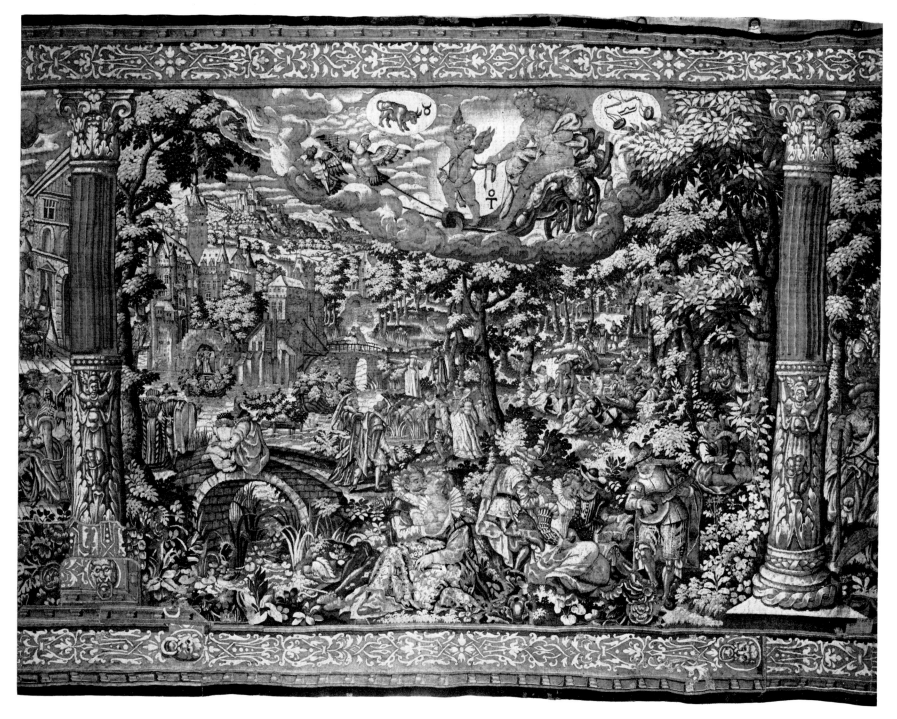

86. (*opposite*) The Planets, Mercury; cat. no. 61. 87. (*above*) The Planets, Venus; cat. no. 61.

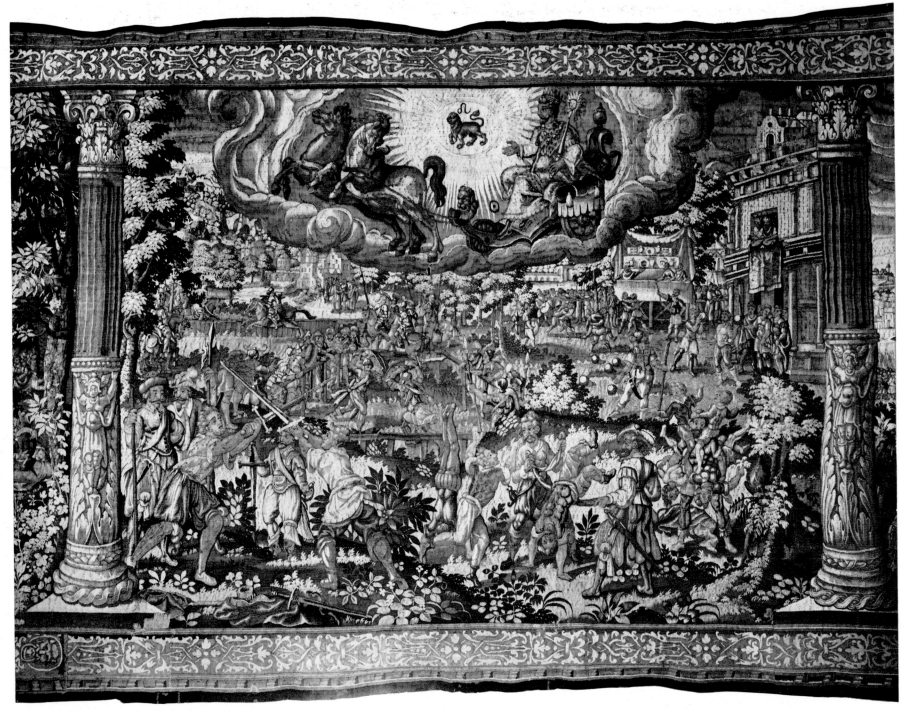

88. The Planets, Sol; cat. no.61.

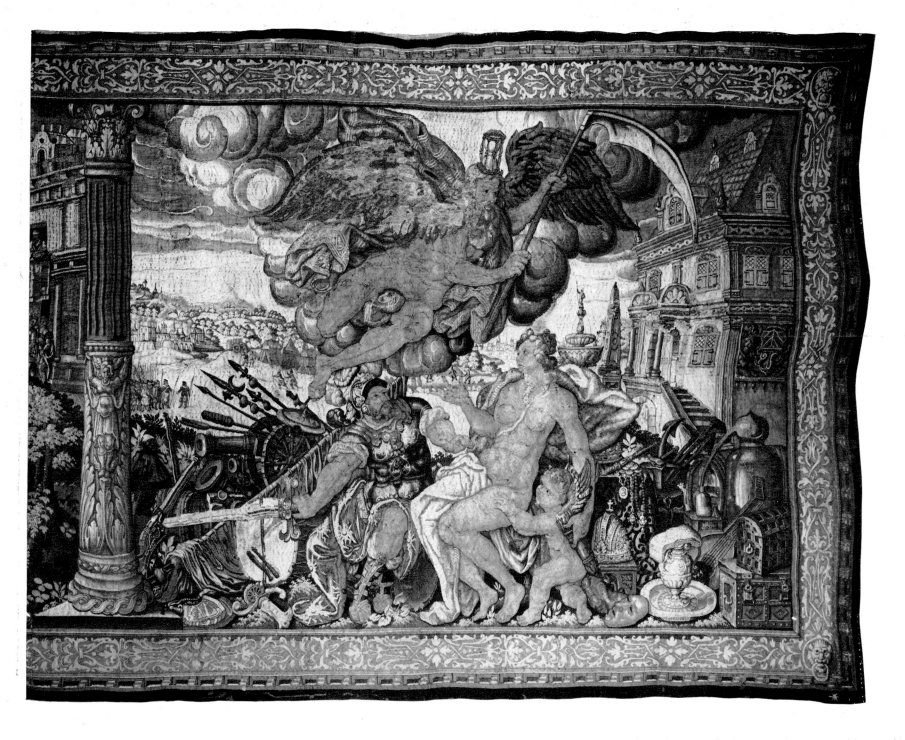

89. The Planets, Time; cat. no.61.

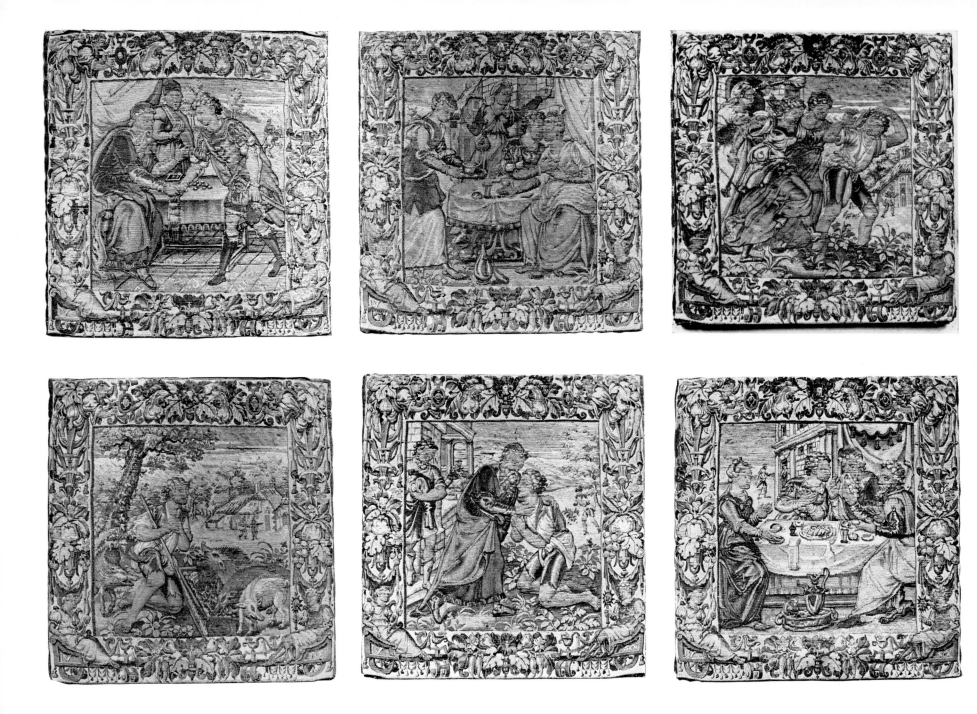

90A–F. Cushion covers, The Prodigal Son; cat. no.62.

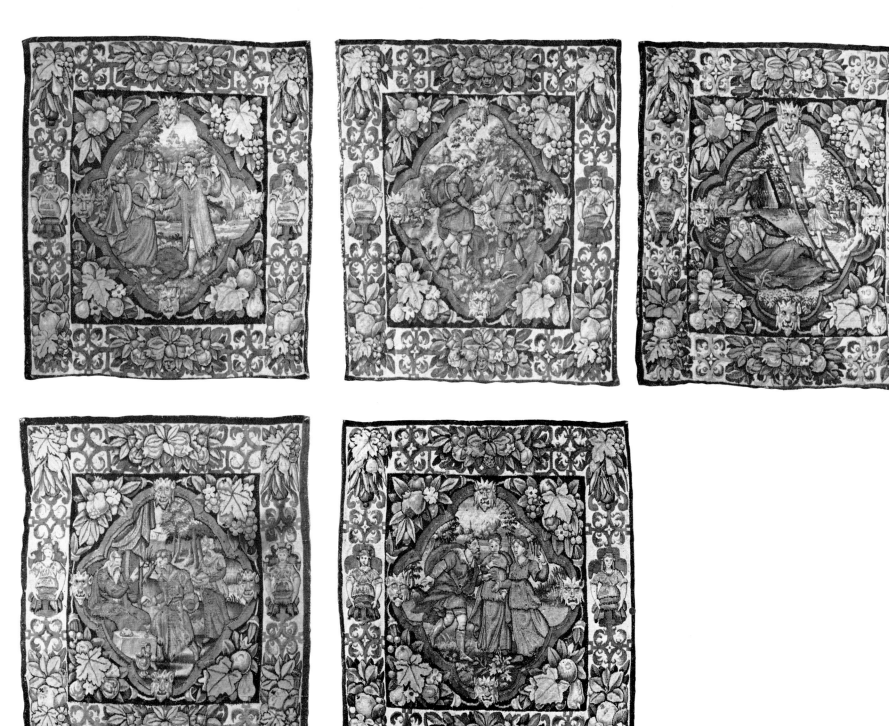

91A–E. Cushion covers; The Story of Jacob;
cat. no.63.

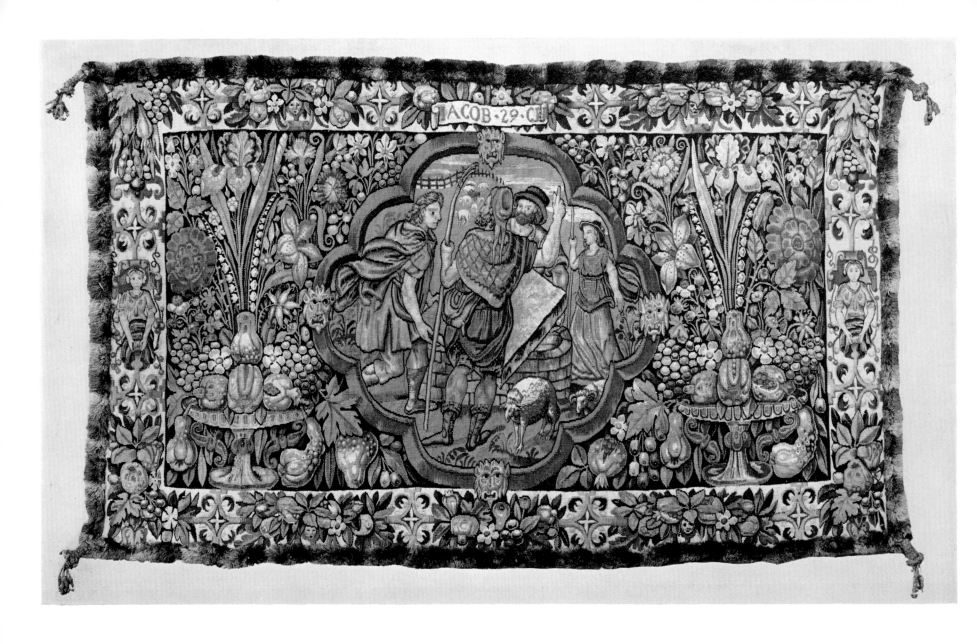

92. Long cushion cover, The Story of Jacob; cat. no.63.

93. Orpheus; cat. no.64.

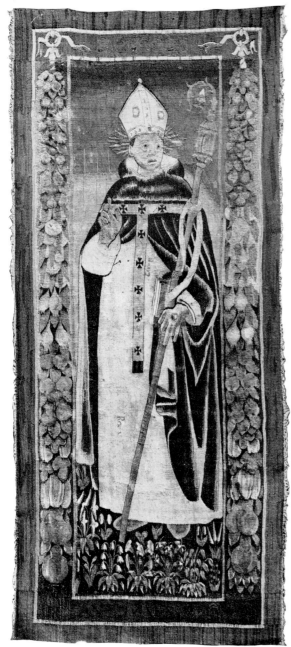

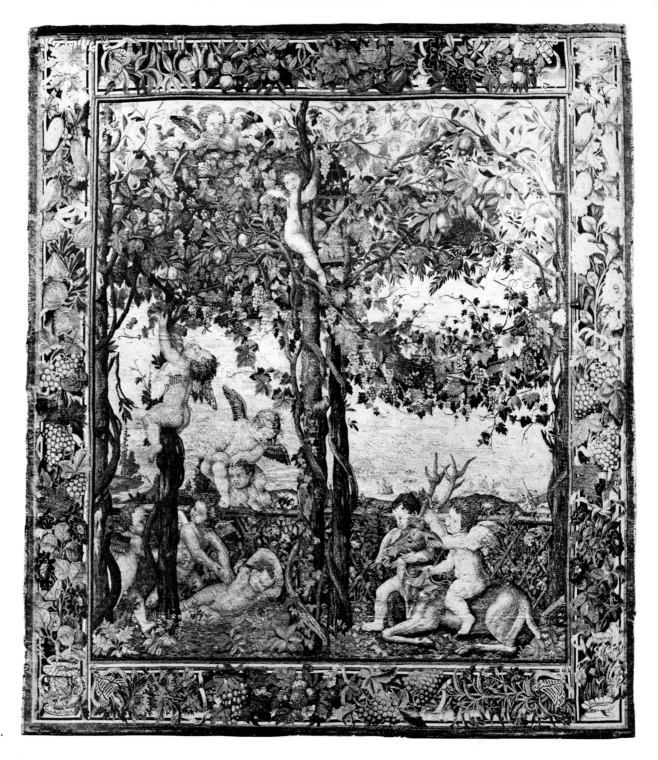

94A. St Antoninus; cat. no.65.
94B. Boys at play; cat. no.66.
95. (*opposite*) Drawing attributed to Giulio
 Romano of the tapestry cat. no.66,
 Victoria and Albert Museum E.4586–1910.

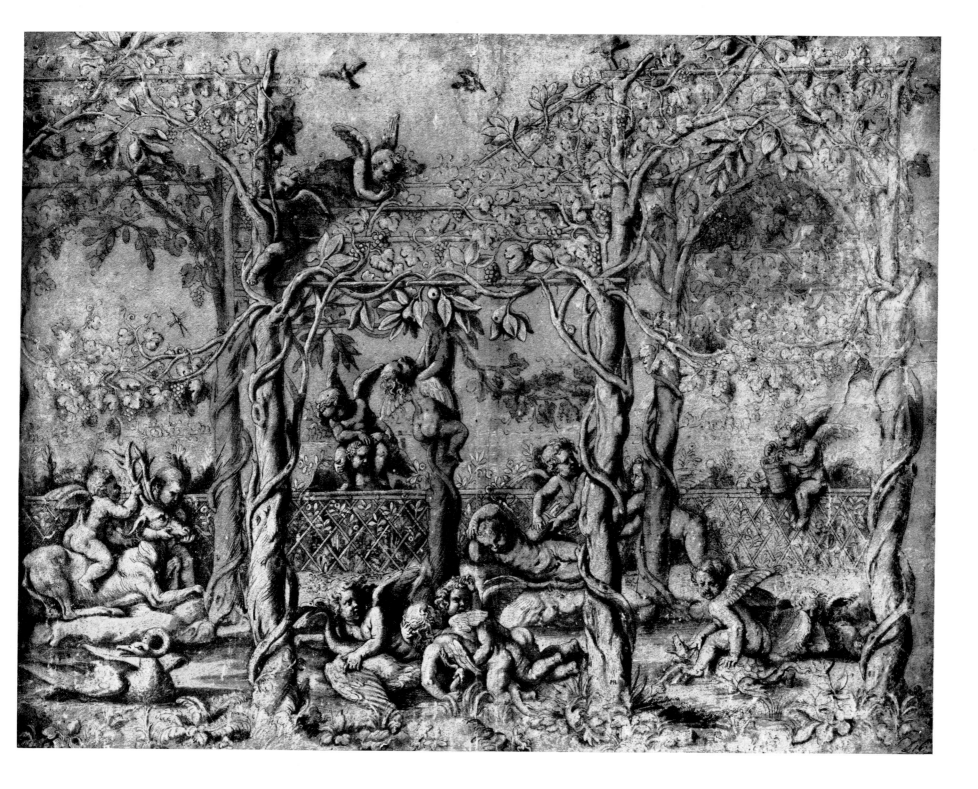

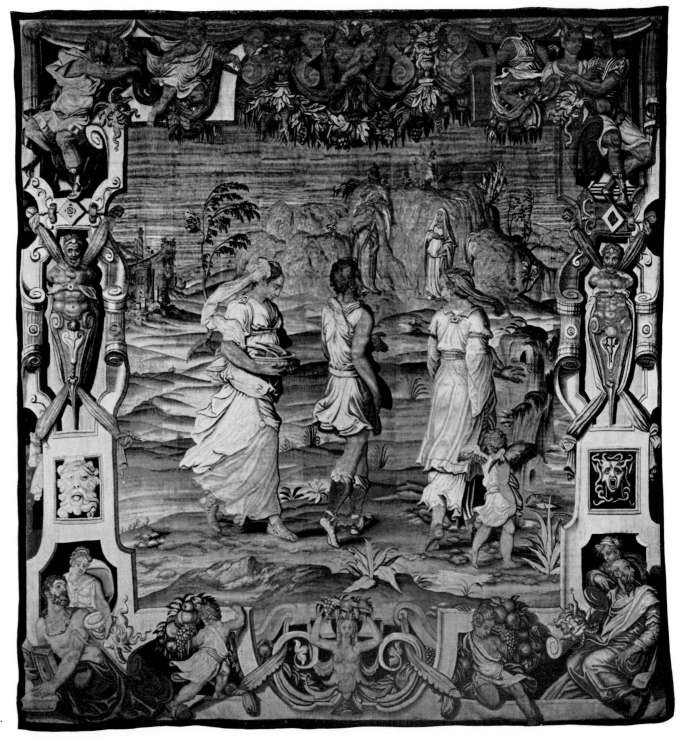

96. The Life of Man; cat. no.67.

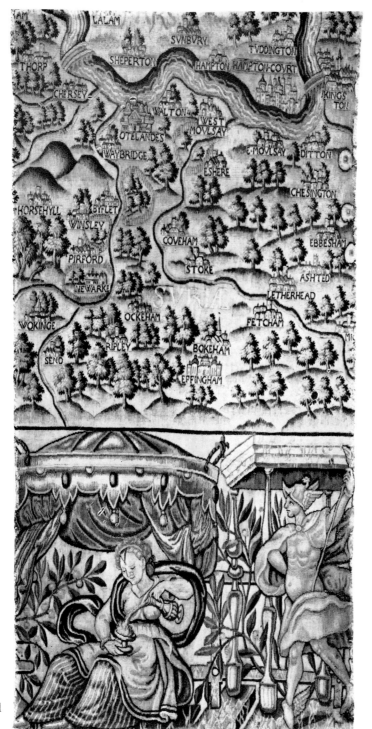

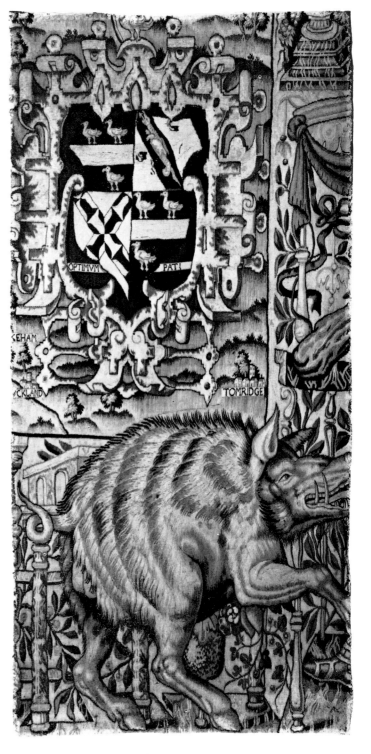

97A & B. Two fragments from a
Map of Oxfordshire and
Berkshire; cat. no.68.

98. (*opposite*) Map of Worcestershire, lent to the Victoria
and Albert Museum by the Bodleian Library, Oxford.

99. (*above*) Map of Worcestershire; cat. no.69.

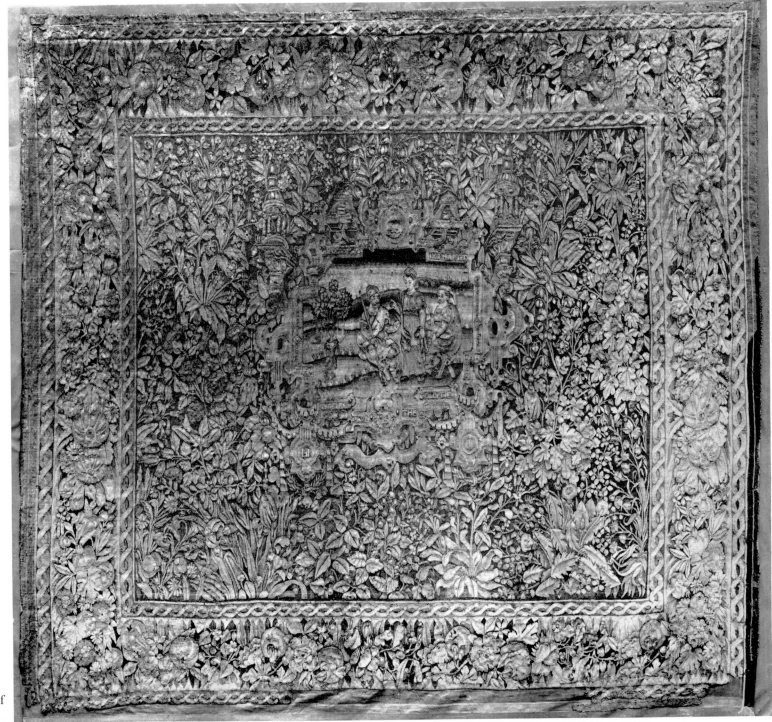

100. The Judgement of
Paris; cat. no.70.

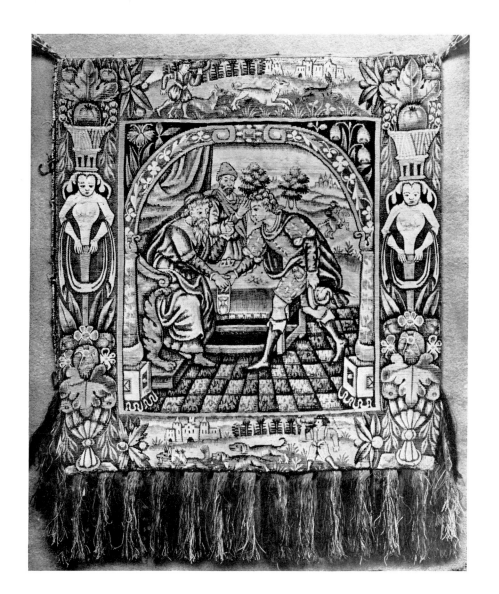

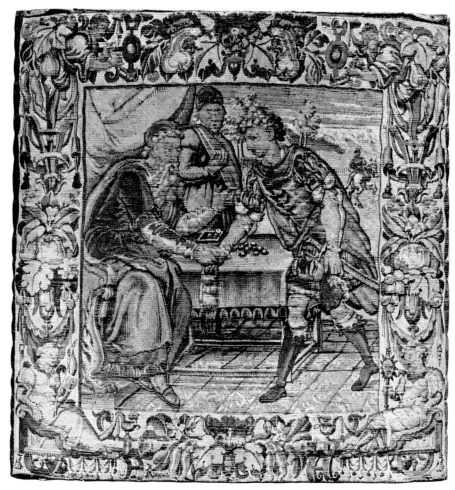

101A. Cushion cover, The Prodigal Son Departs; cat. no. 71a.

101B. Cushion cover, The Prodigal Son Departs; cat. no. 62.

102A. (*upper left*) Cushion cover, Judith; cat. no.71b.

102B. (*lower left*) Small Cushion cover, The Flight into Egypt; cat. no. 71e.

102C. (*upper right*) Cushion cover, Arms of Sacheverell; cat. no.71c.

102D. (*lower right*) Cushion cover, The Flight into Egypt; cat. no.71d.

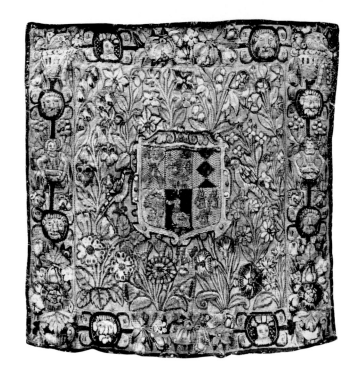

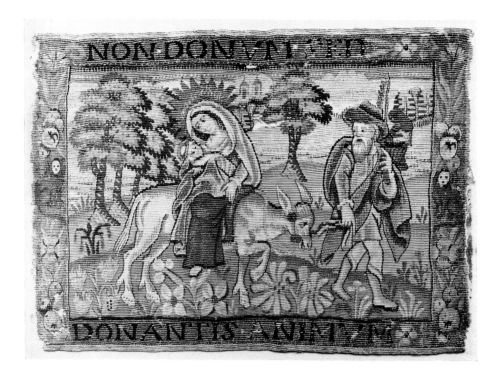

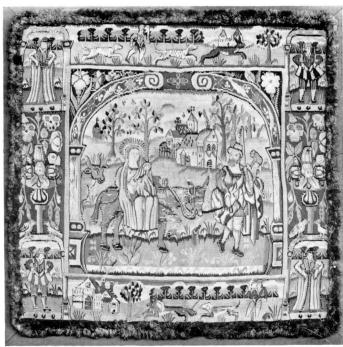

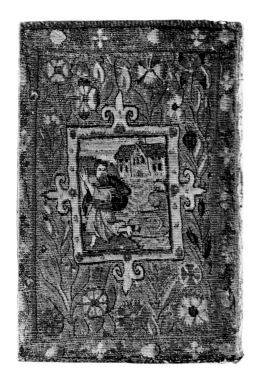

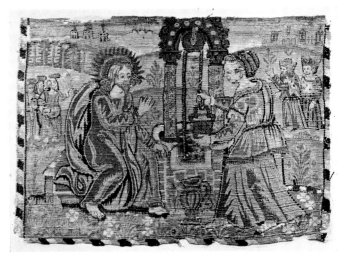

103A, i & ii. (*upper left*)　Cover for a Bible; cat. no. 72b.

103B. (*lower left*)　Small book-cushion; cat. no. 72a.

103C. (*above*)　Small cushion cover, Christ with the Woman of Samaria; cat. no. 71f.

103D. (*below*)　Pair of gloves with tapestry-woven cuffs; cat. no. 72c.

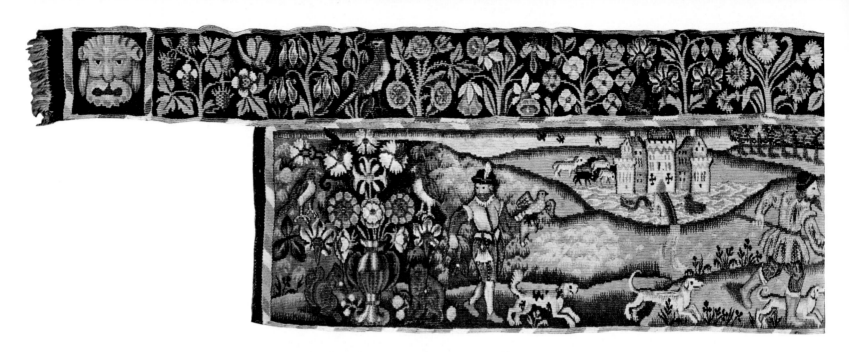

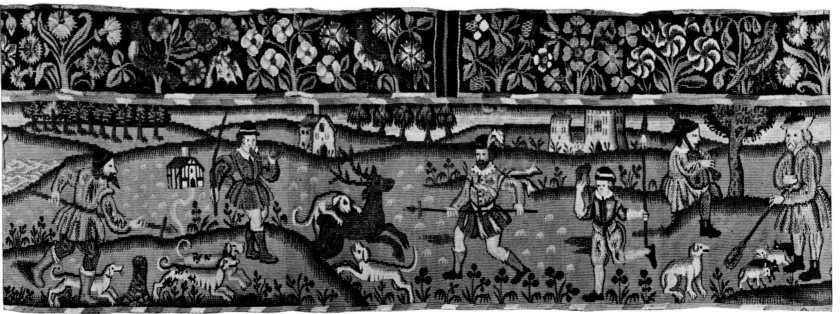

104A–B. Part of the Sheldon valance; cat. no.73.

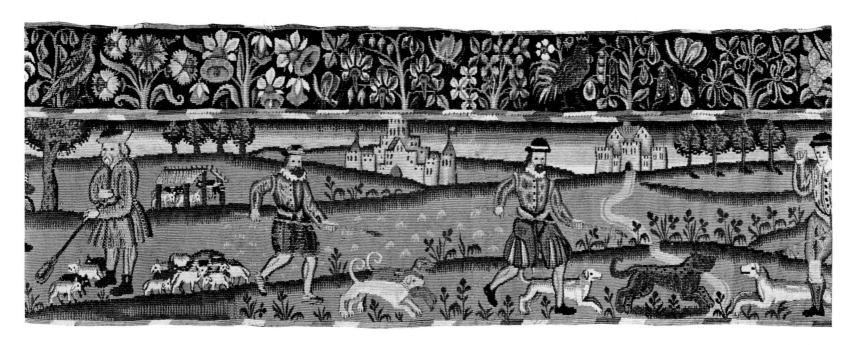

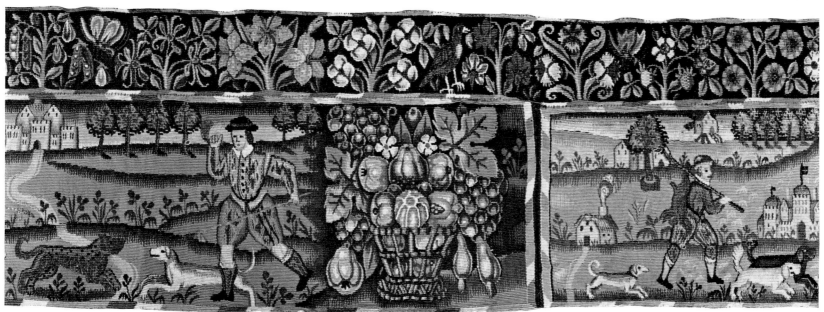

105A–B. Part of the Sheldon valance; cat. no.73.

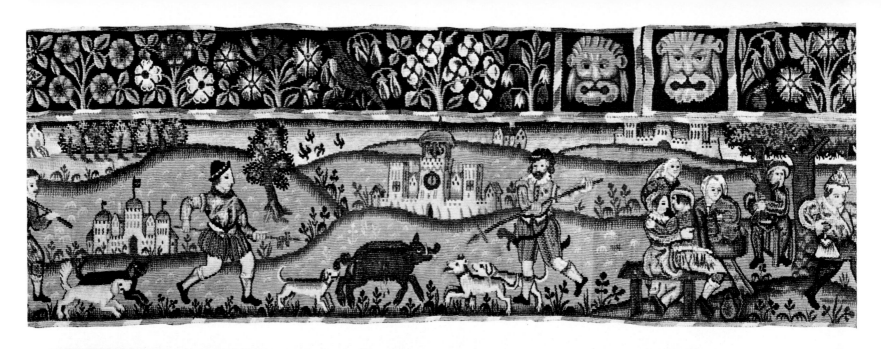

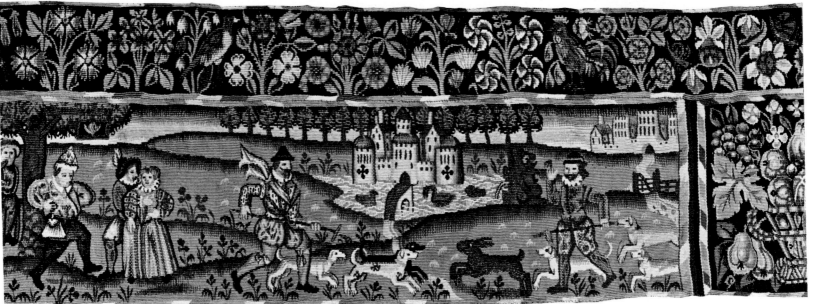

106A–B. Part of the Sheldon valance; cat. no. 73.

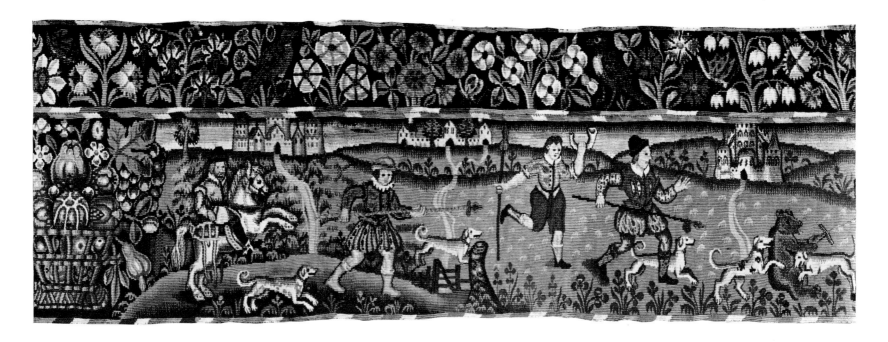

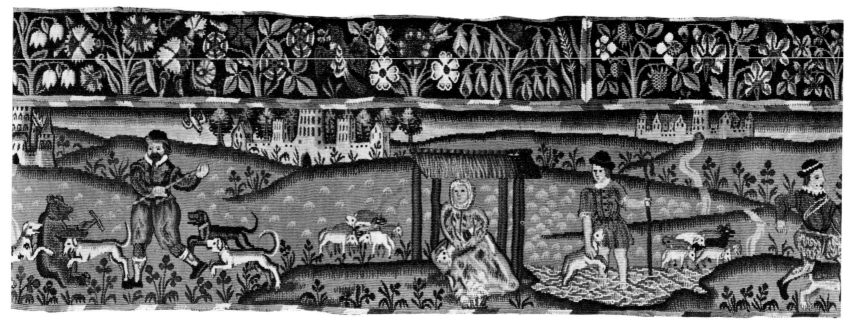

107A–B.　Part of the Sheldon valance; cat. no.73.

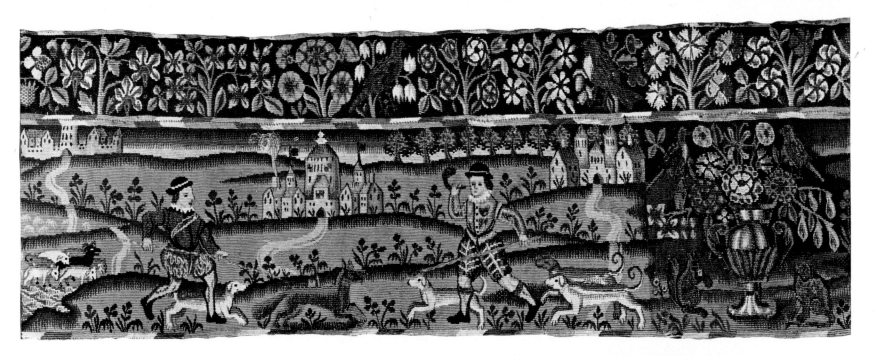

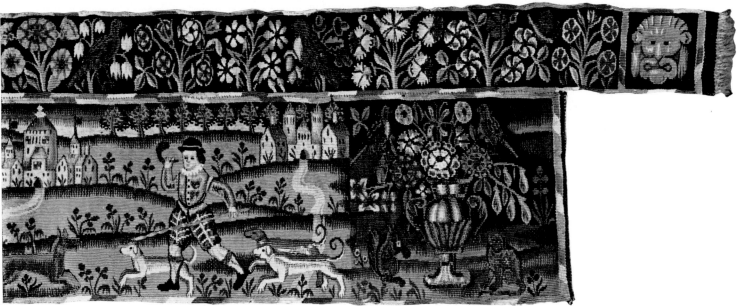

108A–B. Part of the Sheldon valance; cat. no. 73.